I, James McNeill Whistler

HODDER AND STOUGHTON
LONDON SYDNEY AUCKLAND TORONTO

James McNeill Whistler

AN "AUTOBIOGRAPHY"

BY

Lawrence Williams

For Maggie again

FIRST TRY:

*D*ETERMINED that no mendacious scamp shall tell the foolish truths about me when centuries have gone by, and anxiety no longer pulls at the pen of the 'pupil' who would sell the soul of his master, I now proceed to take the wind out of such a speculator by immediately furnishing myself the fiction of my own biography, which shall remain, and is, the story of my life. . . ."

(First paragraph of a projected autobiography by James Abbott McNeill Whistler, 1834–1903. At the bottom of the beginning page this project was permanently abandoned.)

Second Try:

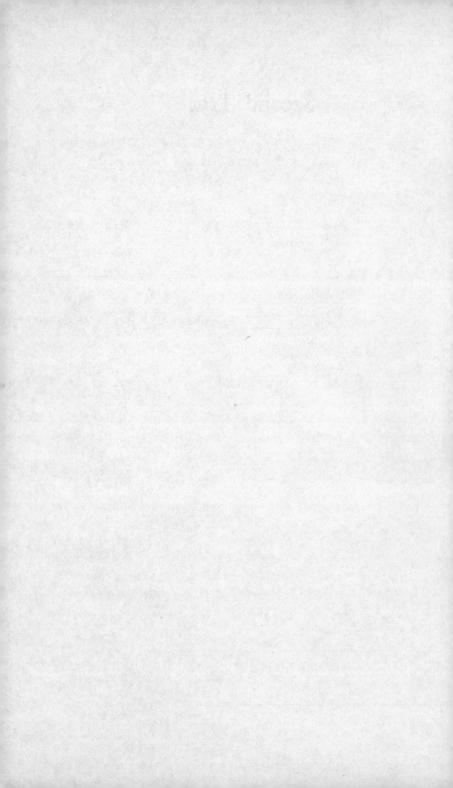

ONE

 S OME TIME ago I painted a portrait of my mother. It wasn't anything planned, really. She was staying with me at my house in Chelsea and we happened to be together in my studio. It was, if I remember, one of those wretched mornings London affords us so generously, a drizzling black sky and the water of the Thames outside my windows the color of slate.

When I say it was a wretched morning, I mean wretched for strolling in the park or for a picnic, but not for painting— not for my kind of painting, I should quickly add. Sunsets I leave to old Turner, and Landseer is welcome to his sun-drenched deer. For me there is a purity in the absence of brilliant light, in shadows that have no definable edges. It is the reason, I suppose, I often undertake the hazardous business of painting the night. People say: But how can anybody paint darkness? There is nothing to see. Well, I can, and there is much to see. The fact that I have repeatedly done so, and with delightful results, has so far escaped the general notice.

To go back to that morning, I was doing nothing of any perceptible use, fiddling on the canvas with the head of a girl I'd started the day before, and which was all wrong. The composition of the face, you see, was just two eyes, a nose and a mouth, nothing to distinguish it from life, which of course will never do.

My mother was chatting along—a gracious old lady in a black dress—telling me some hair-raising recollected incident

11

of how she had managed to escape capture while running the Union blockade in the Civil War, when I looked up. There she was, sitting in a small armchair and in profile from my point of view. What must be instantly said is that she looked absolutely not at all like the picture I finally painted. Why should anyone bother to do that? No. Nature is a trap and should be avoided at all costs by artists of any stripe, even when Nature happens to be represented by one's own mother.

What I saw was something quite different. She, in conjunction with the day outside the window, formed a pattern and an arrangement of subdued color that knocked the breath out of me. Gray and black, it was, clear as night, clear as the moon, and far more interesting. It all came together in my mind, in blocks, in open spaces, in shapes and in the joyous absence of shapes, until there was really nothing to do but to have a go at it.

Then came one of those unpleasant discoveries, not uncommon in my life in recent years. I had no fresh canvas about, not of the size I needed anyhow. For I already knew exactly what I wanted in the way of size. There was no time—and very possibly no funds; I don't really remember—to rush off and buy canvas. But even if I'd been a millionaire I would not have gone. Not only smiths must strike while the iron is hot. So of course I did the only sensible thing. I lifted the canvas from my easel (pudding-faced girl with the raisin eyes), turned it over and set it back on the easel again. I ran my fingers across the rough back surface of the canvas, unsized of course, absorbent as a blotter, not exactly standard equipment in art schools, no doubt. But my need was there, you know, and canvas, right side or wrong side, is still canvas.

I didn't tell my mother what I wanted to do. In my case, I've found, there's no use in telling people what I intend. It only makes them nervous and wanting to go home. So I lied to my mother, as to the others. I told her I was going to paint her portrait.

The idea pleased her, apparently, although I don't know and will of course never know, being her son, what she thinks

of my painting. I suspect that swashbucklers raining primary colors all over the place are more in her line.

But she smiled and said, "Jemmy" (always Jemmy, for some reason long lost in childhood's labyrinth) "Jemmy, you will make me famous."

"No, Mother," says I, in one of my least astounding prophecies, "*you* will make *me* famous."

Well, it hasn't quite worked out that way so far, as you shall presently hear. But at least the finished picture, signed with my butterfly, made a great many people laugh when it was shown at the Royal Academy, which is something, I suppose. I'm all in favor of laughing and do a lot of it myself, in fact. Still, I'm forced to admit that there's more fun in the thing when the laugh is on somebody else.

But I see that I am jumping about between events and opinion, and a garbled chronology is already threatening, while a few plain facts are clearly in order. While all autobiographers are novices of necessity (even the vainest among us could hardly find the gall to be autobiographers *twice*), I mean to be bold, to be honest, to deal in unvarnished facts, varnishing only those that displease me. Let us advance together.

I am Jimmy Whistler, if you want to know who I am. Although I add quickly that at no time in my adult life have more than ten people simultaneously ventured to call me so to my face. I tend to discourage the practice, not rudely, you know, but I find that an appropriate glance while adjusting my monocle suffices.

No. I am James Abbott McNeill Whistler. Painter. Etcher. American. The public press, of course, is an altogether different matter and calls me what it likes. It speaks only of the public man. And it is my frequent amusement to give it much to speak about. Occasionally I allow a new young acquaintance to call me Jimmy, hoping to bring us closer together, a feat, some say.

Now a word about the present. The place is London, the time is the Lord's Year 1874. I am, although I look nothing of the

kind, forty years old. I have lived in London for nearly twenty years, which may sound odd coming from a passionate American patriot. But I am emphatically not an American *expatriate*, as several of my prominent countrymen have declared themselves to be. Some day I will return to America, but the moment must be right, you know. It would be churlish to disappoint a continent.

The events of all those years, of course, will be the substance of my autobiography, and I must relate them in proper order. But I think that now, on this very rotten rainy Sunday afternoon in April, you should be permitted a general picture of my current plight.

Never mind how I happened to begin life on this sceptered isle all those years ago, although I began well. I was modestly honored, in fact. People bought my paintings, sat to me for their portraits, people of public consequence, at least in theirs and the public mind.

But I had notions of my own, you see, about painting, about what painting really is, at least to me. And as the years have gone on, I have become more and more isolated from the general stream, and I rejoice in it! My creditors fail to rejoice, however. They, in fact, incline to gloom.

People say my tongue has not helped me, but that is absurd. While it may be true that in certain aristocratic drawing rooms and in public letters to the press I may occasionally have expressed a somewhat acerbic view of some particular idiot of an art critic, or trend in art, my only object was to amuse.

Then, only a few months ago, I decided to risk all. I gave a one-man show at the Pall Mall Gallery, not a prominent one, to test my precise present standing, so to speak. Anger was the result—yes, anger. I had gone to a place where very few wanted to follow or even explore from a distance. I'll tell you about the public reaction in its proper place, but first watch me now. Jimmy on the high wire. I had been "promising" and "interesting" but now I am a "willful and eccentric painter who has lost his way." So announced the press. Ha-*ha!*

I am in love, my house is full of bailiffs representing my

creditors, my delicate dancing shoes require a spot of cardboard to augment their tired bottoms, our wine is not what it used to be. Fashionable people no longer ask to be painted by me, although they vie among themselves to get me to their dinner tables and enjoy quoting my little jokes. Things are on the downish end, taken all in all. But there may be one slim hope ahead for me, only one, as I diligently count my fingers.

Well, we'll get to that. But that won't be until tomorrow at noon; then we'll see. I pin my hopes now on one man. I will come back to the present shortly, but first things first.

Amateurs must follow accepted professional rules or they are lost. Publishers in general, I would imagine, not really knowing any, must sleep rather easier with the conventional than its opposite. Therefore, I will begin the story of my life in an entirely orthodox way. Amateurs are not allowed gaiety, else they will not be taken seriously. I will try to be as dull as possible.

I was born somewhere, like so many, although authorities —myself chief among them—differ as to the precise whereabouts of that event. Various people have said that I was born in Lowell, Massachusetts, even going so far as to remember me there yelling in my cradle, but I do not choose to be born in Lowell. A French writer of art history states unequivocally that I was born in Baltimore, Maryland, and we must never treat the utterances of art critics lightly. Particularly about matters having nothing to do with art. And I, myself, made the statement, under oath in an English court of law, that I was born in St. Petersburg, Russia, an agreeable lie, no more. All that really matters is that I was also born an artist. I later became a painter because, after all, an artist must do *something*.

I was graduated from the United States Military Academy at West Point. Well, now, you know, that is another lie, in a purely technical sense. Actually, I was dismissed during my third year for failing chemistry. But I was very dandy in gray, and it was too bad to turn me out. I informed my instructor dur-

ing an oral examination that silicon was a gas—which proved to be inaccurate—and I was summarily sent packing by Colonel Robert E. Lee, then commandant of the premises, who went on to lose the Civil War.

The occasion was a memorable one for me, dashing as it did all hope for a military career, sending me off in an altogether different direction. I had never spoken to Colonel Lee before. Well, I didn't speak to him then, as far as that goes. *He* spoke to *me*, and only a couple of sentences at that, but I remember the scene distinctly.

I was summoned to Lee's office by an orderly. It was early evening, Lee sitting behind his desk in a pool of lamplight in the otherwise darkened room and I standing at strict attention in front of the desk. I remember thinking it was a rather small and dingy office for someone in so exalted a position as commandant of West Point, and stark as a monk's cell except for an American flag in a standard and an alarming framed engraving of George Washington on the wall, his lower cheeks all puffed out as though he had the mumps.

Colonel Lee looked up at me rather sadly, I thought, and sighed. His hair and beard weren't yet as white as we are accustomed to seeing in pictures nowadays, but pepper and salt, his back straight, his eyes the palest blue, and gentle, odd soldier's eyes. This was not to be a sentimental encounter, however; more like a court-martial it was. Lee simply said in so many words that I was getting the boot. Then he sighed again and brushed his palm across his forehead.

"I regret, Mr. Whistler," says he, "that one so capable should have so neglected himself that he must now suffer the penalty."

Blindfold? Cigarette? No? *Bang!* Well, you know, the Army may be a trifle peremptory from time to time, but did you notice he called me "one so capable?" I have never forgotten it.

But I see that I have jumped ludicrously from my birth in Lowell or St. Petersburg, or wherever it was, directly to my departure from West Point, as though nothing had intervened.

16

Orderly chronology is plainly lacking. Naturally various things happened to me between birth and West Point, though not of equal interest either to you or to me. But I mean to tell the straightforward story of my life in proper order. That is my intention and one to which I promise to adhere rigidly, so long as nothing else turns up.

Something must be said. Something must be frankly announced if fairness is to be served. I am a man who finds it almost impossible to speak of what I really feel—not what I *think*, what I *feel*—to the extent that when I find myself backed against the wall, I have the tendency to say the reverse. Not, perhaps, an altogether happy admission, but at least an honest one. Watch for the guileful emotional lie, I announce.

Now then. I see that St. Petersburg has turned up, rather mysteriously, two or three times in this leisurely chronicle, and merits clearer explanation. When I was nine, my father, Major George Washington Whistler, who really *was* a graduate of West Point and a first-class civil engineer, happened to be building a railroad between St. Petersburg and Moscow at the behest of Nicholas I, Czar of all the Russias. Once settled, he sent for his wife and family to join him. Which may sound a relatively simple excursion in these progressive times but which in 1843 decidedly was not.

Which brings me back to my mother—the woman, not my portrait of her. (The two are quite different entities, as I hope I have made clear.) Now, my mother is a most extraordinary woman. She is frail in these days and no longer young (she lives in Hastings with a nurse, in order to be by the sea), but she has spent a lifetime exhibiting an indomitable courage of quite extraordinary example.

In middle life she packed up her four children and took the lot of us from Boston to Russia, in a day when there was no railroad crossing central Europe, but she got us there by carriage, by stage, by steamer—losing to death her youngest son, my brother Charles, along the way.

That, of course, is an extremely terse summary of what

were for us overwhelming events. Bewildered American travelers to a land scarcely less exotic than the surface of the moon, we Whistlers tottered along across seas and continents by any old means, secure only in the fact that at the end of our journey was our father and my mother's husband, a man of strength and ingenuity and character, who would welcome us and care for us.

Which indeed he did, but one less of us. Poor little Charles, my youngest brother, had managed at least as well as the rest of us until our final leg of our journey to St. Petersburg. Then on a ship that was taking us up the North Sea from Travemünde to Kronstadt, Charles went seasick. Well, so did we all, for that matter, but it was somehow different with Charles, most mysteriously different. He died in a single day, health to death between suns, and I never will understand it.

We buried the small coffin in Kronstadt, stunned and bewildered and dry-eyed with shock. And my mother led the rest of us to the end of our journey.

I have seen her on a St. Petersburg street in the dead of winter distributing Methodist tracts to a startled troop of wild-eyed mounted Cossacks (who, regrettably, used them for rolling cigarettes), and I have seen her making a gay celebration of the Fourth of July within a hundred yards of the Winter Palace, so that none of us, her children, in our seven Russian years, should forget that we were Americans. And in the hottest year of the Civil War, as I have mentioned, my mother ran the Northern blockade from Baltimore to New York and eventually to my house in London.

The few people who have known both of us for many years have suggested that it is my mother in me that makes me fight my battles with what they choose to term "ferocity." I take it as a splendid compliment. And I hope there is some truth in it.

Now, with Russia fairly out of the way, I expect we might go back to the days after West Point. No, that is flippant nonsense. Of course, Russia is never altogether out of the way in

the back of the mind of a man who has spent seven of his most impressionable years in that peculiar land. Russia is a point of view. I don't know why, really, but it isn't quite the same for an American ten-year-old to skate on the frozen Neva in St. Petersburg as to skate on Hubbard's Pond back in Massachusetts. To see one's first overwhelming Velásquez portrait in the Hermitage is rather cockeyed, you may agree, out of place.

And to stand at a Court levee at twelve, in hired knee britches, to watch one's father kissed on both cheeks by an Emperor, made an officer in the Imperial Army and presented the Order of St. Anne for his crack railroad, is different from watching one's father similarly blessed by—oh, say—the Fraternal Brotherhood of Bison in Reward, Connecticut. Not more worthy, you must understand, but not the same, either.

In this connection you may be amused at my father's reaction to all this Russian glory. He was a republican to the bottom of his soul, my father, and cheek-kissing emperors not at all in his line. Still, to refuse the Order of St. Anne would only have got him a firing squad, and nothing proved, so he accepted it. But the uniform that went along with his commission in the Imperial Army—an astonishing marzipan in scarlet and gold, feathers and epaulettes—was a different matter and he never put it on. The men back at West Point would have understood completely. They never got the chance to congratulate him, as things turned out.

Cholera in Russia, a great sweeping plague of it in 1849, took my father's life along with a million others. A gallant man, he tried very hard not to die. I remember him in his St. Petersburg hospital bed, looking with fevered eyes at his family gathered round him, his wife, his sons, his daughter, four frightened Americans five thousand miles from home, willing him to live. And he fought, trying to smile with dying lips, to speak reassurances with a voice no longer his own. But one does not blandish cholera.

I salute you, my father, George Washington Whistler. To find unique fulfillment at your craft, honor as a man, joy in

19

your wife and family does not happen to us all, though dead at forty-eight.

The Emperor most graciously suggested that we Whistler boys be brought up in the school for pages in the Imperial Court. He made his suggestion, however, to the wrong woman. My mother, an American, took us to America from Liverpool on the steamer *America,* to Stonington, Connecticut, to a very different life.

No longer associated with the glitter of a court, under the protection of a distinguished man, we Whistlers set up a somewhat bewildered housekeeping in a New England village, a brief era having come to its end.

For the statistically minded, our family income was reduced all in a twinkling from twelve thousand dollars a year (a Czar's grand stipend) to fifteen hundred dollars a year (an army major's pension). The discrepancy was altogether noticeable in our day-to-day lives. But I come from good bloodlines, you see, and I want you to know that so much is true.

Russia taught me a lot of things. Along with my brother, Dr. Willie, half-brother George, Deborah, my half-sister, and, of course, my mother, I learned only enough of the Russian language to ask how to get around the next corner, no more. For it was then the custom, and still is, I'm told, for the educated classes in Russia to speak to each other in French. Social historians more learned than I will have to explain this national aberration. All I know is that the lot of us Whistlers swallowed down the French language, of necessity, and made it as close to our own as any foreigner can ever do.

A gentleman does not choose to boast of small accomplishments, I suppose. Well, yes, I suppose a man does. Here's a pretty showy one, for example. Years later in Paris, Baudelaire once told me that I spoke more accurate French than Degas. And that was very swank and flattering on the surface, you know, but it really had to do with Degas' regional accent, which had nothing to do with the case. Snobbism is not my game. With

my father and mother, I am a wait-and-see republican. Though a monstrous man who has given me much personal trouble, Degas speaks the French of France.

I left my native land, and here I am in England, where I've been for nearly twenty years. The history of expatriation is long and complex, and I have absolutely no intention of examining it here. Ruth went pottering off to the land of her beloved Boaz and finally managed to find a life in alien corn. I went off to Paris only for the love of an idea. I did not fit in the end. It seems I rarely do.

It is so very nearly impossible to explain to sensible people why an otherwise intelligent man knows at some point that he must spend his life in art—that he is predestined to take seriously things like colors and forms and shadows. It requires a certain sort of selective dementia, a special insanity, reserved—and God may here be praised—for a few. Velásquez, Buonarroti and Hals come to mind, although you may have your own particular pantheon of the divinely criminally insane. My own first abuses of the sensible way of life came at the age of four when I painted a green robin. A trifle late, you may say, for your all-around genius. I grant the point, but I plead geography.

The United States of America, when I left them in 1854 or thereabouts, looked upon art, when it looked upon it at all, as a rather arcane European occupation. Oh, we'd had our Copleys and our Gilbert Stuarts, of course, but they and their like were dead and had been useful, anyhow—in the general American view—only as chroniclers of our history, so to say. They informed us that George Washington had a big nose and false teeth, that Ben Franklin wore spectacles and was overweight, and so on. Vital statistics, no doubt, but was it Art? So reasoned the few Americans who could afford to think about buying art at all when I was twenty.

No, art to them somehow had to do with simpering Fragonard ladies taking a Pekingese dog for a ride on a beribboned swing,

Canaletto bashing about the Grand Canal with an excess of vermilion on his palette, and, of course, Rubens' pink bottoms.

We despise ourselves so, good Americans that we are. We are clever at building railroads, we admit, and dams and bridges. We wrest coal from our soil in unprecedented quantities, we sail to ridiculously remote seas to hunt the whale, and not so long ago some energetic man dug a well and sent petroleum spewing all over Pennsylvania. These things we take for granted in Americans. Being young and uncluttered of mind, free of hidebound European dominance of tradition, why shouldn't we soar? Why not, indeed? But there is a single exception, you see.

We have no faith, none at all, in our native capacity for artistic creation. More particularly, I mean the special craft of painting. For art, when I was twenty, *was* allowed to be respectable, in certain limited forms, so long as it was not called art. Mark Twain, Edgar Poe (my fellow bouncee from West Point), and Bret Harte managed, in their way; Stephen Foster was permitted his tunes, so long as he remembered his place. But painters, "Real Artists," all lived in Europe. We all knew that. Even *I* knew that. And ideally they lived in Paris.

After Colonel Robert E. Lee had so arbitrarily dismissed me from West Point (if silicon had actually *been* a gas instead of whatever it is, I would be a major general today, but it may not have been my game), I hurried to Washington to right my wrongs, as I saw them. I called on the Secretary of War, a Mr. Jefferson Davis. The gentleman offered no hope in the matter of getting me reinstated at West Point. If Lee said no, Davis agreed altogether. (The historically alert will already have detected the folly of my enterprise, taking into account later divisive events in America.) But he did offer me a job.

For four months I worked in the U.S. Bureau of Coast and Geodetic Survey. My pay was $1.50 a day, excessive considering my attendance record, but oddly I learned a craft which became a special art for me. I had to copy maps, render a loose drawing onto a copper plate with perfect accuracy. Now that, as you

would naturally imagine, could be, and was to most, a dreadful servitude. But not to me!

It is entirely possible that at this very moment some hapless navigator is steering—from one of my charts—toward an island that is forty miles from where I told him it was, toward some treacherous hidden reef I neglected to chart at all. But, well, you know, sailors take warning. The thing is, I learned to etch. The needle in my hand came to be as facile as a pen over paper, the bite into copper absolutely sure.

Apart from learning to etch, life in the Coast Survey office was unmitigated hell. A great musty barn of a room it was, with row on row of slant-topped wooden desks before each of which perched a poor, ink-stained devil on a high stool, each of us only counting the hours until we could get out of the place.

As luck had it, I presently found reason—even more than my fellow slaves—to long for the end of the day. Not to go home, as the others did, for I lived in a dingy furnished room in a lodging house at the corner of E and Twelfth streets, but to gad about in Washington's most elegant drawing rooms. If that sounds like an implausible activity for the most junior clerk in the Coast Survey, well, it was. But I had fallen into a bit of luck.

The Russian Minister to Washington at the time, Edward de Stoeckl, had been a great and good friend of my father's back during our St. Petersburg years, and he took me immediately under his wing. The Russian Embassy in those days—perhaps it still is—was by far the gayest in the city and I came to spend five evenings a week in it, at dinners and dances and magnificent formal balls, eating and drinking the best food and wine in the city, flirting with the pretty daughters of archdukes, hob-nobbing with diplomats and senators and so on. To return their favors in my only possible way, I invited the Minister and his lady to my furnished room for a late-night supper or early-morning breakfast, whichever you will, where we laughed and chatted the night away over vodka and American buckwheat cakes of my own manufacture, to the extreme displeasure of my land-

23

lady. I suppose it was the first of what were to become my famous Sunday-morning London breakfasts.

As time went on, I naturally turned up later and later at the Coast Survey office. Some days I didn't turn up at all. It became a sort of obsession with me that they discharge me. (A West Pointer, after all, doesn't simply quit.) If *I* had been the Coast and Geodetic Survey, I would have fired me, but they were more kind, apparently, only clucking their tongues. Something more drastic was required—for I knew by then, you see, at least dimly, that I must go, that an altogether different life was waiting for me just over the horizon and I must begin it.

I found a way; I had to. I was eventually dismissed for placing two charming sea gulls, beautifully etched, on a chart of Nantucket Sound. My sense of composition absolutely required those sea gulls. The U.S. Geodetic Survey had no sense of composition.

Here in London, twenty years after, a man in the critical press chose to remark apropos a set of etchings of mine in a local gallery: "It rather stuns one to say so, but the truth must be said: the etchings of Mr. Whistler, for all their unconventionality, rank only scarcely below, if not actually beside, those of Rembrandt in their astonishing technical accomplishment."

Well, of course one can't go by these blokes. But I thought I might as well mention it. Anyway, the man hates my painting, so that's all right.

But let us return to the dream of Paris. At twenty-one I might very easily have been taken for a Frenchman, or, at any rate, something or other non-American. By that I mean, of course, not particularly Anglo-Saxon. By ancestry I am a Celt— half Anglo-Irish Whistler, half Anglo-Scottish McNeill—and I looked it. Not very tall, slim and muscular, black eyes and eyebrows, dashing black mustache and brief chin whiskers, fit for immediate duty as a musketeer, or anyway a Parisian art student.

Penniless though I was, I informed my family that Paris

was where I had to go. And do you know, in some strange way, they knew it too? I don't know why; perhaps they had only some vague intuition that their uneasy son and brother, always drawing and not attending to graver things, belonged somewhere other than where he was.

We all sat in the big kitchen of our small rented house in Stonington, my mother, brothers Willie and George, and I said what I had to say. The kitchen, I remember, was partly below ground, spring the season, so that wild flowers outside pressed against the windowpanes, and a Bible always open on the table. A token blaze burned in the big fireplace against the evening chill, our handsome Carolina cook, Black Margaret by name, stirring the batter for tomorrow morning's corn bread.

"Mother," says I, "I think I have to go to Paris."

"Yes, Jemmy. We know that."

"You do?"

"It's the right thing. But we'll miss you."

It was the most extraordinary feeling, as though my family had planned for me further ahead than I had myself. I found that I couldn't speak; my throat suddenly tightened, looking into the faces I knew best in the world.

"We'll manage to send you a quarterly amount of money, Jim," said good solid George, "until you get on your feet. Can't be much, of course, but enough to live on if you're careful."

How does one explain such simple graciousness, how explain such generosity of spirit toward a twenty-one-year old son and brother who had so far proved himself not capable of performing anything useful in the world? Had they some private premonitions of a great future for me? Could they see some special mark upon my brow invisible to others? *Rot!*

How explain it? Plain blind love explains it, and that is what is never forgettable.

They didn't even go into it much more. They just bought me a ticket. And there wasn't any extra money about in those times. My older brother, Dr. Willie, was only barely a doctor, just making a precarious beginning. And my half-brother George

ran, in partnership, some sort of shaky locomotive works in Baltimore which he halfheartedly tried to persuade me to join, in what capacity I have never really understood, but soon gave up.

No, the good Whistlers did not argue. A ticket to France and three hundred and fifty dollars a year is what they promised me, to be paid me quarterly by systematic George.

For how long? Well, we didn't go into that, you know. Better to delay the glance into the pit, meanwhile watching the roses grow. We wept, we kissed each other, spoke of high fortune with slightly averted eyes, and so I left America, not to return, as it has worked out.

Before leaving, I read, as did all romantic gallants at the time, Henri Murger's idiotic *Scènes de la Vie de Bohème*. I dared to skim through it again the other day and it—how shall I say? —put me into a state of combined hilarity and indigestion that was not easy to subdue.

The picture was more or less this: The dedicated art students of the *Quartier Latin*, in the book, pursuing their special angel, wore velvet berets, ragged smocks and raffish airs. They lived in squalor, and squalor was the best of it all. There was apparently nothing like a bit of starving in wretched circumstances to get required artistic results; on a chilly night stoke the dying stove with poetry and sonatas—there will always be more and, anyhow, everyone knows sonata smoke smells better than coal smoke. Paint your masterpiece with a rope's end for lack of a real brush, steal your paints from rich, unworthy dilettantes, live with a charming *grisette*, poor and possibly doomed, who shares your particular vision; talk the night away in shabby cafés with your peers, passionate young men who would change the world of art along the very lines you have had in mind all along. Freedom at last, and joy in creation! And so on and so on. Nonsense, all romantic nonsense, of course, only silly book talk, one knew it instinctively.

Well, do you know, I went to Paris at twenty-one, and the

whole thing, right down to the most alarming details, the whole thing was absolutely *true*.

Green and a foreigner, I didn't see it immediately, of course. Indeed it took me four years to go in one end of bohemian Paris and come out the other, knowing at last that it was not for me— or I for it; but I am anticipating and incidentally inciting the French art community to riot, always a mistake.

Arrived in Paris, I went about purely practical matters. First your velvet hat, you see. Next, a studio—well a room, if you will —seven gasping flights up into the sky. (Three hundred and fifty American dollars, while no doubt very grand and wholly undeserved, were not precisely a door key to the Tuileries Palace.) And, anyhow, I dredge up this interesting calendar as a lemon-peel man of forty. Seven gasping flights, indeed! At twenty-one I did not gasp. I ran up the stairs two at a time, sometimes running to the eighth for the principle of the thing, saving the precious francs that were properly extracted from flutter-heart potbelly on *étage* one.

I was very serious, for a little. An art student, it seemed to me, should go to an art school. I had heard about the studio of Charles Gabriel Gleyre, where a certain number of students were instructed by that good gentleman. Gleyre's painting was much admired at the time, but that was not why I went to his classes. He is remembered these days, if he is remembered, as the successor of David and the classicists in general, not my cup of tea at all. But he was more than that, for in spite of his work he held theories that were very disquieting to the academic minds of the time, and therefore worth listening to.

I don't, I promise faithfully, mean to tax the patience of the non-painting reader with the technical aspects of my art. Indeed, it is one of my most profoundly held beliefs that the technical means by which a painting is achieved is not, and should not be, of the slightest concern to the untrained observer. If that observer is compelled to admiration of a painting because of its flashy brushwork, or eccentricity of composition, or even only

clear evidence of a great deal of hard work, then the artist has failed him. Means should not show, only original vision achieved.

But back to old Gleyre, a fascinating case, he was. The only painter, at least so far as I know, who preached a particular and very carefully thought-out principle of painting, and then practiced it not at all.

He painted alarming (and glacial) nymphs and satyrs chasing about Mount Olympus, and dreadful smiling muses and that sort of thing. Yet, at the same time that he was committing these academic disasters, through his hands were passing some of the most brilliant young painters of the day, Monet and Renoir among them, just to pluck out a couple. In fact, it was Monet who told me that Gleyre—natural classicist to his dying day—had told him casually, "Nature, my friend, is all right as an element of study, but it offers no interest. Style, you see, is everything." Well, well. I don't complain; I only puzzle.

But it was Gleyre who taught me at least one thing about painting that has become a basic rule of my method. It has to do with the preparation of one's palette. Now, to many painters, to most, the business of placing globs of raw color on their palettes before beginning work is only a boring preliminary, more or less comparable to a carpenter's making sure he has a saw, hammer and enough nails on hand before he attacks his wood. And no doubt carpenters have built splendid hen houses by this method. Painters, using this same logic, have produced ten thousand coffins. I do not mean to imply that coffins are any less useful than hen houses, only that coffins are less inclined to raise the spirits.

No, to me the planning of a palette is more than half the finished picture. Here is my way, at least. I look at a subject I have planned to paint. The subject makes no slightest difference, by the way. Whether it is a person or a seascape or, as often happens, only a memory of something observed, nothing alters. What I plan to paint is, in my Byzantine mind, already painted. There remains only the journeywork of committing it to a stretch of canvas.

It is all there, absolutely all, particularly in the matter of

color. If my eye has told me that this bit is to be gray, that bit rose and the other black, well, then, I mix precisely what I need on the palette before I begin. Although *it* is the true beginning. The actual execution, assuming some degree of technical competence—and if we cannot make such an assumption there is no point in the whole thing, anyway—is almost an anticlimax. Everything is *there* ready to use, and full attention can be applied to drawing, to modeling on canvas in color, and so it goes on apace.

Harry Greaves, a good chap in the neighborhood who would seem to want to be a painter himself, often rows me about the Thames at night so that I may perhaps one day understand the special meaning of darkness. Harry told somebody—I don't really know who, and it doesn't matter, but it somehow got into the *Times*—that "I've seen Mr. Whistler spend two days arranging and mixing the paint on his palette, and then spend no more than two hours painting his real picture. That's his special way."

I thank you, Harry. And I thank you, more especially, M. Gleyre, who taught me the lesson. But of course nothing is true all the time, like stopped clocks. I have been known, for example, temporarily to unhinge the mind of an otherwise delightful twelve-year-old child whose portrait I was painting by insisting that she stand absolutely still for seven hours a day for seventy days. And she did it, too. She is older now, her mind brilliantly recomposed, but still unable to speak my name in natural conversation.

Which only shows my plan (and M. Gleyre's) was not altogether infallible. For sixty-nine nights I wiped out sixty-nine daytime portraits, to the despair of the poor child, but I had tried to stick to the vision of my eye and my palette. It would seem, however, that artistic theory can be pressed only so far for the earnest practitioner. We are alone and often mistaken, which is quite as it should be. I admit to sixty-nine days of mistakes. But I point to triumph on the seventieth. Frock-coated old Gleyre would have been amused, I should think. Dead now, of course. I followed his word absolutely as far as I could.

But at twenty-one I really wasn't much of a follower, to be

honest. (At forty, to be still more honest, I am not a follower at all. I am at present a leader—of a one-man band, it has been suggested—but I prefer to believe that my legions are only in embryo, gestating barely under the crust of the earth and ready to spring from it, fully caparisoned for battle, the spawn of planted dragon's teeth!) Oh, my. We can't stand much of *that* sort of thing in this nostalgic review, can we? Calm and considered retrospection is my admitted goal, fingers laced across belly, chair in recline, absent smile, port and walnuts, a very occasional modest belch for emphasis, no exclamation points.

M. Gleyre, as I've pointed out, was a peculiar combination of imaginative artistic man and dreadful painter. I was willing for a time to take one with the other, so it was not he who drove me from his classes at last, but the British. That sounds odd, I suppose, but it can be cleared up in a moment. If you have ever read *Trilby* by George du Maurier, you will have a certain advantage.

In that peculiar work you will find the lot of us at old Gleyre's studio, at least the English-speaking lot of us, among the art students depicted. Some are now well known, some not, some dead. Also in the original magazine serialization of the book you will find an objectionable little character named Joe Sibley, a lazy American art student, dark of complexion, who rolls his own cigarettes, wears his broad-brimmed hat at a rakish slant and affects a monocle. Joe Sibley is referred to throughout as "the idle apprentice, *le roi des truands* . . . in debt, vain, witty . . . most original artist." And he was also immediately referred to in knowledgeable circles as James McNeill Whistler.

Not for long, however. Through my solicitors I was forced to inform du Maurier—once my good friend, or so I had supposed —that if Joe Sibley appeared in *Trilby* when published in book form, I would find it necessary to sue him for a million pounds. Well, you know, Joe Sibley disappeared from *Trilby* as though he had never been, to be replaced by one Bald Anthony, an exceedingly colorless character, or at least he seems so to me, but then literature is not my dodge.

All these English art students in Gleyre's classes were at bottom, as is so often true of Englishmen in general, far more interested in games than in art. They were forever punching each other about in boxing matches, swinging Indian clubs, running races, breathing at open windows and so on.

I remember coming into the rooms we all shared one day to find Poynter and du Maurier battering each other with boxing gloves in one place, while in others Armstrong was swinging upside down from a trapeze and Lamont hurling about a gigantic medicine ball. Well, it was a hot summer day and the lot of them were scarlet in the face, gasping and sweating.

"Tell me," says I, "can't you get the concierge to do this sort of thing for you?"

They didn't like it, you know, thought I was making sport of them or something. Actually, I was being perfectly serious. Anyway, they kept at it. They turned the whole place into one great English boarding school, which was not my idea of bohemian Paris.

Although it took me some months to realize it, my arrival in Paris had coincided with a singularly exciting and vital revolutionary moment in painting. And a very far call it was from the British boarding school. My gradual reaction to the latter was simply to attend less and less at Gleyre's classes until I finally went not at all. Hence I became, I suppose, du Maurier's "idle apprentice."

But I had the advantage of fluent French, learned in my Russian years, and so I came presently to know my French contemporaries, leaving my English ones to their Indian clubs and barrack-room ballads. And there I found the startling joy, the intensity and the nonsense, the gravity, love, fist fights, fornication, dedication, all put together with much laughing, that I had had in mind all along.

In artistic terms, let me put it to you this way: You will no doubt find many of the following names familiar here twenty years later. Which will make a special sound in your ear? The

31

English? (My classmates at Gleyre's.) Poynter, Lamont, du Maurier, Rowley, Armstrong. Or the French? Manet, Courbet, Bonvin, Renoir, Monet, Degas, Fantin-Latour, Legros, Pissarro.

Well, yes. And a good thing I knew French, too. In the end, one owes the most unexpected things to geography. Naturally all these men were of somewhat different ages and stages of artistic development. Courbet, for example, our special hero, while not yet actually acceptable in a public sense, was an undisputed leader of the *avant-garde* and even occasionally *sold* a canvas to some adventurous patron, a staggering event. Fantin and Legros were, like me, at the bottom of the heap, my "no-shirt" friends, as the English called them. So we formed together the Société des Trois, a distinctly loose organization which existed mainly as a sort of mutual protection and admiration society, holding nightly meetings in shabby cafés in order to keep our courage up.

But these distinctions are, or were, trifling at the time. Since then, each man has hurtled off in his own private direction, some to uncommon fame in the Impressionist movement, some to oblivion, some to whatever lies between, almost all of us to contentious public abuse. But then, then we were all comrades, without time or inclination for small differences, because we were so few, you see.

Our enemy was a formidable establishment hundreds of years old, fat and satisfied and rich and solemn as the grave is solemn. Romanticism, classicism were the common enemy to us, as was sentimental anecdote as acceptable subject matter. We, on the other hand, were passionately interested in the reality that we saw around us; everyday subject matter, whether beautiful or ugly, was the stuff of our work. To be painted with masterful truth, of course. Well, the God's truth, you know.

The cry of realism, which we raised at any or no provocation, is of course for any practical purpose a totally meaningless term. It is simply the handy catchword of the would-be reformer in art who dislikes what has immediately preceded him. It was in the name of realism that Ruskin praised Turner and his melo-

drama. Realism was invoked by the Pre-Raphaelites as their reason for painting every vein in every leaf in the foreground of their pictures, to the absolute sacrifice of reality. Zola defended the early canvases of Manet for their realism. Indeed, I can with no effort at all imagine old Giotto, flapping about the streets of thirteenth-century Florence wearing a sandwich board inscribed: AVANTI REALISMO!

No, realism is a delusion, and actually no part of a painter's business. It is even the last thing we hope to achieve. But the opposite of realism is, of course, falsity, and you can't very well go around starting a falsity movement. Recruits are lacking. Nowadays, portraits apart, I myself paint from memory. What I remember from a scene carefully observed *is* reality. What I forget was just a bit of clutter in the first place.

So, in a very general way that's what we were all about, we no-shirts of the 1850s in Paris. But too much history, like too much wine, inclines to muddle strict attention, as some traitor-historian has pointed out. I belong to his legions.

Well, I mean, midnight discussions about the relative merits of classicism and realism in art were not my only occupation in Paris at twenty-one. No, lust must have its place in even the most earnest life. And quite properly so.

I have said that in order to be an authentic bohemian it was understood by us all that an art student must share his garret with a charming *grisette*, or he wasn't playing the game properly. Actually, I shared quarters with several during my four years in Paris, but a man does not like to boast, so I will confine myself to one, the only one that matters in any case, for we spent two whole years together: Fumette. Her real name was Eloise but for some reason now well beyond recall I named her Fumette. It will be a good deal more illuminating, in any case, to tell you that around the *Quatier Latin* she was kown as *La Tigresse*.

I met her one evening in one of the gardens along the Seine embankment where dancing went on nightly. She was

33

small and not particularly beautiful, although the green-and-yellow tiger's eyes were certainly arresting. But it was not her superficial appearance that first attracted me to her, but a joke, and I fall in love with jokes. I noticed at once that she was carrying a book under her arm, a dog-eared volume she would not relinquish even when we danced. I asked her what book it was.

"My bible, *monsieur*," she replied, looking vaguely mysterious.

"Oh? *Mademoiselle* is religiously inclined? The Church's gain will be our loss."

She was impatient with me. "Not *the* bible, *my* bible."

"The distinction has possibilities. And what is its title?"

Fumette fixed me with her glittering eye, a rather unnerving experience, and continued. "It was written by a genius named Henri Murger," she said intensely, while my eyes began to pop, "and it is called *Scènes de la Vie de Bohème*."

Well, it was altogether too good, you know. Fumette and I were living out of the same book! It didn't matter that I had read my copy in a dreary government office in Washington, D.C., and that Fumette had read hers (as I later learned) on a farm in Brittany; the result had proved the same.

Both of us had been pulled to the same place at the same time, determined to be gay and possibly tragic bohemians in a world dedicated to art. Of course Fumette was one up on me, carrying Murger's book around with her the way a tourist carries his Baedeker, ready for instant reference. But Fumette was my Mimi, which was all I needed to know, what I had dreamed of.

Though small, she came from tough Breton peasant stock and had probably never experienced any illness more debilitating than a runny nose and never would, she chose to be dying of consumption. She coughed a lot, with considerable effort, searching for nonexistent bloodstains in her handkerchief. She looked into my eyes and said, "*Cher ami*, Murger says we must not expect that tomorrow will really arrive. Only the present moment is true." Naturally, I fell in love with her at once. It was as inevitable as sunrise.

And so we shared my poverty—there was nothing else to share—in a combination of sexual bliss and interesting domestic uproar. No, it was better than that, while it lasted. Even though Fumette became an art critic, particularly of my portraits of her.

"Jeemy!" she would shriek—I tried to make her call me Jacques, for simplicity's sake, since we spoke only French together, but it was not foreign enough for her—"Jeemy, you make my face look so damn *healthy*. Are you so blind a painter you cannot see that the pale hand of Death has already lightly brushed my cheeks?"

"Forgive me, Fumette. I mistook it for the pale hand of cornstarch."

"*Salaud! Saligaud! Espèce de Canaille!*" And my charming *tigresse* would fling herself at me, claws flying at my face. Even today I still have a very minor scar or two somewhere around my left eye. They are scars I would not part with, for they were earned in a joyous time of my life, one I cannot always recall clearly nowadays.

And, anyway, Fumette frequently forgot that she was supposed to be dying, and we would in those times hire a boat and row up the river, sometimes with Legros and Fantin and their ladies along, and spend an hilarious day, laughing at our own jokes, picnicking on a fifty-centimes sausage, a great loaf of bread and a bottle of wine that would have instantly rendered the sacrament of Communion obsolete in any self-respecting church, splashing about in the river in our skins.

None of us had any money to speak of, you will have gathered, but we found ways. Fantin, for example, put me onto a good thing, or a fairly good thing. Many of the hundreds of little parish churches around Paris, he discovered, wanted to put on a bit of swank with their own paintings of the Stations of the Cross, but lacked funds, at least for the Raphaels they had in mind. Fantin and I took over.

We painted dozens and dozens of them, and they were damned good, too, if you like imaginative Stations of the Cross. But there was a hitch, as in so many worthy business enterprises.

The wretched parish priests, intent on getting their money's worth, insisted on bigger and bigger Stations, and we were supposed to provide our own materials.

Well, by the time we'd bought and stretched a canvas four feet by eight feet and painted it with our own paint—even with Fantin starting at one end and me at the other, both working like damned otters—the cost and the rewards came out to pretty much the same thing. At last we gave it up. The Holy Church didn't really lose much by our decision, I suppose, although it might have gained a parishioner or two who could have come to smile as they prayed. Fantin-Latour is well known these days.

No matter. We found a new dodge to buy us our breakfasts: copying. Now, this is a practice I really don't understand at all—from the standpoint of a reasonably serious painter, I mean, of course. The galleries of Europe are cluttered with copyists from every corner of the globe, huddling in groups before accepted "masterpieces," squinting at their easels, teetering on tiny canvas stools, making exact, or more often inexact, copies of what hangs on the wall. They are supposed to be learning the technical methods of their chosen "master." Why in the gracious name of artistic reason . . .

Well, well. I wish them a fine day. So long as it doesn't rain. It should certainly be clear to anybody—in an arithmetical sense —that if one painting is regarded as a "masterpiece," plain as Euclid, ten copies of it must enhance its initial value by a quotient of ten. But I am getting dizzy.

Still, out of an uncomplicated need for the plain necessities of life for Fumette and me, I became a copyist in the Louvre. My choices of subject matter, I see in retrospect, were dictated by an interest in food. Veronese's "Marriage Feast at Cana" was overwhelming in its appeal to me; defunct Dutchmen, whose names I can't even remember, were represented in the galleries by marvelous works—from a culinary point of view—called things like "The Kitchen" or "The Glutton's Reward," in the second of which the protagonist lay expiring on the floor beside his dinner table, gasping his last, presumably from an overdose of guinea hen and truffles or whatever. A well-deserved fate, no

doubt, but you should have seen what he left untouched on the table! I copied each mouth-watering detail with the fixed concentration of a man painting his beloved mistress.

And, you know, the curious thing is people actually *bought* some of those things. Not for a great many francs, of course, but on our particular budget any francs were better than no francs so long as the income exceeded the outgo for paints and canvas. But just by luck I had happened to coincide—in my Gastro-Intestinal Period—with a fashion among the *petite bourgeoisie* for what were then known as *Salle à Manger* pictures. That is, you hung them in your dining room and looked at pictures of food while you ate actual food. I have never really understood why almost photographic representations of gaping dead fish and strung-up rabbits bleeding from the nose were supposed to stimulate the appetite, but then I expect I am a fussy eater. Anyhow, it was the fashion. Needless to say, my copy of the dying glutton was not at all in fashion. Gluttons tend to eschew dying gluttons, even in effigy.

What happened to the wretched painting was this: Fantin and I, carrying the huge canvas between us, crossed the Seine and offered it to the big dealers on the Right Bank for five hundred francs. No. So we went back and offered it to the smaller dealers on the Left Bank for two hundred and fifty. No. One hundred and twenty-five? No. So we went back across the river and offered it for seventy-five, back again for twenty-five, then ten. Well, it was a hot day.

As we were crossing back over the Pont des Arts (well named!) trying to get rid of the thing for five, Fantin and I looked at each other and there was an instant, though silent, communion of minds. He took his end and I took mine. *"Un,"* we said, starting the thing swinging, *"deux, trois et—v'lan!"* And over it went into the river, where it had properly belonged all along. I can recall no more deeply satisfying artisic experience. There was a great outcry, *sergents de ville* came running, all traffic stopped on both banks, boats pushed out from shore. Fantin and I were enchanted with our success. The picture sank gracefully to the bottom.

I must be frank and admit that I was not the public's ideal copyist. Some are, some aren't, that's all. My trouble always was that, sitting before a "masterpiece," I did one of two things. If I became interested in the subject matter of the painting, I painted it more and more my own way so that in the end it was not a copy at all, defeating my client's whole purpose. Or, more frequently, I tried to copy as exactly as I could and, in consequence, dozed off rather a lot. God knows where all those copies are now. I only hope I may never have to see them.

But—and, oh, it is so great a but—copying idiot paintings for idiot dealers and clients in the Louvre means that you must spend a thousand hours in the Louvre. I have said that what small formal training I've ever had was from the studios of Gleyre, from Courbet and Bonvin, and I acknowledge my debt to them with honest thanks.

But my teacher was at last no man. My teacher was the Louvre. That most extraordinary three or four miles of footpath encompasses absolutely everything and constitutes a private education. The Louvre is, of course, a glorious hodgepodge, as is any great museum, a seemingly brainless mix of trash, hopeful trash, and then the miracle of so much that is very great and very beautiful. I suppose I wore out five pairs of shoes in the Louvre, and it was shoe leather well spent.

For a young man mustn't be exposed only to the highest achievements in art, you see. If he saw only those, he would be forced, in despair, to become either a suicide or a plumber's assistant; never a painter. Rubbish in museums is very important to the young man, a great source of courage. His own early rubbish is automatically endowed with a certain dignity by comparison with established rubbish exhibited in marble halls.

In a day's tramp, during which the young painter has been exposed to Velásquez, Hals, da Vinci, El Greco and Rembrandt, it is enormously comforting suddenly to come upon a painting forty feet long by a French or an English Academician, depicting, say, oh, anything, the Coronation of Napoleon, Zeus as a Shower of Gold—anything that took some dismal misguided clot

ten years to paint a splendid postal card—and the young man is no longer hopeless. Velásquez is in the very far distance, to be sure, but the young man's goals have been narrowed, his field defined, and he dares to go on.

Along about this time I ran across a crazy American in the *Café Molière*. I was sitting there one evening with Fumette and Legros, the three of us trying to make a tiny Vermouth apiece last until bedtime, chatting about this and that. (Well, no, people who sit about with me in cafés don't actually chat much. They listen to me tell them stories, mostly about myself, a practice for which I have been criticized over the years. Well, you know, I've never seen anything wrong with it, so long as my listeners are *amused*. I enjoy amusing people, and I enjoy amusing myself. For I promise you faithfully that if I ever saw so much as a flicker of boredom cross the face of such a listener, I should promptly take the Trappist's vow. To bore one's friends is no less a sin than to betray them.)

Suddenly, from behind my chair, came a great booming voice, accented in an unmistakable New England twang.

"Do I have the honor of addressing Mr. Jimmy Whistler of Lowell, Massachusetts?"

I turned around and saw a rather heavy, red-faced man dressed in a white suit and smoking a cigar, a Panama hat on the back of his head. Mark Twain was just starting to be all the rage in America just then, and some American men made the mistake of trying to look like him.

"My name is Whistler, sir," says I, without too much warmth, since he had interrupted a good story. "The rest of your information is hearsay."

"Well, sir, Mr. Whistler," says this citizen of my motherland, "I'm Captain Billy Williams, Stonington Bill my friends call me. Stonington, Connecticut, not a hundred miles from your own home town, sir. Met your mother once, fine lady."

"My home town is the town in which I make my home. And your mission, Stonington Bill?"

"Just so. I have a little business proposition, Mr. Whistler, good for us both, if you agree. I would enjoy buying you and your French friends here something to drink, whatever you like."

"Take a chair, Stonington Bill," says I, drawing one out with my foot. For in those days I was not frequently offered both a drink of my choice and a "business proposition" together, or even separately.

Poor Legros and Fumette, neither of whom spoke a sentence of the English language, were looking at me and at the sudden American apparition in much bewilderment. I introduced them, if that is the exact verb I am searching for, and Stonington Bill sat down, snapping his fingers for a waiter.

At least that much was clear to Fumette and Legros. Both simultaneously polished off the quarter inch of the cheap vermouth still in their glasses and looked up expectantly.

"Cognac," says I, "Napoleon."

"Cognac," says Legros.

"Cognac *double*," says Fumette, sensing no reason to skimp. Aside, she says, *"Mais qui est ce type, Jeemy?"*

"Un vieil ami, je pense. Attends."

"I've seen two of your copies of masterpieces from the Louvre art museum," says Captain Bill. "And I want some for myself. More copies, that is."

"But why?"

"I admire your style, Mr. Whistler, and I ain't ashamed to say so. I'd put your pictures right into my own house."

"But, sir," says I—rather unknown ground here—"any copies I have done are not in *my* style, or else they wouldn't be copies, would they?"

"Call 'em whatever you like, it don't matter to me. You've got the touch I've taken a fancy to, that's all, so your pictures look better to me than the ones in the art museum," says crazy Stonington Bill. "And I'll pay twenty-five good American dollars apiece for as many copies as you want to make."

Now, for a man whose predictable income was three hundred and fifty dollars a year and who was supporting Fumette

as well, an uninterrupted stream of twenty-five-dollar copies—always provided I didn't go mad in midstream—was like offering me the key to the vault at the Banque Nationale.

"Tell me, Stonington Bill, which paintings in the Louvre did you want me to copy?"

"Oh, anything, anything at all," says Bill airily. "Whatever you like, always taking into account it's a picture with a high moral message. None of your orgy pictures or anything. I'm a family man, Mr. Whistler, dear little wife and two pretty little girls."

By now poor Legros was clearly going out of his mind for lack of understanding, his eyes glued to my face for possible clues. Now he leaned far forward across the table, speaking for reasons of secrecy in a loud stage whisper.

"*Qu'est-ce qu'il a dit*, Veestlair, *qu'est-ce qu'il a dit?*"

I explained.

Legros rolled his eyes. "*Chacun vingt-cinq dollars?*"

"*Oui.*"

"*Il est fou, tu crois?*"

"*C'est bien possible.*"

"*Mais ce n'est pas important, n'est-ce pas? Garçon! Un autre cognac!*"

"*Pour moi aussi*," chimes in Fumette, "*double.*"

"*Moi aussi*," says I, and when the brandy came I raised my glass to my art-loving compatriot and patron. "I accept your terms, Captain Stonington Bill, with pleasure, for they are at least honest terms. I will, for as long as it is necessary, and no longer, paint what *you* like so that I may the sooner paint what *I* like."

"Fair enough," says good, crazy Bill. "Clean Yankee bargain." And we shook hands.

I have never known a cleaner bargain, although I have since made bargains with nobility and lesser swells, not all of them kept to the letter. I salute Stonington Bill, for, in spite of his somewhat alarming taste, in his modest way he set me free, far sooner than I had any right to expect, to become James McNeill

Whistler, presently reviled American painter. Without him I might not have been reviled for years. Or even noticed at all. I thank you humbly, Bill.

Well, you know, I trotted off to the Louvre the next morning and started copying everything in sight, all within the boundaries of Stonington Bill's stated preference, of course. More than twenty years have intervened now, and it's difficult to remember details, but I know I copied a picture by some German or other of a woman holding up an infant to a barred window beyond which, dimly seen, was the face of a haggard man; a terrifying inundation scene, probably called "The Deluge," with lots of people going down for the third time; a St. Luke with a halo and for some reason crossed eyes.

(How can even the most divinely inspired biblical painter know that St. Luke was cross-eyed? Halos, we all know, are General Issue to saints, rather like fatigue caps in the army, so that was all right. But, while I had no special feelings about Luke one way or the other, I straightened out his eyes. I felt it was the gentlemanly thing to do for a topnotch saint.)

Then there was Ingres' "Andromeda," chained to her rock, sea serpents smacking their lips; "Diana" by Boucher, stags and so on; and a great quantity of animal life in general (Stonington Bill's taste ran to animals, predatory or docile, dead or alive; it made no difference to Bill so long as they had four feet), dogs, horses, armadillos, heroic dogs, dead horses on battlefields, chimeras just loitering.

By and large, while I am sure none of these copies would ever pass muster in the underground trade in counterfeits, I think I made something interesting of them all.

At least, Stonington Bill was pleased and that was the whole point. And he paid my twenty-five dollars at the exact moment of the delivery of a canvas, which was my point. I have never seen any of these canvases again.

But I am haunted by a recurrent nightmare, fanciful, if you will, yet altogether too possible. Stonington Bill, as was quite

natural, shipped each of these copies as they came along back to Stonington, to his wife. Which can only lead me to believe that, in spite of the passage of twenty years, there must be somewhere in that pleasant Connecticut village an appalling collection—in the town hall? In the public library? Possibly in the town jail? —of all those pictures, all bunched together *in one place*, as my dream has it.

I have never dared to inquire of those who might happen to know. I prefer my nightmare. There is a special grace, however, unconsciously allotted to a man who believes in himself and some particular destiny, which stays his hand. Never once did I sign my name, not on one single copy.

But it was Stonington Bill who made me rich, in a manner of speaking, and after I had a few hundred of his good dollars in my kip, I began to look around me for matters more consuming to Jimmy than to Bill, all part of our bargain.

The thing to do, you see, in the Fifties in Paris was to have a canvas of yours shown at the new French Salon, the official gallery of the Académie, where reputations could be made or broken on opening day. Having no reputation, I had none to lose and only one to gain, but I had nothing to offer the Salon.

The matter was remedied, again by my ill-gotten dollars— though no more ill-gotten than the francs and lire and marks and rubles and whatever that had been paid the original perpetrators of the daubs I had copied—and I went to England, first class all the way.

Fumette didn't really think much of the idea, to tell the absolute truth, although it was to be only a brief visit, no more than a month. Fumette, who had possibly crossed the Pont des Arts twice in her whole life to observe respectable Paris, now felt that it was time for her to inspect the great world beyond and accompany me to England.

"*Mais, Fumette, ma chérie,*" says I, counting out Stonington Bill's dollars onto a table so that she might live in relative grandeur during my absence, "you would never be able to

stand the English. As a race they are cold, *glaciale*. You are a *tigresse*, my lovely hot-blooded *tigresse*, but in England they would chill you down to a poor cat in a week's time, probably kill you in the second week. No, Paris is your logical home."

"Jeemy," says Fumette, colder than any Englishman, if you don't count Charles the First, "*j'irai!*"

Well, she didn't, although it wasn't easy. I crept out of town in the dark of night to the Gare du Nord with nothing but the clothes on my back and a half pocket full of dollars, converted now to pounds sterling. My reunion with Fumette, when it happened some weeks later, was not altogether a blissful realliance.

No matter. The scene in London now. And I see I've neglected to tell you any reason why I should have gone there, Paris being the capital of exciting artistic ferment, London being led by the nose by John Ruskin down the dim and distinctly blind alley of Pre-Raphaelite vacuity. This will become more complicated as we go along, I'm afraid, a sort of nasty ferment of my own. But let us first notice things on the surface.

I went to London to visit my sister, Deborah. Well, my half-sister, to be exact. Debbie was older than I, a daughter of my father's first marriage, a most charming girl whom I dearly loved and possibly never really understood. We had rattled around together in New England and Maryland and finally Russia together, taking things as they came, throwing Russian snowballs at Imperial policemen, planning the assassinations of our various instructors and so on, and then she grew up. It was a great pity, you know.

Lovely Debbie met my boat train at the station, carrying a little fur muff and a saucy fur hat to match. We ran into each other's arms and started talking a mile a minute and kept it up all the way across London in a hansom, catching up on each other's lives.

Deborah had married an Englishman of the worst sort, from the upper class, determined to be an artist. Seymour Haden

was a physican, possibly even a good one for all I know, but he would not let well enough alone. No, he must paint as well as lend succor to the afflicted and dying. Today he is Sir Francis Seymour and my sister Lady Haden—nothing to do with art, of course, those titles. Something to do with adenoids, if I'm not mistaken.

Lest I should sound more than usually uncharitable, the Haden house in Sloane Street in Chelsea was a wonderful haven for me, and I was grateful for it, in spite of a nightly lecture from the good doctor on the "right" methods of painting. Have you ever noticed how many doctors paint? It has something to do with their hands, you see. They are obsessed with the notion that since they can snip out your adenoids wih some agility their hands must possess some special quality of delicacy that makes them natural painters. This is not so, but then art is not so, either.

"Jemmy," says good Dr. Haden one night (he got the 'Jemmy' from Debbie, who got it from my mother, and the doctor was if nothing else a traditionalist), "why don't you paint Deborah?"

"Good idea," says I, snoozing along with his Havana cigar and his Portugal port. "Fine figure of a woman."

"And Annie, too," says Haden. This last in reference to his and Deborah's charming daughter, my niece, a ten-year-old gawk, temporarily out of proportion. "Two portraits for my study, Jemmy, so that I will have always before me those whom I love best." I can't help that. That's the way Haden talked. And in this game accuracy is all.

"Both at once in the same picture," says I, port at the ready, and Paris-conditioned as I was. "Mustn't waste canvas, Seymour."

Well, you know, it was just chatter then, but it got into my mind, and, to cut it short, I painted Deborah and Annie together in a picture that has come to be known, not very happily, as "At the Piano."

Perhaps it was the very conventional presence of Seymour

Haden that goaded me. I painted a picture that was, for its time, considered most unconventional. It is simply a picture of Deborah playing the piano while Annie leans against it and listens. Well, that is putting it rather inaccurately, I suspect. It isn't really that at all. It is primarily a design and subtle harmony of color. Deborah is dressed in black, Annie in white. There are pictures hanging on the wall behind the piano, but I only show you a half or a third of them, cut right off by the frame, which irritated people. Then the worst offense, I was to discover, was that the painting didn't *mean* anything. The two figures are completely calm and placid, both posed in profile, static as a stopped clock. I mean, it is immediately clear to anyone that Debbie is playing to her daughter neither *Götterdämmerung* nor "The Star-Spangled Banner." She may even be practicing scales. There is no emotion, you see, or so I was told.

I worked very hard on my Piano Picture, with more sustained concentration than I'd ever put into work before, and it marked a new sort of seriousness in me, which I was naturally at great pains to conceal from everyone. In fact, our sittings there in the music room of the house in Sloane Street were more hilarious than otherwise, Debbie and I telling young Annie stories about our lives in America and Russia and Annie telling about some ghastly elegant girls' school she went to. I made them pose for hours and hours on end, but they got even by making me wait through their interminable afternoon teas just as I was getting something right. It's a joy to paint your own family, though. Since they're not paying you anything, you can always tell them to sit still and shut up. It was a good time we all had.

Well, when I'd finished the picture Seymour Haden didn't like it, but then that had never been precisely my goal.

I took the canvas back to Paris and offered it, along with two etchings, to the Salon in 1859. The etchings were hung, the painting refused. I was very far from alone in my rejection. Poor old Legros had spent the better part of a year on a portrait of

his father, Fantin submitted two portraits, Ribot submitted three studies of still life—all refused.

Well, now, you know, a marvelous thing happened. François Bonvin was outraged, and he came to our rescue. I don't know what you think of Bonvin's work, if you know it at all. It is fairly conventional in execution to tell the truth, in spite of its subject matter—scenes of working-class Parisians for the most part—but I would be happy to defend him as the greatest artist alive, if anyone should ask me. In a week he made the lot of us famous.

Old Bonvin (he wasn't really old, but he was fifteen or twenty years older than Fantin, Legros, Ribot and me, and fairly well established) had more money than all the rest of us put together. He had a very big studio in the Rue St. Jacques in the Quarter. He called it his *atelier Flamand*, and in it he arranged an exhibit of all our work the Salon had refused, mine, Fantin's, Legros' and Ribot's and some others. Then Bonvin invited all his friends to come and have a look, and they came, too, crowds of them. Even the great Courbet came, our idol, our hero. It was an awful moment for me. Was the picture really any good, had I made some mad mistake in showing it? I wanted to hide, but I made myself stay. Although quite ready to run out and hurl myself into the Seine if Courbet hated what I'd done, I stayed.

Courbet stood for a long time in front of my Piano Picture while I stood trembling beside him. Finally, after what seemed to me an hour but was not, he put his arm around my shoulders and gave me a sort of hug.

"*Ça va*, Veestlair," he said. "*C'est bon.*"

That's all he said, but it was worth more to me than the gaudiest praise of a thousand professional art critics. People cheered, people wept. Oh, it was a fine day!

And after that, all artistic Paris came. Well, all artistic Paris on *our* side of the river. In no time we found ourselves famous, arrived, as standard bearers of the *avant-garde*.

I think it was during this exhibition that I ceased to think of myself as an art student and dared to think of myself as a

47

professional artist. My Piano Picture was not a copy of anything, it was not painted under the guidance of any teacher, it owed nothing to anybody—if that can truly be said of any painting ever painted—it was mine. I say I ceased to be a student, which, of course, is nonsense. Any painter worth his salt must remain a passionate student until the day he dies. I meant "student" only in its technical definition.

Whoever first said that virtue is its own reward was either a cynic of a high order or else a dewy-eyed fool. Someone, I forget who, came over from Paris the other day and told me that Bonvin, good, generous, François Bonvin, whose admirable indignation first forced the public to see my work, is now blind. He can no longer paint. He sits in darkness in his studio, no doubt contemplating the rewards of virtue. I don't think I will light any candles today.

I see that in my excitement in telling you about my sudden success I haven't mentioned my reunion with Fumette on my return from London. You will remember that our last glimpse of my tigress was of her sleeping form, visions of a visit to England dancing in her lovely head, while I was creeping on tiptoe down the stairs in the middle of the night.

Now I came back, not without some apprehension, to our dismal quarters, expecting a fight, of course (what else are tigresses for?), but something that time would eventually make all right. Still, I entered our little flat with my fists in front of my face, just to be on the safe side.

But everything was quite crazy, you know. No fights, not one. Fumette was all charm and forgiveness, although still pretending to be at death's door. We resumed our old relationship, and I mean *all* of our relationship, precisely as if I had never sneaked off to England without her at all.

"No, no, Jeemy," says she, brushing aside whatever lying excuses I was presenting her with at the time, "you are an artist, a true bohemian like me. We are not like other people. When we have an impulse, a feeling that we must do a thing

some inner voice is telling us to do, then we must *do* it, without looking back! For the inner voice we hear is the voice of Art."

That was how Fumette went on, only it sounded even gaudier in French. Still, they were my sentiments exactly, although postulated from a rather unlikely quarter, given the circumstances. "How well you understand, Fumette," says I, all innocent credulity. " 'Impulse,' as you so cleverly point out, is the artist's message from his talent that the time has come to act. It is what unartistic people call 'inspiration.' "

Fumette smiled at me, her cheeks blooming through their sketchy cornstarch camouflage. She had a charming, rather unorthodox smile, which showed more lower teeth than upper teeth, if you follow me, small, very white teeth. "Jeemy," says she, "*I* know what it is to be impulsive, too, or I wouldn't have come to live with you in the first place, would I?"

"Lovely Fumette," said I, very tenderly. And we kissed, one thing leading to another.

Once a few years ago I happened to be in the reading room of the British Museum on some now forgotten errand. Impulse, indeed. On total impulse, I looked up the subject of tigers, real ones, that is, in India and Burma or wherever, not the Fumette sort of Parisian *tigresse* I have been discoursing on here. Belatedly, I learned much. Real tigers are a rum lot, you see. For all their garish stripes (orange has never been a very interesting color to me), they slink about for the most part in high reeds that are also orange, so that they are for all practical purposes invisible until you stumble on them, which is too late.

The male tiger, as some knowing zoologist suggested to me in a book, is a total poltroon. In an anthropomorphic sense, he would be a sort of grouchy pimp, lying about all day waiting for his girl to come home and dump into his lap the proceeds of her busy life. He does nothing, it appears, but sleep and eat and, of course, propagate the race of tigers, which, to me at least, is not reason enough for his continued existence.

Female tigers, on the other hand, are an entirely different

kettle of fish, I learned. Not only are they the true predators, killing and delivering food back to the male clot hanging about half asleep in the reeds, they are the absolute masters, or mistresses, of the killing strategy. They are keenly aware of their strengths and their limitations, the second of which are few. They have great patience. They will crouch for hours, only moving forward by inches, until they are within absolutely certain killing distance of their selected prey. They smile, knowing they cannot lose. Then they spring for the jugular, and dinner is ready. The *tigresse*, in short, is an animal very poorly described by the word "impulsive." As I was soon to discover. Calculation is more in their line.

Well, that's quite enough clinical zoology, however faulty, for any reasonable man. (Always excepting, of course, my good friend and too close Chelsea neighbor, Gabriel Rossetti, who has a whole back yard full of animals. Only last week he tried to present me with a surplus kangaroo. I beat him off, naturally.) No. The observant will already have observed a more personal analogy.

Fumette was crouching patiently in her reeds, and had been, I suppose, ever since my sneaky defection to London. The exact time to spring—that is the test of talent in your truly worthy *tigresse*.

My success at Bonvin's studio, the great Courbet's encouragement, the general praise from all sides pointed out Fumette's particular moment, and she took it. Nicknames are not accidental, nor are they necessarily coined in heaven.

A week after the beginning of all the flurry at Bonvin's I came home one evening, gaily whistling off-key an air from the latest Verdi. (Some people who know me profess to find it odd that, while I call my paintings nocturnes, symphonies and harmonies, I can't carry a tune. The reason for this seeming discrepancy is of course perfectly simple, and I may explain it later should there be any need.)

With the success of my Piano Picture something extraordi-

nary had begun to happen. The art dealers, not Right Bank dealers, of course, but Left Bank ones, who had scarcely tolerated my presence in their shops and galleries a month before, began inquiring what other major oils *Monsieur Veestlair* had tucked away in his atelier. Amazing!

Well, of course, I had none. I had been so busy in the months before I went to England, trying to make a living with all those ridiculous copies for Stonington Bill, that I had done nothing of my own. Except drawings. I had dozens of drawings I'd done before Bill appeared. And I don't mean sketches or preliminary ideas for paintings. They were finished work.

That is an absurd expression, I know, suggesting as it does that a drawing or any work of art has, like a horse race, an exact starting line and an exact finishing line. In this case, I only use it to mean that the drawings were not casual but the best work I could do at the time. Some were done from models at Gleyre's and later at Bonvin's, some of Fumette, and many of Paris street scenes.

A lot of them were very good indeed, if I may say so of my own work, and I shall probably say so repeatedly as I advance. What I promise not to repeat is the word "finish" in the sense in which I have just used it. In future I shall use it only derisively. I have heard enough of "finish," or, more accurately, a lack of it in my work, from critics over the past twenty years to last me well into eternity.

So it was these good drawings I was coming home to gather up and rush back to the waiting dealers at Bonvin's. If I boast that they were good, I most certainly would never have boasted a fortnight earlier that anyone would actually ever want to *buy* any of them. That's something else again. But the dealers had more than hinted as much, and I ran up the seven flights of stairs to our little flat with the joyous spring of an Alpine goat, and flung open the door.

"Fumette!" says I, all goat, you see. "In ten minutes we'll be rich! Find all those drawings I did last year!"

Fumette was doing her Mimi impersonation, lying on the

bed, handkerchief to lips. "Jeemy," she said, "you must not run up all those stairs, or soon your body will revolt and waste away like mine. . . ."

"Stop doing all that damn dying," says I. "We must find my drawings!"

"Drawings?" says Fumette, blinking herself awake, or whatever you call a return to reality from its opposite. "What drawings?"

"Drawings, drawings, drawings!" I shouted, like some demented street peddler, unhinged by public apathy toward his wares. Chestnuts, chestnuts, chestnuts!

But there was no need to shout. Pretty Fumette, now that she understood my mission, stopped dying immediately. She got up from the bed with the lady tiger's languid grace and stood before me, smiling with her lower teeth.

"You say your drawings will make us rich, Jeemy?"

"Well, anyway, richer than we are."

"Then I will get them at once, of course."

Fumette took her time about crossing the room to our only armoire, if it is possible to take your time about crossing ten feet, opened the door and brought down a hatbox from a shelf, not a real one, just a paper one, and took off the lid.

"Here are all the drawings," says Fumette, watching my face for signs of satisfaction, "all yours and all so nice art. I give them to you, *cheri*."

And then she did rather an odd thing. She reached into the hatbox and flung into my face a handful of confetti. That's what it was. Not simply my drawings torn once or twice across, but my drawings ripped to shreds so small that they would have been useful only in a Sicilian parade. The physical effort alone must have taken gigantic malice.

Well, you know, I think I must have gone a little dotty for a time, although I remember it well enough. All my nice drawings, all that hard work, the dealers waiting down the street, and Fumette continuing to pelt me with my precious confetti, laughing now. A great, anguished sob came up out of my chest.

"Here are your drawings!" she is shrieking. "Your drawings that you love better than me, take them! Take them! Liar! Cheat! *Sal espèce de cochon!*"

"*Assassine!*" I shout, spitting out bits of drawings from my mouth. And I landed her a pretty good clout on the left side of her jaw with my open hand. (A West Point gentleman could never strike a woman with a closed fist, naturally, whatever the provocation.)

The rule did not apply equally to Parisian *grisettes*, apparently. Fumette, taken by surprise, rocked back on her heels for a moment, but only a moment. Then, one, two, crack, crack, a fist in my right eye, a fist in my left, all in a half second.

Then we backed away from each other, the *tigresse* and her maddened victim, blinking painfully, circling each other in the tiny room, crouching, murderous eyes, tentative fingers clawing the air, no sound but heavy breathing. Then suddenly, exactly at the same moment, as though a referee had blown a whistle, we flew at each other.

Pound for pound, we were pretty well matched. We were about the same size and age, both in good health. I anticipate the carping critic who would gratuitously point out that I was a man and Fumette a woman. Such a critic would carp from the vantage of insufficient evidence. For the simple fact was Fumette was stronger than I. While I, in my formative years, had been pottering about the Winter Palace in Petersburg, making sketches and admiring Fabergé Easter eggs, Fumette had been sensibly chopping wood on her father's farm in Brittany, milking cows and pitching hay. The results were immediately evident.

But, as everyone knows, even if only once in his life, there is an inner strength that can be dredged out of anyone, quite beyond his normal capacity, if what is inviolate to him is brutally outraged. It may be his religion, possibly his postage-stamp collection, or his art.

To fight with a *tigresse* is an adventure. In a second we

were locked in a deadly embrace, each struggling for his chosen target. Mine was Fumette's throat, hers was my eyes, slashing nails and grasping fingers. Then we tripped, lost our balance and crashed to the floor, but neither of us relaxed his grip for a second. Panting and grasping, we rolled around the floor of the little room, kicking up dust and sending the scant furniture crashing around us. We had no breath left for invective, nothing left for each to tell the other but what could be told in blazing eyes and bared teeth in two faces not an inch apart.

It is probably just as well that neither of us fully accomplished his original purpose, for if we had, Fumette would be dead and I would be blind, which for me would mean the same thing. It was finally Fumette who decided how it was to go.

In the uninhibited violence of our struggle, it was odd, for two people so recently lovers, how often our mouths touched, touched not for kisses this time around but only as an accidental result of our wild melee on the floor, snarling, not kissing mouths. But Fumette was nothing if not one to take advantage of things as they were. She opened her mouth wide as the Arc de Triomphe and lunged. To have bitten off either my upper or my lower lip would, I suppose, have satisfied her purpose, but she missed by a little and clamped down tigerlike on one side of my mustache. Then she snapped her head sideways as hard as she could.

I have no idea how common an experience this is, even among the members of the imaginative and mustachioed community in which we lived. I only know that it produced a pain so exquisite that it brought to its zenith that special strength of which I spoke earlier; strength arising from an outraged soul was now made Herculean and invincible by simple pain.

Fumette's maneuver had cost her a certain physical purchase. It gave me a chance. With a roar heard three streets away, or so I am told, I finally grabbed her throat. And rolling around in the pitiful scattered residue of my ruined drawings, I began to throttle her.

Yes, gentlemen of West Point, I dug my thumbs into a

woman's throat with full intent to kill. You wag your fingers, scowl, cluck your tongues? Well, I would like to be able to say that I defied you, that by way of murder I made some aesthetic point beyond your parochial understanding. But it is not true. I am one of you, after all, it seems, for good or ill.

At first Fumette's eyes began to pop out of her face, and in my fury I pressed her throat the harder. Then she began to turn blue and her eyelids fluttered shut. Well, it was as plain as the half mustache on my face, you know. Were the scratchings of an artist a fair trade for a real life? No, of course they are not. Even to state the equation is ridiculous. If it is anything at all, art *is* life. Not necessarily the other way around. Life is art doesn't mean much of anything. It's almost never true. Life so often misses the useful point, artistically speaking.

I let up on my thumbs, and gradually Fumette began to breathe again. In a short time the color was back in her cheeks, and no doubt the muscles back in her arms and legs, but these were not tested further. She looked rather calm, almost fulfilled, as a matter of fact. She got to her feet, smoothing her dress, adjusting her hair before the mirror.

"Out!" I cried. "Out, *out!*" Trembling, in a very controlled way, of course.

Fumette went, taking her own good time. So I slammed the door after her, hoping the building might possibly fall down at the impact. It didn't, and so I was left to contemplate alone the subject of winners and losers, all too clear, unfortunately.

I, the clear loser, began aimlessly to fumble through the fragmented remains of my drawings, desolate on an overturned bed, and I would see a pretty good snatch here and another pretty good snatch there, all the size of postage stamps, of course, and I began to weep. I wept passionately, but it didn't last long. There is always comedy around the corner, *Deus Gratias*.

Rain-soaked cheeks, the heart's despair total, there came to me a raucous holler from outside my window.

"Ai, Jeemy!"

Anger thrusts us toward comedy, you know. It is very pos-

sibly our salvation. So I tottered to the window, drying my eyes on my sleeve, and looked down into the street.

There was Fumette, seven floors below, looking as fit as the day she'd left her father's farm, rocking back on her heels, fists on her hips.

"Ai, Jeemy," she hollers, "give me my book! *Voleur!* You stole my book!"

Of course I knew what she meant. Somewhere in the shambles we had mutually wrought, I found her tattered copy of Murger and his *Scènes de la Vie de Bohème*. I took it to the window and threw it out. It landed at Fumette's feet. She snatched it up briskly and went her way. I have not heard of Fumette since, but it must be nice to have a guidebook for one's life to carry under one's arm.

No, that is nonsense, of course. There is no guidebook, nor should there be. Biting off half of one's mustache was not specifically anticipated even by Murger's bohemians, nor its consequences reckoned. I was not immediately mollified, to be honest. I wept rather foolishly for a day, smothering myself in my lost fragments, piecing them together and so on with absolutely no result, of course, then I finally got my wits about me and got so drunk with sympathetic Legros and Fantin that I cannot even remember a single detail of what we did or where we were.

In the end, I took my Piano Picture and went to England.

TWO

*W*HY ENGLAND? I mean, there I was in Paris, cutting a swath—well, rather a small swath—through that perfectly pleasant demesne, praised, even modestly honored, within the tiny circle of the *avante-garde*. And an *American?* Everybody knows that an American in England, polite varnish apart, is only a disguised Attila, barbarian in a frock coat, if he should happen to own one. This was, and is, the general view, shared alike by duchess and cabman.

No, that is an injustice to cabmen. Only last week a hansom driver asked me very seriously if I thought he would enjoy his life more fully in St. Louis. (He pronounced it in the French way, which I thought was rather touching.) He didn't want to live either in New York or San Francisco, he earnestly explained, because they would only be London all over again. But St. Louis, or St. Louie, had a reassuring, sort of middle sound about it. Naturally, I urged him to book passage on the next boat.

But I went to England anyhow. Fumette, you will have gathered, gave me a certain impetus. That, however, was not the whole thing. While it is perfectly true that an Englishman in these glorious days, regards an American as an alarming intruder, unsuited to share the refinements of his life, he is, at the same time, chary. Yorktown, you know, gave him a certain pause. Of course he'll get over it in time. The relationship is, therefore, mutually abrasive, a good atmosphere for work.

France is too soft, too dear, for an American challenger, then and now. Paris is totally tolerant of Americans—and Greeks and Burmese and even Swiss, for that matter. And there lies

the trouble. Toleration is nice, of course, but it is at last a form of disregard. The final, rigid fact remains: Frenchmen are psychologically incapable of taking anybody on earth seriously except other Frenchmen. Englishmen, on the other hand, hold their fists protectively in front of their faces, not to be hit, you see, by foreigners.

So, with Fumette's blessing, I went to England, the better to find my proper jousting fields. Of course, that meant moving into Seymour Haden's and Debbie's house, since I couldn't afford anything on my own. Jousting on Sloane Street may lack something in romantic appeal, but a beginning jouster must start his joust somewhere, particularly where he pays no rent. (The word "joust" or any of its adjectival or verbal modifications will never again appear in this story, so help me God.)

It was a marvelous reunion with Debbie and little Annie because it gave me a chance to boast quite uncontrollably about my Paris success with their picture, telling them it was my models that had been the cause of it all, while we all knew it wasn't true. Most gratifying. I brought them each a Parisian embroidered sac to make up for it.

Caddishly, I avoided Seymour, not very successfully, actually. Well, he was doing no end of good all over London by day, excising appendices from the poor without charge and so on, but he came home at night. And he wanted to talk about Art. A good dinner, no question about it, then there I was, amusing Debbie and Annie having been banished from the dining room.

"Tell me, Jemmy," says Seymour, lolling back elegantly in a smoking jacket and a little cap with a tassel, "it is my frank opinion that there is nothing more important in creating a work of art than a *point of view*, do you agree?"

Do I agree? You bet your shoes I agree, agree with anything. A bed, a roof, three solids a day, not to mention a meat tea at half past four. "Seymour," said I solemnly, "you can't beat a point of view, and I'll stand up to the firing squad to defend our position. It's got to mean something, we both know that."

"Gratifying," says Seymour, who doesn't listen much, sucking his teeth and planning that Victoria will live two thousand years, which she may. "But about the Academy . . ."

"Yes, I thought I'd just totter over there this week with my Piano Picture. I understand the Hanging Committee is deciding just now who to hang."

"Ah . . . Jemmy, old man," Seymour went on, rolling his eyes up to the ceiling, so as to be looking somewhere other than at me, "we're always totally frank with one another, are we not?"

"Oh, absolutely, Seymour."

"Then take my advice, old chap, and don't submit your Piano Picture, as you call it, to the Academy this year. Wait until next year's exhibition. By then you'll have another canvas—or perhaps five or ten, depending upon your diligence—more worthy of you than this one. I urge prudence on you."

"Well, Seymour," says I, "each of us must pick his own time to place his wares on the counter at the bazaar. I'm ready to take my chances now."

"A mistake, Jemmy," says Seymour, still studying the ceiling. "The painting is not a finished one."

"But your operation last Wednesday to eliminate a tumor in somebody's stomach—altogether successful, except that the patient died—that was a pretty finished job of work, wasn't it?"

I always say too much; it is my besetting sin. Good Seymour Haden housed and fed me, and still I had to cut him down. Forgive me, ingenious God who invented me, but never forget that I am *your* invention, not mine.

Seymour finally looked at me, coldly to be sure, but with a reassuring (to him) condescension. "My dear Jemmy," says he, "I have always found your views on art stimulating. You will, I hope, forgive me if I find your views on medicine . . . ah . . . uninstructed. Shall we join our ladies?"

"With pleasure," says I, flying for the door like a prisoner released from his cell. "And let us do it more often, good brother."

• •

I must now recount a time that seems very curious in recollection, considered from my present dismal vantage point. It almost seems to me now that it never happened at all, but it did. The Royal Academy accepted my Piano Picture for its exhibition of 1860, hung it well, and I became the talk of the town, in a manner of speaking. Amazing!

I think perhaps this may be the place to deviate somewhat from the normal chronological sequence of events of my life, so suitable to my orderly literary form, and leap about a bit in time, forward and backward, for a page, in order to explain what may seem puzzling in what I have related and in what I will relate.

You will have noticed dismal allusions to my present state of penury and professional disrepute, and I can hear you say, "What's this whiner complaining about? It all looks pretty good to me. A little low on cash as a kid in Paris, maybe, but plenty of fun, and a success in the end. In England, they hang his picture in the Royal Academy and people take a lot of notice. What's wrong with that?"

True! Oh, true, true! There is nothing wrong with that. A young man of twenty-four started at the top, or somewhere near it, against all reasonable odds, and enjoyed every minute of it. But that is not the accepted sequence of things, as any earnest reader of our own Charles Dickens knows. The young man should start at the bottom, and eventually, after an extended period of selfless toil and worthy works, rise to the top.

But I have managed to reverse the proper order of things. Starting near the top, I have ingeniously arranged to arrive in twenty years at the bottom, if one judges the bottom by public esteem, pounds, shillings and pence.

It has been a gradual, though inexorable, process. And there is a perfectly logical reason for it. My Piano Picture, though some regarded it as peculiar, was still within the confines of what was acceptable to an establishment at the time.

My work since has dismayed a great many people. Following my particular vision, I have done what *I* have wanted to do, and, in doing so, I have placed myself so far outside the main-

stream of contemporary art that I am everybody's easy pariah. In my heart I know now that I am painting for a time that has not yet arrived. But it will, reason wotting. So I no longer try to explain the inexplicable to curious folk. Instead I make jokes, for there is much solace in laughing, you know. Of course I must find some way out of my immediate mundane problems. And I will. Only watch!

Now let's return to that other, that joyous time. I've said it was amazing that the Royal Academy hung my picture. Well, of course, it isn't amazing unless you know something about that extraordinary institution, the Royal Academy, as it existed in 1860—or twenty years on either side of 1860, for that matter. Things move slowly at the Academy; time is reckoned, taste is altered with the deliberate speed of an Alpine glacier—which may even be a rather racy trope.

In a word, or in several, when I first came to England art *was* the Academy, as it still is, a fossilized institution that had totally strangled the serious traditions of art, and had set up saccharine sentiment and anecdote in their place. Bearded men of middle age quite seriously presented the yearly Academy exhibition with paintings called "My Good Dog Fred" or "Jessie's Doll Is Broken."

But that was only one sort of lie. There were all sorts of others. My favorites, really, were the solemn blokes who called themselves "classicists." Frederick Leighton, Alma-Tadema, Poynter (Sir Edward Poynter now, God save the mark, my grave fellow student at Gleyre's in Paris) will serve to illustrate. With infinite detail, they painted what I call "four-o'clock tea antiquity." Christians and lions faced each other in the Colosseum, for example, all very historical and so on. But in the paintings of these classic machines, Christians, in fact, face no one and nothing. They are isolated, scowling professional models in humbug Roman-Victorian costumes, rather bored with hours of staring at a studio wall, most meticulously painted, of course, stultifying in detail. Even the lions look stuffed. Some of these daisies

took their perpetrators six months or a whole year to paint, but the pay was good.

Sir David Wilkie, a longtime Academician, publicly declared the true ideal of our nineteenth-century academician. Now, this is not a joke. This is exactly what he said, and said seriously: "To know the taste of the public—to learn what will best please the employer—is, to an artist, the most valuable of all knowledge."

There was no public outcry, there was precious little private outcry, for that matter, at this definition of an artist's function. He must satisfy his "employer," that's all. Just as the cutler of Sheffield or the crofter-weaver of the Scottish highlands produce their wares to satisfy a public demand. (Except, of course, for the important difference that the weavers and cutlers produce something well made and useful.)

And so, you see, year in and year out the Academicians produced something for everybody, and Art was on the town! Everybody's taste was catered to. The "classicists" I have mentioned appealed to the artless scholar, the romantic idylls of Millais, Marcus Stone and their fellows appealed to the artless sentimentalist. George Frederick Watts delivered sermons for the artless serious; Stacy Marks got some laughs from the artless humorist, and a list too long to set down edified the artless pious. Everybody wins! All this was not just an accident of history.

There must, it seems, be appointed a God of Art to make up the rules, point the way, to encourage the faithful and chastise the heretic. Victoria did not appoint him. The Prime Minister did not appoint him. There was no need. He appointed himself. His name is John Ruskin.

John Ruskin is my enemy. I could not have invented a more perfect enemy for myself than nature did for me. If by enemy we mean an antagonist whose every waking thought and deed are in precise contradiction to our own. Ruskin's towering influence on contemporary British art is as tyrannical as was any

Roman emperor's on his subjects, and has been for forty years. I am his natural enemy just as he is mine, and he is largely responsible for my own presently disastrous plight.

Since I have described the Royal Academy there is no real need to describe Ruskin on art. The two are inseparable. Ruskin has said. "There is no such thing as an art which does not serve a *moral* purpose." *I* say: "There is no such thing as an art which does not serve an *artistic* purpose." Well, there you have it. We two were destined to meet in violent collision, and we did.

And, well, you know, what finally is there to say about a man who took his mother to Oxford with him and who, married for six years to a beautiful and charming woman, forgot to consummate the union?

I must be fair and admit that I once read a statement of Ruskin's with which I am entirely in agreement. In Volume V of his *Modern Painters* (I admit it took four and a half volumes for his insight to rise to the surface, only instantly to submerge again forever), Ruskin wrote: "It seems to me, and seemed always probable, that I might have done much more good in some other way." And it's true, you see! Ruskin would have made a real stunner of a missionary, for example, brow-beating hilarious heathens into St. Paul's word and long night shirts. The golden chance was missed.

Mr. Ruskin is reported presently to be suffering from "brain fever," whatever that is. Whatever it is, it does not prevent him from writing. And all England reads, and all England accepts. With one distinct exception, as I have hinted. No, I do not accept and I will never accept. But then, I am an American and suspect. Worse, I even venture to have notions of my own about art. John Ruskin and I are natural enemies as the cobra and the mongoose are enemies. I always preferred to cast myself mentally in the role of the venemous cobra in this exercise until somebody told me the other day that it is the mongoose who usually wins.

• •

But to get back to the Royal Academy, which is not really a change of subject. As a result of its "something for everybody" exhibitions, the Royal Academy had become not an artistic power but a social power. Everybody was given comfortably to understand that art was everybody's business (Oh, *that's* all it's about), and it had never been so popular in England. And as art, even in its most primitive definitions, was the very last thing an Englishman looked for on his walls, so an "artist" was the last thing he expected an Academician to be.

No, an Academician was expected to be first of all a jolly good fellow, interested in sports and politics, a good judge of beer and chops, just like everyone else. A trifle aside from the mob, perhaps, or else he wouldn't be in the painting business at all, but essentially a knowable, accountable and proper English gentleman.

It got ridiculous, you know, this painter as non-painter, that was supposed to make art respectable. Only last year, by some calamitous misjudgment, I found myself in the company of a number of ladies in somebody's swank drawing room.

The swankest lady was going on about Sir Frederick Leighton, current president of the Academy, one of the "classic" painters, if you'll remember.

"But Leighton is such a charming host, such a gallant colonel, such an orator," says swank lady, kissing the fingers of her gloves, "such a dignified president, such a linguist! Such a musician!"

"True, madam," I said. "Paints a bit, too, don't he?"

It was an extraordinary state of affairs altogether. (And still is, twenty years later.) But you will perhaps better understand now why I say it was astonishing that the Royal Academy accepted my Piano Picture at all. But I was summoned before the Hanging Committee of that august institution. So I brushed off my Paris clothes and shoes—not quite the thing for the occasion, but all I had—and turned up hardly ten minutes late.

The committee was very polite to me. Of course, sitting like

a lot of proper judges in frock coats, they could afford to be. But *noblesse oblige* is not dead at the Academy. The chairman of the committee was Sir Lawrence Alma-Tadema. God knows what Balkan outrage got him a name like that, but you'll remember him as the painter of the stuffed Christians in the Colosseum I mentioned earlier.

"We've found your picture most interesting, Mr. Whistler," says this discerning gentleman. "What do you call it?"

"I call it my Piano Picture, sir," said I, "in order to distinguish it from other pictures of mine in which no piano appears, you see."

"No, I meant its *title*, Mr. Whistler. We all noticed you neglected to include one. Some description of the domestic scene, you know, something to illuminate our understanding of the charming relationship between mother and daughter, which we found so touching."

Aha! Naturally, I saw what they were about. Ruskinism afoot. And a private dilemma ensued inside my too young head. If I said, truthfully, "It has no title; interesting paintings don't need titles," I ran the all too certain risk of being booted down the front steps of Burlington House, painting and all. On the other hand, if I said, "Gentlemen, the title is 'Mother Teaches Best,'" which would have delighted my hearers, simple conscience would have obliged me to run out of the place and throw myself into the Thames at some deep point.

But I wanted to be hung at the Academy, if only to confound my good brother-in-law, Seymour. To be honest, I wanted to be hung there myself—there is the truth, contempt and all—in order to test my wings on those alien walls. (The semantically inclined will already have observed a jest in the terminology of these proceedings. A Hanging Committee? To be hung or not to be hung? Or hanged. For grammar amuses me. Hung on a wall or from a gibbet?)

This, you see, was before I had devised my crafty plan of calling paintings by musical designations. If I had simply said my Piano Picture was a Harmony or an Arrangement in

Black and White, which it most certainly was, they wouldn't have liked it but I suppose they would have had to lump it. But I was not as wise twenty years ago as I am now, nor as rigid in my opinions. Then, in my ignorance, I could still yield a little and be accepted. Nowadays, in my wisdom, I yield to no man and am universally rejected, my house occupied by bailiffs. I draw no moral; morality has nothing to do with art. Ha-*ha!*

But standing there before the committee, I suddenly remembered that when the picture was exhibited at Bonvin's in Paris some idiot had affixed a little handwritten card to the frame which read, *Au Piano*. (The French are not immune to this title nonsense, either, but show considerably more restraint than their sentimental Channel neighbors.) I made only a token objection at the time because I was so anxious to have the picture shown. I might have objected more strongly to something more storytelling, but *Au Piano* seemed, while perfectly superfluous, at least innocuous. Rather like painting a picture of a horse and labeling it "Horse."

"Gentlemen," I said, looking them most gravely in the eye, "after much thought, I have decided to call my painting 'At the Piano.' "

Well, they didn't think much of it, you know, but it *was* a title. So they sighed a little at my lack of imagination and hung the picture anyhow.

The press reception wasn't exactly glorious, as a matter of fact, but as a child must eat his vegetables before he is allowed dessert, I will state matters in that order.

Said the *Daily Telegraph:* "This painting presents us with an eccentric, uncouth, smudgy, phantom-like picture of a lady at a pianoforte, with a ghostly-looking child in a white frock looking on stupidly."

Said *The Athenaeum:* " 'At the Piano,' despite a recklessly bold manner and sketchiness of the wildest and roughest kind, has a genuine feeling for colour and a splendid power of composition and design, which evince a just appreciation of nature very rare among artists. If the observer will look for a little while

at this singlar production, he will perceive that it 'opens out' just as a stereoscopic view will—an excellent quality due to the artist's feeling for atmosphere and judicious gradation of light."

I quote these journalistic opinions only to show that even as a new arrival on these hidebound shores, an unknown upstart of twenty-four, and a barbarian American into the bargain, I have always been noticed. (Of course I am still noticed—noticed by ten times ten. It is just that the quality of the notice has fallen off somewhat.) I care not a damn for journalistic appraisal of my work. I would only point out that in an exhibition of several hundred canvases, mine was the one singled out among the newcomers. Never mind what they said. That is quite beside the point.

But, behold, it seemed then an age of miracles. The swells of the city chose to pat me on the head. The great Thackeray, so Lady Ritchie tells us in a memoir, "went to see Whistler's picture of Annie Haden standing by the piano, and admired it beyond words, and stood looking at it with genuine delight."

George Boughton, an American, one of the few who was a full member of the Royal Academy, and an admirable painter— if your taste runs to depictions of Rip Van Winkle arousing from his sleep and things of that sort—immediately told the world that my Piano Picture was the *only* painting he could bring to mind after he got home from the exhibition.

On Varnishing Day the prodigious John Everett Millais came up to me and introduced himself. Yes, yes, I know he now paints impossible pictures. Only a year or two ago he painted a picture of his grandchild blowing soap bubbles, which has since been used as an advertisement for Pear's Soap. (Naturally, he is to be next president of the Academy.) But his fault is in his mind, not his hand. In any case, twenty years ago Millais was not painting "Bubbles" pictures. His technical skill was, and is today, breathtaking. It is only one of God's smaller jokes, like endowing Velásquez with the imagination of a Putney barmaid.

"Mr. Whistler," say Millais, clapping me on the shoulder,

smelling of soap, good port, tweed, pipe tobacco and all-round solid Englishmanship, "I never flatter, but I will say that your picture is the finest piece of color that has been on the walls of the Royal Academy for many years."

There was even more to boast about, as a matter of fact. An Academician by the name of John Phillip, who specialized in Spanish-subject pictures—ladies in mantillas peep out seductively from behind barred windows, matadors in pools of blood, and so on—wrote me a letter. He said he wanted to *buy* the Piano Picture, and what was its price?

I answered him in a letter which, I am sure, must have been very beautiful. I said that, in my youth and inexperience, I did not know about these things, and I would leave the question of price to him. Well, Phillip sent me a check for thirty pounds. And it meant a great deal to me just then. It's all I ever got out of it. The last time old Piano Picture was sold, I'm told—to Edmund Davis, at a bargain—it cost him three thousand pounds. Ha-*ha*! Art prices fluctuate, you know.

Of course, Seymour Haden regarded even the thirty pounds —to say nothing of the Academy's acceptance of the picture in the first place—as some sort of travesty of justice. Seymour had said the picture would never be accepted, and when it was, Seymour felt betrayed. It was as though he had put his professional medical reputation on the line; as though, after solemnly predicting certain death for one of his patients, the uncooperative patient had jumped out of his death bed and danced a horn pipe and lived to be a hundred. Seymour didn't like things like that in his life. It is, after all, the doctor's business to be infallible, or the whole roof would cave in, wouldn't it? We would be back to charms, incantations and goat's blood for breakfast.

"But, Jemmy," says Seymour gravely, on the evening after the day of my triumph—once again across the lonely dinner table, our charming ladies once again shunted to the limbo of the drawing room—"Jemmy, you *sold* my picture."

"*Your* picture?" I repeated, all earnest confusion, as you may imagine. "I thought I painted it."

Seymour cracked a walnut and looked very sad, a sort of general sadness, it was, only indicating that perfidy is man's lot on earth, and no way around it. "You gave the picture to me, don't you remember?"

Well, there was a certain fuzzy truth in his statement, if you want to be tiresomely literal. A month or so earlier, in a very off-hand way while full of Seymour's splendid port and my own uncontrollable good nature, I had more or less given it to him. That is to say, dear Debbie and Annie, my subjects in the picture and my loves along the way, wanted the picture hanging about the house. So I suppose I said something like "Well, hang it then" or perhaps "Well, have it then." Nothing to take seriously, you know. And here was Seymour accusing me of selling *his* property.

"But, Seymour," says I, "it's my picture, no matter where it hangs, isn't it? When it hung on your wall, it was still mine, just as it is still mine on the wall of the Academy bloke with the thirty pounds. A painting is not a chattel to be signed away from one owner to the next like a barn or a cow. It can never, and must not ever, belong to anyone but the painter who painted it. Will Annie no longer be your daughter when she grows up and marries some dreadful named Smith?" I was warming to this subject, although it had never really occurred to me before. That is, I was discovering a permanent truth simply by stating for the first time what must have been somewhere inside my head for years. Exhilarating, it was.

Well, to some of us. Seymour sipped his port as I suppose hemlock-sippers do, altogether unconvinced by my simple logic. Sadder than ever, he said, "I suggest you try out your theory in the tailor's trade. I think even you would resent a tailor reclaiming his work of art off your back and selling it to someone else."

"My point exactly, Seymour," says I, "and how clever of you to have thought of it. But a tailor, of course, makes all his coats alike, or nearly alike, according to a fashionable pattern. And so he must give up any claim to private inspiration. Such coats should rightly be bought and sold on a permanent basis. But show me the tailor who makes a coat with one sleeve! No

pockets! Can only be worn back to front! In short, an artist, and a man who is entirely entitled to change his mind whenever he likes. He may discover after he has finished his work and turned it over to the custody of someone else that it isn't as good as he thought it was. That it doesn't represent him properly, and an artist should never allow himself to be represented by anything but his best. Well, then, he should take it back and improve it, or if he can't improve it, destroy it."

"Or," says Seymour, somewhat coolly, it seemed to me, "take it back and sell it to someone else."

"No, that is a misconception, Seymour," says I. "You see, the man doesn't own my picture any more than you imagined that you did. It has simply changed residences."

"Tell *him* that."

"Should the time ever come that I find myself dissatisfied with the painting, I certainly shall."

"And then what? There are laws in this country pertaining to private property rights, you know, Jemmy. And under those laws a painting of yours, bought and paid for by someone else, is not a jot different from the tailor's coat."

In the absurdly limited lexicon of the law Seymour was correct, of course, but who can take seriously laws that make no distinction between artists and tailors? Certainly, I have never done so, nor will I ever. Since that day many years ago when I first discovered my admirable rule hidden perfectly formed inside my head, I have never altered it in the slightest detail.

However, you will have noticed that Seymour Haden found my arguments unconvincing. Well, you know, he was not alone in that. I've found over the years any number of people who agree with him, and this has sometimes proved awkward, though far from insuperable. For some time I had a system that worked perfectly well. If I encountered a painting of mine on somebody's wall that I thought unworthy of me, I would simply ask that it be sent around to my studio for a spot of "improvement."

Now I don't really believe in improving pictures that I have

once let out of my hands. The original spark that interested me in the first place is long gone, and any tinkering with the canvas will only make it worse. No, that is not my real object, but it is necessary to say so. My real object is that there shall not be on exhibition, public or private, anywhere in the world a picture signed by my butterfly that is not a successful work of art, as I apply that term to myself.

But we all change, of course, and make mistakes. What once pleased me sometimes pleases me no longer. I can freely admit now, for instance, that I once allowed Japanese art to influence me unduly—in execution, not in spirit. The spirit is glorious and eternal. But for me to admit a mistake is one thing; to remove the mistake from circulation—particularly after somebody has paid a good sum for it, and may not have the wit to know it is a mistake—is something else again. Hence my little game.

For a few years people were most obliging and even flattered. "Mr. Whistler saw his portrait of me" (or whatever it was) "in my drawing room the other night and said he saw a way of improving it. What a conscientious painter he is! Of course, I sent it right back to him, and I can't wait to see the result."

Well, yes, they waited. Some more patiently than others. A few weeks or even months were all right. Everyone knows an artist cannot summon his muse as he would summon a hansom cab. But then the months became a year or two or five, understanding among my patrons tended to diminish. They began to clamor for their paintings even in their original unimproved state. They sent retainers to my house by the dozens, demanding "their property." Some even sent lawyers waving papers. My response was perfectly straightforward and reasonable: "Be good enough to tell Lady Awful that she agreed I was to improve her portrait. Well, I am still improving it."

There wasn't much they could do, you know. Ha-*ha!* But, unfortunately, in time word got around that if you sent your Whistler back to Whistler you would never see it again. This turn of events in no way diminished my zeal, naturally, but did introduce a note of melodrama into my methods.

• •

One evening I dined at the house of a certain lady, and there was my portrait of her over a fireplace, painted a few years before. And, you know, there was a very poor relationship between the upper part of the body and the lower; the legs did not support the torso, the neck did not support the head. Give that painted woman no more than a genial pat and she would have fallen over flat on her face. I was appalled. What to do? The picture *could not continue to exist*. I made my little speech about "improvement." My temperature was going up. Bad painting upsets me.

"No, Mr. Whistler!" proclaims this rather positive lady, "you may *not* improve my portrait. I know what that means from my friends."

"But, my dear lady," I protest, "it is not a good painting in its present state. How can you want a painting that is less than perfect hanging on your wall?"

"Because I paid a good price for it, Mr. Whistler. I may have been bilked, but I'd rather have it as it is than not have it at all. Shall we go in to dinner?"

So I gave the lady my arm and the whole party went into the dining room. There was no more talk about my painting. As a matter of fact, after a few minutes I had the whole dinner table laughing over an incident that had happened years ago in Washington when I had attended a ball at the Russian Embassy, the penniless clerk in shoes borrowed from a hotel corridor and a frock coat pinned back so as to resemble a dress coat, strategic pins falling out, and the owner of the shoes turning up at the ball to denounce me, and so on. At any rate, it was a good enough story to divert the company's attention from the subject of painting and to mellow the disposition of my hostess, which was my object.

Just as I finished my little anecdote, I let my voice trail off a bit, you see, closed my eyes, shook my head as though to clear it, touched my dinner napkin to my brow, took a quick swallow of wine.

"Mr. Whistler," said the possessor of my imperfect portrait, leaning toward me anxiously, "are you ill?"

"No, no, madam," says I, a brave little smile on my face, "only a trifle faint. It's nothing, nothing at all, just seems to happen sometimes." I rose unsteadily to my feet. "A few breaths of fresh air . . ."

"But at least let me send a servant with you . . ."

"*No!*" says I, possibly too definitely for one so faint. "No, I will do better entirely alone. I apologize for a silly interruption to a charming dinner party. Ten minutes' brisk walk in the open air, and I'll come back to you a new man, I promise. Please, no one follow me."

So I sort of teetered out of the dining room, not too much, you know, so as to cause any real alarm, and fulfilled my promise —to come back a new man, that is.

By luck, there was a room or two between the dining room and the drawing room, so that in no time I was absolutely alone with my picture. My recovery to robust health was instantaneous. I lifted the canvas off the wall—pretty big, too, people demanding head-to-toe portraits the way they do these days— fiddled open the front door, down the steps and away!

A sight I was, I suppose. That is, your average Londoner, at least along Park Lane, is not altogether attuned to the sight of a monocled gentleman in full evening fig galloping desperately along a London street with a life-size framed portrait on his back. But such superficial censure, of course, does not reckon with an artist's duty to himself, and there can be no useful discourse between the two parties. A pity, but true, so I hurried on.

I knew exactly where I was going. Hyde Park is not much frequented at night—lovers and anarchists, gentle people, tend to predominate—and within its confines is the twisting pond, lake, call it what you will, named the Serpentine. Panting for breath, I reached its shore. And there I cut my canvas to shreds and ribbons with my penknife, tossing each successive shred and ribbon into the waiting water until there was nothing left but the expensive gilded frame. I broke its bars across my knees and hurled its parts far out into the water, then finally sat back on the shore, not breathing all that well, you know, but laughing in silent joy.

"Everything all right, sir?" asks the passing young constable, after the fact.

"Just feeding the swans, Constable. Been a hard winter for swans. They affect a cheap nobility, so that's what I fed them."

"Beg pardon, sir?"

"Bread crumbs, Constable, crumbs from a noble table. Good night."

But it was back to the dinner party, then. I returned, looking alogether too healthy considering my exit, but I had forewarned the company.

"Why, you look like a different person, Mr. Whistler," says my robbed hostess, pleased to have things back on the track.

"And so I am. Fit as a fiddle, madam."

The ladies then left us gentlemen to our ritual boredom, but not for long, thank God. One minute was enough to produce a good-throated shriek from the drawing room. Dining-room doors thrown open, ladies rustling in in their silks, hostess as commanding rustler.

"Mr. Whistler! My portrait has been removed from the drawing-room wall!"

"Amazing!" says I. "What do you suppose could have become of it?"

"I would like to ask that question of *you*, sir."

"Well, then, I should imagine someone had stolen it, wouldn't you?"

"Who, Mr. Whistler?"

"Some misguided wretch, falsely dazzled by the painter's reputation, I suppose. No artist, certainly."

"Yes, but *when* was it stolen?" demands this persistent lady.

"Why, between then and now," I answered, puzzled by this foolish question. "While this charming company was dining in this very room, chuckling over the reminiscences of an impoverished American clerk. That must have been when the crime was committed, don't you agree?"

"I agree. And no doubt you will agree that only you left the dining room during dinner."

"Well, I agree that I was the first to leave. I can't be held accountable for what happened after that."

"No one else left, Mr. Whistler, I assure you of that. And on your way to the street, you passed through my drawing room?" says Mrs. Torquemada, squinting up her eyes in a most unattractive way.

"I know of no other route to the public byway."

"So *you* and only *you* . . ."

"*Madam!*" There are limits, or so one would have thought, to public accusations of this sort within a properly organized society. I reset my eyeglass and aimed it at my hostess. "Madam, as I passed through, I was too faint to notice any burglars in your drawing room. Had I encountered one, however, I should have encouraged him in his felonious intention. That picture, as I pointed out to you earlier, absolutely deserved to be stolen. I am happy that it has been, and I revel in the fantasy of a jolly, misguided jimmy-man sitting alone in a dismal room in Soho, wondering hopelessly how to dispose of his treasure. But he will have risked the anger of the law for nothing. The thief would have done better just to toss the picture into the Serpentine, for all the good it will do him. Good night, madam. I shall not entertain your guests again."

"Or steal my pictures?"

"I will overlook your rudeness," says I, ready to set fire to the bloody place, you know, but really above the whole thing. It was worth a laugh. "Goodbye, dear lady." Bowing a bit too low. "You accuse me of the ridiculous theft of my own picture. My revenge would be that you retrieved it and had to spend the rest of your life looking at it."

Well, well. That is probably altogether too much evidence to prove a point. I only meant to say that I draw the line somewhere. Perhaps I may best indicate my idea by a printer's error in the catalogue for my last exhibition. A line in it was supposed to read: "Mr. Whistler's pictures kindly lent by their owners."

But the good, dozing printer—my sort of chap exactly—left out the word "by." "Mr. Whistler's pictures kindly lent their owners" expressed my philosophy in the absence of a little two-letter word more precisely than I could have done in a hundred other words. That I let the error stand goes without saying, of course. Indeed it so delighted me that I had the worthy printer run off a few score extra copies of the catalogue than were actually needed, just to distribute among discerning friends.

Yes. My paintings are kindly lent to their owners. My rights in them are not diminished by the simple writing of a check, however princely. If they prove wrong, by my own assessment, then they must not exist. Fortunately, over the years, my ability to assess my own work has grown more accurate, and ridiculous scenes like the one just recounted happen less frequently. I am much slower to let work out of my studio at all. Much never leaves it. In my life I have destroyed at least five times what I have allowed the world to see as my testament.

Now that I was thirty pounds richer from the sale of my Piano Picture it seemed reasonable that I should set up somewhere on my own, away from the grandeur of the Hadens' house in Sloane Street. But in the end one had to acknowledge that thirty pounds was probably not really all that lordly a sum to set up housekeeping, and I am free to admit to a certain inertia brought about by charming company—if we may exclude earnest Seymour for the moment—the food, the wine, the feather bed. And so I stayed, although rather briefly. When I left, my leaving had nothing to do with the pleasant amenities of life, or the lack of them, but with something quite different.

After my "recognition" in London, if that's the word I'm after, I wrote to Fantin and Legros in Paris, a trifle giddily, perhaps, but only in the spirt of our Société des Trois. "*Venez, venez, venez à l'Angleterre, mes chers amis!*" I wrote. England was their true, their spiritual home in which their art would finally be understood, I told them, their fortunes already assured. So they came, bringing nothing but a few canvases and

the sketchy clothes on their backs—and I installed the two of them in Seymour Haden's house in Sloane Street.

Now, to be fair, Seymour was very nice about it at first. It must be admitted that with the arrival of my two Frenchmen life in Sloane Street was not quite the same as it had been before. Fantin's habit was to sleep until the afternoon, then, if luck was with him, which it was, to eat two or three meals and work until four in the morning. The habits of Legros were less eccentric chronologically, but he had his special problems. For one thing, he had no shoes, or, at any rate, no shoes that would pass muster in a drawing room in Sloane Street. So the good chap found a way of pretending he had shoes but was unable to use them. He scuffed about in bedroom slippers and a tattered dressing gown, claiming some arcane foot illness, ate as much as Fantin and disappeared to paint a lot.

Actually, it was modest, quiet Legros who caused me to leave Haden's house forever. Seymour meant to be kind to his curious French visitors, my good friends. He ordered some copies from Fantin, and from Legros he bought a painting of a church interior, what church I don't know, for a few pounds. Now, Legros was in so deplorable a condition just then that the price of a new pair of shoes sent him into ecstasies. Seymour was his hero, *sage et sympatique* beyond normal men. At least for a time.

What he didn't know was that he was dealing not only with Seymour the patron and philanthropist but also Seymour the eager artist. For it turned out that Seymour, while he liked Legros' church interior in a general way, felt that the painting of the church floor was out of perspective. One day he took it to the room upstairs where he did his etchings and locked himself inside with paint and brushes. When he emerged the perspective had been made right, according to Seymour.

Neither Legros nor I were in the house that day, but when we came home at dinner time we found much to be impressed with. Legros' picture now hung in a frame—a magnificent gilt frame that must have cost twenty times the cost of the picture —in a conspicuous place in the drawing room.

Well, Legros was overwhelmed, you see. He had never before seen a picture of his in such a frame. Mostly, he had never before seen a picture of his in *any* frame. So that's what we both looked at, the frame. We had a gay dinner and Debbie played the piano beautifully and finally we went to bed. It was not until the next morning—Seymour off at the hospital, of course—that Legros and I took another look. Finally, gradually, happy Legros looked inside the elegant frame, and Seymour's tampering with his painting dawned upon him. He stared. He began to tremble. I thought he was having some sort of terrible epileptic seizure until he was able to convey to me—by pointing a palsied finger and making gargling sounds at the back of his throat—precisely what manner of rape had occurred.

"*Sauvage!*" cries out honest Legros, a real artist to the tails of his coat and my man all the way. "*Les Anglais sont tous sauvages! Veestlair! Veestlair, qu'est-ce que je peux faire? Je suis désolé. Je suis mort, tu sais?*"

"*Attends, mon vieux,*" says I, all calm anger now, taking charge of the situation from my poor upset friend. "First we take down the picture." So we managed to do that, fancy frame and all. "Now we go up to Haden's studio." And we did that, too, tottering and panting a bit on the stairs with the big picture. "Now I lock the door," says I, doing that. "And now you paint exactly what you wanted to paint in the first place. Everything changed back exactly as you wanted it. I will sit here by the door and kill whoever tries to stop you. *En avant!*"

And Legros flew into the thing with a will, you know. Was his perspective any righter or wronger than Seymour Haden's? I have no idea. Nor do I care a damn. It was Legros's piece of canvas, and that was the point, inviolable.

Well, Legros was still working when Seymour came home. The doctor came rushing up the stairs two or three at a time, furious apparently, banging on the door. I let him in. It was, after all, his house, though not his to control this particular room, if I had anything to say about it.

"How dare you, Jemmy!" cries Seymour, lurching about in

the doorway, his bat-wing collar and cravat one half an inch askew, an appalling solecism in his life as he lived it. "You are allowing the Frenchman to alter my picture, bought and paid for!"

"No, Seymour," said I, all very cool, "you dared to touch another man's work, and for that offense you will certainly spend many extra seasons in Hell. But I really don't know about things like that. I only know that our friendship is at an end. I will see Debbie and Annie whenever I like, and you will have nothing to say about it. I wish you well with adenoids. Come, Legros."

Legros had by then dabbed his way back to his original vision, whatever it was about the perspective of church floors, and he tossed down his brushes and took my arm.

"*Au revoir*, Monsieur Cannibale," says he as we started down the stairs, his new shoes squeaking honestly, the rest of him flapping like a determined scarecrow. And I, at his side, another scarecrow, though pretending to be more modish. We went out into the street, and, while going nowhere in particular, we blinked at the garish day and foresaw our own glory in it.

"To the slums!" cries Legros. "Where no one repaints a man's pictures!"

"Nonsense, my friend," says I. "To the Café Royale, where no one repaints a man's pictures, either, but where the food is better."

Well, we tried that, but in spite of Legros' dashing new shoes and my freshly earned thirty pounds, we were most undemocratically denied a table. It may have been that Legros' dressing gown threw them off, I don't know.

Since then, our Société des Trois has dispersed, regrettably. Fantin returned to Paris, which I should never have persuaded him to leave in the first place—a Frenchman to the tips of his toes—and has made his considerable reputation there. Legros, on the other hand, stayed on in England. I can't think why after his tirades against the English *sauvages* and *cannibales*, but he

has made a very good thing of it, popular, successful. In fact, not long ago I was staggered to read in the *Times* that Legros had become a naturalized British subject. We met in somebody's house not long after this curious bit of news.

"*Mais pourquoi, mon cher ami?*" says I to this proper little gentleman in a black frock coat and a gold watch chain across his silk waistcoat. "*Les Anglais . . .*"

"Please speak English, Jimmy, old man," says Legros, in an accent I can only describe as that of an officer of Anglo-Bulgarian origin, recently cashiered from a good Guards Regiment for cheating at cards. "I now speak perfect."

"Yes, I see. But *why* did you want to become an Englishman?"

"Simple, Jimmy," says Legros, as though it really were. "So that I could claim I had won the battle of Waterloo, *parbleu.*"

A reason, I suppose, though not mine. I stay in England because I have only contempt for its ways. I choose to stay and fight the arrogant, self-satisfied, present-day bully-boy on his own soil, win, lose or draw. It will no doubt be the end of me. *Adieu, cher* Legros, our methods are different, but we will always share together in our souls a day's honest business.

So there I was, in God's Year 1861, twenty-seven years old and not a serious connection in the world, just one more painter out of thousands, as far as the world was concerned, thirty pounds in my pocket, no roof over my head and a most unpopular vision in my mind. Altogether a good place to start.

I took a room in Wapping; that is, along the tough waterfront of London, because it was cheap, but far more importantly because it was smack on the Thames, a river so subtle and glorious that the English do not deserve it.

The river became my obsession, particularly as I saw it at night. I painted it a hundred times in every way it appeared to me. It became for me a mystical experience like no other. It was this harmless obsession—one would think it was harmless, at

least—that finally led me into an English court of law in a suit for libel. But that will come later.

Once established at Wapping, my first urgent need was to fall in love. This is very important. In my game, I have naturally encountered hundreds of young men to whom sex is either an unimportant matter or a greatly selective matter. I belong to neither school, as it happens, and say so without criticism. I love women. They are so much more sensible than anyone else. They accept male behavior, and crime in general, with perfect equanimity. They bend kindness to accept masculine absurdity with true generosity. They are so soft. Their hair is so pretty. And if they sometimes love us only for a time, they love us wholly within that time.

And so I met and fell in love with Jo. Joanna Heffernan, to be precise, a model—to me, to Rossetti, to Courbet, to any number of smaller hacks, who missed her special red-haired, Irish beauty.

But I must get on to the present. In painting I leave out what is not essential to my composition. I take that license here in writing, though it is new to me. For a time Jo was a part of my general scene, but finally not a part of my composition, so I skip on past her, insolent as that may seem. Selectivity is art, after all. Insolence is not far behind, I fear.

So let us talk about me, here and now, long after. Let us defer further talk of John Ruskin and tiresome people like that. I am at the very least worth talking about—and constantly am. It is a curious phenomenon, my present life, but I will try to explain it.

I am regarded—and I really can't think why—as somewhat eccentric. In the little things of daily life, that is, like dress and speech and superficial social behavior. I speak of the public man, of course. Fortunately, these odd Islanders among whom I dwell have a special penchant for what they regard as eccentricity; it is part of their tradition, and with Islanders tradition is all. Give

them a Prime Minister, a dignified man of decorum who merely ministers efficiently and well in a proper frock coat, and he and his entire party will be voted out of authority in the next special election. But give them, as is presently the case with Mr. Disraeli, a Prime Minister who not only ministers well but writes appalling novels, stands on his head in his rose garden, stitches in petit-point and who is, into the bargain, a Church of England converted Portuguese Jew, and they will not only re-elect him for as long as he can stand up in his shoes; they will make him a belted earl. It is their most endearing trait.

In my own case the Islanders have mistaken shadow for substance. There is nothing eccentric about me, not a patch on the Prime Minister, for example, not to mention various alarming specimens among the higher orders, royal dukes and so on. Oh, I suppose the most hidebound of conservatives might regard my dress a trifle unconventional. My top hat may be two or three inches taller than the ordinary, but then I am not a particularly tall man and I have a natural eye for composition in all things. My walking stick is possibly a foot or so longer than most, but that is only to serve an obvious double purpose, grace of gait and a ready implement for hitting art critics.

The matter of my speech is a dilemma to the Islanders, although perfectly natural and comprehensible to more imaginative peoples. As anybody knows who has spent even a single year in the purlieus of this densest of forests, the manner in which one pronounces the English language is of passionate importance. Not because it identifies the speaker geographically —after all, one's accent in any country does that and is of only geographic interest—but socially speaking a man's accent on this strange island is of infinitely more importance than his intelligence, his abilities, his manners or his charm. Let an Englishman, with all of these attributes in abundance, pronounce a single vowel in this way instead of that way, and he will never ever dine here, shoot there, or be put up for such and such a club.

The judgment of accent is so gloriously precise that Euclid would have endorsed it, though not laughed, as mathematicians

so seldom do. It is most comfortable, from top to bottom, to know exactly where one stands. It governs general behavior and sends the adventurous to prison. Also, a nation strictly administered on the pronunciation of vowels has become an empire on which the sun never sets, a fact to jolly even the giddiest elocutionist.

But we were talking about me, my interestingly accented English, which simply will not fit into the proper scheme of things in London society. Therefore, that society, throwing up its hands in despair, so to say, accepts me at all its levels because I refuse to be any classifiable part of it. Oh, it's an invigorating field for a man whose natural tendency is to muddle systems, I can tell you that. And all the advantages are on my side.

Being an American, nothing is expected of me; nothing, that is to say, except perhaps an amiable barbarism. I am expected to speak in the combined accents of Sitting Bull and Little Eva, which honor I have declined. Instead, and quite naturally, you'll agree, now that you know a bit of my background, my accent is inclined to the cosmopolitan—part West Point, part Methodist, part St. Petersburg, part Buckingham Palace (Cockney) and, only in order to allow for no official classification, part French. And every door in London is open to me. Ha-ha!

(I am not a modest man, unlike my worthy fellow American, Mr. Henry James, who has decided to *be* English and have done with it. And as such he is, almost, accepted. This gentleman lives in the village of Rye writing novels and living, so far as I know, an exemplary life and talking like a real Englishman. What he writes is, of course, another matter and subject to personal opinion. I have been reported as saying, in this connection, that "Mr. Henry James is inclined to chew more than he bit off." But I can't remember ever having made so severe a judgment of a fellow artist. It simply isn't like me.)

Maud Franklin is my model—since that term seems to satisfy at least an enlightened segment of the local electorate—

and very beautiful. (There is, in this connection, only one possible social advantage I can think of that an artist has over a Cabinet Minister. The former is permitted a "model," because after all he must paint *somebody*, while the latter is not permitted a visible "mistress" because he doesn't paint, or shouldn't.)

Maud has the most glorious red hair that man has ever seen, a face of quite extraordinary subtlety. Her lower lip, for example, while very full, is only two thirds the breadth of the upper one, a provocative natural phenomenon that disturbs even Anglican curates. And, best of all, she has just a beginning on buck teeth. Now, that is an absurd phrase, I know. For example, precisely what buck is alluded to, I have no idea, but at least usage has made the marvelous deformity (I reject the word!) have a more or less common definition.

I speak only of Maud's teeth, square and white, in the upper jaw, slightly protruding over those in the lower, thereby constantly forcing the lower lip into prominence and inducing in her laughter for some reason a certain absolutely charming gulping. Her body has a grace that is at the same time slender, nearly adolescent, yet erotic—perhaps more so to painters than to curates, who incline to the Rubens endeavor.

With all this, Maud's mind is the mind of a sergeant-major of dragoons, for which I most earnestly thank Somebody-or-Other in the sky, as in these doleful times she has kept me, at least so far, out of prison.

My house, you see, as I may have mentioned before, is not occupied only by ourselves and the servant or two we cannot afford. We are, instead, the victims of an unconscionable legal system which allows a bailiff—a bill collector—actually to move into one's house until a bill owing one's creditor is paid. Maud, however, is not without resources. . . . Well, here she comes now.

"Jimmy," said Maud, walking quickly into the dining room, where I was drawing (yes, drawing) the menus for what might possibly be the most important of my famous breakfasts in Lindsey Row (all my Sunday breakfasts are famous, not all are equally important), "the bailiffs are coming round marvelously, I think. Mr. Tupper, the fat one with the wen, is wearing one of

84

your white Japanese housecoats and is showing talent at salad dressing."

Maud was in cool lavender, which becomes her hair most wondrously, although in her hand she held a great sheaf of bills, taking some of the fun out of it. Of course it is quite wrong that such a Botticelli should have to deal with bills and bailiffs (well, no, Botticelli is wrong, since at last all those long-waisted beauties are essentially sexless deaders, which Maud emphatically was not), but fortunately there is the strength of steel in certain unexpected spines, and Maud's is one.

"Maud, my dear and useful," says I, "if anyone can make a bailiff into a salad chef, I'm sure it's you. But caution Bailiff Tupper against the overuse of garlic in his dressing. Our guest of honor today votes Conservative and advises temperance in all things. As he's the only millionaire art fancier we happen to know at the moment, we mustn't offend even his taste buds, don't you agree?"

I sat down at the breakfast table and went on drawing my menus. Maud, standing close beside me—entirely ignoring the wrenching beauty of the hundred-year-old blue-and-white china at each place, the gleaming Georgian silver, the single graceful branch of rhododendron leaves (which may be stolen from St. James's Park, in season) arching in perfect not quite symmetry across the pristine damask cloth—went on talking. (Maud seemed to regard drawing my menus on the white tablecloth with India ink as a somehow perilous enterprise. I would have thought she knew the steadiness of my hand better by this time.)

"I know Mr. Leyland's all that rich, Jimmy, but I don't know why he's going to share his millions with you. Why should he?"

"Don't worry, Maud," I said, all false complacency, "today will change everything. Mr. Leyland, while rich, is more or less wise. He knows enough to invest in posterity, particularly after he will have eaten my breakfast. How could he not?"

Maud smiled, marvelous teeth. "You know, I thought you were quite mad to suggest it. But I think it's working."

"What's working? Oh, you mean the bailiffs pitching in to

help. Well, you know, it's the most natural thing in the world, if you think about it. Only imagine how a bailiff must usually spend his time, Maud. The unspeakably dreary business of dunning ordinary folk, even having to move in with them. Appalling. Think what a sparkling oasis I and my household must be to the poor chaps. Suddenly they find themselves privileged to wait upon men of genius and the swells of London society, mixing salad dressing for captains of industry, like our imminent guest. No, no, Maud. These bailiffs are men quite blessed, and they have the wit to know it."

"Jimmy."

Oh, well. A special voice, a special flat note struck.

"What?" I knew.

"Even if the bailiffs are having a jolly time and their intellects elevated, the *creditors* are not." Maud whacked the sheaf of bills in her hand for emphasis. "I know you won't like it, but I have an idea, Jimmy."

I know I won't like it either, but I am a West Point officer and gentleman and it is not in my code to be rude to ladies, at least until I am reasonably sure that it will be to their profit. "You have an idea, Maud?" Noncommittal, you see. "And what is that?"

"Well . . ." Maud seemed a trifle nervous, brushing her hand across her glorious hair, but she was determined. "Well, I know you don't like to give titles to your pictures, Jimmy . . ."

"On the contrary, all my pictures have titles."

"Well, you know what I mean, titles that people can *understand*."

"If people can't understand the titles of my pictures, it's simply because they haven't bothered to look at the pictures. But, excuse me, I'm agog to hear your idea."

"I was thinking of the portrait of your mother, Jimmy."

"Yes. I believe I called it 'Arrangement in Gray and Black,' which is exactly what it is. It's somewhere upstairs, I think."

"Now that's my whole point. The Royal Academy refused to hang it, didn't they? Well, why didn't they?"

"Time is too short for me to explain to you the Byzantine reasonings of the Hanging Committee at the Royal Academy, my dear, so you might as well go ahead."

"It was the title, Jimmy. It confused them."

"No, it infuriated them. Ha-*ha!*"

"Now, that's your sour laugh, your . . . hating laugh and it won't get us anywhere. These bills are *real*." Again Maud spanked the papers.

"Real as can be, Maud, real as any other bits of paper." A tot of sham on my part, of course. *I* knew the bills were real, and I knew there wasn't a sou about the house to pay them, but then *someone* had to keep Maud's courage up.

"If you put a different title on the portrait . . ." she said, earnest as you please, "I mean, calling pictures Arrangements and Nocturnes and Symphonies, well, that's about music, isn't it?"

"Originally, no doubt. The notion will change."

"Jimmy, Jimmy, Mr. Holman Hunt . . ."

"Oh, my . . ."

". . . paints a picture of Jesus holding up a lantern with a door and lots of shrubbery about and calls it 'The Light of the World.' And it's hanging in St. Paul's Cathedral."

"Well, you know, the church has its ups and downs."

"And Mr. Burne-Jones calls his pictures . . ."

But all jolly conversations must come to an end at last, and our time had come. "Maud," says I, with my customary good temper, "I would not go so far as to burn Jones, perhaps, but I would most certainly burn Jones's pictures. You had an idea, as I remember."

"I have." Very straight, very stern, bills trembling—a woman worthy of love, surely. "I think, no, I *know* you could sell your mother's portrait for a good round sum if you'd come down off your high horse for a minute and call it . . . 'Waiting'!"

" 'Waiting,' " I repeated, as calmly as circumstances would permit. "And what is she waiting for, a Number Five omnibus? Damn silly place to wait for it, if you ask me, hanging about the

house staring at the wall. Or perhaps she's waiting for somebody to come along and hang an idiot title round her neck."

"No, Jimmy, *please*, you know I don't mean that. Don't be cross," says Maud, taking hold of my arm to steady it, for she seemed to have this curious notion that I was cross. "A title like that is . . . is provocative, don't you see? The person looking at the picture can imagine for himself what the dear little old lady is waiting for. Perhaps she's waiting for her children to visit her. Perhaps she's only waiting for death."

"She won't have to wait long with people like you on the job."

"Well, then, if you don't like 'Waiting,' how about 'Remembering'?"

"Or how about 'Remembering to Wait,' as in trying to cross Piccadilly Circus at teatime, or 'Waiting to Remember,' as in amnesia? God save the mark, Maud! Am I to share my house not only with bill collectors but with a burgeoning art critic, an adder coiling to strike from within my very private pillow case!"

That calmed me a bit. Well, I mean, one can't go around talking about adders in one's pillow case and expect to be taken seriously. I took several deep breaths and they did me good. Your well-adjusted fanatic must, after all, seem to carry a tightly furled umbrella.

"My lovely Maud . . ." I began, for lovely she was, although so gravely misguided.

"I know what you're going to say, Jimmy," she interrupted, looking sternly at the floor, possibly not absolutely keen on the adder part.

"But have you ever really *listened*, my Maud? Listen again, I beg you, for both our sakes."

"All right, Jimmy, although I don't think it's going to pay the bills."

"Good. Only listen to me as though you were a millionairess and had never heard of a bill. Agreed? Now, *I* know the thing is an interesting picture of my mother. But the public can't and

ought not to care about the identity of my model. What I mean for people to see is an extremely skillful artistic arrangement of what is largely two muted colors close to each other on the palette, gray and black.

"I would like people to be moved emotionally by the beauty of that arrangement, of both composition and color, as they might be moved by the subtle work of some Japanese master, about whose subject matter they know nothing and care less. That is all, though that is much, and my title is my signpost. And that, my dear Maud, is precisely why I *didn't* call my picture 'Waiting' or 'Remembering,' 'Whistler's Mother' or 'My Mum' or whatever other claptrap you may choose to grab from the despicable bag. Please see, Maud."

It was at once clear that, for all my rather exhaustive eloquence, Maud did not see, although I really believe she would have liked to.

"But, Jimmy," says she, waving her bills with possibly a little less energy, "it *is* a picture of an old lady sitting in a chair, isn't it? And she's a *real* old lady who lived in this house, a lady I admire and respect . . ."

"That is only special information having nothing to do with the public."

But Maud, of course, is a part of the public, which properly gives her certain rights. She turned her head slightly away so as to disengage her gaze from my glittering eyeglass. "Jimmy—" and she said it very gently, I confess—"but the people laughed."

Well, yes, they did. While it's true the Hanging Committee at the Royal Academy at first refused my picture, they did so without reckoning with the spirit of one of their own members, William Boxall. When I was fourteen this gentleman painted my portrait, commissioned by my father, then finishing his Russian assignment and doing a pretty good thing in rubles, medals and Fabergé Easter eggs. Twenty-odd years had passed when I presented my picture to the Academy, which is of no importance except that in the interval good painter Boxall had been elevated to Sir William Boxall, quite a toff over at Burlington House.

Well, you know, I don't suppose the dear man made head or tail out of my "Arrangement," but he had been my father's friend and he was an "English Gentleman" in a mold that normally has far more currency in literature than in fact. But old Boxall was a real one. He announced to his associates—mark you, solemn, institutional citizens like Frith, Millais and Leighton—that if they didn't hang my suspect "Arrangement" he would resign. Well, they hung me.

My picture was the major attraction of the Academy exhibition of 1872, in a manner of speaking. It attracted by far the largest crowds, I am told—I never attended the exhibition myself —crowds that stood rocking on their heels and holding their sides in merriment, enjoying the spectacle of "a picture of a rather sleepy old lady," as one critic noted, "whom we are given to understand is the artist's mother, waiting in motherly patience for her son to be done with his tiresome conceit, only wishing she could stop being an 'Arrangement' long enough to have a good cup of tea."

There is only one reasonable response to such carefully reasoned criticism—and it is laughter! First, of course, I should say that I have never submitted another painting to the Academy, nor will I ever do so for the rest of my life.

That is an agreement that seems to be mutually understood.

For example, a few weeks ago a letter was delivered to me. It was from America and it had first been delivered to the Academy, for it was addressed: "J. M. Whistler, Royal Academy, England." It was returned to the post office. Across the envelope was written: "Not Known at Royal Academy."

One of the droll things of this pleasant life, you know, and I hastened to share it. I sent the envelope to the *Daily Mail*, which reproduced it accompanied by my comment. "In these days of doubtful frequentation" (I wrote), "it is my rare good fortune to be able to send you an unsolicited, official and final certificate of character."

It is painful to be a joke, you say? It is far more painful to be ignored. I am never ignored.

But let us get back to the merrier encounters of the present. Maud, bills still in hand, was watching me. Her extraordinary lower lip was on the verge of trembling. Then it came, all in a rush, not exactly for the first time. "Nobody can play a game entirely by his own rules! There's no point in a cricket match without a wicket for only one player!" (Maud, you see, is English straight through. If she can prove that something is illogical because it would be illogical in a game, then it must be irrefutably illogical. But wait, she hasn't finished yet.) "Jimmy, the rules are the same for you as for anyone else! Who do you think you are, anyway?"

"I thought I was Jim Whistler."

"Whistling in the dark, if you ask me!"

"Oh dear, Maud . . . you really mustn't get started in that game. If somebody grows up with a name like Whistler, you may be sure he's heard all the possible whistle jokes by his tenth birthday."

"That was not a joke!"

"I'm relieved to hear it."

"I only mean you've got to pay attention to the world you live in, to what . . . to what people *expect* of an artist."

"How could anyone possibly know what to *expect* from an artist? Nonsense, of course, but what else?"

Maud's foot tapped and she was wringing the unpaid bills in her hands into something of a mess—all to the good in one way, I suppose. But a new tack must always be your adept helmsman's response to a contrary wind. "Jimmy," says Maud, in a voice from somewhere else altogether, "do you love me?"

"Of course, my love. And substituting love for logic is absolutely my game all the way. I tell you freely, Maud, the color of your hair has never been matched on this earth."

"Never mind that, Jimmy," says Maud, a trifle peremptorily, or so it seemed to me. "If you love me, pay attention to what Sir Frederick Leighton said only a few week ago in the *Times*."

"You mean you carry things like that around with you? Amazing!"

"I don't have to carry them around with me, they're in my head." And just to prove it, out it came from her head. " 'If Mr. Whistler would only behave himself, he could be our president.' That's what he said, Jimmy. President, *president* of the Royal Academy."

Funny about reading written words, about accenting this word instead of that word in a given sentence, missing the point as often as not. "Maud," says I, gentle as a lamb, "the important word in Sir Frederick's utterance is not 'president'—he means to be that himself—but 'behave.' I do not *'behave'* myself. What, in the name of even partial sanity, does *that* mean?"

"You know what he means, Jimmy."

"Yes. I only hoped you'd found a new way of saying it."

"The *Daily Telegraph* has another way."

"Which I'm sure I've heard, but let's not skip the best parts."

Maud was having the small but important distinction of defining courage between the courageous statement and the courageous lie. The *Telegraph* said, recited Maud, " 'If Mr. Whistler would leave off using mud and clay on his palette and learn to paint cleanly, like a gentleman, we would praise him.' "

"Well, now, you know, Maud," says I, and I was not pleased to hear my voice rising several indecorous notes, "an artist doesn't really mind being told he doesn't 'behave himself.' That, if you stop to think about it, is more compliment than otherwise —a sort of back-handed accolade to his independence. On the other hand, to tell an artist that he doesn't paint like a *gentleman* is intolerable! To *be* a gentleman is socially and humanly necessary. To *paint* like a gentleman is like telling a fish, to be a proper fish, he must fly; a bird, to be a proper bird, must swim! However, you may tell your bloody, anonymous Mr. *Daily Telegraph* that in the future I shall bend every effort to paint like a gentleman—like, say, Michelangelo and El Greco and other such renowned *gentlemen!* Ha-*ha*."

One would have thought that such carefully reasoned argument would have brought the subject to a close, but no. Maud,

strangely unconvinced, only clamped down harder on the bit between her teeth. Her hand on the breakfast table even made my exquisite blue-and-white china dance a bit.

"Jimmy," says Maud, her trembling unpaid bills just under my chin now, "will you never give even an inch to people who are only trying to help you?"

"No, my love."

"Do you really love me?"

"Of course, my love."

"Then you *must* change, Jimmy."

"Never, my love."

Slap.

"My point exactly," said I. There is nothing wrong about being slapped by a woman of conviction, or so it seems to me. Just as long as you haven't altered *your* convictions. We were both the better for it, you know. Maud's head of steam diminished, my little notions alive and well. "I suppose one can only hope to find a single believing fool," says I, in the genial calm that only slapped people can afford. "They grow scarce, I know. But perhaps one is coming to my breakfast."

"Oh, Jimmy . . ."

But at West Point they taught us that a command decision is everything: Do it or don't do it, but once you do it, don't change it. Soldiers and lovers share the edict. "My Maud," says I, "stand with me or against me, not halfway in between."

Regrettably, Maud had no chance to answer. Even though I knew her answer, I would like to have heard her speak it. Instead, one of our bailiffs, impeccably got up like a waiter, white coat and a folded napkin with a frayed edge across his arm, ushered in someone from the outer hall.

"Excuse me, Mr. Whistler," says the bailiff courteously, indicating the man in tow, "but this man says 'e's a bailiff."

Which sent Maud back to the kitchen giggling—if you can judge giggling from someone's shoulders from behind—followed by the waiter-bailiff, leaving me with the new bailiff. I beckoned the newcomer to join me in the dining room, which he did.

This one made five by my latest count, although it was difficult to be sure. He was a bit younger than my other four, and there was even a dim light of intelligence somewhere behind his eyes, suggesting that he might go on to better things, main bailiff or whatever they have.

But then his future was his problem, not mine. Mine, at that moment, was to produce the most amazing Sunday breakfast of my career, and I hadn't any wine. (Wine, you say, for breakfast? Well, yes, because, you see, my breakfasts are not really breakfasts at all, being served more or less at midday to confound the Islanders.) I hadn't a drop, nor did I have the few shillings necessary to buy a drop, even of the rather perilous variety sold down the King's Road nearby by a vintner with the artistically imaginative name of Freddie Borgia. Rossetti, a student of church history and poisoned rings, calls him Pope Alexander VIII. The Seventh being the last known to official Christendom.

I studied my new bailiff with great care. He looked relatively affluent, as bailiffs go—a new dark coat, an unspotted cravat, neat shoes. I wondered . . . I am no snob, and a bailiff's money is as good as anybody's. For all I knew he was a disguised marquess out on a lark to learn the people game. Not likely, of course, but likelihood has not been my portion. I watched his good honest face for signs of life.

"So you're my new 'man in possession'," says I, smiling, an absolute winner, you know.

"Yes, sir, Mr. Whistler, sir."

Well, there went the masquerading marquess, for to even a dullish marquess, it seemed to me that I must be either Mr. Whistler or sir, not both at the same time. But no matter. I had an idea. Vanity, as well as shillings and pence, is to be found at all levels of our rather comic modern social arrangement. Perhaps if I promised to paint him as the young King David . . . My new bailiff was young, stern of jaw, supple of muscle—a bit of lion skin over one shoulder, slingshot in hand, wild sky behind, all very dramatic. (Not, of course, that a month's sojourn on the rack could actually induce me to *paint* such a picture, but it was first things first just then.)

"Delighted to have you in possession, I'm sure," I said. "For how long, would you guess?"

"Well, sir," says David the King as yet unborn, "that depends on your paying Mr. Finlay's bill, don't it?"

"How well you put it. But in that case, your stay may be a rather lengthy one. Awkward for both of us, you may say, but you may be wrong. I have just been noticing the strong line of your jaw."

"Beg pardon, sir?"

"Oh, it's nothing. We painters, you know, we have a different way of looking at faces than other people. You . . . you've never had your portrait painted, I suppose?"

"My portrait painted, Mr. Whistler!" (Nor have I ever met an Arabian bishop or copulated with an arctic polar bear.)

"Well, well, only a notion. . . Mr. Finlay, you say? Mr. Finlay would be the grocer, wouldn't he? Forgive me, but, you see, you are not altogether alone in your mission—there are others—and I tend to become confused."

"The grocer, yes, sir. Mr. James Finlay. And the amount owing him at the time he terminated your credit was precisely— one moment, sir, I have it right here—was six hundred pounds, fifteen and eightpence."

"Amazing! Now, I put it to you fairly, Mr. . . . ?"

"Bright, sir, Ernest Bright."

"Ah, how suitable to my question, Mr. Bright. As you are not only bright but earnest, I put a fair question to you. How could any man—at least any gentleman—conceivably devour six hundred pounds worth of groceries? The suggestion is not only preposterous but unseemly, hinting at gluttony. It could not possibly be accurate, you'll agree. At least, you'll agree now that you've met me."

Bailiff Ernest studied his bill uncomfortably, turning it this way and that, searching for its deeper meaning upside down, then back again. But his jaw grew hard once more. No sense of logic, evidently.

"But, you see, Mr. Whistler, this bill has been carried over for seven and a half years."

95

You know, the curious thing is that I *could* actually paint Bailiff Bright. Not as a bailiff being a bailiff, of course. That would only make me rich and famous in these curious times. Stern-faced bailiff presenting bill to noble-faced widow surrounded by an army of pinch-faced starving children. Call it "The Day of Reckoning." No. He would be one of my "arrangements." An "Arrangement in Pink and Black," perhaps. For his face is extraordinarily pink, his suit death black, and that is what is interesting about him. Let his black suit stand against a background only a little blacker than the suit, and let there be only two pieces of light for us to dwell upon in a painting high as a man—at the top his face, grown paler, more shadowed, as he becomes more mine, and then, two thirds down the canvas, not a bill, not a paper even, in his hand, but a splash of stark zinc white only, placed exactly where it should be placed, to balance, to satisfy the composition as well as the soul, joyously to fill the arid void in modern man, to dignify the raped name of art. . . . Mr. Bailiff really wouldn't like it at all.

"Seven and a half years unpaid, you say, Mr. Bright? Then seven and a half years to pay it is fair enough, you'll agree. Symmetry is everything in the end."

"But I have a wife and children, Mr. Whistler."

"Splendid. I don't marry, though I tolerate those who do."

"But I need my collection fee."

"Just so. And the longer you stay in my house, the more likely the fee. Correct?"

"Well, in a manner of speaking, but in my job . . ."

"And since your stay is to be prolonged, you must be comfortable. The quarters on the top floor are not exactly Windsor Palace, I freely admit—and rather crowded these days—but you will find your stay not entirely unprofitable. For in this house, my friend," I continued, "you will see and hear much that may be extremely useful to you later in life." All absolutely true, of course. But time was growing short, money was short. Short? Ha-*ha!*

I took my sparkling monocle out of my eye in order not to be too alarming. There are recorded cases of fits.

"Just in passing, and by the way, Mr. Bright," says I, with what the Duchess of Cambridge has described in most extraordinary French as *la belle blague de Mr. Whistler*, "you no doubt have a quid or two wasting their time in your pocket just at this moment."

"What's that, sir?"

"Not a matter of importance, really, but I'm giving you an opportunity to get out of your troubles. Your wife and children and all that. One is instinctively repelled by the picture of want."

"I don't quite follow you, sir."

"No, you don't and that's quite natural. Still, it's not very difficult. I speak of money. Follow me closely, Bailiff Bright. In a very few minutes one of the richest men in England is coming through my front door. He is my friend and generous patron."

"Never!" says Bailiff Bright, more or less waking up.

"Now, I must entertain this gentleman in a manner to which his riches have accustomed him—and more. Why? Because if the gentleman is made happy in every possible way, he will find ways to reward me beyond your wildest imaginings. If not . . . The fact is, I need a few bottles of wine to make the occasion all it should be, my dear chap. A quid or two and we'll turn the trick together."

Now the stern jaw slackened and Mr. Bright was regarding me with incredulity, not altogether illogical, perhaps, but something less than reassuring from my point of view. "You . . . you mean, Mr. Whistler," says he, "that you want *me* to lend *you* money?"

"And why should that seem odd to you?" said I, time growing shorter. "You should know better than anybody the delicacy of my financial condition. But I offer you immortality for the coins in your pocket. I intend to paint you as my young King David, somewhat deferred, possibly . . ." But that was a mistake.

"No painting, no painting whatsoever, sir!" interrupts Bailiff Bright with astonishing spunk. "Mr. Finlay made a special

point about that. 'Bright,' he said to me, 'in no circumstances accept any of Mr. Whistler's paintings as full or partial payment of his debt. Only the real brass will do, Bright. He's tried that game before.' I'm only mentioning what Mr. Finlay said, sir, nothing personal in it, of course."

I'd forgotten Mr. Finlay out of so many. Yes, some months before I now remembered I had offered him two lovely nocturnes of the Thames at night to settle his bill, but Finlay was a Ruskin man, born and bred and dead, and wanted only real brass. Well, so did I, as a matter of fact.

"Mr. Bright," says I, putting my monocle back in my eye, "your client is a man of business. So are you, so am I, although we all sell different wares. Now, allow me to point out to you that all of your futures depend upon *my* future, which is to be determined in a very short time. Do you follow me, Mr. Bright?"

"I . . . I think, in a manner of speaking . . ."

"Exactly. My patron, Mr. Leyland, a shipping czar made entirely of gold, mellowed by my beautiful breakfast, will commission some worthy work from me, I will pay Mr. Finlay's bill and Mr. Finlay will pay yours. What could be sounder? Empty your pockets, man!" Well, the thing had gone on too long, you know.

"Good Bailiff Bright started to fumble. "It seems a bit irregular, sir . . ."

"Regular as sunset, old man, and even more rewarding. Sunsets bore me."

Out came two half-crowns, one florin, one shilling, a few coppers. Sensible Bright palmed a sixpence and a farthing for himself. A gesture of independence. Quite correct, and I'd have done the same in his place. No matter, it was enough. Some idiot was pounding on my front door. It was too early for Leyland. At least, it *seemed* too early for Leyland. I could hear someone going to answer the door.

"Mr. Bright," says I, a trifle hurriedly perhaps, transferring the coins from his palm to mine, "you've done a fine day's work. Mr. Finlay will be proud of you. No nonsense about taking pictures in payment."

"Oh, no, sir," says David the King proudly, "only the real brass."

"So wise, of course. As I'm sure time will make clear. I owe you eight shillings and eightpence, Mr. Bright, for which I duly thank you. You'll get it back. In the meantime, go into the kitchen—right through there—and a charming lady will show you to your quarters, or possibly to some interesting employment. There's a good chap."

And off went Bailiff Ernest Bright, looking a trifle bewildered, to be sure, and a few shillings poorer, but into a richer life, you know. And at the same time the other bailiff, the one who had taken on the sort of major-domo role and making the most of it, announced from the doorway in a hot-potato voice, for all the world like an announcement at a court levee, "Mr. Dante Gabriel Rossetti to see you, sir!"

The bailiff went off and Rossetti came into the dining room, looking apprehensively over his shoulder. "Whistler," he says, "what the hell was that?"

"Only one of my men in possession earning his keep. I think you disappointed his sense of decorum by turning up in that alarming corduroy jacket."

"That was a *bailiff*?" And when I nodded Rossetti, who has nearly as peculiar a mind as my own, began to smile. "Are there more?"

"Four or five. I've lost count."

"All working?"

"Naturally. An idle bailiff is an unhappy bailiff."

"Jimmy," says Rossetti, looking around him, "you're a sadly misguided painter, I have to say, but you're a born emperor. If only you'd been Napoleon instead of Napoleon, the world would be French and even worse off than it is, which is bad enough. Leyland's not here yet, is he?"

"No, and speaking of sadly misguided painters, Leyland owns one of your pictures, doesn't he? Something to do with redheaded angels and calla lilies and sin? Or is it virtue?"

"Depends on how you look at it," says Rossetti, smiling

his Sicilian bandit smile. "My virtue is your sin, or maybe the other way round."

Rossetti did look like a Sicilian bandit. Well, not a real one, but one who had just escaped from a rundown touring company of *My Gypsy Sweetheart*. Corduroy jacket, flannel shirt with an enormous scarlet kerchief knotted at his throat, leather trousers, spotted black boots, just the thing for an elegant Sunday breakfast. But then, Rossetti would look like a bandit stark naked. His peasant body is squat and strong as a bull's, but it's really his extraordinary head. The skin of his face is swarthy— black eyes, wild black hair, black beard, teeth as white as the inside of an oyster shell when he laughs.

He is also a lunatic, of course, even going so far as to being a friend of John Ruskin's, keeping a fully stocked zoo in his back yard together with a houseful of malingering poets and other riffraff, and painting, with astonishing success, the indescribable rot of his Pre-Raphaelite brotherhood, whose very name defies definition.

He and his sister, Christina, also write poetry, which also seems to *me* to be rot, but then I'm no judge. Having said all that, I add that Rossetti is my dearest friend, as, I believe, I am his. As artists and as men we are so totally at different poles that there is no conceivable common ground on which we can stand together. Therefore, we never argue or try to split hairs over some half-shared points of view. There are none, so we laugh at each other and have been fast friends for nearly twenty years. We also share an admiration of each other as rather superior confidence men.

"Rossetti," says I, "no more of this elevating chitchat for the moment. No, don't sit down. I must ask you to run a little errand for me. Leyland will be here in a few minutes, so I must be on hand. I haven't any wine and my bailiffs are all needed in the kitchen. Be a good fellow and fetch me three or four bottles of the Pope's white—Montrachet or whatever he dares to call it."

"Good God, Whistler," says Rossetti, "you can't serve ·Borgia's poison to a man like Leyland. He's not used to it the way we are. It might kill him."

"Nonsense, Leyland may be a merchant prince, a shipping king and all that, but he grew up on the docks of Liverpool and he's been too busy making money ever since to bother about things like good wines or bad."

"Leyland serves damn good wines. I've had them at his table."

"Of course you have, and so have I, for that matter. But you're missing the point," says I, growing impatient with all this casuistry. "Leyland drinks good wine not because he knows it tastes like good wine but because he's instructed some wine merchant to send him only the best. Today *I'll* be his wine merchant."

"Well, never mind all that. More to the point, the Pope stopped your credit months ago."

I stood up very straight and elegant, looking through my sparkling monocle at raffish Rossetti. "Credit?" says I. "Who said anything about credit?" I placed good Bailiff Bright's coins in Rossetti's hand.

"One really shouldn't rob poor-boxes, Jimmy," says he. "It disheartens the clergy."

"Oh, he didn't rob a poor-box, Gabriel," says Maud, coming back into the dining room with a trayful of polished table silver. Smiling, she was, just as though she hadn't given me a clout five minutes earlier. "I just heard about it in the kitchen. A young bailiff lent it to him. It was a matter of enlightened self-interest, it seems. That's what he said Jimmy explained to him."

"Quite right," says I, with suitable dignity, I hope. "Sometimes it is necessary to point out to others on which side their bread is buttered."

Rossetti pocketed the coins and went to the door. There, he scratched his beard and shook his head, grinning in bemused admiration, then out he went for the wine.

I turned back to Maud, who was setting the silverware about on the impeccable damask tablecloth. She was humming at her work. Maud is a very exceptional bird, you see, not to be found in your ordinary aviary. She had had her say about my

work, as she has every right to do, slapped my face for the good of her soul, and now she was right back to her charming, extraordinary self. Which may require a little explaining.

There was no anger in Maud's face, no malice, certainly. Her earlier outburst against my own obduracy (likely to drive even your favorite saint to calculated homicide, I freely admit) was only because she cannot bear to see and hear other people mocking my work. Passionately, she wants them to understand what I paint, although she doesn't understand herself. (Which is infinitely more courageous and endearing to me than if she did.) Above all, Maud wants me to be famous and rich and respectable and adored. And I would not object.

Our terms are different, that's all. It is only very privately that she states hers. To the world she is fierce in fighting for mine. Here, then, is a woman to be honored, right or wrong, which is considerably more than can be said for her country. Why, you know, here in Chelsea where we live, Maud sees to it that she is addressed as "Mrs. Whistler." I humbly accept it as the finest tribute, however undeserved.

"But, Jimmy," says Maud, back to things practical, "what do you expect Mr. Leyland to *do*?"

"His duty, naturally. When a man makes ten million pounds, or whatever alarming sum, in the shipping business it is his clear duty to give some of it back, and not only to the deserving poor, either, although I don't immediately exempt myself from the category. No, it's to art that Mr. Leyland would be wise to make a generous contribution, if only to brush up his social standing a bit. In his bones I think he knows the time has now come for him to do some very grand Medici scamper. Play the *patron extraordinaire* who was never really interested in building ships."

There was the beginning of the smallest smile at the edges of Maud's mouth. "Yes, you may be right, of course," said she. "I suppose it could be tiresome just to sit on ten million pounds, as though it were an egg or something, but . . . but I was only wondering, Jimmy, why you feel Mr. Leyland is going to turn first to you?"

"Well, because he appreciates me, of course! You know that. He already owns one of my pictures, doesn't he? Man of taste. He owns two, in fact."

Maud's smile spreads a bit. "He owns two and a half, in fact, your 'Harmony in Blue and Gold' and his own portrait and half his wife's."

"That's just my point, Maud. You're very clever about these things. So, then, you see, he owes me something, doesn't he?"

Maud's smile was now pushing against the boundaries of laughter, a sweet-eyed laughter, to be sure, but this was perhaps not the absolutely right place for it. "But, Jimmy darling," says she gently, "I have the funniest feeling—now, I may be wrong—that *you* owe *him* something."

Maud has the sort of memory that should be permitted only to deposed monarchs and blackmailers. For myself, I live in the present. But on she went, backward.

"You'll remember Mr. Leyland was very keen on your work a few years ago?"

"Of course. Well?"

"Well, Jimmy, he commissioned six portraits, didn't he? One of himself, one of his wife and one each of his four daughters. And he paid for all six of them in advance."

"Good job. Let's hope it becomes a custom."

"Well, you painted Mr. Leyland's portrait . . ."

"And not soon to be forgotten, I tell you frankly, Maud. There's the smell of history in the shine on the shoes alone."

Maud nodded her lovely head, grinning. "And then there was the wife's portrait. Never quite finished, was it?"

"That was her fault entirely," says I, chin in the air, for one must, after all, reject the truth as long as one can reasonably get away with it. "The sittings were inadequate. She was always having to rush off to worthy meetings and so on."

"And the four daughters? They weren't ever painted at all, were they, Jimmy?"

"Well . . . not exactly."

"But the money was paid for the whole family?"

"The girls, when I finally saw them, were alarmingly plain."

"And it's this Mr. Leyland who is suppose to redeem our fortunes? Excuse me, Jimmy, but why should he want to do that?"

"For the good of his soul, of course!"

I was talking very gaudily, as the desperate must, but at that moment Maud and I shared a sly glance. And we began to laugh, more or less quietly at first, but it couldn't last. It took only a look around us, an inventory of things as they were—our own once grand, now not so grand, clothes, bailiffs coerced into domestic service with the hope of getting my creditors' money, more predators always on the way. Well, that sort of thing makes you *really* laugh.

Maud and I laughed until we cried—knowing that there was not one simple inch of basic understanding between us in things that really mattered to each of us—laughed until tears were running down our faces, hugging each other for hope, splendid messes we were.

I learned a long time ago that if one must cry, it is by far the grandest way to cry from laughing.

But, excuse me, there is someone knocking at my front door.

THREE

*W*ELL, MAUD and I dried our eyes and she hustled down to the kitchen again. As I went into my charming little drawing room—adjacent to my dining room—to await my vital guest, I saw from the edge of my eye the grand major-domo-bailiff on his way to the front door. I waited.

I am now going to change my tune somewhat in the matter of frankness. In what has gone before I know I've made rather a show of not caring what people think of me or my work—either the public in general, the public individually or the public press—and so much is true, I don't care a damn. But it is not the whole truth. If it were, why then was my hand the smallest bit unsteady as I placed my brave monocle in my eye? Why then was there sufficient mist on my brow to require a few quick dabs with my silken handkerchief before I tucked it back in my sleeve? Why? I'll tell you why.

Because I must live once again like a man! Because I know I must succeed, I know I must be honored, and honored in my own time and on my own terms! It is not I who must change, but the times!

And they are not changing, as I know very well. Meanwhile, I make jokes and I am told that my laugh grows shrill. Meanwhile, I live in penury and debt and their consequent humiliation, and meanwhile my debts grow larger. I must *manage* somehow, I must *control* the direction of my affairs. I am too *good* for this bloody life! My only chance to change it, even to change it in pounds and shillings—and I will just now settle for that—stands at this moment on my doorstep.

I no longer ask for understanding in art, ask no longer even for reasonable consideration. I ask only that my hand no longer tremble or my brow sweat at the imminent appearance of a parvenu millionaire who is my last, it would seem, my very last chance for human dignity, as I wait. I mean to buy *time*, at whatever cost, at whatever hypocrisy. Damn cost! I damn hypocrisy less well, but what is necessary for survival I embrace, hell or high water. *Nothing* I won't do to demonstrate, eventually, that Jimmy Whistler all along had a special glimpse of the truth. *Only watch!*

Well, well. I'm perfectly aware that it doesn't do for a clown, in the middle of his performance, to snatch off his funny putty nose and make a speech. The lines still show on his real nose where the putty was, and the huge painted grin obscures the tight lips. I only meant for us to understand each other, you know. Best to warn an eater that the cake he's eating, for all its coconut and cream frosting, has at its heart a mortal dose of cyanide.

The major-domo-bailiff was overwhelmed, almost fell down at the door. His first absolutely guaranteed millionaire. Frederick Leyland's name is well known in today's England, and when the bailiff had to utter it, it came out as a sort of gasp. He staggered back to the kitchen and Leyland and I were left alone.

When one day my portrait of Leyland is as famous as, say, a Velásquez portrait of Philip of Spain—and it will be—you will know what he looked like. While my portrait is a good deal more interesting than Leyland himself, the resemblance is excellent. I painted him standing in full evening dress, tall and slim, elegantly posed with one hand on hip, an opera cape thrown across his other arm; his chin is held high, his face nearly chalk white, black mustache and pointed Imperial, piercing black eyes looking straight out from the canvas, a Spanish grandee, possibly, or the Venetian merchant prince of Leyland's imagination.

The Leyland standing in my doorway looked like neither, as a matter of fact. (But then it takes a man a long time to look like his portrait.) He was tall but not all that tall, slim but not

that slim. Above all, he certainly was not that elegant. His black frock coat was perfectly proper, no doubt, his gold watch chain the solidest gold, absolutely no doubt, his linen and cravat immaculate, yet there was still about him the appearance of not really belonging in those clothes, of impatience with their formality. A Liverpool, not a Venetian, merchant prince, in short, not a bad thing to be. But the eyes in my portrait are absolutely true —black and commanding, the eyes of a man who knows his own capabilities because he has proved them, proved that he can do what he does better than other men. They look out upon the world not with arrogance but with authority and possibly a little contempt. Maybe they're something like my own eyes as seen by others looking in as I look out. Leyland would make a splendid adversary for any man. One would not choose him as an enemy.

"Mr. Leyland," says I, smiling my most endearing smile as we shook hands, "delighted that you could come to my little breakfast. The hour is somewhat eccentric, I know, but essential to my menu. Please sit down."

Leyland stepped into the drawing room that was so exactly the opposite of his own in Liverpool. Where his was all brown wallpaper and tassels and hassocks and stained glass, mine was nearly as bare as a barn—although unlike any barn. The walls are the yellow of early-morning sunshine, the woodwork pale green. On the polished floor is an occasional straw mat, on one wall one Whistler nocturne, nothing more; the furniture is sparse but comfortable, sometimes Oriental in ancestry and manufacture, bamboo or cherrywood. While it is the most charming drawing room in London, in this strange land with its society dedicated as it is to a general worship of clutter in all things, the simple fact is not universally appreciated. People are always asking me—like the art critics about my pictures— when I am going to "finish" my house. Both, of course, are finished when I say they are finished; but as I never say, the public is irritated, although there is no logic in it, you know. The great cathedrals of France and Germany are not finished

and never will be; only a millionaire's West End townhouse and a semi-detached villa in Bloomsbury are "finished." And should be. But I grow discursive.

Leyland's handshake was firm but reserved, not overly strong, not weak. "I've heard about your Sunday breakfasts," says he, "and I've learned enough about rumor to give it at least a chance. I've had nothing to eat all morning but a piece of bread and butter and a cup of tea." He sat in a graceful bamboo settee, leaning back, watching.

"Splendid. America will supply the rest."

"America?" Rather alarmed, you know.

"Well, yes. American food prepared by an American chef— myself, in this particular instance. Former colonies can't do less than show their independence was worth the nuisance, can they?"

This was really the wrong tack. One can't joke with self-made Englishmen about even the slightest reduction of the British Empire. Dukes and earls will get the joke, one they can afford, not men who worked and fought for their position. Change the subject.

"I've asked Rossetti, no one else," says I. "You admire his work, I know, and I imagined the three of us might have a pleasant chat without a lot of people."

"Rossetti!" says Leyland, nodding and bobbing, his brow furrowed thoughtfully to show what he thinks of Rossetti. "It will be a pleasure to see him again. I own several of his paintings, you know."

"Several? No, I didn't know."

"A most remarkable man."

"Yes, yes." (So much is true.)

"An unusually gifted painter, a truly . . . inspired painter, or so it seems to me."

"Oh, yes." (So much is not true.) But then I've already warned you that I will lie, cheat, steal—do absolutely anything to get my hands on a piffling part of Leyland's millions, to work, to be a self-respecting man, to follow my mind's private guide.

"Rossetti's an extraordinary craftsman, wouldn't you say?" said Leyland, pressing on.

"Absolutely."

"His *detail* is almost unbelievable."

"Unbelievable."

"But the important point about Rossetti, I think," says Leyland, "is the matter of aesthetics, of . . . of, well, of his feeling for subject matter . . . for the telling scene, you know. Don't you agree?"

"No." Oh, the truth, my God, the awful *truth!* It comes up from inside me like some clockwork eruption of a geyser, and no way to shut it up. I must do better. "What I mean is, Mr. Leyland," says I, like some dubious penitent in the dock, "that Rossetti and I travel different roads. I mean only that our visions are not the same. We see the world through different spectacles. Quite as it should be, of course."

When you mention the devil, as bromide makes clear, he is apt to turn up. I was sitting in a chair facing my central hall; Leyland had his back to it. At that moment Rossetti let himself in, clutching four wine bottles in his arms, and tiptoed like some earnest thief in the night along the hall, behind Leyland's back, and toward the pantry. Leyland never saw him, nor, for the purposes of the moment, did I.

"Well, Rossetti will be along in a moment," I said, without doubt. "He likes my pancakes."

"Pancakes?" Not too sure about pancakes, evidently. It is, of course, only because he has never tasted mine, but the tone was not promising, you know.

Now Rossetti tiptoed back across the hall from the pantry and disappeared momentarily from sight. Immediately there was a loud knocking (on the inside of the front door, presumably), the door was heard to open and close and, behold, there was Rossetti in his brigand's costume holding out his hand.

"Just thought I'd let myself in, Whistler," says he, wringing my hand as though he hadn't seen me in ten years or so. "Saves trouble all around."

"Quite right."

"Ah, Mr. Leyland," Rossetti went on, "a pleasure to see you again. We're rather informal here in Chelsea."

"Especially those of us with zoos," says I. "Sit down, Rossetti. Mr. Leyland and I were just discussing your . . . ah . . . art."

"My bad luck," said Rossetti to Leyland. "If Whistler were my only critic, I'd have been in debtor's prison long ago."

"Oh, I doubt that, Mr. Rossetti," says Leyland, looking from one of our faces to the other rather anxiously. "Surely, there is room for many different methods . . . for different points of view in anything so personal as the business of painting."

"There is, indeed," said I, "and Rossetti and I are here to prove it. His work is not my work, nor should it be. But you've heard me on Rossetti. Now I think you should hear Rossetti on me. Get on with it, Gabriel."

"Well, the thing about Jimmy, Mr. Leyland," Rossetti said, clasping his hands together and pacing around the place in his bandit boots, "is that he goes out and paints a perfectly decent river, the Thames right outside his front door, and when he's finished there's nothing to see but a lot of fog. Now, if *I* were going to paint a river . . ."

"Which, in your case, would be the Arno, and which would never be seen anyway because Dante and Beatrice would be mucking up the foreground."

And so on and so on. Well, you know, Rossetti and I are professionals and we know our business. I'm not talking about painting, not at all. I'm talking about how Philistine art collectors *expect* artists to behave, and we were playing the game Leyland expected of us.

And you could see he was loving every minute of it. None of your nonsense about building ships and commanding a flotilla that sailed all seven seas and brought back a million pounds a minute, none of that. No. All such humdrum was behind him. The time had come for him to rise into a more rarefied atmosphere, to hobnob with artistic folk whose only concerns were

with Truth and Beauty and Divine Inspiration, people who never so much as thought about money. Ha-*ha!*

And so Rossetti and I amused our Liverpool Medici until presently Maud arrived looking very beautiful and composed as you please. Which she was not.

This can be a somewhat delicate situation at times, living as we do in the reign of good Queen Victoria rather than in that of some earlier, more enlightened monarch, Charles II, say, or possibly Ethelred the Unready. Now, everyone in London who is anyone knows that Jimmy Whistler lives with his "model." But everyone does not take an identical view of that good-natured euphemism.

There are houses in London (usually not those of the first rank) in which Maud would not be welcome; there are houses in which Maud is sometimes welcome and sometimes not, depending on the nature of the company and the event; then there are houses in which Maud is always welcome, like Rossetti's and dozens of others of non-Academy painters and literary folk. And it is I who must make these judgments, you know, in order to be certain that dear Maud is never subjected either to the cut direct or even to the raising of a censorious eyebrow. I play the game cautiously in order to be on the safe side. Women, of course, are the least predictable in matters of this kind, hence you will have observed that there was no Mrs. Leyland present at my little breakfast. That Mrs. Leyland is a charming and attractive woman I know well from our long sittings when I painted her and from many other encounters. That she was invited goes without saying. That she did not arrive with her husband—having written me a cordial little note, pleading an earlier engagement—says all that need be said.

Men are a different kettle of fish altogether, naturally. Well, most men. (I suppose if my mind ever became sufficiently unhinged as to cause me to invite John Ruskin to breakfast, he would refuse to come on account of Maud. But, as I believe I mentioned earlier, Ruskin took his mother to Oxford with him.)

But more plausible men like Leyland inclined to almost exaggerated courtesy toward Maud. If they hadn't a mistress already, they probably wished they had, and, in any case, their general worldliness and urbanity were being put to an instant test, and to fail such a test, I have found in most men, would be far more humiliating than to display even the vaguest moral scruple. When Maud entered the room Leyland leaped to his feet more bouncily than he would have done for any princess of the blood.

"*Madame*, may I present Mr. Leyland," says I. I presented *him* to *her*, you will have noticed, not the other way around. *Madame?* Well, yes, I know. It is only making the best of a bad job, but I defy you to try to do better. "Mrs. Whistler" clearly will not do, except among the tradespeople who have high-minded standards and know that Maud *must* be Mrs. Whistler. "Miss Franklin?" No. If she is "Miss," what is she doing presiding over my table? "Maud"? A child or a servant. My "model"? An open admission of the truth as truth is interpreted on this drizzly isle. Therefore, *madame*, which has the singular virtue of not meaning anything in particular, not in England. The word has a married sound, even though only French-married, and I who use it am known as so hopeless an internationalist that I probably don't know what I'm talking about anyway, semantically speaking. Maud's view of this problem, it should be pointed out in fairness, differs from mine from time to time. But that is bound to come up later, or so I should imagine would only be reasonable.

But there we have Leyland, first-generation Liverpudlian economic princeling whose forebears would have drawn their skirts about them in horror in the presence of a "mistress."

"*Madame*," says Leyland, taking his cue like a proper gent, "I am honored." And he kissed her hand, although he well might not have bothered to kiss the hand of some great lady in society. Good man. Good thing he's rich, too, and an art fancier; money so often falls into the wrong hands.

Maud—daughter of a government clerk and his female equivalent—is a shrewd observer and has observed much in this

household during the last few years. She has learned what her parents would probably have deplored—that good manners are not formal manners, but casual and genuinely friendly manners. She smiled, flashing her dear, buckish teeth.

"I'd have known you anywhere from Jimmy's portrait, Mr. Leyland," said Maud.

"I take that as a compliment," replied Leyland. As he damn well should.

"It was meant that way," says Maud. Good girl.

But we had had enough of this essentially useless badinage. It has not been in anterooms that the great moments of my career have been initiated. I did not paint my most extraordinary portraits of Mr. Thomas Carlyle, my acerbic Chelsea literary neighbor; of Sir Henry Irving, actor-manager who has somehow convinced himself that his smallish craft is an art; of Pablo Sarasate, the exquisite violinist; of Lady Colin Campbell, and so on and so on, by discussing art on a sofa over teacups. No. My most successful battleground has always been my delightful Sunday-morning breakfast table.

I motioned toward the dining room. "Shall we go in? I promise you a breakfast fit for a prince—at least an American prince, although they go about disguised."

"Speaking of princes," say Leyland, letting me know how things stood with him socially these days, "the Prince of Wales says he knows you."

"Well, now, you know, that's only his side," said I. "Will you follow *Madame*, please?"

"And about time, too," mumbles Rossetti in his winning way.

Maud seated herself, then our two guests at her left and right. I remained standing, as is my custom at my Sunday breakfasts, for I am not only host at these pleasant festivities but first chef as well. Englishmen expecting to be regaled with kippers and fried tomatoes, or possibly even beef and beer, are often distressed to observe they are to be served none of these things. They tend to frown as I stand before my sideboard on

which appear nothing but a silver chafing dish over an alcohol lamp, a bowl of buckwheat batter and a variety of implements and condiments. They tend to frown—but not for long.

(I might mention, regarding my breakfasts, that a few years ago Rossetti suggested I substitute for the alcohol in the spirit lamp an equivalent amount of laudanum—a mixure of alcohol and opium—in order to invigorate the air and the proceedings and to prove the more invigorating to my guests.)

What my guests are finally served is the most perfect and delicate breakfast imaginable. That it has its genesis in the land of the Yahoo, in the rebellious colonies that could not understand their place in the orderly scheme of things—in guttersnipe America—affords me special pleasure. Listen.

First, there are buckwheat cakes, griddled by these hands to a subtle hue mixed of yellow ocher and a dab of raw umber. Butter and heated molasses served round by white-coated servants (or bailiffs) together with fresh green corn and a salad—dressed in this instance with a dressing manufactured by my talented bill collector in the kitchen—tart escarole and Belgian endive in better days; whatever is about in these days, although quality is not nearly so important as people think—except in the matter of painting—as the manner of its presentation. I shall make this distinction clear shortly when the matter of presenting the Pope's wine to Leyland arises. No, in almost twenty years of my charming breakfasts only one man has had the insolence to find fault with my bill of fare. He was summarily banished, of course, and I should enjoy the pleasure of reporting that he has had the tact to blow his brains out, but he has not. He is at large and on the town, rejoicing once again in his beef and beer. Naturally, he was an art critic—as who is not in our glorious times—but even that fact could not excuse his astonishing boorishness.

Apart from the food, there is another original aspect to my breakfasts and that is in the matter of conversation. There is a minimum of idle chatter, which is not only tedious but profitless. For certain breakfasts—the present one, for instance—must be

choreographed to achieve a specific goal within a specific period of time while seeming to be only the most lighthearted of social gatherings. Since the goal of my present breakfast was nothing less than the salvation of my life and honor (speaking financially), it had been most strictly choreographed into a three-act ballet.

The first act was to be sheer entertainment, gaiety and laughter, no hint of what was to come. The second act was to be largely exposition—by Leyland cued in by Whistler—in which Leyland would describe the enormous house he had just bought in Prince's Gate (all details already known to Whistler) and his plans for turning it into a nineteenth-century palace to rival in beauty and artistic splendor any existing palace on the face of the earth. The exposition over, the curtain would go up on the third act, in the course of which Good Painter Whistler would convince the Merchant Prince that without Whistler's generous and extensive, not to say exclusive, contributions the Prince's palace would end up as the abode of a hopelessly tasteless *nouveau riche arriviste*, which the Prince does not have in mind. Such was the choreography. Of course, choreography and its performance are not necessarily always the same.

But how, it may be asked, could I be so sure of controlling the course of general conversation as though I were controlling the steps in a ballet? Well, now, you know, I once worried about that myself, but not for long. The answer is so obviously built into the question. Clearly, the only way to control the course of any conversation is to do most of the talking yourself. Although I've never actually clocked the thing, I would estimate that at my breakfasts I talk approximately three quarters of the time.

But how, comes the next question, in the name of courtesy and simple reason can anybody get away with that? The answer is twofold. One, I don't eat but only *seem* to eat, which gives me an advantage over chewing and swallowing rivals. Two, and infinitely more important than One, is having something worth hearing to talk about and the ability to talk about it in a way

sufficiently compelling to turn prospective talkers into willing listeners.

Which brings a modest autobiographer to something of an impasse. Self-congratulation is simply not in my line, and I shrink from it as from the cobra's fang. If the point must be made, however—and as a strictly informational duty, I suppose it must—let the information be spoken out of other mouths than mine.

The Duke of Westminister: "For myself, I would infinitely prefer to spend two hours listening to Mr. Whistler extemporizing at one of his Sunday breakfasts than spend a week at the Lyceum hearing the entire Shakespeare canon performed by Mr. Henry Irving."

Mr. Oscar Wilde (something of a talker himself): "As sheer theater there is not a playhouse in London which regularly offers anything to compare to one of Jimmy Whistler's Sunday breakfasts."

Bailiff Ernest Bright: "He makes me laugh, don't you know, and that's the thing."

Enough. My cheeks are already burning with the impropriety of setting down such things. It is a statement of a record, no more. Let us return to the scene of the crime.

I stood at the sideboard, turning buckwheat cakes in my chafing dish and talking three quarters of the time. What did I talk about? Well, you know, at least in Act One, it doesn't matter much. The point is to entertain, nothing more complicated, and here I have my ways. Actually, to entertain a man— or to soften him up, if you will— who has spent twenty to thirty years of his life in the exclusive pursuit of money is child's play. So demanding is such a pursuit that the man will not have had time in his life to laugh at even bad stories, to say nothing of good ones. He will have had no exposure to civilized conversation, so occupied has he been with the vocabulary of the countinghouse and the arcane technicalities of his ship-building engineers. He is absolutely dying to be amused. Even Rossetti could amuse him, if I would allow it, which I won't.

Well, I babbled along, you know, while the good bailiffs served the breakfast I was preparing—and serving it with great pomp and solemnity, far more impressively than real servants would have done. A case for the amateur, apparently, awe of the unfamiliar, just as no doubt a professional waiter would serve a notice of bankruptcy with more aplomb than my splendid bailiffs. The metaphor does not permit of extension into the field of art, of course. There, amateurs will forever be amateurs, and should be so branded with a scarlet "A," as suggested by my countryman Nathaniel Hawhorne, in a somewhat, though not very, different connection.

However, that bailiffs as amateur waiters were not in every respect superior to professionals was suddenly illustrated by a horrifying sight I caught out of the side of my eye. At that moment Bailiff Bright, who had apparently been elected by some plebiscite in the kitchen to act as *sommelier*, entered the dining room with a naked bottle of Freddie Borgia's wine in his hand. While it seemed perfectly fitting for Bright to be wine steward, since he had after all paid for the wine, all else was not fitting in the least. When I say Borgia's wine bottle was naked, I mean just that—no trace of a label on it, you see, not because the label had come off or anything but because there had never been a label on it. The Pope buys his wine in anonymous kegs, siphoning it off into any old bottle as he sells it. Now, as any non-connoisseur of wines knows full well, a label is everything. A label and a little book knowledge, and the need for a palate is obviated. He already knows that the Hock, say, from a particular German vineyard in a particular vintage year is to be respected, just as he knows that all of last year's Rhône reds are unfit for consumption. He has read these things or somebody has told him these things, so he is secure in his label.

But what if the poor devil has no label to go by? Chaos and embarrassment! Not my game at all, not in Leyland's case. His judgment must be protected at all costs.

Fortunately, I was still standing, mucking around at the sideboard, so that I was able to intercept Bailiff Bright before he got to the table. Snatching up a pristine table napkin, I took

the bottle from his hands and quickly wrapped it in the napkin. Immediately anonymous wine, the very best sort.

"Excuse me, Bright," says I. "I'll pour myself."

"Pity," murmurs Bright, robbed of his office most unfairly, and back he went into the pantry.

Whatever delightful rot I had been talking, I stopped it at once. I passed the mouth of the bottle under my nose, sniffed and smiled only the shadow of a contented smile.

"Mr. Leyland," said I, "as you are an eclectic collector of art—Whistler and Rossetti, Botticelli and Burne-Jones—you are surely an open-minded judge of wines as well."

"Well, I'm no great expert," says Leyland, planning to be. "I suppose I have my own tastes in wine like everyone else."

"I ask no more. The bottle in my hand is most regrettably the last of a very few in my cellar, and there will be no more. The tiny chateau from whose vineyards it came is moribund, the vines blighted by some Andalusian caterpillar. Well. What little is left, it seems to me, should be properly consumed by experts, don't you agree?"

So I poured Leyland only a half glass of Borgia's poison, which he held to his nose, then to his lips. Rossetti was staring, as one supposes observers did at the Socratic hemlock-tasting, assuming a similar outcome.

How could I be so sure Leyland would not want to see the label on the bottle? Because Leyland was a Victorian gentleman —not an aristocratic gentleman, who would have ripped off the napkin and damn all manners—but a self-made gentleman, so to speak, one who had learned the game by rote, as one learns the rules of chess or tennis. Those rules stipulated that one gentleman never disputed the stated word of another gentleman no matter how outrageous the evidence, and Leyland would not have broken the rules for his life. Rather touching of him, really. Still, I had removed all possibility of embarrassment from his shoulders simply by acting as the label he would never see. He had only to play my game to retain his dignity. All that remained in jeopardy was his liver.

Leyland took a sip of the wine, rolled it around on his tongue a little, swallowed, looked at the ceiling gravely, then took another sip. Somehow he managed to smile, nodding his head. "Most interesting," says he.

"Just the right way to put it. Interesting. Not a 'great' wine, in the French sense, perhaps, but 'jolly good,' in the less ostentatious English sense."

"Exactly. Pity about the blight."

"What blight?"

"The caterpillar blight you mentioned."

"Oh, yes. Well, you know, the Old Testament put us on the alert about that, didn't it? Locusts and so on. Nothing to be done, really, I suppose. Periodic disaster, all part of the larger scheme."

So that was that. I filled everybody's glasses and immediately went back to the frivolous talk required of Act One.

Talk? Well, lies are important, for example. Only through disseminating lies is there any way of stimulating a serious search for truth. Half-truths are our normal nourishment. Take the matter of my hair. My hair is black and very grand in curls. With a peculiar exception. Up front, near my brow, is a single, and quite extraordinary, exception. There is one absolutely white lock, white as ghosts and snow. Why should that be? I have been asked the question a thousand times; I have been caricatured in the press with the white lock as many times again.

I used the subject as my text for Act One. I attributed the small phenomenon variously to a bullet wound sustained in a revolution in which I participated in Valparaiso, Chile, to an hereditary mystery of some sort, to a cosh on the noggin by French Fumette in search of reciprocal love. Some people say I bleach my little lock in order to engender precisely the sort of attention that happens. I really don't know why it's there, having told so many lies about it, but I'm glad others do.

Leyland, at the end of the table, was chuckling, well, giggling, actually, very promising. All ready for Act Two we were.

Darling Maud was laughing along like the dear creature she is, although she'd heard all this guff dozens of times. And Rossetti . . . well, you can't really go by Rossetti; all he wants to do is *talk*. Which he all too presently did.

My opening line of Act Two was to be "But I've talked far too much about myself, Mr. Leyland. Won't you tell us about your new house in Prince's Gate?" Which he would then do, leading us inexorably down the road to the brass tacks of Act Three.

I opened my mouth to speak when Leyland himself spoke. He had been examining the little menu beside his plate, on which I had drawn some lighthearted odds and ends, including my butterfly signature.

"Most charming," Leyland said. "Is a breakfast guest permitted to take his menu home with him, Mr. Whistler? It is a souvenir I would enjoy keeping."

"I'd be most offended if you didn't," says I, speaking nothing but the truth. People always take my menus home with them. Although each requires some twenty seconds of my time to execute, they are, after all, signed Whistlers. They are, of course, also free, like so much of my recent work.

"Thank you," said Leyland, tucking the menu away in his pocket. "Tell me," he went on, simultaneously uncorking Rossetti, "how did you happen to choose a butterfly as your signature?"

"I gave it to him," says Rossetti.

"*You*—" I fear I was speaking rather loudly— "gave it to *me!*"

"You remember, Jimmy," continued this Sicilian abomination, "quite a few years ago I pointed out to you that scrawling 'Whistler' across the bottom of your paintings in enormous capital letters was aesthetically displeasing. You agreed, so I thought up the butterfly."

Imagine inviting an asp to breakfast. I mean, let Egypt nourish asps, not me. The trouble with this colloquy, if that is the stunning word I'm after, was that there was at the very, very

bottom a minute grain of truth in it. Grains of anything do not truly interest me. But I trust I am always fair.

I composed myself. Rossetti and I could yell at each other about all this in private, but not in front of Leyland, my potential hero, for God's sake!

"Yes, yes, I remember the occasion to which you refer," says I, wearing the stuffiest shirt in the whole of London, "but all you actually did was to devise an ordinary little monogram from my initials J. M. W."

"Which happened to look like a butterfly," persisted my evil neighbor, smiling complacently.

"Which looked no more like a butterfly than my butterfly looks like my initials. Look at the menu at your elbow and find your sterile monogram." All this was very bad, you know, distracting me from my purpose. By this time it was also distracting Leyland, who had fished his menu out of his pocket and was examining *his* butterfly. Take the bull by the horns—a quite extraordinary recommendation, literally considered. "I leave it to you, sir," says I to Leyland. "Can you detect on the fairest consideration even the vestigial traces of my initials in that butterfly?"

"Well . . ." Leyland pursed up his mouth judiciously and stared at his menu. "I must confess I can't."

A man of perception, Leyland. One should not make sport of billionaires simply because they happen to own most of England and buy Burne-Jones's pictures. "Thank you," says I. Rossetti was looking very glum. "If I might change the subject . . ."

"On the other hand, Mr. Whistler," Leyland went on, "I must also confess that to me your signature doesn't look at all like a butterfly."

"Well, it's not just *any* butterfly, you know," says I. Rossetti had now perked up. "I am not a lepidopterist. It is *my* butterfly."

"I see."

"The fact is," says Maud, smiling—and heaven knows there is a very serious lack of Mauds in this blighted world—"Jimmy's

butterfly is simply an evolution from Gabriel's monogram, and what was once Gabriel's is now Jimmy's, just as some notions of Jimmy's are now Gabriel's. What is a nuisance is that they won't admit it, either one of them. What *I* would like to hear about, Mr. Leyland, is your new house."

And Maud leaned toward him, her chin resting on her hand, giving him her absolute attention, all ears and eyes and beautiful red hair, a totally irresistible invitation to any man to talk about himself or his house or anything else she might care to ask him. And the locomotive was right back on the track again, heading straight into Act Two. Or so it seemed for a moment or two.

Leyland leaned back in his chair, all smiles, fussing with his watch chain and trying to look modest. "Well, it's just a house like any other," says he.

(An astounding lie. Leyland's new house was like any other only in the sense that Versailles and the Vatican resemble a temporary Iroquois encampment. But let him go on.)

"I mean to restore it, to alter it, if you will," he went on, "in such a way that it may prove a suitable background for my little collection of pictures and various other art objects. At the same time my home, of course."

(Oh, perfidy! Oh, nonsense! Leyland's little collection of pictures—quite apart from the expensive rubbish of my fashionable contemporaries—includes a collection of the masters of the Italian Renaissance comparable by any standard, except that of sheer numbers, to the finest five rooms in the Ufizzi in Florence. I know because I chose most of them for Leyland myself. But let us overhear no further excesses of modesty.)

"It's rather a large job," said Leyland to transfixed Maud, "and not without its problems. I've got two architects already working on the changes, but the problems, the aesthetic problems, finally go deeper than architecture. They go to . . . to art itself, if I make myself clear."

"Yes, yes, I understand," says Maud, "but I'm sure a man who knows his mind as well as you will find the right way to turn."

"I'm afraid you're flattering me," answered the gallant.

"No, no, I only meant," says Maud, approaching Act Three through a not altogether subterranean route, unpaid bills on her mind, "that perhaps Jimmy . . ."

Well, that's as far as she got with her lovely intentions. She was interrupted by an accelerating hubbub from the kitchen below stairs. Slamming doors and stamping feet were quickly followed by shouts and alarums, indecent language, a broken glass or two —quite enough irregularity to alter my view of bailiffs as splendid house servants, anyhow on this particular occasion.

But I was summarily proven wrong. It was not bailiffs who were at fault, but poets. Indeed, it was the bailiffs—young Ernest Bright and the fat one in my white Japanese housecoat who excelled at salad dressing—who were doing their utmost to restore domestic tranquillity. Between them they were trying to restrain the maddened behavior of Mr. Algernon Swinburne, poet and sometime boarder at Rossetti's animal farm down the road. They all came bursting out of the pantry into our calm dining room.

The bailiffs, in spite of their profession, were getting the worst of it. Swinburne, dressed in some flapping monk's-cloth garment which I will dignify as a dressing gown, entered the room kicking the two gentle bailiffs who flanked him, screaming at the top of his lungs, "Rossetti! There's a *phoenix* in my bed!"

"Steady on, sir," says the logical salad-dressing bailiff. "Things could be worse, you know. Must admit that, mustn't we?"

"I admit nothing!" cried Swinburne, lurching and kicking. (It is possibly a regrettable truth that the grape has often enlivened Algernon's special muse, and with exemplary results, at least some of the time. This was not one of them.) "There is a place for phoenixes," he shouted, "and the place for phoenixes, Rossetti, is in some tiresome compendium of mythological creatures, not in my bed!"

"Don't know the Greek plural for *phoenix*, do you, Algernon?" says Rossetti helpfully.

123

Mr. Leyland was really not accustomed to this sort of thing. It showed in his behavior. He stared at Algernon, huddling down in his chair as though confronting a lunatic, which in a way he was. Such apparitions did not frequently appear in the shipping world, apparently. Clearly, I had to take charge. My breakfast, indeed my whole plot, was fast going down the drainpipe.

"Swinburne," said I, as cold as ice, "I don't remember inviting you to my breakfast. As that is the case, you may now leave my house by whatever clandestine means you entered it."

"Damn your breakfast, Whistler!" shouts the bard, squirming more or less free of the two good bailiffs. "You don't understand at all. You don't understand *crisis*. It shows in your work. I was sleeping peacefully at Rossetti's until a few moments ago. I rolled over in bed. Is that so unnatural? Well, is it? No, it is not. And on the other side of the bed, looking straight at me with his little beady eyes, his head actually on my pillow, was a phoenix! Or a chimera or something. All furry and horrible, some shocking joke of Rossetti's . . ." Here the poet's eyes filled with tears of anger and self-pity, and he tottered toward my pretty breakfast table.

Swinburne looks rather like a mythological creature himself —a tapir's pendant nose, red hair dangling in his eyes, no chin worth speaking of, arms reaching to his knees and quite beautiful long-fingered hands—none of which interested me in the least at the moment.

"Algernon," said I, more firmly than before (Swinburne's crazed allusion to my work had not gone unnoted), "leave this house!"

"Furry?" murmurs Rossetti in his exasperating calm. "But the phoenix is—or was, or was not— a bird, old chap. How could he be furry? Makes no sense."

"You are altogether too *literal*, Rossetti," cries Swinburne, stamping first one foot, then the other. "It's why there is no real art in your work. All those damned exact buttons on people's coats! Where is the poetry, where is the *truth* in buttons?"

Absolutely right, you know. But this was not the moment

for further art criticism, or for further speculation into the nature of fabled animals, for that matter. "Gabriel," says I, admirably controlling my temper, "Swinburne is your house guest. Be good enough to take him back to your house. Now!"

"It really would be very helpful, Gabriel," added Maud, watching Leyland out of the corner of her eye as though he might suddenly jump out the window and be lost to us forever.

Very leisurely Rossetti got out out of his chair and put his arm around Swinburne's shoulders. "A chimera, Algernon," he said, "is even less likely to have disturbed your rest than a phoenix in my house. Head of a lion, goat's body, serpent's tail . . ."

"I *know* what a chimera is!" Swinburne screams. "I *am* a chimera. What you painters don't understand is that poets speak in metaphor. You go around painting buttons and Annunciations, Whistler paints fog. Where's the *good* in it all? I came to your house for tranquillity, for a tiny interval of meditation, and what . . . Oh, my God!"

And with that Algernon swooped down on Leyland's wine-glass, polishing it off in a gulp.

"Blimey," whispers salad-dressing bailiff to Bailiff Bright. "Well, I expect it takes all sorts to keep this old orb spinning."

"You've got hold of a truism there, Mate," nods Bright, transfixed.

"Out!" says I, pointing toward the door like a policeman. "Out, now!"

And they went, at last, Rossetti chatting amiably. "It was nothing but a wombat in your bed, Algernon," he was explaining, "a charming creature, actually. An Australian marsupial, female by gender, has a waistcoat pocket vastly superior to yours or mine capable of harboring and nourishing her young, which are a modest inch in length at birth. Victoria is her name."

"An inch!" shrieks Algernon, flailing about in search of someone else's wineglass. "You have chosen this moment to tell me of inch-long marsupials . . . Oh, God, oh, God . . . Strike down Pre-Raphaelites and others."

125

But Rossetti had craftily eased his chummy arm around Algernon's shoulders to a firm grip on the collar of Algernon's burlap dressing gown or whatever, and hauled him out of our presence. The two bailiffs followed along, their day absolutely made, you know, nudging each other in friendly sport.

Well. It is not a simple matter for a stage director to get his performers to return to their prescribed choreography when Act Two has been interrupted in the middle by an unplanned dash of Petit Guignol, but it had to be done. I quickly looked over at Leyland to see if he was dead or anything of that sort, but it was all right. He was merely staring reflectively into the wineglass Algernon had so recently emptied.

I refilled the glass at once with the Pope's bellywash, smiling and gently murmuring what I announced to be a direct quotation from Pliny the Elder. "A wise man's wine, though it come from the same cask as the fool's" says I, "will only prove the wisdom of the one and the folly of the other." (Well, who knows *what* Pliny the Elder said?) I only wanted to get us back on the track where serious business is transacted, where Leyland and I represented solid reason, and bibulous apparitions like Swinburne were outsiders; not at all like *us* was my point.

Well, you know, it didn't work out that way. I simply can't get it through my head that grave patrons of the arts—no doubt beginning with Greek slave-traders or possibly long before— who have made vast sums in commerce, fair or foul, simply don't *want* artists, any artists, to be in any way like themselves. Not even superficially, for it takes away the grandeur of patronage, I suppose, the handsome stooping of the conventionally successful man to come to the aid of the gifted mountebank.

Oh, I understood it up to a point, of course. I think I mentioned earlier that Rossetti and I put on our harmless little show of expected eccentric behavior for Leyland's entertainment. But I really thought that Swinburne's unannounced flapping about my breakfast table in his nightshirt, swilling Leyland's wine and carrying on about imaginary creatures in his bed, would prove

too heady an experience for even so liberal-minded a patron of the arts as Leyland. Not so. Follow the logic carefully. Or perhaps the syllogism.

"Mr. Swinburne," says Leyland, solemnly tapping the ends of his fingers together, "is a most extraordinary poet."

"The most extraordinary I know," said I. "No doubt about it."

"Mr. Swinburne is also . . . ah . . . has certain tastes and habits not shared perhaps by the vast majority."

"How well you put it."

"I mean only to say that I think the first fact should so heavily outweigh the second, in our judgment of Mr. Swinburne, that the second may be charitably overlooked altogether."

Well, now, you know, that is the sort of madness-as-logic I had no intention of disputing in the circumstances. The fact that I would continue to banish drunken poets, however gifted, from my house until they sobered up was really neither here nor there. What was both here and there was that Leyland's form of logic as applied to Swinburne—odious as I found the comparison—also applied to me. It was the same logic that had permitted him to pay me in advance for six portraits and accept one and a half.

"I find your attitude both generous and enlightened," I said. "To dismiss Shakespeare simply because we were to learn that he was a child murderer would be to throw the baby out with the bath water. Unthinkable."

"Well . . ." Leyland begins, then tapers off. There are limits, apparently, even to non-logic.

"You were telling us about your new house," said Maud, all bright attention, thank God.

"Ah, the house, yes," Leyland went on, leaning back comfortably again. "I think I was telling you about the problems of altering it to suit my needs. Well, for example, I've just bought the gilded staircase from Northumberland House. You may have read the house is being pulled down. Moving the staircase, installing it, finding the room and so on naturally raises problems,

but they are finally only an architect's problems and my architects will deal with them. My graver problems are less tangible, less . . . mundane and I confess that is why I am here, throwing myself into the capable hands of Mr. Whistler."

Now that's what I call pluck. It takes a millionaire to come right out and admit he doesn't know about something outside his regular line of business. Where the rest of us cannot afford such vulnerability in the ordinary course of things, tuck a few million pounds in our waistcoat pockets and we may safely confess to any manner of ignorance, so long as we withhold to ourselves a particular preserve of activity in which we excel all others. In this, Leyland and I were much alike. I was as absolutely sure in my demesne as he was in his. The analogy falls down in the matter of cash in the waistcoat pocket, to be sure, but things were looking up, altogether up. Leyland throwing himself into my hands? Well, just the right hands, you know.

"We must certainly make yours the most perfect house in London," says I, "and not only for today, Mr. Leyland. For generations still to come. A monument, so to say. I'm flattered you've decided to throw the whole thing into my hands. You'll not be disappointed."

"Well, now, Mr. Whistler . . ." said Leyland, gently, taking another sip of Borgia's ferment, "I'm afraid I've rather overstated my case, misrepresented it, perhaps."

"No, I think we understand each—"

"I'll explain," interrupts Leyland. "I mean to construct my house along the lines of the great builders of the Renaissance, if that is not too immodest of me."

"No, no. Must elevate our dreary times. Almost a duty, you know."

"By that I mean, I intend to employ the very finest artists, artisans, craftsmen of my own time, each to contribute his best work. Each man to put in place his own small piece of the great mosaic."

"Oh, I think that sounds absolutely thrilling . . . well, inspiring!" cries Maud, one step behind the parade, I feared.

128

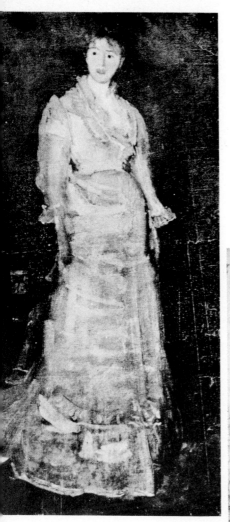

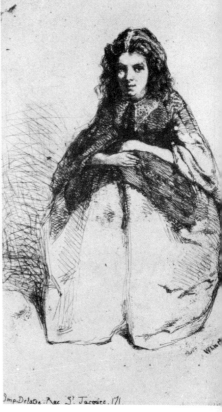

Maud.

Fumette.

9
1 10
2 3 4 5 6 7 8 11

F. R. Leyland.

Mrs. F. R. Leyland.

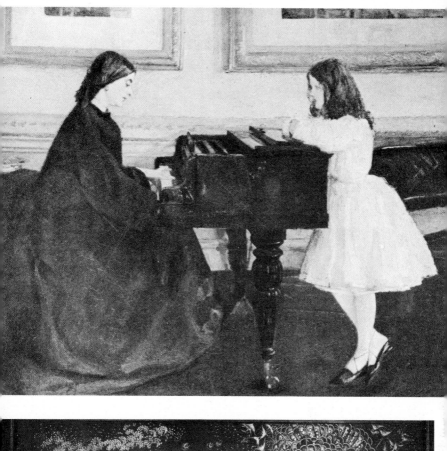

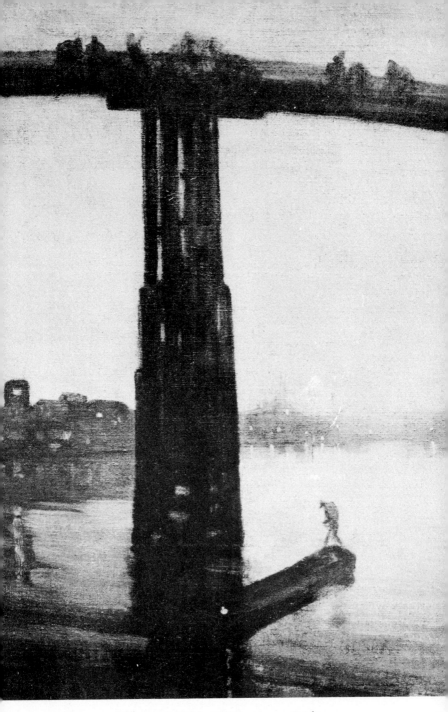

Nocturne in Blue and Gold: Old Battersea Bridge.

"I'm pleased that you think so, *madame*," said Leyland, diddling complacently with his million-pound watch chain. "Now, the question arises, which of our modern artists are to be represented and to what extent—in the matter of decoration, I mean? As I've indicated, the matter of general architectural changes are in the hands of two professionals. All is well there. Also I have a collection of experts to decide where each of my antique paintings should hang. But, my good Mr. Whistler, for certain crucial matters I must turn to you."

Yes, yes? (O, craven swine!) There might still be hope. There *had* to be hope or I had defiled the dignity of my West Point Gray-Britches. "Yes, tell me, Mr. Leyland."

"I'm speaking of my dining room, or anyway the dining room I mean to have," continued Leyland. "I have your exquisite painting *'Princesse du Pays de la Porcelaine'* . . ."

True, and more's the pity, you know—a portrait of a delightful young friend, painted several years earlier in an Oriental frame of mind—because it had long since been paid for, and no longer much use to me in the way of real brass, as good Mr. Bright would put it.

"You mean to hang the *'Princesse'* in your dining room?" says I. "Splendid."

"In the place of honor, over the fireplace. Then around the walls, all on delicate little shelves I'm having built, will be my entire collection of blue-and-white china, the very pieces you picked out for me, Whistler!" He absolutely flapped his watch chain in anticipation of the whole thing.

Well, I had already been reduced to a dining room, having begun two minutes before, at least in my imagination, as the Bernini of the great project. Now I must hold what I had—not much in the grand, general scheme of things, but possibly better than stealing from bailiffs.

"Mr. Leyland," says I, all smiles, "how well you've planned . . . and chosen exactly what you want. So few men *know* exactly what they want. Your dining room, the single thing you've entrusted to me, will be a work of art. I think we agree on what that means. We trust each other, I know."

"Again, Mr. Whistler, you . . . ah . . . interpret me rather too broadly," Leyland continues mercilessly. "The actual re-designing of the room, together with its final decoration, I've entrusted to young Henry Jeckyll, my second architect—a brilliant fellow, by all accounts, been making a great name for himself lately redecorating some of the great country houses. For example, you'll never guess what he's found to cover my dining-room walls."

"I'll never guess."

"Leather. But not just any leather, not at all. It's magnificent Cordova leather from the sixteenth century, once belonged to Catherine of Aragon. She brought it to England as Henry's bride, absolutely exquisite, painted with a delicate flower pattern by some Spanish master, priceless. Well, perhaps not exactly price-less, as I paid a price of a thousand pounds for it, but beyond price in the longer historical view, don't you agree?"

Did I agree? Good Queen Catherine's astonishing leather apart—which might be beautiful or hideous, genuine or bogus, and I didn't care a damn which—I agreed only that Jimmy Whistler was now holding the dirty end of a very clean stick. Not my end at all, you know. But how to get hold of the other end? (Only consider the spurious benevolence of a millionaire art fancier—art is all, money is no object—who must quote the price of his latest acquisition!) But I deal with the world as it is; moral judgments are not my game, although my mother would disagree. Jimmy Whistler is my game, and I know of no one who plays it better than I.

"Well, now, Mr. Leyland," said I, "you leave me a trifle baffled, I confess. In your fine dining room your promising Mr. Jeckyll supplies the design and the decoration, Catherine of Aragon supplies the leather for the walls and no doubt Mr. Ebenezer Scrooge will supply the Christmas goose. A most distinguished assemblage altogether. But I fail to see . . ."

"Where you fit into my plans?"

"The very words I was groping for."

"Well, first of all, your 'Princesse' will dominate the entire

130

room making it for all intents and purposes my 'Whistler Room.' That is your very considerable contribution to the great mosaic I spoke of."

"And a most honored bit of mosaic," says I graciously, considering that I am not really much of a mosaic man in the long run. Or in the short. But then beggars can only very occasionally be significant choosers.

"But as I thought the thing over," continued Leyland, growing still more earnest, "talked it over with my wife, you know, it seemed to me that I was being untrue to my grand design."

"Oh? How so, Mr. Leyland?" asked Maud, leaning forward, sensing some subtle change toward fairer weather in the barometer of Leyland's mind.

"Well, you see, madam," says he, "I want my house to contain only the very best work from our own time, the *very* best, and to show it cheek by jowl with the very best from the Italian renaissance. My object is to show that our present British renaissance is every bit the equal of the other!"

Now *there* was a proposition to stagger the minds even of newspaper art critics, who do not stagger easily. Only fancy, if you will, Botticelli cheek by jowl with Rossetti; Filippo Lippi and Burne-Jones neighbors on the same wall, my God. Well. Back to the lunacy. For I will be a willing participant.

"I came to feel," Leyland goes on, noticing the ceiling for the first time and squinting at it, "that the contemporary artists in my collection should be represented in number according to my own very humble evaluation of their lasting contribution to art in general. Arbitrary, of course. Couldn't be otherwise. But as I assessed the matter, I came to our friend Mr. Whistler."

"I am in suspense, sir," says I. (Rot, rot. Moral rot is more sinister than physical rot, which at least only leads to orderly decomposition.)

Leyland chuckled, sort of gargled in good nature. "Looking the whole thing over," he says to eager Maud, "I saw that Whistler, in spite of his glorious '*Princesse*' and my Whistler dining room, had not been properly represented for the giant

he is among us. The scales require further balancing, and that's the fact. My house needs another Whistler touch."

Well said. Absolutely well said, except for the thing about balanced scales. I couldn't think who was on the other end of the seesaw. But at least we were getting somewhere.

"My entrance hall leading to the new staircase," Leyland continued, "I would like to be particularly beautiful—a sort of introduction, a . . . a key to the whole house that lies beyond it, if you see what I mean."

"Your conception is like the charming Oriental legend," says I, immediate Oriental legend writer, Penny-Plain or Tuppence-Fancy. "A man designs a house whose entrance hall is so beautiful that no visitor ever feels a need to pass beyond it. The man sensibly concludes, therefore, that there is no need to build the rest of the house at all, except for one small, comfortable bedroom just off the hall. Thereby saving himself any amount of bother and expense. I tell the famous little story, Mr. Leyland, only to illustrate the pitfall inherent in turning your hallway over to me. As your problems and those of my legendary Chinese protagonist are not at all alike, I must avoid his error, mustn't I?"

"I've got to say, Mr. Whistler, you have the most remarkable memory for the apt anecdote I've ever known. However do you do it?"

"Oh, well, one reads and so on, you know." (Modesty in all things.) "But the lesson we must take from our parsimonious though gifted Chinaman is that while your entrance hall must be very beautiful, it must be only beautiful enough to entice further investigation into the glories that lie beyond it. A difficult assignment—at least for me."

"But one you are artist enough to perform with consummate tact, I'm sure," says Leyland, emptying another tot of the Pope's Peril. To all appearances he seemed to be neither drunk nor dying, altogether amazing. The proof was at hand.

"What I would ask of you, Mr. Whistler," said he, "to be precise and so we may understand each other, is that you suggest

the color for the hall and in addition paint the detail of blossom and leaf on the panels of the dado that go round the walls. That way I shall have my second 'Whistler Room,' in a manner of speaking."

In a manner of speaking. A manner I did not care for in the least. It was on the end of my tongue to say, "Paint your bloody hall flaming red and I'll send round a beginning art student to daub in the leaves on your dado! And a cordial good day to you!" But I didn't say it. Why? Even on my uppers as I am, and given even a nature as placid as my own, I do not think some such response would have been altogether out of place to this offer of a house painter's job. But I didn't say it, and I was glad I didn't say it. Again, why?

Well, now, you know, I learned years ago that in a curious way to insult me can have a very salutary effect. On me, I mean, of course, not on the insulter, certainly not on him. For when a man insults me he sets me free. He liberates me from all further obligation to him of any kind, whether moral or social or merely human. I am automatically relieved of the nagging niceties bred into me by nature and education. He is forever cut off from the sort of behavior he might otherwise expect from a man of my natural sensibilities; he would be well advised to expect only vengeance.

It was all quite splendid in a way. Where a moment before I had been excluded from profiteering in some way out of Leyland's new palace because I felt obliged to abide by his rules, I was suddenly placed entirely beyond rules. Now I could steal his whole house, if I liked, whistling at my work. In fact, I already had an idea. Well, not fully formed, but capable of immediate implementation at the appropriate moment. And so I smiled at Leyland, holding up my glass to him.

"A charming suggestion," says I. "I shall be delighted to look after your hall. But I must insist that for so slight an undertaking I can accept no compensation other than my pleasure in the work."

At this Maud looked downright alarmed. She kept trying to shake her head without actually, visibly shaking it, an enterprise doomed to failure, only looking like some sort of tick.

"How you have relieved my mind, Mr. Whistler!" said Leyland, rising from his place at the table. "Now I can go home knowing I have another brilliant bit set into my mosaic. I can say now that when I accepted your invitation, having my small proposition in mind, I had a certain apprehension . . ."

"I can't think why, sir," says I, rising along with him.

"Well . . ." He waved that off to somewhere. "However, I most certainly can't agree to your generous notion of no compensation. Absolutely absurd."

"It is my one absolute condition," said I, screwing in my monocle and smiling gravely.

"But why? I mean, I must insist . . ."

Now poor Maud was trying to do the opposite of her earlier pantomime; that is, she was trying invisibly to nod up and down instead of back and forth, the results being identically futile.

"No, it is *I* who must insist," I went on. "I'd rather become a piece of your very personal mosaic as a friend than as a hireling. Let it be my little gift. But there's really no need to talk about it any longer."

Maud groaned, or, rather, her silent face groaned, if such a thing is possible. But it was Leyland who was having the worst of it, as I had hoped. As everyone knows, there is nothing so thoroughly alarming to a rich man as to give him something for nothing. It throws everything absolutely off, you know. His money is his power, and to disdain the one is to disdain the other, most unpleasant. Ha-*ha!*

"Mr. Whistler . . ." Leyland tried making some sort of last stand, but it was weak, my monocle having done its work, "I would vastly prefer—"

"Please," I interrupted, "please . . ."

And the matter was closed. Leyland looked perfectly miserable, as well he might. He had every right to feel suspicious of an unsolicited generous gesture from a poor man, but it was a

suspicion he couldn't acceptably express. It simply wouldn't do to come right out and say, "All right, laddie, so what's your game?" No, no, wouldn't do at all. He must accept a free favor, however much he loathed it, accepting along with it a debt, an obligation, a commitment. In short, what he wanted least on earth. My plan exactly, you know.

Leyland bent again over Maud's hand, although somehow less cavalierly than at his entrance. I believe he kissed her thumb, or possibly only the free air above it. "This has been a great pleasure, *madame*," said he, "an encounter I shall not forget." Truth in that, you know.

"Thank you. Your new house will be very beautiful, I'm sure," says Maud. "Do come again."

"Pleasure," mutters Leyland, and I led him through my little drawing room to the hall and to the front door.

Which last was not easy, as at least five white-coated bailiffs suddenly appeared from nowhere, fetching Leyland his hat and his coat, his stick and opening the door.

"I must say, Mr. Whistler," says Leyland, more or less behind his hand, "you have the most devoted servants I've ever seen."

"Yes," I said, "not one of them would leave me for anything." Whenever possible, tell the truth.

"No hurry about my hall, by the way," Leyland goes on. "The great staircase isn't actually fully in place yet, and I want you to have the hall entirely to yourself when you come to put your mind on it. May I drop you a note in a week or so?"

"I am at your service," says I. "Nothing but a summons, you know. I'll be there."

And at last I closed the door and turned my back to it. Good bailiffs hovering all about in the hall, good kind and honest faces, waiting.

"My friends," says I, as in Shakespeare plays that don't turn out very well in the end for most of the people involved, "I think today we've made tremendous strides toward our common goal. None of you has anything to worry about, really,

only a matter of time. Fees will be paid to me, debts will be paid to you, and I suggest you all have a good game of whist."

"Excuse me, sir," says reliable salad-dressing, "but is it true that Mr. Leyland owns a fleet of a thousand ships?"

"Very likely," says I, "far more likely than Helen of Troy's vague boast in similar arithmetic. Have a good game. And please feel free to finish the wine."

I went back to the living room, where poor Maud waited for me, collapsed in a chair, exhausted and sure of nothing. Beautiful as something Rossetti tried and missed, but too full of genuine emotion for Rossetti.

"Oh, Jimmy," says she, her eyes closed. "Jimmy, what were you thinking of? You told Leyland you wouldn't be paid for his hall . . ." It was a grave moment from her point of view, grave as all get out and clearly needing immediate correction.

"It's nothing, my Maud," said I, rolling the compulsory cigarette that contemporary folklore has associated me with, and I smiled to ease her mind. "I think I'll find another way."

Maud tried hard to brighten, almost smiled, waved her hand uncertainly in the direction of truth, which seemed to lie somewhere in the northwest corner of my charming little drawing room. "Even if it's just Leyland's hall, Jimmy," she said weakly, "you could make something *really* good out of it, something special, something of your own, don't you think so?"

"Yes, Maud," says I. "I will make something good out of Leyland's hall. But in the long run I don't think I will do quite what Leyland expects. I'm really not very good at suggesting colors and painting blossoms on dadoes, you know. No. I have the oddest feeling his house already belongs to me."

Maud looked at me uncomfortably, lying back in her chair from plain tiredness and bewilderment, but wanting reassurance. "Mr. Leyland's new house belongs to *you*, Jimmy?" she said. "What kind of nonsense—"

"Only in a manner of speaking, of course, but bit by bit his house will be mine—you'll see. Believe in the future, Maud."

"If you'd thought of the future," said Maud, "you could have had a hundred guineas for Leyland's hall." Although she didn't actually have her sheaf of bills in her hand, they shook under my nose now, plain as noon.

"A hundred guineas?" I repeated. "What would be the good of that? I owe a hundred to the grocer alone. I need thousands, you see Maud. Thousands and thousands—come by any old way—are what I need to set me free."

Maud grins. "Jimmy," says she, "you talk like a crazy man."

"Bless you," says I.

FOUR

*I*T WAS WELL to have a little time to brood on
the best method of taking over Leyland's new
house, for I meant to do the job thoroughly. And I have found
that the place I brood most rewardingly is while floating on my
beloved Thames at night.

So the following evening, just as the sun was disappearing
rather garishly over the horizon, I set out to find my good
friends Walter and Harry Greaves, whose father was a boat
builder and lived only a few score yards farther down Lindsey
Row from my own house at No. 2.

Simply out of habit I took along some sheets of dark-brown
paper and black and white chalk. Maud bundled me up to my
ears in an old greatcoat and muffler like a polar explorer, a
namby-pamby sort of cossetting I wouldn't usually have stood
for. But when I go out onto the Thames it is not just for a brisk
half hour's row, you see; it is more often than not for a whole
night, or until the sunrise comes along and spoils everything. I
tried it a few times in the white linen suits I wear in summer
to upset the Islanders, but on the Thames at five o'clock in the
morning it can be devilish cold, even in July, and I tottered back
home in the dawn's early light with purple lips and chattering
teeth, ice in my veins. So I now submitted to Maud's plainer
wisdom. All the same, she didn't really think much of my little
expeditions, and for the most curious reason. It had to do with
sleep.

"Your sleep should be at regular hours, Jimmy," said Maud,

adjusting the scarf around my neck like a seasoned hangman. "When you stay up a whole night through, you're upsetting Nature's Plan."

"And what is that plan, sleepy Maud?"

"Everybody knows: 'Sleep in the dark, work all the day, stroll in the park, life will be gay.' "

"*Good God!*"

"More: 'To lose a single night of sleep, so philosophers do say, is not God's covenant to keep, who'll take from you a living day.' "

"What do you mean, God will take from me a living day— out of my life? For not sleeping at night? Well, he'd better not, Maud, or he'll have to take with me every night watchman, physician, constable, prostitute and cat burglar in the business, an unacceptable price. To sleep by day is not the crime set out for us in your appalling doggerel, but to waste the night. I'm only going tonight to watch the water. But there's a lot to see, blacker the better, good place to find one's own delightful nature. And if there is a nocturne lying about for me out there, I'll gladly buy it with a night's sleep. Good dreams, Maud."

Walter and Harry Greaves were splendid young men in every way except one, the single exception being that they both wanted to be painters. Any professional painter is plagued by aspiring amateurs in search of free instruction, of course, and we learn to flee from them, for they would devour us. And I am as fleet of foot as any. But exceptions must be made on purely pragmatic grounds, and Walter and Harry are my exceptions. Although neither had any perceptible talent for painting. I have let them come to my studio from time to time and paint along with me whatever or whoever I may have been painting and gave them a bit of elementary instruction. Naturally, I asked nothing of them for these small favors, but I was amply repaid.

Harry and Walter make their living letting out rowing boats on the Thames, and nothing pleases them more than to row me about in one of their boats, anywhere and at any time of the

night or day, watching me work, chatting if I chat, silent the length of a night if I am silent. From them I pretended to learn to row, although I'd oared myself up the Connecticut River before my seventh birthday, but I take it as a rule of thumb that every man who possesses an honest skill (particularly if he possesses only one) should be allowed the pride of passing it on to a friend.

Harry summed up our relationship once for Rossetti—also a neighbor of the Greaveses—far more succinctly than I see I have done. "You see, sir," explained Harry to Rossetti, "Mr. Whistler taught me and Walter to paint, and we taught him the waterman's jerk." Generous Harry, just my kind of equation, false at both ends.

When I was admitted to the Greaveses house—a hideously cluttered confection, tidy as a pin—and explained my mission, Walter and Harry were off to their dock like bounding stags, you know, to prepare the boat, but not before I'd had the chance to observe a rather peculiar development. For some time past both young men had cultivated trim chin whiskers and mustaches exactly like my own, and when they were not on the river they could often be seen around Chelsea with unusually long walking sticks and what some people considered overly large boutonnieres. Well, no great harm in that, you'll agree. But tonight I noticed that Harry, as he rushed out the door to see about the boat—Harry is an enormous young man, barrel for a chest, shoulders wide as a door, fists like coconuts—was wearing a monocle on a black silk ribbon.

The elder Mr. Greaves, the boys' father, clearly had something on his mind, although he seemed not quite sure how to put it into words. "Ah . . . Mr. Whistler," said he, avoiding my eye, glowering at his feet as though he hated them, "my boys owe you a lot, and that's the truth."

"No more than I owe them, and that's another truth."

"Well . . . but, you see, sir," says this perceptive, bedeviled man, "Mr. Whistler, sir . . . imitation is a kind of flattery, they say, and I suppose that's true, but . . . but when it comes to the

business of letting out rowing boats on the river, there's something about a monocle that puts people off . . . I don't know . . ."

"You're absolutely right, Mr. Greaves."

"Oh? You think so, too?"

"I most certainly do. I, for example, would never rent a boat from a man with a monocle. I would suspect him of a lack of seriousness in his character and therefore in his work and therefore in his boat. And I'm certain the general public feels much the same way. I speak with stunning authority in this matter, Mr. Greaves, as you may imagine. I'll have a word with Harry."

Mr. Greaves was vastly relieved. "I knew I could count on you, sir," says he, pumping my hand. "It's not that there's anything *wrong* with wearing a monocle, you understand, not the slightest bit of it . . ."

"But bad for business. Quite so, Mr. Greaves. Good night."

Walter and Harry were all ready for me at the dock and helped me into my seat in the stern of the boat.

"Where will it be tonight, Mr. Whistler?" says Walter, shoving off into the river.

"Why, wherever you like, Walter. You might head in a general way toward Cremorne Gardens . . . we could potter about a bit in the shadows under old Battersea Bridge . . . it doesn't really matter tonight. Tonight," I explained, "is not so much for painting as for thinking."

"Thinking," Harry repeats, taking up his oars behind Walter. "I trust you made a note of that, Walter. Mr. Whistler's going to do a spot of thinking tonight."

"Quiet as the grave's my motto, Harry," says Walter. "Shouldn't think it such a bad one for you, too."

"Just took out membership in the club, Walter," says Harry, screwing in his monocle and leaning back on his oars.

It was dark now, the last of the sun's glow swallowed up in a light mist rising from the river, no foolish, gaudy moon about, only the incurious stars to point out what was slightly

lighter than what was dark, and darkness that was still not blackness. A good kind of night for me, you know. I tried to set my mind on redeeming my poorish fortunes from Leyland's new palace, cutting out all thoughts but those, hearing no sounds but the gentle tap-tapping of the water against the sides of the boat, the dripping from the feathered oars.

I tried very hard, tried for more than half an hour, I suppose. But, well, you know, it didn't work. I am incapable of sustaining feelings of anger and revenge on the river at night, or so it would seem. I would have to put them off until the banality of sunlight brought me to my senses again. For the time being, I let myself fall back into the enveloping arms of my acute obsession, like the insatiable lecher to bawdy Jill, the toper to his bottle. So it is with me and the river at night.

What by day is a coal barge coasting in midstream under quite unremarkable Battersea Bridge seems to me at night to be something altogether different, not a barge or a bridge at all, just as the warehouses and factory chimneys along the shore are only what I choose them to be. All—all that I see, and much that I prefer not to see—in time become only pieces of my composition. I have, for example, painted Battersea Bridge, black against a greenish black sky, as the stark and graceful T-shape of a Chinese ideogram, under which pass the dark rectangular shadow of a barge and bargeman, if you like, and high on the bridge may be some foot passengers, if you like. It doesn't matter. Whatever you may see, in the matter of specifics, you cannot help but see in the whole a design, a composition of such disciplined and sustained beauty that it must knock the wind out of you like a mule's kick in your belly.

Steady. I have said "you cannot help but see . . ." Well, some can. Indeed, a great many can help but see, as I have spent some years discovering to my foolish astonishment.

"Mr. Whistler, in his paintings he so capriciously calls 'nocturnes,' would seem to be trying to persuade us," says Mr. Tom Taylor of the *Times* (more of him later, and if he didn't say precisely this he has said dozens of times things so nearly

like it that it is all one), "that where there is less there is more, and where there is almost nothing at all there must be everything. A curious proposition, indeed. It would follow, or so we think, that if Mr. Whistler were to cover a canvas in Navy gray with a house painter's brush in five broad strokes, he would have achieved the highest peak attainable in his own art."

Well, you're *almost* there, Tom, but not quite. Bred, as you are, on Ruskin, you almost gave yourself away. You wrote the story of my life in a jibe, although it was not your intention, old Tom. But you did say, meaning to run me through with your poisoned quill, that "where there is almost nothing at all there must be everything." Quite amazing, Tom! For a man of your awesome density of mind to stumble over something close to the truth about me, however accidentally, is something only very short of a miracle. Of course, you immediately negated your splendid insight, as was to be expected, with that blather about covering a canvas in plain Navy gray with a house painter's brush. But as the *Times*, in spite of my repeated suggestions, has so far not seen fit to transfer your writing talents from Art to Crime, I must make the most of the small joys you offer me, Tom.

Floating on the dark river the clever-idiotic sentence of Tom O'Dreams tells me that I am right. The essence of my night pictures, my nocturnes, is this: The elimination of factual detail is so severe that with one brush stroke less, nothing would be left, nothing at all; but with one brush stroke more, the night would be stripped of its mystery, and again nothing would be left, or far too much. Life lived on the edge of the razor suggests a somewhat perilous whereabouts, you say? Well, yes. But better the razor's edge than in the plowman's furrow. Or so, at least, say I. So often at the bottom of the furrow one finds John Ruskin squatting, engaged in earnest converse with Tom Taylor, also squatting, both congratulating Nature on her fidelity to herself.

"Tell me, Harry," says I, breaking more than an hour's

143

agreeable silence, "I see you've taken to wearing an eyeglass. Would you tell me why?"

Harry caught a crab with his oar, not at all like him, just taken by surprise, I suppose.

"Why, sir? Well, I . . . well, because," mumbles Harry, and if it had been daylight I'm sure I'd have seen his face in glorious blush, ". . . because only recently I've felt this peculiar failing of sight in my right eye here. Strange."

Now Harry Greaves has the sight of a particularly keen-eyed bald eagle. I have seen him casually point out objects on the river which were totally invisible to me until he had drawn nearer to them by a full hundred feet. But to remind him of that would not serve my purpose.

"I see," said I, nodding solemnly in the darkness. "That's a pity, Harry. And probably more of a pity than you realize, I'm afraid."

"More of a pity? How's that, sir?"

"Because if your right eye is failing, it is statistically predictable that your left eye will not be far behind. Cases of one perfect eye and one deteriorating eye in the same head are next to unheard of," says I, not having the faintest idea of what I was talking about, but leading directly to my point. "Now, if your sight is failing, Harry, the very worst thing you can do is to wear a single eyeglass. You favor one eye at the expense of the other, you see, so that the better eye, not called upon to do its normal work, goes downhill on the double-quick march. No, I fear it's plain old spectacles for you, my boy. Pinch them on your nose like a librarian or hook them behind your ears like Ben Franklin, all for your own good in either case."

"But . . . but, Mr. Whistler," says puzzled Harry, saying exactly what he is supposed to say, "but *you* wear a monocle."

"So I do, Harry. And now you are supposed to ask me why."

"Well . . . well, why?"

"Affectation. Pure and simple."

"Sir?"

"Do you imagine that I read a newspaper while wearing a

monocle? Of course not. I read with proper spectacles like everybody else who can't see the print on a page. No, no, Harry, you are trying to explain your behavior logically, which is a mistake. I've worn an eyeglass since I was twenty years old; it was an affectation then, it is an affectation still. It is also, of course, a useful theatrical property and weapon of combat and various other things having nothing to do with improving one's vision. No. Until you can freely admit to yourself that you wear a monocle as pure affectation—simply to draw attention to yourself, either as an aspiring painter or as an accomplished boatman, out of sheer egocentricity, forswearing all guff about failing sight in one eye—you have not *earned* your monocle. Disraeli has earned his by playing the role of a conspicuously dotty, though highly effective, Prime Minister. I have earned mine by playing the role of a man of artistic genius unacceptable to the conventional wisdom of his time, and enjoying it. What role are you prepared to play, Harry?"

Well, it was unfair, I suppose. But I kept thinking of poor old Greaves back there in the boatyard and business going to pot in the letting of rowing boats all on account of Harry's monocle, and perhaps I thought of myself, too.

What a pleasure it would be to my onetime friend and fellow student in Paris, du Maurier, to draw one of his tedious little jokes about me in *Punch*, if the matter ever got back to him. I could easily imagine it: Whistler, dressed in the curiously extravagant way du Maurier always draws me in *Punch*, striding along the Chelsea Embankment followed by ten sturdy boatmen, oars over their shoulders, all wearing monocles. No, it wouldn't do. I abhor banality, even in cheapjack art, and so I let stand my unfair question to Harry.

"What *role* am I prepared to play, sir?" says honest Harry, leaning forward on his seat, oars tucked up. "Well, I . . . I don't suppose I'd thought of it in just that way."

"Time you did, Harry," says Walter. "Mr. Whistler's got a fine point there, Harry, fine as you please. Worth a good think, I'd say."

"It was only my weak eye . . ." begins Harry, but no more.

"Mr. Disraeli's worth a think, I should say," continues Walter, "thinking of his position and everything."

Mercifully, there was suddenly an end, something flashy to divert our attention. And as it happened Harry Greaves unobtrusively took the monocle from his eye and let it slip over the side of the boat, never to be seen again. Genuine, unaffected sensitivity is rare in this world. It is a great pity that Harry Greaves will never learn to paint—and he won't—because his soul is ready.

But to return to our diversion. From the other side of the river from Cremorne Gardens there shot into the sky a great burst of fireworks, rockets whooshing every which way, lighting the black night with marvelous gaud, pushing ordinary discussion aside. I can think of nothing so useful a deterrent to logic as a skyrocket. People scream Oooh! and Aaah! at fireworks, all sense having left them for the moment as they concentrate on childhood. A perfect moment for a topnotch robbery, I should imagine, or a murder. No one would remember the facts.

They were absolutely stunning, you see, not really more stunning than any other fireworks but they stunned me just then in a most personal way. Why this night and a particular rocket instead of another night and another rocket, I have no idea and I will certainly listen to no reasoned theories. What has reason to do with it? Nothing whatever, thank God.

(Cremorne Gardens, by the way, are not gardens at all in a botanical sense any more than German beer gardens are gardens; Cremorne is just a jolly, slightly raffish stretch of embankment on the other side of the river where undemanding folk may eat and drink and dance to their heart's content, play games, ride ponies—and watch fireworks—an altogether splendid place.)

Now, I have seen hundreds of skyrockets launched into the night sky from Cremorne, and very good rockets they were. But now came this one, not very different, probably, and I knew I was going to paint it. I would paint it if it took an hour or took eternity, or anything in between that seemed suitable. Why? The answer is obvious. Because it was clearly impossible.

There is no imaginable way to examine, to study, the rise and fall of a skyrocket. It has come, and done something dazzling, and gone before we have an accurate way of recording any sort of actual feeling about it. We know only that it was a joyous thing while it was there, not important, certainly, but we are glad that it was there at all.

But *this* rocket—this particular rocket that was above me on the river—shook me out of all reason, made me stare into the night sky like a caveman plagued by his first bewildering comet. The rocket's rise was of no particular interest because it was too predictable, as was its climactic explosion. What I wanted to paint was its fall, those few swift moments somewhere between its glory and its total extinction, a blast of color already fading into the black sky, truly a nocturne.

Well, of course, there wasn't much I could do about it, sitting there in the stern of the little boat with only some dark sketching paper and black and white chalk. What I really intended to paint had already gone the way of the dodo bird and melted snow, never to return, except in my memory. In my other nocturnes I could at least glance back at a bridge or a barge or a chimney to re-enforce my memory, for they were constants, however dimly perceived. But my rocket could as well have come and gone on the day of Creation.

Still, I thought I should try to put down a little of what I could manage to see of Cremorne Gardens across the dark river, now that the brilliance had faded. All nonsense, you know. I knew exactly what I was going to paint. But I owed something to the Greaves brothers for all their kindly rowing, and this was exactly the sort of moment they went to their trouble for. Both young men took solemn pleasure in bandying about the word "inspiration," and what they meant by it—at least what I *think* they meant by it—was some sort of mystical instant visited upon an artist during which some masterpiece was conceived, executed and immediately delivered to Valhalla by special messenger.

Well, the notion was not *absolutely* wrong, of course. So few things are. Murder and arson, as everybody knows, are

frequently the only correct answer to certain situations. Yes, I saw a painting all in a second as the rocket fell, saw it gloriously done, saw a vision made awesome fact in the blink of an eye. The difficulty with this notion as a definition of "inspiration" is that I have experienced almost exactly the same blinding insight, born full-blown, as it concerned a good dinner at the Café Royale. Soup to nuts, it was all there, just as my painting was all there. But there is the end—the very, very end of all similarity.

At the Café Royale the highly competent chef will produce exactly the dinner of my imagination, and it will be very good indeed. But it will be good precisely because he has created it a thousand times before. My painting will be good—and it may not be good at all—in spite of the fact that it will never have been created before in the history of the world.

So there is a difference, you see, in spite of the obvious similarities, and is the reason why the word "inspiration" has about as much meaning, in a qualitative sense, as the word "omelet." With both we must await results.

I skimmed this over in my mind dispassionately, there in the stern of the boat on the black river, even while my pulse was running a bit ahead of itself and the palms of my hands were not dry, because I was becoming the chef. The chef and I were professionals and we knew how to mix a good sauce, properly spiced, properly stirred, a cautious eye to the heat. And I was thinking as technically as the chef, my palette before me, mixing colors in my mind: paint on a flat black background, same as this sky, scrape it off once, maybe twice, just to let the black sink into the canvas, cover once again, then, while it was still wet, throw on the brilliant, dying rocket, searing spots and streaks of red and gold, blue-white smoke still rising from the ground, shadowy shapes and figures of people of a lanterned bandstand of silent water of bloody inquisitional ghost . . .

Damn all, at home only one broken palette knife! Well, a bailiff's pocketknife would do as well, count on bailiffs for all things. The canvas, what canvas? Not a new stretch, that's for certain, not at current prices, but something that went wrong,

already lying about in the studio. I'll find a canvas to paint over, for the new must always be better than the old, or so I must believe. Ha-*ha!*

Well, now. All that would never do if it were said out loud to the kindly Greaves brothers. I must play the game, their "inspiration" game. After all, a good evening's row, and future rows, should be paid for. I needed only to get back to my house and work. It could be quick. So I reached for my pad and my chalks, staring interestingly and mysteriously at the night, hand held tentatively over the paper.

Walter had his brother's night-eyes and he was sitting on the rowing bench closer to me. He suddenly froze where he sat, like a perfectly trained bird dog coming to point.

"Ship your oars, Harry!" he whispered, in a stage whisper that could surely have been heard half a mile downriver at London Bridge. "Mr. Whistler's been struck again, I think!"

"The old Muse come calling, has she, Walter?" Harry whispered back, awe in his voice. "Welcome aboard, I say, and eat all the chips she likes." And Harry, too, froze in his seat.

So I scribbled a bit on the paper for a few moments with the chalks, not really drawing, since there was nothing to draw that would be of any value to the painting that was already finished in my head, frowning judiciously, until I felt I had paid my debt. That done, I closed up my fraudulent shop.

"Home again, gentlemen, if you please," says I. "I have a night's work ahead of me, to say nothing of a lifetime's. Show me your good muscles."

And indeed they did. We skimmed back across the river to Chelsea like a waterbug skimming the surface of a pond. Only at the very last did anyone speak. It was Harry, who usually spoke least, but perhaps because on tonight's voyage I had robbed him of his monocle he felt an unusual freedom to ask a direct question, sort of an eye for an eye, you know.

"Mr. Whistler, sir," says Harry, "I'd like to know. What was it you saw at Cremorne tonight that was any different from any other night? I mean, what is it you mean to paint?"

"Gibberish, Harry," says I, smiling pleasantly, "or so it will be called. And quite properly, too, I suppose. Because, you see, I think I mean to paint it in a foreign language—that is, in a language not often spoken hereabouts. And if a man came to your house, babbling out his story to you and Walter in Middle Eskimo or whatever, you could hardly be blamed for calling his tale gibberish, now, could you? Or, even more annoying than Eskimo, suppose he told his tale in a language not yet invented, not even occasional banter at the North Pole, you know. Gibberish would be a very mild critical assessment, I should think. Lacking in imagination, of course, but quite natural."

But Harry was not to be put off with any such roundabout blather. He shook his head roughly, as though shaking my words out of his ears. "The fireworks, sir," says Harry bluntly. "Is that what you mean to paint—the fireworks blowing up in the sky?"

"Seems you might tread a little lightly here, Harry," says Walter. "Mr. Whistler's got his own—"

But what with the fish at the bottom of the Thames looking at each other through Harry's nobly discarded monocle, Harry deserved a straight answer. "Yes, the fireworks, Harry," I said. "More exactly, a falling skyrocket, like one we just saw. I look forward to your opinion of it. Good night."

I jumped off onto the dock and hurried along the Chelsea Embankment. It could only be somewhere about midnight, early homecoming for me in the usual order of things after a night on the river. Plenty of time to paint, you see. I let myself in and went straight up to my workroom on the top floor, passing sleeping Maud on tiptoes. Better sleep than art criticism just now, there's a good girl. But I did take a cautious look into the bedroom, holding the door ajar only enough to let a thin shaft of gaslight from the hall fall across Maud's sleeping form. I could see that her wonderful red hair was all done up in the hideous curl papers I have expressly forbidden her to use, at least when I am anywhere about.

But that was the point, of course; she hadn't expected me before dawn, and I would have found her mysteriously more beautiful at breakfast. Why did those wretched curl papers make me suddenly sad? I don't know. Because I was not meant to have seen them, I suppose, because I have always found the secret manifestations of love more touching by far than the heroic ones: sad curl papers—and at a moment when I was single-mindedly intent on painting a picture of great private importance to me. But we are never actually single-minded, not one of us. As the footpad holds his menacing gun to our heads demanding our money or our lives, we will—at the very outer edge of our fright—observe that the thief's shirt cuff is badly frayed. So with art and curl papers, apparently, both sad in the end because both private, both unlikely to convince our betters that much of anything has been changed. Good dreams, sweet Maud, they are your due.

In the studio there was no canvas. Oh, of course there was canvas, but not the right canvas; the size was the thing and the size was already determined in my mind to the half inch. In the end I found a wood panel, part of a dismantled door, not at all familiar to me as something to paint on, but the size was exactly what I wanted and the surface virginal, and my need brought about concessions. Good God, people painted on wood centuries before they painted on canvas, so *that* was nothing. I took out my monocle and put on my proper spectacles. And I began to lay on the black of the Cremorne Gardens' sky, the untouched sky, before the rocket. As I worked, I whistled some off-tune Stephen Foster tunes between my teeth. I was all one with myself, you know. There's nothing quite like it, short of Death and Resurrection, and that's just a guess. Doo-dah-doo-dah . . . Gonna run all night, gonna run all day. Bet your money on the bobtail nag . . . All night I painted, until the clumsy sun sent me to bed.

I had told Harry Greaves that my picture would be called gibberish. As it turned out, I had been alarmingly lacking in imagination. It was called much more. One good man, however

—it's very bad of me that I can't remember his name or his somewhat obscure journal—said, wrote, that "Mr. Whistler is fast becoming our one-man English Impressionist movement."

It was intended as an insult, of course, as it meant to compare me with my much abused colleagues on the other side of the Channel, who, as a rather amorphous group, had already been dubbed the French Impressionist movement. To understand what the kindly critic intended to convey, one need only substitute the word *Lunatic* for *Impressionist*, for such was the generally accepted English view of the work of my French comrades.

I was properly insulted, yes. But not at all for the reason the critic meant me to be. Although their kind of painting is certainly not my kind of painting, I did not object to being tossed into the hopper with my fellow students at old Gleyre's studio. Manet, Monet, Renoir and, yes, even a regrettable monster like Degas, who fancies himself a wit, are at least serious painters. Nor had I any objection to being called a one-man Impressionist movement. Much as I abhor the facile labels critics love to place on periodic changes in painting, to make their job easier, I suppose "Impressionist" is as good a way of labeling me as any, since the word has no exact meaning beyond its ordinary dictionary definition. And I certainly had no objection to being called a "one-man" movement of *any* kind. Indeed, it was a brilliantly unintended encapsulation of my life.

My insult lay elsewhere. This extremely ignorant man had called me a "one-man *English* Impressionist movement." *English*, mark you! What is the good, I ask in chauvinistic fury, of being born and bred an American only to be publicly insulted as an Englishman? Let him insult me for what I am! Is his country so poor that he can find no native to insult? I'm making too much of this, and it is finally beside the point.

The point, then? Yes. The critic I have quoted here is—at least after I have rolled a cigarette and put my feet up for a little —not important, in a professional sense. But he was not the only one to comment on my Falling Rocket, my "Nocturne in Black and Gold," as it was finally called.

The great John Ruskin, too, in his own good time, chose to publish his comments. I'll set them down when their time arrives. For the time being, it is only a matter of record to say that John Ruskin, properly restrained in his house as a madman, reached out from his crazy-bed to point his finger at *me* as mad. And with so trifling a gesture he collapsed ten years of my life. Well, an art critic, you know.

FIVE

I MADE MYSELF a cup of tea in the studio and slept for a few hours on the sofa. At some point I heard the door inch open and sensed rather than saw Maud peek in. I snored instructively once or twice and she went out again. Finally I got up and had another look at the picture. This can be a tricky moment, as experience has taught me. By some mysterious alchemy a picture, left entirely alone for a few hours, can appear to me to have changed so drastically as to be the opposite of what I had thought it was, and almost never for the better.

But this time it was all right. In fact, it was so all right that I decided not to go on with it just then. I knew precisely where I was going with it, you see, and I wanted to stretch out the fun, the way you'll sometimes set aside a cracking good book a few chapters short of the finish and go do something else for a while, just because you don't want it to come to an end. If I feel compelled to spend every waking minute fussing and daubing at a picture, it usually means there is something seriously wrong with it.

So today it was a leisurely hot bath and shave, crisp fresh linen, an ample fuchsia cravat and a white duck suit, the last in order to dismay the Islanders, who could not so much as *imagine* a white duck suit—and in the *city*. White trousers at a country cricket match, perhaps, or on somebody's boat, along with a navy jacket. But a white suit was what you went to hell in on a desert island. Well, I was on my desert island. Ha-*ha!*

It was Bailiff Ernest Bright who answered my ring, and

when he returned in a few minutes, loping up the stairs on his strong young legs with a bucket of steaming water in each hand, he was grinning like a cat. After another trip and the water was cooling in the tub, I said, "Bright, my dear fellow, sit down and catch your breath for a moment. Why are you grinning like that?"

"Bit of excitement below stairs in the kitchen, that's all, sir, among us chaps," says Bright. "Fact is, you just had a letter delivered to you from Mr. Frederick Leyland. Not by post and not by foot either, none of that. A private carriage, coachman and a footman to deliver the letter, the whole lot, it was."

"I see. And it occurred to you gentlemen that Mr. Leyland may be summoning me to make all our fortunes?" I tested the water with my toe and slipped down into the steaming tub.

"Oh, we wouldn't be presuming anything, of course, Mr. Whistler . . ."

"Well, why not?" says I. "It's what I promised you, isn't it? You chaps are doing me a good turn, so now . . . Just soap that sponge there beside you, Bright, and give my back a bit of a scrub. Right. So now it's my turn to pay back the favor, quite as it should be. Fair's fair and honor's honor, and I defy any man to tell me otherwise. . . . Just a little bit lower, there's a good chap, now a little to the right . . . up, up . . . Ah. Bright, you are talented beyond your years. Now, run along with your buckets and in a quarter of an hour I'll be down to read the good news."

"We'll all be waiting, sir," said Bright, fairly skipping off.

Well, yes, they would all be waiting. I, too, was waiting, in a manner of speaking, to see what Leyland had to say. More accurately, I was waiting for the precise words to come to me in which *I* would say what Leyland had to say. For, of course, I already knew what he would actually say. "Tuesday at four," more gracefully phrased, nothing else. Why should a man in Leyland's position say more? He knew I would come. But instinctively I had a notion that so simple a summons would not entirely satisfy the expectations of my honest bailiffs—or, more importantly, my creditors whom my bailiffs represented, who

would hear the news within the hour. They would prefer something more elaborate, something more generally reassuring to their peace of mind, and they would have it.

So I let the bath water grow cool, then shaved and finally dressed with great care in the charming costume I have described earlier. By then I knew what was needed to lighten the hearts of bailiffs and creditors alike. Well, only what would be best for all of us, you know.

Downstairs Maud was waiting. She had Leyland's letter in her hand, but only holding it casually at her side, not as though it mattered. My breakfast was all that mattered, apparently. She led me into the dining room and sat me down at the table.

"Tea and an egg, Jimmy?"

"Good idea."

"They'll be along in a minute. Ernest told me you were up, so we went ahead."

"Ernest?"

"Ernest Bright, the young bailiff."

"Oh, of course."

"Came in rather early last night, didn't you? For you, I mean."

"Half past twelve or one."

"Get a picture out there, did you?"

"Maybe. Can't really be sure yet."

"It'll come along well, I expect."

"We'll wait and see."

"Yes."

"Get back to it later. Things darken down a bit."

"Good idea."

"Yes."

"Ah, egg."

(Did you *follow* that idiot, rotten, affected conversation? It's what *happens* to even the best-intentioned visitors who spend only a few years on this sequestered island, at least if the visitor is obliged, for whatever enforced reason, to mingle with

the educated classes. It is part of a mystique which propounds that civilized people never refer directly to what is uppermost in their minds: for *vital letter* one substitutes *egg* and so on. It is a game which I generally—some say belligerently—refuse to play, often publicly calling an egg an egg to the despair of hostess and clubman alike.

But this morning Maud had caught me off guard and before breakfast, and so I had momentarily played the game. Not, of course—and this is the splendid silliness of the game—that Maud was from an educated class; she was not. She was from a semi-educated class, but the semi-educated, on this merry local roundabout, tend to parrot the folkways of the educated, you see. That they do so unsuccessfully in a variety of subtle ways is not clear to them, but it doesn't matter because their pretensions are for the most part only tested on others equally semi-educated.

Only the *un*educated, therefore, are free men. They may say what they like and what they feel because nobody pays any attention to them—except, of course, dukes and princes, in certain circumstances. For there exists in all England no closer personal rapport between human beings—including marriages and similar alliances—than the one between your horticultural duke and his head gardener (who can smell the presence of an invisible aphid, although he cannot spell his name), or between the blooded prince, a hunting man, and his Master of Hounds (who can determine the precise whereabouts of a fox by some mystical intuition, but could not point out his father in a crowd of three.) Quite as it should be. A society of merit and nothing else. My idea exactly. Take Bailiff Ernest Bright.

Bright had brought me an egg and a cup of tea, set them down properly in front of me, salt and pepper, everything in order. Then he moved back a step, but only one step, and there he stood awaiting developments. It was now time, in his entirely rational judgment, to get on with what was on everybody's mind and never mind the faddle about paintings and eggs.

"That will be all for the moment, thank you, Ernest," says Maud.

But by that time I had had a swallow or two of scalding black tea, which brought me back to my senses.

"That will not be all, Bright," said I, whacking the up end of my egg with the bottom of my spoon and clipping off the top bit with the single precise gesture of your seasoned executioner. "Be good enough to call in your troubled colleagues, and we will all share in the morning's post together."

"Yes, sir, Mr. Whistler." And Bright disappeared on the instant as though he had never been.

"Jimmy," says Maud apprehensively, watching the door close behind Bright, "are you sure you know exactly what you're doing?"

"The most awkward question ever put to man, Maud."

"Well, at least read Leyland's letter, now, quickly, before . . . Here, let me . . ."

And Maud all in a second had a table knife in her hand, ready to slice open the letter.

"Don't open it!" I said quickly, snatching the letter out of her hand with a certain lack of gallantry, possibly, but with cold logic my solemn guide. A bit of egg here and there. "My dear Maud," I continued, all calm now, "you are overlooking the power of melodrama. Melodrama will sell more tickets any day in the week than the real thing. Present my bailiffs with an opened letter, already read, and there's no fun in it. I got to it first, you see. But let us all open the letter together—a shared glimpse into the unknown—and we have sudden melodrama of the very best, or worst, sort. I leave the qualitative choice to you; it doesn't really matter in the end. A burst of confidence is what's wanted."

Maud, all furrowed brow and so on, wanted to extend this essentially frivolous conversation—she for some reason couldn't get it through her head that it made not the slightest difference *what* Leyland said in his letter, but what *I* said he said—but fortunately we were interrupted.

It was amazing, you know. Bright couldn't have been gone

more than half a minute when he reappeared through the dining-room door, leading a somewhat scraggly file of his colleagues, numbering five in all, including Bright. Plainly they had all been waiting just off stage in the butler's pantry while the kitchen below was taking care of itself.

I had seldom before seen all five of my bailiffs in the same place and at the same time, and as they more or less lined up beside the dining table I was reminded of the natural dangers of casting our fellow men by physical types according to their occupation. Say *bailiff* or *bill collector* to your ordinary bloke— and I place myself in his ingenuous company—and he comes up with the picture of a weasel-faced, cavernous-chested, pointy-nosed citizen, all greasy black hair and chipped fingernails, possibly one gold tooth up front.

But not at all, you know. My particular complement of bailiffs could easily have been mistaken for an earnest group of madrigal singers come to cheer my Christmastide.

There was young Bright, my fanciful King David, smiling, eager, bound to win on a horse race some time in his life; then came salad-dressing-major-domo bailiff, roly-poly and solemn, the heavy musings of an emperor slightly stooping his shoulders. Among the other three, one was a jolly village curate, his nose red-veined at thirty, afraid lest he should not smile; the next was invisible, although I could almost make out his outlines with some effort, for he was gray from head to foot, hair, eyes, face, collar, cravat, coat, trousers, all were gray; and the last, at the final insistence of God and our friend Charles Dickens, I suppose, looked exactly like the bailiff of my and the other bloke's imagination, right down to the chipped fingernails. Well, order in everything so that people can sleep peacefully at night.

"I've brought the other chaps, Mr. Whistler," says Bright, "just the way you ordered it."

"Thank you, Bright." I got up out of my chair and put in my monocle, just to be sure that everything would proceed properly. "Now, you men know that for the immediate future

159

your prospects and mine are very much the same," I said. "I have but to prosper, and you and your employers will prosper. Simple as can be."

"Right as rain," says salad-dressing bailiff, hitching up his invisible toga in a very correct way. "Hear, hear."

"Mr. Frederick Leyland, whom you all know," I went on, "has written me a letter. It is, I feel, not just a letter to me, but one to you as well. It may show us the way out of our common problems. We will read it together."

"Decent of you, sir, if I may say so," says the weasel-faced, or literary-correct, bailiff.

I took the envelope from Maud, cut it open with a fruit knife and unfolded the letter. It was a brief note, actually, of only a few lines, easily read at a glance. Its entire content was as follows: "My dear Whistler, Pursuant to the matter I touched upon at your charming breakfast of Sunday last, I hope it will be convenient for you to call on me here at Prince's Gate on Wednesday, July the Tenth, at ten in the morning. Mrs. Leyland and I look forward to your visit with pleasure. Yrs. F. R. Leyland."

I cleared my throat, glanced up gravely at my assembled bailiffs, fixed my eyeglass, and read (or said): "My dear friend Whistler, I find myself overwhelmed with eagerness to get on with the glorious projects I discussed with you at your charming breakfast of Sunday last. Here, parenthetically, I must confess that in no house in London, nay, in no house in all my travels, have I ever encountered such perfect domestic order, such effortless efficiency and grace among a staff of servants as I encountered in yours. But let me return to my obsession. My own house cries out for your genius, Whistler, and I cannot sleep until that genius has graced it. May I dare hope that you will call at Prince's Gate on Wednesday, July the tenth, at ten in the morning? Mrs. Leyland and I await your reply as we would a royal summons. In conclusion, my dear Whistler, I would not offend your fine sensibilities with crass commercial talk of specific compensation for your work. Let me say only this, and I know of no way of saying more: In all affairs between us *my* purse is *your* purse,

and that to the final shilling. Your most obedient servant and patron, F. R. Leyland."

Well, now, you know, Leyland must have had remarkably small handwriting to get all that on one side of a single sheet of note paper, but somehow he managed. In any case, I quickly put the letter back into its envelope and the envelope into my coat pocket. "Seems a fair sort of proposition, I should say," I said, brushing one side of my mustache thoughtfully, "not . . . ah . . . stingy or anything, would you think?"

"Crikey!" says the invisible bailiff, speaking from inside the gray shroud that enveloped him. " 'is purse is Mr. Wissler's purse, that's wot 'e said, lads."

"Like an offer of marriage from the old Lady of Thread Needle Street, if you'd perchance care for my private opinion," says grave salad dressing.

"Mr. Whistler, sir," joins in Ernest Bright, articulating the general mood engendered by Leyland's stunning letter, "our employers are going to be the jolliest men in London when they hear this news, and that's a fact. I trust we all have your permission to repeat what we've heard."

"Well, now, Bright," I said, trying to look as though I were weighing the matter seriously, "we must remember that I have so far contracted no formal arrangement with Mr. Leyland, and even when I do I must work for my reward, the same as any man jack of you."

"Yes, but—"

"At the same time," I went on quickly, "I should think it only fair to give your employers some hint of the reassurance they so much deserve. Yes . . . While perhaps one should avoid quoting Mr. Leyland too precisely, simply for propriety's sake, I'm sure I may trust in the discretion of each one of you to convey the correct impression as he sees it. So, on this happy note, I bid you all a fine good morning."

And out they trooped, nudging and whispering among themselves.

• •

Maud was watching me with great intentness, it seemed to me. "Jimmy," says she, when we were entirely alone, "I could hardly believe my ears."

"You know, no more could I, Maud."

"Saying things like offering you any amount of money . . . Like . . . well . . . well, it just didn't sound like the Mr. Leyland who had breakfast here last Sunday, did it?"

"Perhaps not to you and me, Maud, but the bailiffs seemed to enjoy it, didn't you think?"

"Oh, yes."

"Then that's the important thing, isn't it? Let's see . . ." I took Leyland's letter out of my pocket and glanced at it again. "Wednesday at ten. Yes, that's all I need to remember. Take the letter, darling Maud, and study it carefully. If you find it somewhat pedestrian, that is only a trick of light. My real letter from Leyland is the one I just read aloud, to be heard, not read in private. At the moment it is more prophecy than fact, possibly, but then prophecy is only history waiting to be made. Well, I must get back to work."

"You've hardly eaten anything, Jimmy," says Maud taking the letter and looking vaguely apprehensive, as why should she not?

"Plenty for now," I said, heading for the stairs. "By dinnertime, I have the oddest feeling that our credit will permit us a saddle of lamb or a brace of partridges, if the fancy should take us. Anyhow, order whatever you like, Maud."

"But, Jimmy, how do I know . . ."

"Wait an hour, no more, then test it. It's all just faith, you know, right on down the line. Creditors and bailiffs must have faith in humankind. What else have they got, good chaps that they are? The law will get them nowhere. It costs too much, and it is a very angry creditor indeed who can get much satisfaction out of seeing his debtor in prison just for the fun of the thing and no money coming in. No, faith in me, I believe you will find, has been restored—at least temporarily. By the way, Maud, I wouldn't leave that letter lying about if I were you . . . might even burn it, there's a good girl. Till dinner."

"Jimmy?"

"Yes?"

"Jimmy . . . Jimmy, it's not true then? What you read to us from the letter—" Very tentative, poor dear.

"What is truth?" I interrupted. (When I steal a line, at least my sources are always top-drawer.) "The bailiffs' truth becomes the butcher's and the baker's truth, and their truth becomes our current nourishment, so all's right with the world again. But all this unassailable logic is taking the sap out of me, Maud. I have half a painting waiting for me upstairs."

But Maud was taking Leyland's letter from its envelope, and I had to put a stop to that. I had already made my case as clear as glass, and anyhow it was my firm opinion that a painter ought to paint, just as a banker ought to bank, a robber to rob and so forth.

I put my hand firmly on hers that held the letter and kissed her, just to close her mouth, or anyway that had been the idea. But a mistake, you know, as is so often the case with me. Maud's incredibly beautiful lower lip, trembling as it was now from the complexities and uncertainties of English commercial life, her stunning buckish teeth, her red hair quite beyond comparison on this or any other island—well, all put together they were about to thwart my already blunted purpose. But Maud saved me at the last moment—saved me to paint the picture that was to prove my rather garish ruin.

"No, no, Jimmy, *no*," says Maud, wriggling about until she was her own woman again. "You've only just had your *breakfast*."

Breakfast having nothing to do with it—although I was gentleman enough, I hope, not to particularize past precedents—I saw that the letter in Maud's hands was her all-in-all just then, and no point in trying to change the subject.

"A pity," says I, in a rather shabby state, to tell the truth.

"Night must fall, Jim," Maud answered, unfolding the letter. "A place for everything and everything in its place."

"Right-o," I said, in the idiot argot of my time and place, tottering upstairs to speed my undoing.

163

For the rest of the day I worked on my painting, and toward nightfall I began to realize that I had done something quite extraordinary. By that seemingly immodest statement I mean to convey something far more immodest. By the word *extraordinary* I don't refer just to technical excellence, although the painting was most excellent technically, but to the far more demanding standard of originality. Well, that's a rather empty word, too, since even the worst painting or a child's first scrawl are original in the narrowest sense that there exist no others exactly like them. The same claim may be made for snowflakes, I am told, which is of no interest to the person who catches a snowball in his ear, and to the rest of us only proves that God has an original turn of mind, a most unoriginal idea.

I speak of a larger originality consisting of three separate stages, each perfectly achieved: the vision on the river, the gestation in my mind that ordered the details of a commonplace into a work of art, and finally the unflawed execution on a rectangle of wood. And there it was at nightfall, you know, just standing there calmly on an easel, an entirely original creation. A blow from a fist, an unknown language deciphered, a good bawdy joke from the man in the moon, something like that. It was an abstraction of reality.

But I don't describe paintings. John Ruskin describes paintings, more's the pity. I felt a kinship with other men, all the same, and it was exhilarating, you know, not with painters, not artists of any sort, in fact, except by the broadest possible definition.

Rather oddly, I felt one with the peculiar coves whose exploits fill our local newspapers in these days and years, the African explorers. Sir Richard Burton, Dr. Livingstone, Speke, Grant, Samuel Baker, Stanley (an American by choice, but no less peculiar than the rest), Chinese Gordon and so on and so on.

My kind exactly, you know. The sort of people who look at a map of Africa in the middle of which is a vast unimaginable empty space marked *terra incognita*, and say to themselves: "Might be something interesting in there. Maybe not, but it's worth a look-see."

And off they go, like men possessed, with the muted blessings of the Queen and the Royal Geographic Society (of course it's altogether different when, and if, they ever get back), and are not heard from again for months or even years. But the discoveries these brave men make, and are still making, in the face of incredible peril, are in a sense their creations. While it is true that they are merely observing for the first time with white men's eyes what had been there all along, they make the unknown known to the civilized world, they enrich both the map of our planet and our lives, and so they are creators. Simply, they do what no other man has ever done before them.

And so, if we may return from the mysterious headwaters of the Nile in darkest Africa—not without a certain jolting sensation, possibly—to my house at No. 2 Lindsey Row, Chelsea, and to my rocket picture, my metaphor will finally swallow its tail and make a full circle.

For good or evil, praise or blame, vilification or even indifference, I had just painted a picture that was like no other any man had ever painted before me.

I enjoy celebrating important events. Living's dull prose needs a bit of punctuation here and there, or one is inclined to nod over the monotony. When President Abraham Lincoln was killed by a second-rate actor some ten years ago, I wore a black armband for a week. By the same logic, on Rossetti's fortieth birthday the other week, assuming— falsely as it turned out— that Rossetti had reached the age of reason, I wore a sunflower in my buttonhole. And so forth.

So now I dressed in full evening fig, white cravat and tailcoat, and very carefully, too. A modest dash of French toilet water here and there, a dab of pomade on my Italianate locks, the lightest touch of Grecian beeswax to order my mustache, a high shine applied to my eyeglass, and I went down to dinner. Well, you know, an act of genuine, certifiable creation deserved no less. If we are not prepared to come up to the rare and most occasional heights, to celebrate them in joy and gravity, then we are undiscerning poltroons and do not deserve to own a tailcoat,

even a somewhat shiny one like mine. I descended to the first floor at a suitably measured pace.

Maud, who naturally was not expecting so gorgeous a sight, was properly stunned. "Jimmy!" says she, standing in the little drawing room. "Whatever are you all dressed up for? Oh, how grand you are! You look like the Prince of Wales."

"Yes, I am very grand, Maud dear," I agreed, "but I do *not* look like the Prince of Wales. My present weight is precisely what it was when I was a cadet at West Point, while the Prince of Wales, a younger man, looks like a beached whale. And, no, I will not stoop to pick up the obvious pun about Wales and whales. I am dressed to celebrate an event. I've just finished a very remarkable picture."

"Oh, may I see it, Jimmy?"

"Wait until morning when you can see it by daylight. By gaslight you would merely dislike it, by daylight you will actively loathe it. Save time all round, you see."

"Why do you say I'll loathe it, Jim? I don't loathe your painting."

"Not in general perhaps, my darling, but this one you will loathe because it will be absolutely impossible for you to find a title for it."

"Don't be too sure," says Maud, smiling in an altogether fiendish way.

And so we laughed together as was only sensible between two people, fond of each other, who are convinced of opposing truths. Anyhow, I had quite belatedly begun to take a better look at Maud, so preoccupied had I been with my own grandeur. She was pretty grand herself. No, the word is wrong, not grand but elegant, carefully, subtly elegant. She wore a formal gown of turquoise silk, which must have cost her a dozen hours or more of meticulous needlework, cut low in front and falling straight from beneath the bosom to the floor in neo-classic style—all out of the fussy fashion—but Maud, as are all models worth their salt, was above popular fashion. Her wonderful red hair was

166

drawn up loosely with a velvet ribbon, also of turquoise; a casual discipline of curls lay on her neck. Her only ornamentation was a pair of hooped golden earrings, once given me in payment for a painting, which were very beautiful but turned out to be, on formal assay, not gold but gilded brass. Still, the effect was a glorious one.

"You're looking particularly beautiful tonight, Maud."

"Thank you. I'm celebrating tonight, too."

"Not taken up painting, I hope."

"Don't be silly. Oh, Jimmy!" Maud cries out suddenly, hurling herself into my arms and laughing like a girl, biting my right ear in passing. "Jimmy, you were right about the creditors, absolutely right! Late this morning I sent out all the bailiffs, each one with a great long list of things to buy. I really didn't believe much would come of it, but by early afternoon they started coming back so loaded down they could scarcely walk. It's . . . oh, you wouldn't believe it . . . below stairs, the kitchen, the larder . . . well, it looks like Fortnum and Mason's! Every wonderful thing . . . wait till you see our dinner. Everyone's given you credit again, Jimmy!"

Well, it was very touching, you know, to see such blind faith placed in me by honest tradesmen even though a measure, not to say the bulk, of that faith belonged not to me but to Leyland. Still, they believed I had the skill to open Leyland's purse, and while that remained a trifle unsure at the moment, it was kind of them to believe it so. But Maud gave me no chance to mention these presumably worthy sentiments.

"And it's not just the butcher and the baker, Jim," she rattled on, losing her breath along the way. "It's the tailor and the bootmaker and the hatter. . . . Oh, you'll be so handsome!"

"Yes, and so will you, Maud. It's almost enough to make one believe that art might be a paying proposition, though not quite. Whatever we mean to order made for us, I think we'd do well to order it tomorrow. No point in waiting."

"No point," says Maud, gurgling at the back of her throat and showing her perfect little lower teeth. "Sherry?"

"What?"

"A glass of sherry before dinner?"

"You don't mean *real* sherry, by any chance? Not the Pope's?"

"It's from Spain, is that real?"

"Real as Velásquez and Sancho Panza and Christopher Columbus, who was not real. Give us a try."

And—altogether amazing it was—Maud only stepped to the other side of the room, poured out two glasses of wine from a very serious-looking bottle on a table and placed one in my hand. "Joy, Jimmy," says she, touching her glass to mine.

"Take a glum clot who wouldn't drink to joy, Maud." And we took a sip. Well, it was almost worth a tear or two, you know, for a man who had systematically poisoned his insides for a year or longer. It was real Amontillado, save the mark, just the proper edge to tell you the right time of day as it touched your tongue, then smooth as honey the rest of the way.

I quickly crossed the room and picked up the bottle, a mistake, though one I might have anticipated in a calmer state of mind.

Without looking back, I seem to remember writing earlier a brief monograph about the labels on wine bottles and of their extreme importance to the inexperienced bibber in forming his judgments. All true, of course, but I discovered now that I had left something out about wine labels, an unexpected oversight. It had to do with their emotional content.

"Maud," says I severely, "how could you bring this sherry into my house?"

"Why? Is there something wrong with it?"

"On the contrary, it's the finest."

"Well, then . . ."

"It's called Pedro Domecq. Does that mean anything to you?"

"No. Sounds sort of Spanish, I suppose."

"Yes, yes, but down here at the bottom of the label, in much smaller print. Let me read: 'Imported by Ruskin, Telford and

Domecq.' Surely, there is a familiar name in there somewhere, Maud."

"Well . . . Oh, Ruskin?"

"Ruskin. Nowadays the name is not much associated with sherry, but without the sherry there would be no John Ruskin, god of art and architecture and similar matters," says I, pacing the floor in agitation. "The old man made a very great fortune, you know, importing Spanish wines to England. Modestly, he composed a private company slogan: 'Domecq for sherry, Telford for money, Ruskin for brains.' The good merchant sired an only son, Maud, by way of a wizened, middle-aged, Scottish religious bigot—an extraordinary achievement altogether—and together they set about adoring him as a miracle of all virtue and unique genius. The sherry fortune became John's fortune to squander as he chose, although it was so large by the time the parents died it was unsquanderable. And so he bought artists—yes, bought them, wretched idiots they were—for a house or a suit of clothes or, far worse, for a bit of 'artistic guidance.' Horrible, horrible!"

"Yes, a pity, I suppose," says Maud, "and all that, but still if the sherry's good . . ."

"Of course the sherry's good!" I shouted in indignation. "Which has nothing to do with the case! Have you no *standards*, Maud? Would you have me dine at my enemy's table?"

"Well, Jimmy," says Maud, cool as a turquoise cucumber, "in my part of the country we have a saying: 'Even the devil sometimes roasts a proper saddle of mutton.' "

"Oh, my God!"

"One really shouldn't look gift horses in the mouth, I think."

You know, if I should happen to die in Maud's company, it will not be on account of a heart attack or anything normal like that; it will be because I have been smothered under a welter of maxims.

But I was getting nowhere, my pious indignation had run its course and, into the bargain, I was ruining our great double

169

celebration. It simply would not do; we did not celebrate that often. I set my unfinished glass of Ruskin's nectar back on the table.

"Drink your sherry, Maud," says I, all reasonableness again. "I can't drink with you, but the penny you put into John Ruskin's pocket won't change anything now. The damage was all done too long ago."

Maud smiled at me in relief, took the bottom sip of her wine and set her glass aside. I offered her my arm and together we moved—I say *moved* rather than *walked* because it better describes what we did—toward the dining room. Oh, what a splendid sight we must have been! It called for an awful Royal Academy painter of serious rank, a baronet at the very least, to get it down properly.

Into the dining room we came—where waited two smiling and attentive bailiffs—Maud, straight and elegant, in her hard-wrought home-made gown, and I more or less camouflaged as a swell in my weary tailcoat grown rusty at the elbows, eyeglass shining. Owing the whole wide world, owning only the holes in our pockets, we sat down to a most excellent dinner. My imaginary Academy painter would have been at a loss for a title to his picture. What do you call successful failure? Maud set things straight. I pulled out her chair at one end of the table.

"Thank you, Jimmy," she said, sitting down and putting her dinner napkin in her lap, exactly as though she had nothing much on her mind. "I think you were very admirable not to drink Ruskin's wine even though you liked it. Very admirable."

"Well, only a matter of principle, Maud."

"Quite right. Ernest, you may serve the soup now," says Maud to Bailiff Bright, who was presiding over a tureen on the sideboard, dressed in one of my white Japanese housecoats. The sleeves of the coat were a bit short for Bright and the cuffs were fraying slightly, but it was starched and immaculately clean and Bright had his native King David dignity to carry it off. Solemnly he ladled out the soup which was then brought to the table by another bailiff—the jolly village-curate one—dressed for a

change of pace in a frock coat, a bat-wing collar and an imitation pearl in his stickpin. That job done, the pair marched off to the pantry.

Fresh asparagus soup. Well, amazing, you know. Maud and I smiled at each other over our soup spoons like wicked children who had inadvertently run across the key to the family larder and raided it.

"You're to go to Mr. Leyland's day after tomorrow, aren't you, Jimmy?" says Maud.

"If that's what his letter said."

"About your principles, like not drinking John Ruskin's wine, I mean . . . I suppose your same principles apply equally to Mr. Leyland?"

"Absolutely equally. Poor as we are," I continued, maddened by true asparagus soup and so on, "I mean to be meticulously fair, like practical Goneril. I drink only half a glass of Ruskin's sherry, Maud. Appropriating only half of Leyland's kingdom will do."

SIX

*I*т is not a simple thing to make the arrange-
ments for a major triumph and a major dis-
aster in one's life all before lunch on a single summer's day, but
then I am not a simple man. I accomplished both where another
man might have accomplished only one or the other, triumph
or disaster, take your pick. But halfway measures have never
fallen to my lot, which is not to say that one way is more virtu-
ous than the other, only that Nemesis seems to have taken the
matter out of our hands, passing about half pints here and full
pints there, until we have no recourse to logical explanation
except from tomnoddy German philosophers and you have al-
ready heard the last about *them*. Now, here's how I managed the
thing.

I was standing at my open front door waiting for a hansom
to arrive, Maud by my side. Very grand I was, on my way to
Leyland's new house in Prince's Gate, conservatively attired in
a fawn-colored frock coat, curl-brimmed top hat to match, lav-
ender cravat, yellow gloves, a periwinkle in my buttonhole, a
four-foot-long walking stick in my hand and a compelling need
for justice in my heart.

"Good luck today, Jimmy," says Maud, nervously plucking
from my shoulder some speck of something which could not pos-
sibly have been there.

"Yes, luck is a pleasant thing to happen along, Maud, no
doubt about it. But, you know, on the whole, in the matter of
getting things done, I'm inclined to think that malice is more
dependable. Ah, here's the cab. Goodbye, my dear."

And so it was, just an ordinary hansom cab with an ordi-

nary driver driving an ordinary horse, except that this particular cab had a rather extraordinary postilion in the person of Gabriel Rossetti, huffing and puffing along beside it in some impervious disguise having to do with enormous workman's clodhoppers and a sailor's blue visored cap, turned back to front. Cab and Rossetti arrived together.

"Jimmy," pants Rossetti, who was not really made for trotting, even from his house to my house, "dismiss the cab. Where are you going anyway?"

"To seek my fortune, Gabriel."

"Then there's no need to go. I have your fortune in my pocket—yours and mine both." The winded fatty then waved at the hansom driver, high on his box. "Summoned in error, I'm afraid, cabman. Better luck next time."

"You were not summoned in error, cabman," I corrected him. "Now, Gabriel, I've got to be at Leyland's in a quarter of an hour. While I'm all for making my fortune twice in a day . . ."

"Oh, Leyland's?" says Rossetti. "Then I'll just ride along with you."

"You will not! Today is *my* day, my friend, tomorrow or some other day is yours. To burgle a rich man in pairs would smack of organization, don't you see, and that would never do."

Well, I had offended good Rossetti and I was ashamed at once. Tears came to his eyes at the same time that his face grew ominously darker. He stood up very straight, for all his Father Christmas belly, his fingers working at his sides.

"Whistler," says he very formally, "Whistler . . . I believe —indeed, I am certain—that I know the artist game as well as you. I had supposed we stood together, side by side as comrades, not as rivals."

"Oh, we do, Gabriel, we *do*," I assured him, "but I'm afraid I need hardly point out to you that Nature, in her much advertised largess, has cursed me with a certain measure of suspicion of my fellow man."

"True," said Rossetti, "and more's the pity, too, for it costs *you* far more than it costs your fellow man."

Most truths about myself, which I have not personally in-

173

vented, depress me badly. Rossetti's truth was not an exception. For it was a truth and an aching one. The chip on my shoulder is no chip. It is—no, *they are*, for there is one on each shoulder, two of the most precariously balanced bits of wood in the Western world, and they are not my friends. So much I know. It is only that I prefer not to be reminded of the fact. Well, well, perhaps I am not altogether alone in my little failing. At least let us hope so. Bound to be a touchy cannibal or two somewhere, I suppose. But back to Rossetti.

"Gabriel, I only meant . . . well, you know what I meant. I misunderstood you, I offended you, I'm sorry. Now you've managed to offend me back, so everything should be all right, shouldn't it?" Amazing! Words like these do not exactly spring from my lips with the spontaneity of song, as may by now have become apparent, but Rossetti for all his hopelessly misguided ways was a worthy man.

Well, you know, it must be a very great joy to harbor an Italian soul in one's breast (give or take a Savonarola, exceptions in all things), for at once Rossetti cast off his bitter tears and his dark face, clapped me on both shoulders, where the chips should have been, and kissed me formally on one cheek, then on the other.

"All I wanted was to talk to you in the cab, Jimmy," says he, "and to get a lift across town to a shop near Leyland's where a chap has the most astonishing supply of beeswax in the world. You never saw so much beeswax, at least not all in one place."

Beeswax? I did not question the need for beeswax. While I personally felt no need for beeswax, that did not mean that he had none. Gabriel and I were ourselves again—he, the nominal Englishman, I, the nominal American—neither acting his assigned part.

"Into the cab, Gabriel."

"Into the cab," says he, "and listen to the way the world turns—our side up, for once."

And off we went at a brisk trot clattering over the cobbles toward Leyland's house. Rossetti turned his sailor's cap around

right side front and stared at me like a mesmerist with his great hound's eyes. "Listen," says he. "Ever hear of a swell named Sir Coutts Lindsay?"

"Really, Gabriel, you should know that all paupers know the names of all rich bankers. How else should we scorn them properly?"

"Banker, that's right. But not just any old banker, Jim, and that's the beauty of the thing. This one is opening an art gallery . . . in Grosvenor Square . . . a gallery for modern painting, he says, for painters who can't or don't or won't exhibit at the Royal Academy, that's what it's *for*."

I sighed, I wanted to believe, but I sighed. "Somebody's always talking that way, Gabriel, you know that. Either the whole idea will die aborning, or if your Sir Coutts's gallery does open, one of two things will happen: either the critics will ridicule it into closing in a month's time, or it will be forced to become just another overflow from the Academy. In the latter case, cowardly retreat will be called temporary prudence. All the same in the end."

But Rossetti would not have it so. He gripped my arm in his bear's fist, forcing me to listen. "I know, Jimmy," said he, "I know what you mean, but this time I think it will be different."

"Why should it be?"

"First of all, Sir Coutts and his lady and all their friends are not only rich, like Leyland, they're also a coven of crashing aristocrats. There's the difference. Swells like that can set a fashion—it doesn't matter to us what they *really* know or *really* think—"

"And swells like that, Gabriel," I interrupted rather severely, "can be infinitely more inconstant in their opinions and in their loyalties than the honest cabman who at this moment plies his trade above our heads. I know whereof I speak. You have the good luck or the wit to paint either dead people or, even better, legendary people. When I paint people at all, I paint living ones and they are your swells and your toffs and at this moment I am owed hundreds of pounds by swells and toffs who

175

welshed on an honest bargain because a remarkable painting of them was not a flattering photograph!"

"Jim . . . Jimmy . . ." says Rossetti, patting my arm now instead of cutting off the circulation of my blood, "you're changing the subject."

He was right, of course. Not just about the subject, but about my anger. It is not only useless, it bores people. "Go ahead, Gabriel. At least your optimism keeps me sane, more or less."

"Let me tell you what Sir Coutts said to me last night and you'll see what I mean," Rossetti goes on. "Sir Coutts and I—"

"If only he didn't have such a ridiculous name."

"What does his name matter, you idiot? Listen to what he said. Sir Coutts and I were talking last night at the Garrick Club . . . What are you laughing at?"

"You at the Garrick Club."

"What's so funny about that?"

"Nothing, nothing, Gabriel," says I very quickly, for it was apparent that I was on the verge of offending this touchy Latin for the second time in ten minutes. It was just that the Garrick Club, for all its having been started by and named for an actor, has in recent years become a sort of bastion of conservatism, and a picture of Rossetti, in one of his bandit's costumes, being greeted at the door by the club's very proper president had crossed my mind and given me pleasure. It is such trifles that dispel anger, thank God. "Please go on."

"I *do* own evening clothes, you know," says Gabriel.

"Of course you do. A regular fashion plate and let no man deny it in my presence, but you're interrupting yourself."

"Yes. Well, Sir Coutts said to me, 'Rossetti, something must be done to rescue English taste from the dreadful lethargy it seems to have fallen into.' That's what he said, Jimmy, and if I know you at all you might as well have said it yourself. As a matter of fact, you say it every time I see you, which is rather a bore, but it isn't any bore when a man who is ready to set up his own art gallery says it."

Well, there was something in that, you know, and I couldn't help recognizing the fact in spite of Gabriel's charming way of putting it. "What exactly does your swell *mean* by modern painting?" I asked. "If he means a painter simply has to be alive at the present moment to qualify as a modern painter, I must disagree with him. But I mustn't make unkind assumptions, not my way at all."

"Never your way, Jimmy."

"For example, who does Sir Coutts Lindsay count as a modern painter?"

"Well, you, for one," says Gabriel, chewing gravely on his mustache with his lower teeth.

"He specifically mentioned me?"

"That's right. And I promise I didn't laugh or anything."

"Kind of you, Gabriel."

"It wasn't lying, really. After all, you *are* alive, and so on. Modern painter . . . good neighbor . . ."

"Me, he decided on, and who else?"

"Well, me, of course."

"*You?*"

"Well, you don't have to sound as though I were some bloody thief in the night!"

"No, no, I didn't mean that. I only meant that, by your own definition of yourself, you can't possibly be a modern painter. *Pre*-Raphaelites, say you and your moonstruck comrades, which automatically puts you some four hundred years out of date. Has no such idiot anomaly—"

"Jimmy . . ."

"—ever entered your mind?"

"Jim . . ."

"What?"

Gabriel was smiling, good and dreadful man. He turned his sailor's cap front to back again, smiling, knowing that we were only talking nonsense long ago discussed and found wanting in interest.

"We're alone, Jim."

"So we are." I had to smile back at him.

"We might as well tell each other the truth."

"An incautious expedient, but one into which people are forced from time to time."

"Both of us have a demon riding on our backs. Two quite different demons, of course."

"Of course. Still, they might surreptitiously nod to each other in Hell on a fine day."

"My point exactly. People plagued by demons—sad lot that we are—should . . . shouldn't . . ."

"Shouldn't pitchfork each other's demons?"

"Yes, something like that."

"Aphorisms are really not your thing, Gabriel, but I agree with your sense. You're absolutely right. The demon-possessed, however much we and our demons disagree, share more with each other than we do with the *non*-possessed. We must stick together, because in a general way we are the enemy, you know. Make people uncomfortable and all that. Most people—even crazy people—don't think much about truth, for the most part. We do, and it's upsetting. You think my quest is a mad one, I think yours is madder still, but at least we share the quest. And we both want the world to see what we paint. If we didn't we'd be nothing but black cowards, wouldn't we? So let it be Sir Coutts Lindsay and his Grosvenor Gallery, and a smallish candle to fair weather."

"Never heard you talk such good sense, Jimmy."

"Only happens on Wednesdays, Gabriel."

"What will you show?"

"A new picture, only just painted it. It's not about a falling skyrocket in Cremorne Gardens."

"What else is it not about?"

"So many things. And you?"

"An 'Annunciation.' Spent damn nearly a year on it," says Rossetti, and his eyes glistened, his hands groped the air there in the hansom cab for explanation. "It's . . . it's . . . Well, you wouldn't understand it."

"No. But I admire it."

"And I admire your firecracker, Jimmy, just so long as I don't have to look at it."

"Fair enough."

"Beeswax."

"What?"

"Over there. Quantities of beeswax. Thanks for the lift."

And Gabriel was gone to pursue the creative nonsense of his life while making my own somewhat clearer to me.

I said a little while ago that on this particular day I managed to contrive a major triumph and a major disaster for myself, both before lunch. Well, I had just arranged one and was about to arrange the other as the cab drew up before Leyland's house in Prince's Gate. What was awkward at the moment, of course, was that there was no way of knowing which was which.

Leyland's house? It was, on the face of it, ridiculous to describe it as a house. Or would have been in any country other than mock-modest England, where the understatement of plain fact is regarded not as manifest distortion but as a sign of gentility. Royal residences and a few ducal ones may be denoted as "palace" or "castle," but that's the end of it. Anyone else, may he build a structure of a thousand rooms in a park of a thousand acres and fill it with the rarest treasures of the world, calls it a "house."

Well, the exterior of Leyland's house at 49 Prince's Gate did more or less resemble a house, not differing greatly from its neighbors there in the West End of London. The *exterior*, I say. Once I had been admitted into the entrance hall by a manservant in knee britches and buckled shoes, to use the word "house" was mere frivolity or worse. Everyone, I suppose, has his own idea of what an entrance hall should be. (My own, for example, has in it a number of unpacked packing cases for the reason that that is where they were left by the draymen who

brought them.) There were no packing cases here, although they probably would not have been noticed if there had been, since this entrance hall was first of all approximately the size of Waterloo Station. But it was not in various other ways most people's notion of an entrance hall.

How may I describe it? How give even an inkling of what is considered ultimate grandeur in our fair times? Well, now, you know, it was a hell of a mess. But not just your ordinary West End palazzo mess, for here the resources had been greater. Here was, in a very large nutshell, almost everything one could think of to typify the desperate state into which art in all its manifestations has fallen in modern England. I go about crying for simplicity, for Oriental reserve which allows a person to concentrate his attention on one thing of beauty at a time, the absence of clutter, the reward inherent in a few lines by some master of line, the joy of empty space. Well, no raised voices. Precisely how I am attended as a prophet in my time will become clear on a brief tour of Leyland's entrance hall. Follow at a discreet distance, for fear of sulphur burns.

I was at once struck (that's the way Ruskin writes in his guidebooks) by an enormously wide gilded staircase at the end of the great entrance hall, its balustrade in giddy gilt bronze, the whole business having been transported from recently demolished Northumberland House—another "house," whose size may be estimated by the fact that it has been replaced by Northumberland Avenue. The pillar from which the balustrade sprang—or newel post, as we would say in New England—consisted of an entire statuary group depicting two ladies in gilded wood, one sitting, one standing and wildly waving a torch, both in the prow of a Venetian galley.

The floor was of marble mosaic, some sort of hallucinatory pattern, and on it was strewn a profusion of Oriental rugs, also patterned, of course. Against one wall was a great paneled screen, minutely decorated by a man who, whatever else he may have been, was most certainly blind by the time his work was done. But the screen was only meant to be a background. In

front of it were a number of gigantic vases of cloisonné enamel, and the whole set piece was interspersed with a number of Italian gilt chairs. At the very center of this great cluttered space was a large, heavily upholstered and tasseled divan, intended, I suppose, as some sort of concession to comfort in the mausoleum in which it existed, sadly failing its intention.

But wait. We raise our eyes to the walls, lots of walls, and not a bare inch on one of them. And all comes clear! The whole awful place was a monument to Rossetti! I mean that quite literally, for it was at once apparent that Gabriel had made off with far more of our merchant prince's loot than I had realized. There must have been a half dozen of his alarming canvases on those walls, "Blessed Damozels" all over the place in various disguises, you know, and to top it all off at the center of one wall was G. F. Watts's portrait of Rossetti, just to make clear who was the presiding deity. Amazing!

It made me almost want to laugh. Almost, not quite. I think I've explained that I'm not jealous of Gabriel's success, and it's quite true. There would be no point in it, just as there would be no point in the color blue being jealous of the color red, or an elephant envy a whale. The elements in which we live are not the same, that's all. But what, in the name of God—or Anyone Else you may care to mention—was I doing in this hideous Victorian clutterworld? And, of course, I remembered, I knew. In Leyland's words, I was here to "suggest the right color for the hall, and in addition to paint the detail of blossom and leaf on the panels of the dado that go round the walls.

It was a memory altogether distinct in my mind and needed no prodding. The blood was as chilly in my veins as on the day I had first heard my assignment. The only difference was that the moment to act had arrived, the moment to repay, and it arrived now, exactly on cue, as only a most unimaginative stage director would have planned it. Mr. and Mrs. Leyland appeared at the top of the hideous staircase and, smiling graciously, hands outheld in welcome, came quickly toward me.

• •

Ask Whistler to paint a flower or two on the wall of your entrance hall, which happens to be filled with the grandly distributed canvases of a ninth-rate (altogether good man) hack? Well, a mistake, you know.

I have an extremely charming smile. (What's the good in denying it? My teeth are unusually white and sound, due perhaps to all that fish we ate in Russia as children, but I am only quoting others, in any case.) I smiled, I hurried to meet the Leylands halfway in their glorious entrance hall, my hand held out to meet theirs. Caesar, at least if we go by Shakespeare, was astonished to find that Brutus, who had just plunged a sword into his breast, was not his dearest friend. Even the mightiest make these little mistakes, you see.

"What a pleasure," says I, "and a revelation."

"The pleasure is ours, Mr. Whistler," said Mrs. Leyland, with the charm she possessed in such great abundance. But more of Mrs. Leyland shortly.

"Good of you to come, Whistler," says Leyland. "And what do you think of your little province now that you've had a look at it?"

"My little province?"

"This entrance hall, I meant. You'll remember it was here I particularly needed your help."

"So it was."

"I'm not altogether satisfied with the color of the walls. This color was William Morris's idea, but I'm not sure . . ."

Bad to worse, you'll notice. I hadn't even been first on the list to do the journeyman's job, only brought in to fix up Morris's botch. My ledger grew apace. I pretended to study the walls, which I think I have neglected to mention in the general shambles. They were painted a sickening mud-green color, what results if you smear all the colors on the palette together in equal parts, the bottom of the sea on a sunless day.

"Hmm . . ." says I, taking out my monocle and tapping it against my teeth in order to see as little as possible. "Morris has his inspirational uses, or so I'm told. I believe he wallpapered

some rooms in Thomas Carlyle's house in Chelsea with paper of his own design, and Carlyle went on to write *The French Revolution*. Or perhaps it was the other way around and Morris put up the wallpaper after reading *The French Revolution*, which had depressed him. Either way, what is needed as a background for all these . . . remarkable . . . these ineffable . . . these . . . well, these paintings of Rossetti's . . . is a touch of lightness, you know, set them off from their surroundings."

I was hardly listening to what I was saying, anxious as I was to get on with the real business of the day, so I was surprised to hear Leyland asking me a plain question.

"And what sort of color do you suggest?" he asked, all attention.

"Curious how it's all come to me in a flash," says I. "For the wall above the dado, I suggest a very delicate cocoa color— I'll mix the paint myself—and for the panels of the dado below for your leaf and blossom pattern, pale green for the leaf, yellow for the blossom, all rather Japanese in style, understated, calm . . ."

Mrs. Leyland laughed, bless her discerning heart, for I think she had grasped at least some hint of the inner workings of my heart. "So you see, Frederick," she said to her husband, "everything's settled. Ask a true artist what should be done and you'll get a true artist's straightforward answer, all in one sentence and all to the point. Now . . ."

"Cocoa . . ." Leyland is muttering to himself. "Yes, I think I see. Cocoa, very pale I should think, yellow and green—"

"Madeira now, Frederick," interrupted Mrs. Leyland, "cocoa later. May I take your arm, Mr. Whistler? These stairs are very grand, I'm sure, but dangerous. First you must have a glass of wine, then we shall give you the sixpenny tour. We'll absolutely overwhelm you with art. Are artists overwhelmed with other people's art? I think if I were an artist, I shouldn't be."

"Which makes you a very real artist indeed." And this lovely person took my arm. We paraded up the gaudy stairway together, Leyland tagging along behind, his mind on cocoa.

Mrs. Leyland is the only woman I can think of to whom I could stand to be married. In fact, if she hadn't already been married to Leyland at the time I painted her, we might very well be married now. She knows that as well as I know it, although of course we have never spoken of it, but it is a pleasant bond between us. She is a slender, elegant woman, dark-eyed, a charming profile, with an abundance of the quick feminine sympathy which I suppose I prize most highly in women. And we make each other laugh a lot, an absolutely first-rate qualification for marriage.

At the time I painted her Leyland was out of the city much of the time on business, and I was permitted to escort her to the opera and here and there. (Maud didn't think much of the arrangement, to tell the truth. In fact, poor Maud hadn't much use for Mrs. Leyland on still another count. Not finding exactly the right dress in Mrs. Leyland's enormous wardrobe in which I wanted to paint her, I designed one I did like. While it was being made, I went on with the head and hands until they were more or less right, but when it came time to paint the figure in the new dress Mrs. Leyland had to leave town for some reason I've forgotten and couldn't pose for me. Well, there's no good wasting time, you know, so I put the dress on Maud and painted away—the dress, that is, not Maud. For some reason Maud felt strangely humiliated by the experience, although I can't think why. I mean, I couldn't very well paint the dress without somebody inside it, now could I?)

Anyway, Mrs. Leyland and I had laughed and flirted and given each other little presents, which led me to one of the silliest acts of my otherwise dignified life. Because Mrs. Leyland was so charming, so extremely attractive to me, once when her husband came back to London for a prolonged spell I became for a while secretly engaged to her youngest sister. Yes, yes, I *know* that, illogical and so on. But then substitute brides are not altogether unknown either to literature or to life.

No, the trouble was not in the *idea* of the thing. The sister, as a matter of fact, was prettier than Mrs. Leyland. The trouble

arose from the fact that while I kept the sister in gales of merriment, she never made *me* laugh. Not even once, you know, and the thing sort of petered out.

At the head of the stairs Mrs. Leyland gave my arm a pleasant squeeze and she looked up at me, the final, the actual and ridiculous joke of the whole thing in her eyes, the joke that lies at the bottom of all pretentiousness, the prince's palace in the West End of modern London. She made two little gestures.

"Italian masterpieces to the left," she said, "English masterpieces to the right, Madeira straight ahead."

"Straight ahead every time," says I, giving her arm a bit of a squeeze back. It really is a conspicuous error for society to sanction inappropriate marriages when the principals might have done so much better elsewhere. Nothing to be done, I suppose.

So we sat and sipped our wine, the three of us, in the cozy morning room—if your idea of a cozy room is one hung floor to ceiling with Beauvais tapestries.

"How is your remarkable mother, Mr. Whistler?" asked Mrs. Leyland, peering at me over her wineglass with her great dark eyes.

"Not very well these days, I'm afraid. She's down at Hastings, you know. I suppose I should visit her more often than I do."

"Yes, you should. You owe her something after that picture. Oh, it looks like her, right enough, and it's quite marvelously painted, but it isn't *like* her. I mean, this vital . . . this vibrant woman brimming with life—"

"My dear," interrupted Leyland, "I really don't think Mr. Whistler needs the benefit of your—"

"Oh, it's quite all right," I said, and it was. Very few people can talk to me like that, but Mrs. Leyland was an exception, perhaps because she is always partly laughing at herself when she seems to be laughing at me. "But you're forgetting the picture is called an 'Arrangement in Gray and Black.'"

"Of course I am. How dull of me. In that case it doesn't matter whether it's like your mother or not, does it?"

"No, it doesn't," says I. Then, because she was still watching me with her charming curiosity, I fell right into her trap. "On the other hand, I think the picture is very like my mother."

"More of an artistic arrangement, I should think, now that you've reminded me of your purpose."

"Why, I've seen her sitting exactly like that hundreds of times," I go on, ignoring the precipice. "Perhaps at the end of a long day's work. Of course my mother is a vital woman, but nobody can be vital *all* the time." At last I stopped, too late.

She had me sitting back to front on my favorite hobby horse—*she* defending the picture as an artistic arrangement and *I* defending it as a likeness of my mother. Oh, this dreadful, delightful woman. Absolutely what's wanted, you know. We smiled across at each other, and I swear that if her wretched, intrusive husband hadn't been sitting there, it wouldn't have stopped at smiling. Well, well.

"Perhaps, Mr. Whistler," says she at last, "the picture is a little bit of both?"

"Perhaps it is, but I would admit it to no one on earth but yourself."

Leyland was getting distinctly bored by all this, his awful castle on his mind. He rose. "Perhaps . . ." says he, gesturing. And we set off on the sixpenny tour.

Well, enough of descriptions of the place; they are a bore and in any case irrelevant to my final purpose, which we were coming to sooner than even I had expected. Suffice it to say that the rest of the house was simply an extension of the entrance hall some twenty times over. What sensible comment is there finally to be made about a man who can cover his walls with his Rossettis and his Burne-Joneses and his Ford Madox Browns, hanging them side by side with no fewer than *nine* exquisite Botticellis, and not even smile, to say nothing of rolling on the floor in hysterics? There is none.

"And now," says Leyland at last, as we approached a large double door, "we come to my Whistler Room, as I call it, the dining room."

"A title I have done very little to deserve," said I modestly, following Mrs. Leyland through the door. (A word with you, *caro Principe: You* may call it your Whistler Room but *I* don't call it your Whistler Room—not yet. Ha-*ha!*)

So we stood together, I looked at the room, and they watching me look at it. And my moment had arrived.

The young decorator Henry Jeckyll, the brilliant young man Leyland had talked of so enthusiastically, had done his work well, in a manner of speaking. That is, his dining room was all of a piece with the rest of the place—dark, heavy, oppressive, with pendant gas lamps drooping from the ceiling. All along one wall on rows and rows of shelves, as an apothecary displays his herbs and nostrums, was lined up Leyland's collection of blue-and-white china. At the end of the huge room in the place of honor above the mantelpiece was my delicately beautiful "*La Princesse du Pays de la Porcelaine.*" Poor lady, my God.

Why poor lady? Well, you see, Leyland's original idea had been that my porcelain princess and his collection of china should share a room and complement each other. Well and good, and had they been alone together in an otherwise undecorated room they would have done so. But here!

When Leyland had told me the walls of his dining room were to be covered with three-hundred-year-old Cordova leather once belonging to Catherine of Aragon, the idea had sounded more or less quaint, I suppose, although my passion for leather walls is easily restrained. But I hadn't seen this abominable leather then! It was patterned, painted all over the place with pomegranates and red and yellow flowers, all but obliterating my delicate princess. The job was completed by the rug on the floor, which had a great, screeching scarlet border.

Well, now, you know, it is quite wonderful how some natural law of justice gives meaning to our actions. I had come here to seize this room like a pirate, to make it my own as an act of vengeance, a motivation some—though not I—might have found somewhat less than praiseworthy. No matter, it was my motivation no longer. Suddenly, all in the blink of an eye, my

187

act of vengeance became a virtuous, a sacred obligation, a *duty* so compelling that not to perform it would be no less than cowardly desertion on the battlefield. And exactly the same act, mark you. Amazing!

I took out my monocle and turned slowly to face my patron. "A most remarkable room," says I.

"Delighted that you think so." Leyland rubbed his hands together, absolutely gobbling up the place with his eyes. "Rather extraordinary leather."

"Extraordinary."

"I don't know whether I told you—"

"Catherine of Aragon."

"Yes. Came along with her when she arrived to be the bride of Henry the Eighth."

"Cost a thousand pounds, I believe you said."

"Oh . . . the cost is neither here nor there." Shrugging, waving away the thousand quid. "It's the richness of color of the leather that I find so gratifying, the brilliance of the flowers . . ."

"The brilliance of the pomegranates."

"Catherine's symbol, you know. When her father Ferdinand the Fifth—"

"The brilliance of the rug."

"—conquered Granada or in Spanish pomegranate . . . The rug, you say?"

"Very red rug."

"Yes, young Jeckyll thought the red border on the rug would pick up the red from the pattern on the walls."

"Young Jeckyll was right. It does. The red on the walls also picks up the red in the rug, so he was doubly right."

"Mr. Whistler . . ." Mrs. Leyland began tentatively, "I sense—please correct me if I'm wrong—a certain qualification in your praise."

"Qualification?" I said, amazed. "Why should I have any qualifications about this room? I'm sure it's precisely the room Mr. Leyland had in mind when he hired Mr. Jeckyll to design it. Everything according to plan, everybody happy."

"Are you sure there isn't something . . ."

"Oh, there *is* one trifling modification I should like to see made, hardly worth mentioning."

"And what is that?" says Leyland, all brisk attention.

"Nothing of any importance."

"No, no, I insist."

"Well . . ." I waved my monocle in the direction of the fireplace. "I should have thought it was obvious. My *'Princesse'* will have to come down, naturally."

"Come *down!*" Leyland stared at me as though I'd lost my mind. "The *'Princesse'*?"

"Well, I mean, you can't see her anyhow, can you? She'll never be missed."

"Can't see her, can't . . . *I* can see her."

"Then your eyesight is better than mine. Oh . . . I can make out a vaguely rectangular shape there over the mantelpiece, I admit it, and perhaps some bluish, pinkish scratchings at the middle, but that's about the size of it. All this blinding red . . ."

"But . . . but, Whistler," Leyland went on, in much agitation, all very gratifying, "the whole point of the room . . . I mean, this is my Whistler Room. If I take down your picture . . . well, what's to become of it?"

"Why, it becomes your Jeckyll Room, I suppose. In fact, it already *is* your Jeckyll Room once we get my *'Princesse'* out of the way. You have only to replace her with a fine raging sunset on the Grand Canal by Turner, or possibly with a Spanish bull-fight poster—something to compete with the surroundings, you know—and the job's done."

"But my whole conception . . ." Leyland began, about to have a conception, but his wife stopped him.

"Frederick," says Mrs. Leyland gently, "I think we may have to concede that Mr. Whistler has a point."

"Well, I don't know . . ."

"Not that the room isn't exquisite just as it is, as a dining room in any other circumstances. But as a frame for Mr.

189

Whistler's and our *'Princesse'*," continued this most perceptive woman and ally, "it may be a little too . . . well, bold."

"Jeckyll knew the room was to be for the picture," says Leyland. "I told him so."

"Well, Mr. Jeckyll is a different sort of artist than Mr. Whistler, that's all, Frederick, each a master in his own way." (Good God!) "The *'Princesse'* is a masterpiece—or so it seems to me although I don't pretend to know much about such things— precisely because of the delicacy of its coloring, it's subtlety . . . well, the way it speaks without shouting." (More like it, you know.)

"Be all that as it may," grumbled Leyland, quite miserable at this point, "and I'm inclined to agree now that I take a second look and think about it a bit—still, all we're doing is crying over a bottle of spilt milk, eh, Whistler?"

"Very spilt milk."

But Mrs. Leyland would have none of this sort of talk. Consciously or unconsciously she was doing my work for me, playing the devil's advocate, setting the stage for my hero's entrance. "It's not spilt milk at all," said she very positively. "It's just a matter of making some . . . adjustments. I'm certain so resourceful an artist as Mr. Whistler . . ." And so on.

Well, she kept it up for quite a while, insisting that somehow "harmony" could be brought to the room, that "peace" could be arranged between my *'Princesse'* and her surroundings. Good words, peace and harmony, my idea exactly. Of course, as everybody knows, peace is the condition that follows war, and in every war there is a victor and a vanquished. Yes. *Pax Whistlera.*

At length Mrs. Leyland stopped talking and both of them turned to me. "Well, Whistler?" said Leyland.

I didn't answer immediately, but put in my eyeglass and paced slowly about the room, like a man thinking about something. Then I appeared to have an idea.

"Perhaps . . ."

"Yes?"

"It would only be a start, of course."

"What would?"

"The red border on the rug."

"What about it?"

"I would like to cut it off."

Leyland did a bit of gasping and scowling, but not so much as you might think. A rug was, after all, only a rug and if you didn't like the way somebody chopped it up you could always buy another one. It was not desecrating a priceless work of art, like, say, painting a top hat on one of Rossetti's angels or something of that sort. Mrs. Leyland didn't even gasp. So that was all right.

"I'll attend to it myself," said I. "About the pattern on the walls . . . Well, I'll have to sleep on it."

"The leather's rather a different matter," Leyland says, frowning. "Catherine of—"

"I shall do nothing without your advance approval."

"Nothing could be fairer than that, could it, Frederick?"

"No, no, of course not, my dear. Delighted that Mr. Whistler has offered to put his mind on our problems. I was just wondering . . ."

"Yes?"

"Well, I suppose it might be a courtesy to consult Jeckyll before altering his work."

Aha! A nip in the bud needed here.

"I was under the impression that Mr. Jeckyll had finished his work," says I.

"Yes, he has. I only thought perhaps—"

"Then we must assume he has nothing more to contribute?"

"Yes . . ."

"Then it seems to me it would be most unfair of us to ask the poor chap to contribute what he hasn't got."

"Frederick, Mr. Jeckyll has gone to Scotland to do something about a castle."

Leyland looked rather relieved, the way we look when we owe some tiresome people a dinner, invite them and find they

have been previously engaged; not only do they not come to dinner, they don't even have to be asked again. "Oh, he has," says Leyland. "Then I expect we can fairly forget about him."

Yes. Let us forget about promising young Mr. Jeckyll, let us forget all about him.

On my way home I left a message for Harry Greaves telling him to meet me at my house at ten the following morning with his sailmaker's shears, which he did.

"Shouldn't have thought sailmaking was quite in your line, Mr. Whistler," said Harry, snapping at the air with the great scissors.

"No more should I, Harry. It's rugs today."

"Rugs?"

"Those shears will cut through a rug, won't they?"

"Cut through a hippopotamus front to back, I shouldn't wonder."

"Good. Just take that box of paints—there's a good chap—and we're off."

In half an hour we were all back again in Jeckyll's Folly, the Leylands taking an excited interest in the proceedings now, watching the artist at work and all that rot.

"Now then, Harry," I began, "you see the red border on the rug."

"And very pleasing to the eye, if I may say so."

"I want you to cut it off."

"Pity. I should have thought it was the best part."

"Harry! It is destroying my picture there at the end of the room!"

"Oh well, in *that* case . . ." says loyal Harry, albeit a trifle late. "We'll see who gets destroyed around here soon enough. Off with the red . . . we're not in some blinkin' fire station, you know."

And Harry attacked the rug like a personal enemy, down on all fours viciously clack-clacking away with the mighty shears, and in no time at all the red border was not only cut off

but heaved unceremoniously out into the hall and the door shut on it.

"Difference between night and day," Harry murmured to himself, "as pertaining to Mr. Whistler's picture."

"I entirely agree with Mr. Greaves," said Mrs. Leyland, laughing in her own way, half at the moment, half at some inner, private joke. "Don't you, Frederick?"

"Yes, yes, much improved, no doubt about it," says Leyland, nodding, fiddling with his watch chain.

"Well, a step in the right direction at least. Now then . . ." I was peering distastefully at the ghastly leather walls. "Harry, if you'll just fetch me that box of paints. Thank you. I'd like to change the color of a few of the red flowers, Mr. Leyland, if you have no objection. Some inconspicuous ones there by the door."

"Well, I suppose so . . ." says Leyland.

"Just to give you an idea of what I have in mind."

Now, to give Leyland an idea of what I had in mind was not precisely my battle plan. In fact, if he had known what I really had in my mind he would have fainted dead away. No, my opening strategy was based on two separate considerations. The first was the fact that the London Season was now over and in a few days the Leylands would be returning to Speke Hall, their country house near Liverpool, where they would stay throughout the summer and autumn.

The second part of my plan was simply to paint over as many of the offensive flowers and pomegranates as possible and still seem to be merely experimenting. Not to paint them in any way that might improve them, you understand. On the contrary, if I made them even vaguely acceptable my whole plan would be ruined. The idea was to render a patch of the leather so hideous that something truly drastic would have to be done to fix it up again. But that would come later—once the Leylands were safely off in Liverpool would no doubt be a good time for that development.

"I think a very pale yellow may be our answer," says I, mixing away on my palette. "Tone things down a bit."

"Oh, I think that's a splendid idea," said Mrs. Leyland.

"Ah . . . splendid." Leyland nods.

Well, it could have been a splendid idea, or at any rate not a totally disastrous idea. It all depended on the yellow. In general, there are two separate families of yellow, those with a red base and those with a green base, each capable of infinite variety, of course. The background color of the leather was a muddy orange-yellow. The yellow I mixed, and immediately applied, was its extreme opposite, a sharp, acid greenish-yellow, harsh as an unripe lemon.

The effect of one on the other was blood-curdling. At once the background leather looked not three hundred years old but a thousand, and filthy dirty at that. My yellow flowers placed on it were screaming abominations, bilious, blinding things, unimaginably vulgar. Well, just right.

I painted as fast as I could, and I must have covered a full dozen of those wretched flowers before Leyland's harumphings and throat-clearings behind me grew too loud to ignore any longer. I stepped back a few paces, squinting and cocking my head, joining my patrons in contemplation of my handiwork.

"Ah . . ." begins Leyland at last, but, too stunned to go on, he only stares.

"The . . . the contrast of colors," said Mrs. Leyland, taking her turn, "seems to me to be . . . Well . . ."

"Horrible?" says I, helpfully.

"I wouldn't . . ."

"Abominable?"

"Those are very strong words," Leyland muttered.

"That's a very strong wall," said I, laughing in my most engaging manner. "Well, even Homer nods, you know. I, for one, can't bear to look at it any longer. Before we all go blind . . ."

And, merrily, everything a good joke now, I picked up a fresh brush, put it in a dab of burnt umber on my palette and made some quick zigzags across my work. I tactfully overlooked Leyland's sharp intake of breath.

"There, that's better," I said. "I was absolutely off on the

wrong track, I admit it freely. I'm inclined to think that some of the pale turquoise from the 'Princesse' will prove much closer to the mark, but I don't mean to test it today. A bit of sober reflection is in order, I should say."

"But, Mr. Whistler," says Leyland, having got his breath back, "my wife and I are leaving London in a very few days."

"Good idea this time of year, no question about it."

"I shall be wholly occupied with business matters in the coming months. I'm launching the Leyland Line for the first time into the Atlantic trade."

"I congratulate both you and the Atlantic."

But Leyland's glance was now fixed on the mess on Catherine's leather. "This . . . this simply can't be allowed to remain."

"I most heartily agree with you."

"Then . . ."

But I cut him off. There comes a time, I have discovered, in dealing with all patrons, or customers, to use honest words, when I must straighten out relationships. A general in practice maneuvers may tolerate a degree of amiable insubordination from his various colonels and majors eager to demonstrate their abilities. At best it may prove stimulating, at worst it does no serious harm.

But on the battlefield, where the only issues are victory or defeat, life or death, the same general must become an absolute and total autocrat, the views of his colonels and majors of no more interest to him than the views of his groom. If he is not everything, he is nothing. And so it must be with the painter and his customer, or so at least it is in my own case.

I stand, invisibly, beside Nelson on top of his column in Trafalgar Square, hat askew but shoulders set in iron defiance. My way is the only way, my authority complete. Ask for equivocation, ask for artistic compromise, I don't care how small, and my good patron has to deal only with the vanishing tail of my coat.

Does such consummate arrogance really *work*? you ask. Are you not regularly hurled down flights of stairs or beaten with

cricket bats and so on? It is strange, I admit, that the answer is no.

It is simply, I suppose, that in professional matters my confidence in my own judgment is so absolute that in dealing with me people tend to doubt their own. This may sound odd coming from one who is generally regarded not only as out of step with his contemporaries but not even marching in the right parade. Yet it is so. My customers very quickly come to understand that I know exactly what I am doing and that I will do it. Art is a subject about which a surprisingly small number of people have solid opinions. Unlike politics or football, about which most people would rather die than alter a fixed opinion, art is a negotiable topic. With them, of course, not with me. Which is why I win many more battles than I lose. Ha-*ha*!

"Mr. Leyland," I said, and I was no longer his genial house painter, suggesting colors for his halls, smearing about calculated mistakes on his walls, but a middle-aged man of dignity and high seriousness, an authority, *the* authority on the business at hand, "I promise you that I will bring perfect harmony to this room. When, even precisely how, I cannot be sure. But done it will be. You must either believe that or question it. Believe it, and my time and energy are at your disposal until the job is done. Question it, and I will bid you good day, making only the simple request that my '*Princesse*' be turned to the wall."

"Thereby rendering this old world a far poorer place, if I may say so," says Harry.

Leyland heard me out, his face expressionless, his eyes never leaving mine. Now at last he smiled very faintly. "I could use you profitably in my business, Mr. Whistler," he said.

"That seems unlikely. How so?"

"Not very many men have the ability to lay down an ultimatum—take it or leave it—with such conviction. Most men are inclined to qualify ultimatums so that they are not quite ultimate. You are not one of them, I see. That inspires confidence, and I give you mine. I trust you to bring your own harmony to my room. I ask nothing more."

"Oh, you have no idea," said Mrs. Leyland to me, smiling and touching my arm, "how very nice it is to be married to a man who always makes the right decision."

Now, if she'd only been married to me she could have made the same salient observation without changing a word.

So there it was, you see. A week later (the Leylands safely packed off to Speke Hall for months to come) I stood alone in the great dining room with my own picture, my own notions and another man's handiwork. I had promised to bring harmony to the place, and there was of course only one way to set about that. The other man's work must be destroyed.

SEVEN

I HERE PROPOSE a somewhat unconventional
literary innovation for the author of an auto-
biography, which is to let somebody else write it for a while.

This is not pure laziness on my part. Rather it is a means
of escaping for a chapter the confines of first-person singular,
with its sometimes tiresome I, I, I's, for the third-person singu-
lar and its less subjective he, he, he's—someone looking from
the outside in, so to speak, rather than a man looking forever
from the inside out. Variety in all things.

But how can anybody write even one chapter of another
man's autobiography? The rules of the game are violated, the
dictionary flatly contradicted. Well, yes, but let us calmly violate
and contradict, we will almost certainly survive it, and may even
be rewarded. For it is my firm conviction, held by me for nearly
half an hour now, that in every autobiography there should be
at least one chapter written by someone other than the subject.
Just to keep him honest, you know, and not have everything his
way. Naturally, this someone must be a person who has had an
opportunity to observe his subject at very close quarters and in
circumstances of some importance.

But who is this mysterious Someone, gifted with the ex-
quisite sensitivity to enter another man's thoughts and emotions
and to report on them with all the assurance of someone report-
ing the events of a cricket match he has just watched? The
answer, of course, is No One. Although No One has at various
times masqueraded under the name of Plutarch, James Boswell
and the King James Version. So that's all right, and always
room for one more.

For my own Someone (or No One, just as you like) I choose Harry Greaves. Since this chapter concerns the creation of what was to become my famous Peacock Room, and since Harry, along with his brother Walter, acted as my assistants from start to finish, the choice seems eminently logical, possibly even inspired.

As in some, though not all, of the cases of the No Ones cited earlier, their subjects were their friends. Well, Harry Greaves is my friend, also my admirer, but no sycophant, for such a one might be accused of distorting plain truth. Walter Greaves more or less fits the same description but Harry talks more, he talks a great deal, which seems to be better to recommend him for the job at hand.

So, good Harry, write the truth of what you saw and what you heard and what you felt as we brought life to the Peacock Room, and nothing but the truth. I give you my solemn promise that I will change not so much as one of your words, not a syllable, even if they should hurt.

Here, Harry, take my somewhat blunted quill.

* * * * * * * * * *

To begin with, I and my brother Walter are not what you would call finished artists although our natural instincts since birth have always bent toward artistic tendencies. I, myself, at the age of only eight years, painted a picture of the sun setting behind Wormwood Scrubbs, to give but one example. But in the ordinary course of things Walter and I let out rowing boats to pleasure seekers on the Thames from our father's boatyard.

So the thrill for Walter and me to be summoned by Mr. Whistler to assist him in his great and glorious work, the Peacock Room, may be well left to the imagination. We dropped our oars and followed him, just as in Another Time certain Jewish Fishermen dropped their nets to follow Another Great Leader—thereby meaning absolutely no disrespect for the fine multitude of the Christian brotherhood, of whom my father is one, and who didn't think much of the idea.

The main thing about the Peacock Room is that it didn't

199

start out to be a Peacock Room at all. In the beginning the only idea was to make the room a proper setting for Mr. Whistler's fine painting of a Chinese lady holding a fan in her hand called "*La Princesse du Pays de la Porcelaine*," meaning in the original French language "The Princess from the Land of Porcelain," I believe, although why a Chinese lady should answer to a French name, I don't know. But Mr. Whistler has a vivid imagination and things got to moving in a different direction before we knew it.

On the first day when Walter and I arrived at Mr. Leyland's splendid mansion of a house in Prince's Gate we found Mr. Whistler in the dining room, stripped of his coat down to his shirt sleeves rolled up to his elbows, stirring a pail of paint with a broom handle.

"Ah, there you are, good colleagues!" he cried out when he saw us, and no doubt you will have to laugh outright at him calling Walter and me his colleagues, but Mr. Whistler is nothing if not generosity itself. Also one to have his little joke and a bit of fun. "First we must do away with all this nerve-wracking fiddle-faddle on the walls," he went on. "The very first requirement of any painter is a fresh, clean canvas. I know you both agree to that." And he handed me and Walter each a paintbrush, not an artist's brush, you understand, but a great wide house-painter's brush. "There's the paint and there's the wall," he said. "Splash it on, lads!"

The walls of the room were covered with this antique decorated leather that once belonged to Queen Catherine of Aragon and cost Leyland a thousand pounds. Now, as for me, if Mr. Whistler says do something, I do it, artistically speaking. If I can't trust Mr. Whistler, who can I trust? is my way of putting it. And I would have said the same thing about Walter, but now Walter was looking troubled.

"But . . . but, Mr. Whistler," Walter said, looking at the paintbrush in his hand, "isn't it true that there's a kind of a special historical connection about this leather? I mean . . ."

"Historical, Walter?" said Mr. Whistler slowly, putting his monocle in his eye and looking at Walter through it. "What is

not historical? A handful of earth from my kitchen garden is infinitely more historical than this leather, if age is your criterion. Stonehenge is smashingly historical, but would you like to dine there?"

"Well, I was thinking more—"

"It's the queen business that's upsetting you, Walter," Mr. Whistler said, very gently now, "and I must respect that in you as a proper Englishman. Being myself an American, a republican, some of the mystery of monarch-worship no doubt escapes me. That's only natural. But on your own terms, Walter, recognize that you on this island have had queens and queens. Take a vote among a million Englishmen, five million: Who is your favorite queen? Victoria and Elizabeth, half and half, no doubt about it, the earnest and upright for Victoria, the jolly and bloodthirsty for Elizabeth.

"Oh, perhaps a mulish Cambridge don or so would press for Queen Anne or make the most of Mary Tudor. Nothing much would come of it, you know. But who in God's name would venture to make a serious case for the primacy of Queen Catherine of Aragon? A sad, unjustly discarded lady, no doubt about it, but the same applies to so many of one's closest friends, Walter, that historical example tends to lose its majesty and only bores us. Let us not yawn as we set about making artistic history. Let us advance in joy. Just paint over the leather, there's a good chap."

And so we were off, Walter and me, on the most amazing adventure of our lives up to that point, little knowing at the time that we were going to spend the better part of the next six months in that room helping Mr. Whistler fashion what I expect is one of the most famous rooms in the world—well, in England, anyhow. But, if I may be permitted to inject a note of philosophy, the course of creating a true work of art, as in the course of true love, "Ne'er Runs Smooth!" Before it was done we'd had enough excitement of every kind to fill up a five-act drama by William Shakespeare, and that's a fact. But a place for everything and everything in its place.

In those first few days everything was calm enough. Walter

and I covered the walls of the room with the paint Mr. Whistler had mixed, a color one man might call blue and another green, and both be right, somewhere in between. Mr. Whistler was pleased with the results, as well he should have been since now his Princess picture was the main thing to catch your eye in the room, except for Mr. Leyland's china collection and you may as well forget about that. Forget about it, I say, because on the very first day Mr. Whistler had Walter and me carry the china to another room and lock it in. That was for its protection, as he explained to us, and very well protected it was as I never saw it in the dining room again.

But once we had the leather on the walls covered, all the bright flowers and pomegranates out of sight and the china tucked away, Mr. Whistler began to fret and pace up and down, back and forth, staring at the empty walls, at the plain panels and shutters and doors, almost angry at them he seemed sometimes, the way I'd seen him look at a blank canvas on his easel. He'd run his fingers over a surface for the feel of the thing, almost caressing it one minute, then the next giving it a regular whack with the back of his hand. He would sit cross-legged on the dining-room table, his monocle in his eye, his black hair with the odd white forelock up front going every which way, smoking dozens of his own cigarettes, and he would swear very quietly under his breath, staring at the empty spaces, sounding— although you would hardly believe it in so fine a gentleman as Mr. Whistler—quite like a drill sergeant in the Regulars, sometimes baring his teeth and hissing as I have heard an angry swan do on the Thames up near Hampton Court when it was being baited by stupid children.

Now, I will be frank and confess it pains me to set down the aforesaid pertaining to so great an Artist as Mr. Whistler, but I have promised to tell the truth and so I must.

We all of us have, I dare say, our own fine picture of an artist communing with his Muse and finding his Inspiration, like sitting on a hilltop at dawn and hearing in his mind some stir-

ring words of Alfred Lord Tennyson or something of that sort, which send him on to his masterpiece—I speak of English artists, of course, as I know nothing to speak of about Italians and Dutchmen and so on. Mr. Whistler is an American, naturally, through absolutely no fault of his own; no man is privileged to pick his parents, is what I say, and there's an end to it.

But for whatever reason, his communion with his Muse in search of Inspiration is more like a fist fight with some tough in a dockside pub on Saturday night than it's like any uplifting chat with Lord Tennyson, or even with some celestial Person, harp, flowing white robe and the whole lot. Walter and I have come to know the signs, so we just wait, staying rather in the background.

And we didn't have to wait very long, as it turned out. One morning, the day after the paint on the walls had dried, Mr. Whistler came into the dining room where Walter and I were waiting for him. Right away you could see that something was altogether different from the day before. From swearing and smoking and glaring and hissing, he had returned to his own very charming self—a smile and a compliment for all, his physical bearing elegant and assured, rather like a conquerer who is so sure of his conquest that he has no need to lord it over anyone.

"Good morning, my comrades," he said, shaking us both by the hand and setting his tall top hat on his taller walking stick and tilting them both against the wall. "How very thoughtful of you both to wear those quite marvelous blue shirts."

"Well, sir," Walter said, sort of pushing at his cuffs, "these are only the ordinary shirts we wear every day working around the boatyard."

"Not ordinary in the least, Walter," said Mr. Whistler. "Most subtle, in more ways than one. For yourselves, your blue shirts do great service to your excellent Saxon eyes. For me, they are a happy presentiment of things to come. We all need good auguries, don't we, however confident we may be of a battle's outcome? Inspecting warm bull's gizzards and so forth, perfectly

natural. The shirts are absolutely right today. I want to paint a harmony in blue and gold."

"A painting, Mr. Whistler?" I said, although I should have known better by that time. "I thought you meant to decorate this room."

"A painting, Harry," said Mr. Whistler, and rather dejected for a moment he was, I have to admit, "is wherever you happen to apply the paint. In this case my 'Harmony in Blue and Gold' will be this entire room."

"Well, I never," I had to say, expressing my surprise. "Sounds to me like old Michelangelo in his Sistine Chapel all over again."

"Now you're getting the idea, Harry—more or less. Only in this case my subject is to be nothing so trifling as the birth and death of mankind, but peacocks."

"I don't quite follow your artistic line of reasoning there, Mr. Whistler," said Walter, blinking a bit. And no more did I.

"Peacocks, Walter. Peacocks are nasty, vile and raucous creatures. Mr. Rossetti owns one which is the bane of our neighborhood, but it is also surely the most decorative of all God's creations, including man and the earthworm. The Orientals have long been aware of that fact and have exploited it often with brilliant results. For example, have either of you ever looked really closely at the eye of the peacock?"

"A bit on the beady end, I should have thought," I said. "Not much to choose between your peacock and your boiling chicken in that particular respect."

"No, no, no, not his *real* eye," Mr. Whistler went on, "his *metaphorical* eye. It's been called that for centuries. It's—"

"Being a bit literal today, aren't we, Harry?" said Walter, trying to make out he knew the whole thing. "Mr. Whistler wasn't referring to the peacock's *real*—"

"Well and good, Walter, " said I. "Now, suppose you tell me just what particular eye Mr. Whistler *was* referring to."

"It's the 'eye' in the peacock's tail feather, Harry," said Mr. Whistler, thereby saving Walter from what was rightly com-

ing to him. "It's a natural pattern more or less resembling a human eye, including the eyebrow if your fancy chooses, that is repeated over and over again on the tail feather. It can be used in hundreds of ways in decoration, but that's neither here nor there. . . . Peacocks are our subject, fabulous and glorious peacocks—gold ones against a blue ground, blue ones against gold and all in perfect harmony with my '*Princesse.*' Well, you know, you chaps are going to get thoroughly sick and tired of peacocks, but I'm going to need your help and need it badly."

"And you shall have it, sir!" I said, for this was even more than we'd bargained for. "To be associated in any way at all, be it ever so humble, with a Whistler creation has long been my fondest dream."

"And Harry speaks for me. I need say no more," said Walter, trying to make it up to me, you know, for being so smarty about the peacock's eye. Actually, Walter can be a bit of a toady at times, but he tries to make up for it in his way. "The way you describe it, Mr. Whistler, I shouldn't wonder if Mr. Leyland will hardly recognize the old place."

"Ah . . . I shouldn't wonder either, Walter," said Mr. Whistler, putting in his eyeglass. "But let us surprise him, shall we? The best time for Mr. Leyland to see his new dining room is when I decide he should see it."

"Oh, absolutely," said Walter.

"Not a minute before," I said. Although it didn't work out exactly like that in the end. But all that comes later.

"Good," said Mr. Whistler, rubbing his hands together in a way he has when a piece of work is about to start. "Now. You'll have noticed that to produce a 'Harmony in Blue and Gold' something is missing. Blue we've already got all over the place, so that's all right, but the gold . . ."

"I'll just fetch that on the double march," says Walter, halfway to the door. "Sealed bucket of gilt in your studio, right under—"

"*Walter!*" interrupted Mr. Whistler, stopping Walter as though he'd shot him in the back. "Walter, I'm about to paint

a 'Harmony in Blue and Gold,' not blue and *gilt*. The distinction is not unimportant, as any banker will point out to you. I want real gold in the form of the best gold leaf available in this city."

"How right you are there, Mr. Whistler," Walter said. "Don't know what I could have been thinking of. The real thing every time. Start the race with the stoutest shoes you can find and you'll have no blisters ere the course is run."

"How splendidly you put it, Walter," Mr. Whistler said. "Now that we have established quality, we must move along to quantity. I shall need an alarming quantity of gold leaf, enough to cover this entire ceiling, these bare panels, those shutters. . . ."

"It'll take a bit of brass to pay for all that gold," said Walter, making something of a mistake in the line of jokes, as is his way. Well, I mustn't be a harsh judge, having only one brother.

"Fortunately our patron is not without brass," said Mr. Whistler, taking an envelope out of his pocket. "I've just been upstairs in his study writing out this little authorization on his letter paper. I'm sure it will get us all the gold we'll need."

Well, do you know it did? To make a long story short, Walter and I had only to flash that note with Mr. Leyland's address at the top of it in front of the gold merchants and they fell all over themselves heaping hundreds of pounds' worth of gold leaf on us. I think we could have emptied the Bank of England with that note if we'd been so minded. I can only say it was a real eye-opener for me and Walter, testifying as it did to the virtues of having a reputation for high moral character and a packet of money.

So now we began to work in earnest, and earnest it was, too. Mr. Whistler set Walter and me to laying on the gold leaf, urging us to work faster and faster so that he would have the surface to do his painting on, pitching in along with us. And a wild sight we got to be, gold in our hair, gold on our faces, in our nostrils, in our ears.

Then the peacocks began to appear, great, glorious golden birds against the blue leather walls, then blue ones against the

gold, they were, their tail feathers sweeping up toward the ceiling. I don't know quite how to describe it, but Mr. Whistler seemed to go a little mad as he worked, a kind of joyous madness, it was. He got into a very frenzy, rushing around the room with his brushes and paint-spotted clothes, running up and down ladders and all the time whistling and singing, urging me and Walter on to greater efforts with the gold leaf.

The strength and energy of the man I swear I haven't seen in many dock workers. It was dawn to dusk for weeks on end, and him just as spry at nightfall as at sunrise. There was no job that couldn't be worked out somehow. When he found he couldn't quite reach certain parts of the ceiling from the top of a ladder, where he wanted to paint his design of his peacock's "eyes" around the pendant gas fixtures, he had Walter and me rig him up a hammock. That's right, a regular seaman's canvas hammock stretched tight about halfway up the height of the room. Then he got into it, flat on his back, and did the painting with a paintbrush attached to the end of a fishing pole, all the while singing those American black slave songs of his about somebody carrying him back to old Kentucky, and that sort of thing.

Then, as the weeks turned into months, a very curious thing happened there in that room, I can tell you. Almost weird, it was. Gradually it became not just a place where a famous artist was working with his two assistants but—it's a bit difficult to put this in just the right words—but a sort of party is what it became, a party without beginning or end with Mr. Whistler as host. Or to put it another way—as my father did when he dropped in one day to see when Walter and I might be coming back to the business of letting rowing boats—a blooming circus.

What I understand had happened was this. Wherever Mr. Whistler went, and he went everywhere that London society goes, in his enthusiasm and excitement he talked of nothing but his Peacock Room and invited everyone to come and see it. And, believe me, before it was over "Everyone" came. I don't just mean his artist friends and so on, although they came too. But

after them came the great swells, the sort of people with whom I frankly admit Walter and me are not on a day-to-day basis, Knights and Lords and Ladies. It became all the fashion to drop in at Prince's Gate and see how the Peacock Room was getting along. There were always tea and cakes, sherry and sweets for all in the afternoons. And always Mr. Whistler scrambling down a ladder or out of his hammock to greet his visitors, to shake them by the hand, to show them round the room, pointing out this and that detail.

"Oh," he would cry, "I am doing the loveliest thing you ever saw!" And they all agreed with him, as well they might, making him the grandest compliments. It was a gay life, I can tell you. One day I remember we even had a bit of dancing, Mr. Whistler whirling about among the paint pots with some fine ladies in silks and crinolines.

But that was not all. The newspapers got onto the whole business. First there was an article about the Peacock Room in the *Morning Post*, which got everything all wrong and Mr. Whistler had a fit about it. So, in order for the papers to understand what he was about, he had a little leaflet printed to explain it all in the proper way, and he passed them out by the dozens to the pressmen. The result was that dozens of popular articles began to appear about what was going on in the Peacock Room, not only its decoration but its social life, if that's the correct way of expressing it.

I must say that along about in here it did occur to Walter and me that if Mr. Whistler, as he had told us, intended to "surprise" Mr. Leyland with his Peacock Room, this was a rather strange way of going about it. Although of course it was not our place to say so.

There was one day, an afternoon to remember, as they say, for more reasons than one. There were already a few fashionable ladies and gentlemen in the room, chatting and refreshing themselves and watching Mr. Whistler work, when in walks a bit of your True Royalty, your Blue Blood and so on, in the persons of the Duke of Tek and the Princess Louise. Well, Mr. Whistler

had them charmed in no time, as he knows so well how to do, showing them about, making them laugh, making his enthusiasm rub off on them. Then more people arrived, and more. The conversation became very animated, which I hope is a polite way of saying loud. You could only say that Mr. Whistler was holding a regular Reception.

Walter and I were working off in a corner of the room, trying to keep out of the way, although I must confess we'd come to find a glass of champagne was not at all amiss around four o'clock when the energy tends to flag.

Now, in the midst of the general hilarity, there appeared this solitary figure in the doorway, a young gentleman I'd never seen before. He was paying not the least attention in the world to all the laughing, talking toffs, but was simply standing there holding his hat in his hand and staring about him at the room itself, at the peacocks on the walls, at the ceiling, at everything but the people. His eyes were wide as saucers and his body began to weave in an odd way from side to side so that I thought he might be ill.

"Beg pardon, sir," I said, going over to him, "but may I be of help to you in some way?"

Well, at first he only stared at me with those strange eyes as though he didn't even know if I was fish, fowl or herring, his hands trembling so that he nearly dropped his hat. Then he said, very high and piercing, "I . . . do you see, I'd heard rumours, read things about my room . . . do you see, I thought I'd better come and look for myself . . ."

"*Your* room, you say, sir?" I said, all very gently, for I didn't know what I had on my hands here, Royalty present and so forth. "I don't quite understand."

"*My* room!" he went on, and he started to flail about him this way and that with his hat while running his fingers through his hair with his other hand, very agitated. "It *was* mine . . . it *was* bloody well Jeckyll's room, damned well Jeckyll's own room!"

Then, of course, it all came back to me. I'd forgotten about

Henry Jeckyll, as indeed had everyone else in the last months, the young "comer," Mr. Leyland's discovery, you'll remember, who had spent his own months in the room, laying on the ancient leather and decorating the place to his own taste. Well, I dare say what he saw now, for all its glory, must have been a bit of a shock for the young chap, not a trace of his original work left, as you'll have gathered.

"Well, now, Mr. Jeckyll," I began, trying to calm him and show him what I must admit was only the better head on a two-headed sovereign, "there is no accounting for tastes."

But I never got anywhere with my good intentions. For just then from the other end of the room where Mr. Whistler was standing at the center of a grand group of his friends came the sudden sound of his particular laugh. "Ha-*ha!*" Only his way of rounding out a good joke, I always thought.

Mr. Jeckyll suddenly saw it otherwise, though. Without warning of any sort, taking a deep breath and bending his knees to support the tone, Mr. Jeckyll leaned back against the door and yelled, "Listen to the strident peacock laugh! Listen to the robber bird shriek in the marketplace!" There were now tears streaking down his cheeks, and there's no way to deny it. "*Peacock! Peacock, filthy, stealing peacock . . .*" And then he turned and ran, blindly, wildly, moaning and throwing his hat to land where it might, out the door.

Strange as it may seem, what with so many people in the room and everybody talking at once, even such extraordinary behavior as Mr. Jeckyll's went almost unnoticed except for those standing closest to the door. Mr. Whistler, in the middle of a story, had noticed him not at all. In a moment everything was back exactly the same as it had been.

Not the same for Mr. Jeckyll, of course. We read a small paragraph about him a few weeks later in a newspaper among the death notices. It seems that when he had left the Peacock Room that day he had gone home to his flat in Bloomsbury, where his landlady found him in the middle of the night, demented and babbling to himself, down on his hands and knees

and trying to paint the floor of his bedroom gold. They took him to a madhouse, where he died two weeks later, although the doctors said his body was sound enough, poor chap.

Naturally, I told Mr. Whistler about Mr. Jeckyll coming to the Peacock Room and later I showed him the paragraph from the newspaper.

He put his monocle in his eye and read it, then he sighed and handed it back to me. "Well, now, you know, Harry," he said, "I suppose that *is* the effect I have on some people."

But we were due for a more important caller, speaking in the way of business, than poor Mr. Jeckyll. At long last Mr. Whistler reached the point where he had about finished the Peacock Room —all except for a long panel on the wall opposite his Princess picture where he meant to persuade Mr. Leyland to hang another of his pictures in the same vein as the Princess—when Walter and I got first wind of something that had been blowing for some time past, it seemed.

One day Mr. Whistler, in one of his frequent jolly moods in these times, told the pair of us about certain letters he had been receiving all along from Mr. Leyland in Liverpool. Well, letters they were at first, but more recently they had been telegraphs with the word URGENT marked at the top. The gist of the messages, as Mr. Whistler told it to us, in a very droll account, ranged from polite inquiries in the beginning as to how long the work in the Peacock Room might possibly take, to the few telegraphic words: I URGE YOU TO FINISH, WHISTLER, AND LEAVE THE HOUSE."

Our curiosity at concert pitch, as the musical artists say, Walter and I asked him just how he had answered these particular communications, since he had seen fit to take us into his confidence.

"Well, how should I have answered him, lads?" Mr. Whistler said. "With plain truth, of course. I know no other way. I told him I was going to present him with the most beautiful room ever to be seen on this barren island, that it was going to cost

him a bit more than he possibly had in mind and I added that he was not to come to see it until I deemed the work ready to be seen. No beating about the bush, always the best way."

While this was no doubt the best way, Mr. Leyland seemed to have missed the bit about not coming to see his new dining room until he was summoned, for even as the three of us were standing there sharing a good chuckle over the matter the door opened, without any preliminary knocking or anything of that nature, and Mr. Leyland himself walked in.

He wasn't looking exactly like Father Christmas, if I make myself clear. That is to say, he stood there in the doorway still as a statue, lean and tall, no particular expression on his face, black beard, blacker eyes like shoe buttons just staring at Mr. Whistler. I don't think he even noticed me and Walter at all, although we were under his very nose.

"Whistler," he said, still standing there and making no sort of gesture, "I gather I'm fortunate in finding you so available."

Walter and I, moving somewhat crabwise so as not to become public figures, made our way to the farthest corner of the room where we began to stir up buckets of paint and pretend to pay no attention.

But we saw Mr. Whistler play out the game he had to play —although with him it's no game, but live or not live—and he played it with a drunken dockman's daring, both fists up.

"Ah, Leyland!" he said, holding out his hand and smiling in the charming way he does. "You're early, I believe. I'd hoped you'd take my advice and wait."

"I've done rather a lot of waiting," Mr. Leyland said, and he shook hands in the briefest way a person can shake hands. "Not, of course, without plenty of day-to-day information from the newspapers. No, no . . . I haven't missed, or haven't been spared, any detail of what has gone on in my house—the dances, the reception of grand people, newspaper writers issued some printed bulletin . . . I confess, sir—"

But he didn't get any further than that. Mr. Whistler put his monocle in his eye and he stared at Mr. Leyland with a look

that would turn a monkey into a penguin on a hot day, as the saying has it.

"I accept your confession," he interrupted, very coldly. "However, I must withhold absolution until you have looked at the room you're standing in. You carp about trifles. Look, *look* at this room I'm giving you!"

"I am looking at it," Leyland said, although he barely glanced around him. "While it's no doubt a handsome enough piece of decoration, I think even you might agree that it's hardly the ideal setting for a collection of blue-and-white china, which was after all the original idea."

"The china can be shown in another room. You have lots of them."

"Fortunately." Mr. Leyland clasped his hands behind his back, looking across the top of Mr. Whistler's head. "I would like you to finish your work here as soon as possible. I would like to conclude our entire transaction as soon as possible. We have never discussed your fee. Kindly name it."

"Two thousand guineas."

"That's ridiculous."

"Is it?"

"I've already paid a small fortune for half the gold leaf in London."

"I would point out that the gold is on your walls, not on mine."

"I would point out that I never asked for any gold at all. I'll agree to a thousand."

"My two assistants and I have spent six months at work in this room. A thousand guineas. . . ."

"I didn't say a thousand guineas."

"What?"

"I'll pay you a thousand pounds."

Well, Walter and I could hear the sharp intaking of Mr. Whistler's breath clear at the other end of that big room, almost like a hiss it was. Mr. Whistler may be an American but he knows England quite well enough to understand that a gentleman

is paid in guineas, a tradesman in pounds. Twenty-one shillings for the artist, twenty shillings for the greengrocer. It's not the odd shilling that makes the difference—the tradesman may earn a hundred times the number of pounds that the gentleman earns guineas, and usually does—but it's the social custom, so to speak, a rigid, unspoken rule, and Mr. Leyland was breaking the rule.

Mr. Whistler isn't the sort of man to be knocked off his balance for long, however. "Very well," he said, smiling slightly, and if I'd been Mr. Leyland I'd have started counting the spoons, "but I have a little more work to do."

"I can't think what it might be."

"That empty panel there at the far end of the room," Mr. Whistler said, pointing, "will be at the foot of your table. It will be what you as master of this house will face each time you dine in this room."

"And what do you intend to paint there?"

Mr. Whistler waved his hand vaguely. "Only some sort of extension of my general peacock theme," he said.

Leyland nodded and looked at his watch. "I must get off to Liverpool tonight, but I'll be back in London in a fortnight. You'll be quite finished with the room by then?"

"Quite finished with it."

"My check will be in tomorrow's post."

And that was the end of that. Or so it seemed to Walter and me. Half a year of a great artist's talent, time and energy used up to create something of extraordinary beauty—as all the world agreed—only to be snubbed and insulted by the man of business, who felt that his house had been made free with. I've said it was the end of the matter. Well, it wasn't.

Never in our years have I seen Mr. Whistler so calm as he was in the Peacock Room the next morning. But it was a studious calm, a sort of cold, eerie calm, if I express myself properly. The slight smile on his face was no smile at all, but only a way of controlling his lips so he'd know what they were up to and not just left to themselves.

214

At last he stood in front of the empty panel at the end of the room, brushes and palette all ready, and I don't know how to describe what happened next except as an act of mad fury. In a very short time he had sketched in the outlines of two enormous peacocks, and as they grew it didn't take a very sharp eye to see that they weren't going to be anything at all like the rest of the peacocks in the room.

The one on the left became a rather nasty-looking bird, clutching in his claws great piles of coins. In fact, the whole of his long tail seemed to be made out of coins.

"The rich peacock, Harry," Mr. Whistler said when I asked him about it, "grasping the stolen shillings of the poor peacock. The patron, in short, performing his normal function."

Then he painted the second peacock. This one was doing some sort of wild dance, feathers flying all over the place, a defiant, disdainful sort of dance it was, more cockfight than dance, really. And this one seemed to be laughing so you could almost hear it, high and haughty. Well, I didn't have to ask who *that* peacock was.

When he was finally done, Mr. Whistler painted in his butterfly signature. Then he went to the other end of the room and stood for a moment where, as he had pointed out earlier, Mr. Leyland would sit at the head of his table when he dined.

"*Bon appétit, mon patron,*" he said.

Which means, as I understand it from those in a position to know, "Eat hearty, mate" in French.

EIGHT

I THANK YOU, Harry. Your account is totally accurate, your French impeccable. You really are much better at this game than I, but as we must now concern ourselves with events of which you were not a direct observer, I must reluctantly ask for my pen back. You have used it honorably and done no end of good for my writer's cramp. Soon we must have another good midnight row on the river. Until then, Harry.

There is only one small event Harry has not mentioned, and that only because he doesn't know about it.

On the last day I worked in the Peacock Room—although I hadn't planned it to be necessarily or absolutely the last day— a rather grand Personage in society (there is no point in specifically implicating others in dubious matters) came with a small entourage to see what I was up to. This sort of thing was not uncommon, as Harry has explained, but this particular visitation turned out to have a rather different result than the others.

After admiring the dining room where I was working alone, the Personage and his friends made a brief tour of the rest of the house, then returned.

"What an extraordinary house this is, Mr. Whistler," says the Personage. "This chap Leyland would seem to have a rather erratic taste."

"Oh, well," I answered, without giving the matter much thought, "what can you expect from a *parvenu*?"

I had only just finished speaking when I happened to glance over at the door. And there I was treated to the sight of Mrs.

Leyland's back as she swept out of the dining room. (While I normally deplore the easy literary resort to ladies sweeping in and out of rooms, in this case it is fair, I think. Mrs. Leyland did indeed sweep out of the room, her elegant head held high, her back as straight and stiff as a broom handle.) Anger in that back, much hurt in that back. And I won't soon forget it. Sometimes even I don't think much of Whistler's little jokes.

But what, in reason's name, was Mrs. Leyland doing there at all? She was supposed to be in Liverpool. Why had there been no advance warning? Why had she come? How had she got in without my knowing? What kind of rotten servants . . .

Well, all rubbish, of course. The sort of rubbish one invents quite hopelessly to make bad a little better. It was her house, not mine, and one to which she quite naturally owned a door key. To humiliate her husband as a greedy peacock on his own wall had been for me a heady pleasure. But to humiliate his wife, to hurt in the smallest possible way delightful, intelligent, beautiful Mrs. Leyland, the only woman I'd ever known who laughed my language, was to put a heavy stone in my belly. One should try hard not to hurt the genuinely attractive people among one's friends, there are so few of them. And hurt breeds hurt.

The next morning I returned to the house. To do what? Oh, to put a touch here or there on the Peacock Room, I explained to myself, but in fact—and quite mysteriously—I hoped for more. Mysteriously, I say, because I know perfectly well that only a second-rate woman will hear her husband—fool or prince or both—publicly offended and tolerate the offender. I was dealing with a first-rate woman.

A butler greeted me at the door with a neat package of the odds and ends I'd left behind in the Peacock Room together with the information that there was no one at home. Nor, I gathered (butlers take special pleasure in conveying such subtle tidings without actually saying so), was there ever likely to be. Yes, the right sort of woman all the way. I never saw Mrs. Leyland again. Oh, of course I saw her, but always at a distance and we never spoke.

I have been told by some learned person that the Ancients

217

regarded peacocks as a sign of ill-omen. But one can't take seriously the superstitions of Ancients, not in these civilized times of the lighter-than-air balloon and the debtor's prison.

Well, now, you know, after the Peacock Room for a short time I led a relatively ordered life, if that is the correct euphemism. I had behind me a work of art, on the one hand, and a thousand pounds in cash in the other. Not guineas, I know, but I'd left the odd shillings on Leyland's walls, which was the greater satisfaction.

I paid off all my splendid bailiffs—young Ernest Bright, noble salad dressing and the rest—and it was a sad day for the lot of us. We all drank champagne in the garden and cursed the social system that was parting us. (We really needn't have worried; our reunion was not to be so very distant. Maud had a dozen new frocks. And I set about building myself a new house.)

If that last sounds to you a rather ambitious undertaking for a man with nothing in the world but the remains of a thousand pounds after paying his debts, a houseful of paintings nobody wants, who has just alienated his richest patron—you have a point. But so had I.

For some time it had been in the back of my mind that the only sensible way for me to earn a bit of regular money was to take students. That may seem a peculiar notion coming from someone constantly reviled by the established painters and critics. But the old established painters and critics are not students, more's the pity. The young are students. And if the young had the money to buy pictures, I would long ago have become rich and famous. The young, or at any rate some of the young, seem to have an understanding of my work. They have told me so with flattering regularity, at least, and begged me to give them some instruction.

But my house in Lindsey Row was simply a house like any other (of course it wasn't the least like any other in the matter of decoration or furnishings; I refer only to the number and

size of its rooms), and if I were to take students in any quantity likely to make it a paying proposition I needed an atelier, a practical studio of considerable size. So what could be more natural than to build a house containing one? A bit chancey, given my financial position, you say? A rather odd, not to say foolhardy, decision? Not at all.

Oh, it's true enough that in a strictly limited, commercial sense the house I built didn't quite come up to my expectations for it. For example, as luck had it, I was finally allowed to live in it for less than a year, and in that time no more than a handful of paying art students ever set foot in it, but those are details. The important fact remains that my White House in Tite Street was, and is today, one of the very most beautiful houses in London.

I designed the White House together with my good friend Edward Godwin—an architect of admirable imagination and disgraceful amatory habits—but we'll get back to him and my house after a bit. Most particularly, we'll get back to Godwin's new and beautiful young wife. For it seems always to be the totally unexpected by-product of nearly any ordinary situation that is its true reward.

Meanwhile, we must go to the opening of the Grosvenor Gallery about which Rossetti had raved so wildly those months before. You'll remember how Sir Coutts Lindsay, the rich banker who was behind the whole enterprise, was going to be the savior of modern British art and all that guff. If so, you'll remember, too, that I don't really put much faith in such things. Renaissances of any kind—so-called Golden Ages in the arts—seem so rarely to have been inspired by bankers. Oh, of course it's all very nice to have a Sforza about who is prepared to encourage a da Vinci with regular meals and a bit of pocket money, but in any such equation one must start with da Vinci, not with Sforza. Sforzas (and Sir Coutts Lindsays) abound, relatively speaking. Da Vincis do not, and therein lies the trouble, you know.

Still, one wants to help out worthy endeavors, however

mindless, if only to give them a bit of tone and alarm the upper classes as to the future of Art. Simply stated, as Sir Coutts Sforza was lacking a da Vinci among my London contemporaries for his new Grosvenor Gallery, it seemed to me the least I could do was to see that he had a few Whistlers on his walls.

So I'd sent him a couple of my Thames nocturnes, my Thomas Carlyle portrait (recently reprieved from a Chelsea pawnbroker for twenty pounds of Leyland's loot), but what proved to be a more significant matter, I sent him my "Harmony in Black and Gold"—that is, my Falling Rocket Picture, the one I'd invented at midnight on the river with the Greaves boys and the Cremorne Gardens fireworks splashing up the sky.

The famous opening of the now famous Grosvenor Gallery —how to describe it? Well, you know, I don't think it's worth the ink, because in the end it was only a rather lavish fraud. That it turned out to be the fashionable event of the season of 1877 there can be no doubt, but what does that mean? Last season's great event was the opening of a ridiculous new Italian opera at Covent Garden that even the Italians couldn't bear after a few performances; and next year it may well be only the Royal Academy show again, the most ridiculous "event" of all. So there is really nothing to describe of the event except to say that I was there, the Prince and Princess of Wales were there, as were several hundreds of others.

My keenest memory, however, has nothing to do with princes or even paintings. It has to do with a woman, one I didn't know then or even speak to that night. Now, I realize this will all sound extremely romantic and silly, very "Academy" —not my style at all—but perhaps a touch of revealing inconsistency in a character as rigidly disciplined as mine may prove endearing, who knows. However that may be, this is what happened.

I was pottering about the gallery with Prince Edward and his lady. (This was at His Highness's request. I have been told that Edward finds me amusing, but then I suppose almost any-

one would seem amusing to a man whose standard of merriment has been established at gatherings around the family hearth at Buckingham Palace with Victoria and her winning consort, so I don't get puffed up about it, you see.)

I was chattering along, pointing out some of the more spectacular lunacies in the works of my *confrères*, when I spotted this most extraordinary-looking young woman at the other end of the gallery. Slim and dark, with a natural grace and elegance, she reminded me of a younger Mrs. Leyland, with her high-bridged nose and huge deep-set eyes. She was dressed like no other woman in the room, all in their fashionable ball gowns. Her abundant hair was bound up loosely on her head with a blue velvet ribbon; she wore no corset, unlike the cast-iron-encased ladies about her, revealing the natural lines of her absolutely stunning figure beneath her plain silk gown. On her feet were flat-heeled slippers.

I believed I understood the reason for this style of dress. (And this is where the tale starts getting ludicrous from my standpoint). I had heard recently that certain dashing young London ladies had taken to affecting the dress of Burne-Jones's ladies in his awful medieval paintings. Well, here was one and she was very far from awful, but here nature had not imitated art, thank God. If she had intended to look like a Burne-Jones painting she had failed hopelessly. If Burne-Jones had been able to create her he would have been a very great painter indeed, but since he is what he is I was instantly able to sever all connection between him and the beautiful young woman at the other end of the gallery and continue my staring.

She was talking to a man whose back was toward me. He turned around, and it was Edward Godwin, my architect and friend who was about to build my White House for me. So the charming apparition must be Beatrix, Godwin's bride of a few months about whom he had talked to me much of late. Small wonder. Godwin was a delightful companion and the most imaginative architect in England; at the same time he enjoyed a well-deserved reputation as a nearly epic philanderer with women—

illegitimate children all over the place and so on—which fact had never before concerned me in the slightest one way or the other. (I myself am father to three natural children, about whom I may or may not tell you later, but you'll agree I was in an odd position to carp.) Now, most curiously, it did. It made me vaguely unhappy. Oh, nothing rational, you know, and nothing really serious, but this girl, this charming, elegant young girl, it seemed to me, somehow deserved better.

So, totally ignoring the heir apparent to the throne of England and his princess, I gawked like some moon-struck schoolboy at a stranger.

All that I've described actually took place in no more than a few seconds, of course, words being clumsier than thoughts, but enough time to realize at last that I was being made an ass of by not one Pre-Raphaelite but two. If Burne-Jones had inspired Beatrix Godwin, Rossetti had presupposed me as I was just then. Not long before Rossetti had painted a picture, to much popular acclaim, in which he showed a stricken Dante catching his first glimpse of his girlish Beatrice on a Florentine street. I had pointed out to poor Gabriel more than once that his picture was a bit of ill-executed sentimental twaddle, which he had accepted with his customary good grace.

But now, here and now, I was acting out the whole of his twaddle. I, dumbstruck Dante, mooning across a distance at an equally inaccessible Beatrice. My God, even her name was Beatrice. Well, Beatrix is surely close enough for your well-tuned ironist. I have never told Rossetti this story; it would make him too happy and encourage his painting. I am waiting until he is lying on his deathbed. Then I will tell him and he'll laugh himself back into another twenty years of life. Well, I mean, what are friends for?

As for Beatrix Godwin, it is enough to say here that she was not to remain some once glimpsed vision, as in poor old Il Purgatorio's case, but a great deal more.

The prince and princess were presently taken off my hands by Sir Coutts, who had wanted them in his all along, and I was

free to mingle with the crowd. Of these I will speak of only two: One was to become (for a time) my good friend and artistic disciple; the other was already my well-established enemy.

As my naturally sunny disposition inclines me always to set the pleasant before the unpleasant, let me first mention Oscar Wilde before I am forced to get around to John Ruskin.

Young Wilde was down from Oxford, where he was still an undergraduate, to review the Grosvenor opening for the Dublin University magazine. He was a tall, pleasant youth, most agreeable in conversation, intelligent, diffident and eager to learn something about the craft of painting. So much was immediately apparent. What was not immediately apparent in meeting Oscar Wilde was the presence of two other facts of his personality, one of which, had I been aware of it at this first meeting, would most certainly have prevented me from offering him a spontaneous invitation to my next Sunday's breakfast.

Two facts, I say. The first fact about Oscar that I didn't know was that he was a pederast, but of course that would have had nothing to do with inviting him to my breakfast. Pederasts are as welcome at my breakfast table as dukes, curates or even Pre-Raphaelite painters—so long as they are entertaining. And Oscar is one of the most entertaining men I have ever known. The whole notion of getting stuffy about how another man finds his sexual satisfaction because it may be different from one's own has always seemed to me totally inexplicable. I mean, what *difference* does it make? So long as he is civilized and entertaining. Am I to shun a good man because he prefers his stout to my champagne? It is simply that his taste buds are not my taste buds, but his taste buds are not what interest me about him.

I will confess that the preference for the backside of a Wapping stableboy to the ineffable glories of a beautiful woman's body strikes me as a calamitous error in judgment. A self-deprivation of joy quite staggering to someone like me. But then it is his deprivation, his calamity, not mine, praise Priapus, and he is welcome at my breakfast any Sunday.

So it was not that. It was the second fact about Oscar's

nature that would have denied him my invitation had I known of it on that first meeting. Whoever introduced us failed to mention that he was a pederast, but that was only a show of manners, I suppose. The other thing he failed to mention—a far graver charge—was that Oscar Wilde was a thief. It took me some years to discover that I was to be the chief victim of his theft.

Now that we've discovered the happy half of my double encounter we must get on to the less agreeable half. Encounter is the wrong word if we take it to mean a meeting and a general exchange of amenities. Indeed, I have never spoken a word to John Ruskin in my life, nor has he to me. I mean only that he stood that night in front of my Falling Rocket—tall, gaunt, wearing a tailcoat two sizes too big for him, red, mad eyes staring, scribbling notes on the back of an envelope. Ruskin has a scar on his upper lip where a dog bit him in his youth, not hard enough to quiet him, more's the pity. People stood at a respectful distance from him, honoring their God of Art practicing his profession.

What follows is in no way a digression but is most necessary to understanding what was to happen between Ruskin and me. If one doesn't know anything about John Wilkes Booth, what is one to make of his murder of Lincoln?

It is all very well to say that John Ruskin had lately been confined to his house in Denmark Hill with recurring bouts of "brain fever," whatever that is, after some unruly public episodes. For example, he has long confessed quite openly to an ungovernable addiction to autoeroticism. Only the other week, in the course of delivering a lecture on the work of J. M. W. Turner at Oxford, to the astonished delight of a lecture hall packed with undergraduates, he unbuttoned his trousers and commenced the schoolboy ritual on the platform.

Some art-loving don came to his rescue by rushing up and enveloping him in an academic robe, rather like the hasty conferring of an honorary degree, Master of Masturbation or some-

thing of that sort. So they locked him up for a while, but they always let him out again, you see, because he is The Prophet. No matter that the next day he identified a stray black cat as the anti-Christ and summoned the full resources of Scotland Yard to defend and preserve the purity of Christian England, they always let him out again.

The general public knows very little of these matters, but even if it did, it would not condemn the man, for Ruskin in England is nowadays no longer just a man but a sort of unquestioned institution, as invulnerable to criticism as beer and skittles. Even among the knowledgeable the refrain goes: "Oh, of course old Ruskin may have had an occasional rocky day of late, no denying that. But just wait for the clear day. Ah! Then he knows a hawk from a handsaw, same brilliant mind at work, etc., etc. . . ." What these kindly observers have failed to observe in their undoubted generosity is that Ruskin has not just recently become intermittently mad. He has always been mad.

John Ruskin was born rich, the only son of doting parents who encouraged his interest in art, manifested early, at least to their satisfaction, by the fact of his drawing lopsided angels in the family Bible. As a young man, being rich, he was saved the bother of practicing art, although he continued to be passionately enamored of the abstract term. So he wrote about it. O, my patient God, how he has written about it! Volumes and volumes, words stretched end to end that would girdle the globe a dozen times, until he thinks he has at last reduced his tattered subject to a science as exact as algebra.

But let us have done with mere opinion, even mine. John Ruskin, like most of us, invariably speaks best for himself. I will quote directly from his addleheaded writings.

On Veronese: "Enter now the great room with the Veronese at the end of it, for which the painter was (quite rightly) summoned before the Inquisition of State."

On Rembrandt: "Now it is evident in Rembrandt's system, while the contrasts are not more right than with Veronese, the colours are all wrong from beginning to end. Vulgarity, dullness

225

or impiety will indeed always express themselves through art in brown and gray, as in Rembrandt."

On Edward Burne-Jones: "His work, first, is simply the only art-work presently produced in England which will be received by the future as 'classic'—the best that has been or could be . . . and I *know* that these things will be immortal as the best thing the mid-nineteenth century in England could do."

On greatness in art: "The butcher's dog, in the corner of Mr. Mulready's picture, displays, perhaps, the most wonderful, because the most dignified finish and assuredly the most perfect unity of drawing and colour, which the entire range of ancient and modern art can exhibit."

Well. Yes. But that's what the bloke wrote, and now he was standing in front of my Falling Rocket.

The following is more or less by the way, I suppose, but Ruskin is worth knowing well if only for our own sanity and an understanding of what he was about to do with me.

In his early thirties John Ruskin married a lovely young Scottish girl of eighteen named Effie Gray. On their wedding night he made an alarming discovery: pubic hair. Poor Mrs. Ruskin was obliged to relate at both a civil and an ecclesiastical hearing (in order to obtain an annulment of the marriage six years after the event) how on their wedding night Ruskin had suffered his first glimpse of her naked body.

He explained to his bride, after he got his breath back, that he had never seen a female body before (he was over thirty, mark you) and that hers was not what he had been led to expect at all. He had formed his expectations of a woman's body, he said, from his observations of Greek and Roman statuary—Aphrodites and Venuses, good reputable folk like that—and *they* hadn't had this curious disfigurement. It was clear, therefore, that this pubic hair must represent a deformity peculiar to his bride alone and that the concealment of her dreadful secret until their wedding night constituted an act of dishonorable chicanery, like not telling him she had a wooden leg or something of that sort.

In any case, the sight so staggered and repelled Ruskin that he spent the next six years in a solitary bedroom. Should this anecdote strike anyone as a trifle farfetched, I may add that Effie Ruskin, as a necessary part of the annulment proceedings, was examined and found to be, in both the clinical and legal senses, intact.

But all that was long ago, and John Ruskin, almost sixty there at the Grosvenor show, was jotting down notes on my Falling Rocket with his mad trembling hand. Apparently I was to be the subject of further penetrating art criticism, right up there with Rembrandt and Veronese. Heady company. And so I was.

I must explain that for some years Ruskin had written, edited and published at his own expense a monthly periodical called *Fors Clavigera,* a catchy popular title, you'll agree, especially when you consider that the paper took the form of letters addressed to the Workmen and Laborers of Great Britain. Now, it is an odd fact that the precise meaning of *Fors Clavigera* was clear only to Mr. Ruskin. No Latin scholar myself, I asked for a translation from two eminent gentlemen who are. They disagreed. My first scholar said the words meant "Fate Carrying a Key." The second said that meant "Fate Carrying a Club." Being given a choice, I tend to go along with the club rendering.

In any event, whatever *Fors Clavigera* means it is abundantly clear that it meant nothing at all to the periodical's nominal readers, the Workmen and Laborers of Great Britain, who, of course, never read it, had in all probability never heard of it.

There is an interesting reason for this neglect, quite apart from the obvious one of Workmen and Laborers feeling rather nervous in the presence of something called *Fors Clavigera.* It is a measure of John Ruskin's touch with his times. The price he had decided on for a single copy of *Fors Clavigera* was two shillings sixpence, a half crown. Now, in the year of which I'm writing, 1877, two shillings and sixpence represented to the Workman and Laborer of Great Britain his entire average *daily*

wage. Twelve to fourteen hours of rugged manual labor, one sixth of his entire income. A pair of shoes. Thirty pints of beer at the public house.

But Ruskin deemed it a suitable price to pay to read the blatherings of his increasingly disordered mind: discussions of politics and art, morality and work, fragments of autobiography, nightmares, anything. And this when your bookish Workman and Laborer could buy a marvelous illustrated journal, filled with the most lurid tales of the very best murders around, the Oriental white-slave traffic and so forth—for a halfpenny.

It was the double arrogance of the rich man and the self-anointed prophet, you see. The rich man born simply couldn't understand that everybody didn't have an extra two shillings and sixpence; the prophet had succumbed to the delusion, common to most prophets, that his Word was now God's and cheap at twice the price:

> As who should say, "I am Sir Oracle,
> And when I ope my lips let no dog bark!"

Well, anyway, Sir Oracle wrote about my Falling Rocket, my "Nocturne in Black and Gold," in *Fors Clavigera*. The review was pointed out to me by a friend one evening a month or so later at the Arts Club. (For, naturally, *Fors Clavigera* was only *actually* read by clubmen and intellectuals).

Ruskin had devoted several columns of print to the Grosvenor show, mostly taken up with the canonization of his favorite apostle and sycophant Edward Burne-Jones, but there was still room for a couple of paragraphs about me and the Falling Rocket, on which I had placed a price of two hundred guineas. The last of them read as follows:

> For Mr. Whistler's own sake, no less than for the protection of the purchaser, Sir Coutts Lindsay ought not to have admitted works into the gallery in which the ill-educated conceit of the artist so nearly approached the aspect

of wilful imposture. I have seen, and heard, much of cockney impudence before now; but never expected to hear a coxcomb ask two hundred guineas for flinging a pot of paint in the public's face.

Well, now, you know, by this time I was practically immune to stupidity in art criticism. For years I had responded to it, in scores, possibly hundreds, of letters to critics and to the press, always lighthearted in mood—oh, possibly a trifle astringent on occasion, but that was only to amuse and to keep a man in the right size of britches—essentially good-natured, you see.

But Ruskin's little critique struck me as something rather different than what I had become accustomed to. Stupidity was one thing, a very common and tiresome thing to which Mr. Ruskin was clearly no more immune than any other art critic, but he had not left it at that. Here was venom, pure and deadly as it is stored inside the adder's head, spilled out on a printed page.

For this was not art criticism at all, stupid or otherwise. Consider again: ". . . ill-educated conceit . . . wilful imposture . . . cockney impudence . . . a coxcomb . . ." What have any of those words to do with art criticism? Nothing whatever, of course. They are an attack not on a painting, not even on a painter, but on a man. On a man, moreover, whom the attacker has never met.

I can turn aside any printed idiocy about my work with a joke. I could have turned aside even a madman's madness about my work in the same way. But when that same madman declares in public print that Jim Whistler is an ill-educated, impudent, wilful, cockney coxcomb, he is no longer dealing with a rather peculiar painter of things with inappropriate musical titles. He is dealing with Jim Whistler, West Point officer and gentleman, American citizen.

As I say, I was sitting in the Arts Club with an old friend who had shown me Ruskin's article—George Boughton, it was, whom I'd met in Paris back in the Fifties when we were students together.

Boughton waited till I'd finished reading, watching my face. At last he said, "Sounds rather like libel."

Clearheaded man, Boughton. He had spoken the right word, and it brought order to my jumbled, angry thoughts.

"Yes," says I. "And that's what I mean to find out."

Well, I found out. In a trial for my life, as it happened, But that was not to occur for nearly a year. The wheels of justice turn with conspicuous slowness, as everybody knows, and the dockets of our courts were crowded with the cases of malefactors who took precedence, at least chronologically, over even John Ruskin. Murderers and burglars and rapists and so on. But it was all set in motion by me on the following day, rather in the way the prologue in the antique Greek plays establishes a doom-ish pattern to be worked out in the later acts.

The facts are simple. I called on my solicitor, Anderson Rose, a totally cynical and pragmatic man—or lawyer in his ideal condition—who agreed to act for me. He believed I had a case and that Ruskin had no case at all. Rose saw Ruskin's lawyers, who entirely agreed with him and tried very hard to dissuade their client from appearing in court against me. Ruskin refused.

Well, that isn't entirely accurate. His "brain fever" would prevent him from appearing personally in the courtroom, he said, but his friends would appear for him in his defense. I would appear in my own. It was useless for Ruskin's lawyers to argue with him at all: He would in no circumstances settle out of court. And do you know why? One of the lawyers told me. It was because Ruskin had heard that I had once called the sun in one of Turner's paintings "a red wafer." An insufferable indignity to his hero, you know. Something to be taken really seriously. Nothing like publicly calling a professional painter an ill-educated impudent cockney coxcomb who had thrown a pot of paint in the face of the British public.

And so I went ahead, brought the formal suit. *Whistler v. Ruskin*. Charge: libel. Damages claimed: one thousand pounds.

Apart from exposing the God of Art as a malicious mad-man, I came to look forward to the impending trial as rather a lark. My case was built on solid rock. I should be able to talk as persuasively in my own defense in a court of law as I had talked in a thousand drawing rooms. And to top it all off an extra thousand pounds would come in very handy now that I was building my beautiful new White House.

Lex vincit omnia. Ha-*ha!*

NINE

\mathcal{M}Y TRIAL against Ruskin was on the docket, so that was all right. The new house was now everything. I've mentioned Edward Godwin, my raffish architect friend, and his beautiful young wife, Beatrix, the one who made such a splash at the Grosvenor Gallery opening in her dashing clothes. Now, and for nearly a year, I was to spend most of my time in their company. It was an association that was to produce, both then and later, more joy than any other I've known.

Joy? And for *Whistler?* Well, now, there's no need to take that tone, you know. I may be middle-aged and considered in some ill-informed quarters to be somewhat impatient with fools, even acidulous. I am still capable of joy. As is the carapaced lobster, for all we know.

First (although not really first, as it turned out in the long run), with Godwin I built my White House in Tite Street. Second, Beatrix Godwin became my pupil.

But seemingly first things first. As an architect Godwin shared with me the appallingly heretical notion, in these our Ruskinian times, that a house is a building for people to live in with a maximum of convenience. That is to say, a house is neither Balmoral Castle nor a Gothic cathedral in miniature; no more is it a stately mausoleum or even a museum for carved and upholstered gimcracks. Godwin and I had this odd idea that a house should be planned for those who live *inside* it rather than for those who pass *outside* it.

Inside we started with a large studio on the top floor, then on down to bedrooms, to drawing room and dining room, to kitchen in the basement. Everything where it should most con-

veniently be, windows distributed about wherever they were required, in whatever size seemed to be needed. Plain, simple, beautiful, an Arrangement in Green and White—green slate roof on top of a structure of whitewashed brick.

Naturally, when you go about placing windows and doors in an intelligent way as to their inner usefulness, from the street they will not be in the least symmetrical, as how could they be? A serious lapse, in one view but not the worst, as we were to discover.

When Godwin and I submitted his architectural drawings to the Metropolitan Board of Works—for its approval is required in order to get a license to build—we were regarded with the utmost suspicion.

"Gentlemen," says the commissioner, or whoever he was—white willie weeper side whiskers, a collar so tight and so stiff and so high that he *had* to look down his nose at you, there was no other way—"gentlemen, the Board, through me, is constrained to express its disappointment, not unmingled with regret, that two men of artistic reputations such as your own should have submitted plans for such a . . . such an inelegant house as this."

"I happen to think," I started off, "that this house will be the most elegant . . ." But Godwin was kicking my leg under the table.

"Tell us, sir," says he, "your specific objections."

"Well, one hesitates to use the word 'ugly' . . ."

"Perfectly good word." Godwin, all reasonable smiles. "But somewhat imprecise."

"This house," explains the commissioner, "would be so plain, so . . . so totally lacking in refined decorations, so simple . . ."

"Simplicity, sir," I started off again, "is the soul . . ." Another kick under the table.

"We on the Board have the responsibility to see that the tone of the neighborhood is not lowered. We must keep it up, up!"

"Quite right too," says Godwin, nodding gravely. Well,

he'd had more experience with the Metropolitan Board of Works than I'd had, and anyway I was growing bored with being kicked. "If I might borrow a pencil, sir," he went on. "Thank you."

And Godwin started to draw on our beautiful plans of the façade of the house all sorts of ghastly "decorative" moldings all over the place, around windows, above doors, along the whole length of the house just under the roofline—hideous sculptured curlicues that of course ruined the whole thing in three minutes' work.

The commissioner was a new man. He preened his side whiskers and even bent down smiling over the drawing, which was not easy to do on account of his collar. "Why, you've done it, Mr. Godwin!" says he. "Bit of elegance, bit of tone . . . hardly the same house at all, is it?"

"Hardly," I said, adroitly shifting my legs under the table.

In no time Godwin and I were outside on the street, hailing a cab, a license to build a house in my pocket. "And now what do we do?" I asked. "Just ignore all that rot you drew on the plans?"

"No, no, we can't do that, old man," says Godwin, looking at me as though I had proposed something unreasonable, "not to the Metropolitan Board of Works. We must build exactly the house in the drawings, or you won't have any house at all."

"Not those bloody awful moldings!"

"You can buy them by the yard, plaster of Paris, don't cost much, considering their virtues. Stick 'em up here and there with a dab of cement."

"Not on my house, you don't!"

"Whistler . . ." Goodwin sighed and lighted a small Spanish cigar. "Whistler, you and I are anachronisms, out of our time whether we like it or not. Some peculiar future is our time, or may be. Meanwhile, we have to deal with the Metropolitan Board of Works. Agreed?"

"I never agree. Explain yourself."

"Well, the Board has an inspector. After you've built a

house the inspector comes and inspects it, sees that you've built it exactly according to the plans, giddy moldings and all. Certificate of approval. Then he goes home."

"And then?"

"We just knock off the bloody moldings, naturally."

"You are a profound man, Godwin. How do we explain that?"

"Vandalism," says Godwin. "The work of back-to-nature Pre-Raphaelites, probably, if Scotland Yard would only do its job properly and run them down."

"And how long before the Metropolitan Board of Works makes you put the moldings back up again?"

"Eternity," says Godwin. "The appearance of the house doesn't matter, just the paper saying you have no principles. Shall we lunch at the Garrick?"

A most practical man, Edward Godwin, far more so than I, I fear. Two of Godwin's several illegitimate children are also the children of the beautiful young actress Ellen Terry, who so handsomely decorates the stage of the Lyceum these days along with Henry Irving. They will probably grow up to achieve some alarming form of success.

And so we started to build my house. And the more we built of it the more apparent it became that I would need five times the money I had in order to finish it.

In no time at all I was happily reunited with my old friends the bailiffs, but now added to their numbers was a new set of dunners—masons and carpenters and roofers—men of little faith who could not get through their heads my simple way of doing business. They wanted their money not when I had it or would get it—a proposition so patently reasonable that I should have thought it obvious to a dull schoolchild—they wanted it now when I didn't have it. They wanted it "as they went along," as they tiresomely explained, in order to buy bricks and mortar and slate and what not. Do I, when someone has commissioned a portrait from me, demand that my sitter provide me with paint, brushes and canvas before I will put in an honest

day's work? Well, exactly. Yet these cloddish workmen found my analogy for some reason imprecise.

In the end it was my old bailiffs who got my White House built, and I shall never forget them for it. One day I overheard a conversation in the partly finished house between young Ernest Bright and a surly bricklayer.

"If Mr. Whistler has promised to pay you," Bright was saying, "you'll be paid, rest your mind."

"Who says?"

"I say." (It was interesting to note the tone of Bright's voice, almost imperious it was, and quite unfamiliar to me. He was merely exercising his God-given right within our amiable society to define his class. He might be only a bailiff, but he was still a frock coat and cravat addressing a workingman's apron.) "I say it because I know it's true. You'll have your money—sooner or later."

"Better sooner than later."

"You say that because you don't understand the manner of Mr. Whistler's income. He doesn't work for wages like you and me. His income—his very considerable income, I might say— comes to him in fits and starts."

"More fits than starts," says the bricklayer, like some awful Shakespeare gravedigger.

"Only half a year ago," Bright went on, "Mr. Whistler owed a certain sum to a man employing my services, and one day Mr. Whistler said to me, "Mr. Bright, I am going off to do a bit of a work of art for Mr. Frederick Leyland, the shipping millionaire, and I'll bring us back a thousand pounds. Well, he did and that's a fact, take it or leave it."

"Better take than leave." No stopping him, apparently. "So where's the next thousand coming from?"

"That's a very good question indeed," says Bright, "and there's a straight answer waiting for you. Setting Mr. Whistler's art to one side for the moment—and only a fool sets Mr. Whistler's art to one side—there's the matter of his lawsuit against Mr. Ruskin, matter of libel."

"I read about it. Think I'm blind?"

"Well then, there's your thousand pounds."

"He ain't won it yet."

"He'll win it. Ruskin called Mr. Whistler every stripe of poaching bastard right out in black-and-white print. He'll win, wait and see."

"Better see than wait." And so on.

And so, also, a grudging faith was built and so eventually was my house. A pity I never actually painted Ernest Bright as the Young King David. He would probably have hated it, but it would have made him famous.

With my cause in such able hands, I took to staying away from the growing house during the day and only prowled its half-done rooms with a lantern after dark when the workmen had quit for the day. It was finally just a frustrating experience for me. While the White House was to become my work of art, it was still only a collaboration, and while one is forced to collaborate in the making of wars and babies, collaboration has no place in art. Beaumont and Fletcher did not write *King Lear*, nor have my friends at the Savoy Theater, Arthur Sullivan and William Gilbert, written—at least not yet—*Tristan and Isolde*. So I spent my time in the house in Lindsey Row until the White House should be entirely mine.

It was not a bad time on the whole. Debts mounted, to be sure, which kept Maud in an habitual state of fret, but that was only normal. My own serenity was soundly based. Young Ernest Bright had spoken more truly than he knew in his conversation with the witty bricklayer. Not only was Ruskin's thousand pounds as good as in my waistcoat pocket; I had in addition been promised commissions for two portraits by two fashionable folk, a husband and wife who had been dazzled by all the fuss at the time of the Peacock Room, at a price of five hundred guineas for the two.

So all was well, or would soon be well. My fashionable sitters had returned to London from their country house, settling in for the new season, and I had written them a jocular little note declaring myself to be at their immediate service and asking them

to decide between themselves which had the courage to sit to me first.

Meanwhile, a new and wholly unexpected joy came into my studio. This was young Beatrix Godwin, my architect's new wife, the stunner who had turned me into Rossetti's goggling Dante at the Grosvenor Gallery opening. She simply appeared one day and asked me to help her improve her drawing. Which I took as a compliment—unlike the hundreds of similar requests I get each year from young people who ask to come to me simply because they've heard I will amuse them—because Beatrix Godwin was already a competent book illustrator; her father, John Philip Birnie, was a famous, though disastrous, sculptor; she had grown up among artists and, consequently, took a rational view of them. Neither prophets nor riffraff, artists in Beatrix's sensible mind were only working people of greater or lesser gifts, to be judged dispassionately, some luckier than others.

Beatrix, when she turned up at my studio in Lindsey Row, could draw and use watercolor with modest competence and not much had changed when we left it. Her genius was not in her hands but in her head, in her heart and being, you see, none of which I knew there at the beginning. Anyhow, she came.

"Mr. Whistler," said Beatrix, not in the least toadying, only standing there with a face of charming curiosity, pupil to teacher, artist to artist, "my trouble seems to be thumbs."

"Thumbs are hell, Mrs. Godwin. In art they tend to the double-jointed."

"Yes. Holy Grails might be split and all that."

"Of course you can always hide them, stuff them in pockets or muffs or behind somebody's back."

"Oh, I do that whenever I can, naturally," said Beatrix, "but it won't always work. I mean, thumbs just seem to keep coming up."

"There's charcoal and paper. I'll roll one of my barbarous American cigarettes. Draw my hands, thumbs and all."

Which she did, and it wasn't too bad, thumbs a bit wobbly

but they held the cigarette. I began to point out certain small deficiencies in her little drawing and in doing so I suppose my voice took on a somewhat distracted tone. (Elementary drawing lessons are not really my joy at my sink-or-swim time of life.) At any rate, I had got out no more than two or three basic platitudes when I became aware of Beatrix's enormous dark eyes fixed on my face, eyes filled with the most extraordinary concern, almost apprehension.

"Oh!" says she, taking her drawing out of my hand and shaking her head. "I'm boring you. How awful!"

"Not at all."

"That's a very terrible thing," she went on, in perfect seriousness. "Artists should never be bored, not by anyone. It's bad for their work."

"How clever of you to know that."

"I can't be exciting, I know that, but I could make us some tea. May I?"

She had spotted my little gas ring and teapot in a corner of the studio and set to work with the secure efficiency of someone who has made a thousand pots of tea but at the same time with a charming grace of movement of someone to whom the simplest occupation is worthy of some degree of ceremony. It was somehow Oriental.

"It seems to me you can be exciting," I said. "Anyhow, you caused quite a lot of excitement at the Grosvenor Gallery opening."

She laughed, giggled really, reminding me that she was younger than she seemed. "Oh, *that*," she said. "That was mostly to tease Edward. He doesn't like Burne-Jones."

"Do you?"

"Only his ladies' clothes."

She brought the tea things and set them up on a little table between us. She found everything that was necessary without a word from me, then sat down and poured, smiling, quite as though she had spent a year, not a quarter of an hour, in my studio. The door behind Beatrix opened and Maud stood there holding a tea tray.

239

"You see, the thing is," Beatrix went on, not noticing, "I don't like wearing corsets."

"I'm late evidently," Maud said.

"Not at all," says I. "Just in time to meet Mrs. Godwin, a new pupil of mine. *Madame* . . ."

"A pleasure, Mrs. Godwin," says Maud, although it didn't look much like one.

"Oh, I'm *so* sorry I made tea first," Beatrix said. "I didn't know it was expected. But now you'll join us, won't you?"

"I never interrupt Mr. Whistler when he's working with a pupil. I'd thought he was alone." And out went Maud, tea tray and all, a trifle stiff in the back. Well, now, you know, you can't blame her. It was her house, in a manner of speaking, and she was accustomed to bringing tea at a certain time and not finding it already prepared and served by a lovely young girl in my studio. Perfectly natural.

Why, then, did I feel the first delicate zephyr of the winds of change brush against my cheek?

This was the beginning of dozens of such afternoons with Beatrix in my studio in Lindsey Row, right up to the Ruskin trial, in fact, and until my White House was finished.

They were the pleasantest of afternoons. We drew, we laughed, there was nothing more to it than that, but it was a constant joy to me to be in the company of a young person who listened (oh, well, of course everybody listens; in my house there is no alternative), but who understood, if not specifically at least intuitively, what I was about, what were my peculiar obsessions.

Only, to Beatrix, obsessions were not peculiar. They were the normal coin of any artist's normal traffic and nothing to get excited about. Unobsessed, he might even prove rather a bore. Meanwhile, there was plenty of time for tea and buttered scones, laughing and general gossip. Sometimes it was hard to remember that Beatrix Godwin was the bride of only half a year of my old friend and architect. It was, however, becoming clear that already all was not going well between them.

Being with a young person, I have said. Middle-aged pro-

fessional artists, you know, see very little of young people. It is in the nature of the game, as the rules are laid out, quite unfairly. Old people have money, young people have none, or not very often, and so in order to live I must pursue the old, or at least the not young. I myself am young—just between twenty-five and twenty-six is how I reckon it and always will—but I pretend to middle age when business requires it.

Beatrix Godwin was young—about the same age as my stated youngness—and others who began coming around my studio were also young. I thought—I suppose all of us think—of the young as people on whose shoulders tradition weighs lightly, who can shuck an old shirt for a new with pleasure, who can find new ways, better or worse, better than before. Well, it was alarming for a man with a strictly calendar age of forty-four to discover that this was not necessarily the case.

Beatrix was in my studio one afternoon. We were drawing each other, my results considerably more interesting than hers, but that should not alarm us, when a gracious bailiff announced that Mr. Oscar Wilde waited on us. I told the bailiff to send him up.

Oscar had taken to dropping in on me with increasing frequency ever since our first meeting at the Grosvenor opening, and I had found his company unfailingly rewarding.

I must speak about Oscar Wilde, or Oscar Wildes, for I have known two, two quite separate people. The later, the public Oscar, is known to everybody. The resplendent figure in dashing dress (copied from mine) standing at the center of a bedazzled group of people in a fashionable drawing room telling witty stories (retellings of mine), expounding a theory of art from public platforms (stolen in toto from me), this man was the calculated invention of the other, earlier, Oscar, via Jimmy Whistler.

It has been widely reported that, after hearing some remark or other of mine, Oscar said, "I wish I'd said that." I am supposed to have answered, "You will, Oscar, you will." I have no memory of saying anything of the kind, but if I did it would

serve as an apt summary of our relationship. If I did not, I congratulate its author for his sensitive insight into that relationship. For Oscar Wilde became a thief of quite marvelous audacity, nothing staying his pickpocket hand, a supreme highwayman laughing at humdrum justice, indeed, laughing at the gallows.

But all that was the later Oscar. The youth who was presently ushered into my studio was a different man altogether. Just down from Oxford's Magdalen College, where he had made a splendid academic record, Oscar came to London purely and simply to conquer it, but in a most engaging way. Nobody could dislike young Oscar, most found him enchanting, even I, which will perhaps give you some general measure of his charm.

I have earlier called Oscar a pederast. That was hindsight and therefore, at least concerning the incident I'm about to describe, inaccurate. Details of sexual transformations such as Oscar's fall, in the end, into the realm of gossip, a miasmic swamp at its very best. All I *know* is that young Oscar was to go on to marry a young lady of quite extraordinary mental density, father her son and for a time live a life of respectability altogether beyond reproach. Pederasty, homosexuality in general, seems to have been introduced to him rather later. By whom, in what circumstances, are only as illuminating as the teller of the story is convincing.

That Oscar chose a different life at some point—and with quite unparalleled enthusiasm—there can be no doubt. But I don't know when, nor do I think it matters. It was somewhere in him all along, no doubt, hiding, waiting, huddled in some fractious corner, waiting to appear, and appear it did. But I am now talking about twenty-two-year-old Oscar, more than twenty years younger than I, closer to Beatrix's age, two young people.

Oscar came into the studio like a great puppy of some breed that eventually grows enormous. Everything about him was big but not proportionately big, his hands and feet being a year ahead in growth of his neck, apparently, which was still so skinny that one wondered if it could actually support for any length of time his massive head on top with its mass of lank dark hair falling into his eyes.

"Oscar," I said, "I believe you've met Mrs. Godwin."

"Not only have I met Mrs. Godwin," says Oscar, who to this day cannot bring himself to say "I have" or "I haven't," "I have met Mrs. Godwin and I am hers." And he made, or attempted, an elaborate sort of eighteenth-century courtly bow in which he very nearly lost his balance. He has since refined and perfected all this.

"Hello, Mr. Wilde," said Beatrix, wiping the charcoal off her fingers. "Like a cup of tea? Or would you like to draw a picture, the way we're doing?"

"Tea," says Oscar, "tea, if you please, Mrs. Godwin. I couldn't possibly draw a picture. It would ruin my barely begun career as an art critic. It was Ruskin's only major mistake, don't you agree, Mr. Whistler?"

"Drawing? I can think of others."

"No, but I mean Ruskin drew rocks and ferns and crofters' cottages and things like that, and the trouble was they weren't either bad enough or good enough. They were just about what anybody would draw on a dull afternoon. Absolutely fatal. Artists were alerted. If they'd been awful, he could have claimed some arcane abyss between the practice and criticism of art; if they'd been wonderful . . . Well, of course, that never happens with art critics, does it? Or they wouldn't be art critics."

"Absolutely right," I said. "Ruskin's run his course, no doubt about it. He's an intellectual fossil, a landmark by which enlightenment can be measured as the archaeologists do it, the end of an age."

Oscar, most uncharacteristically, made no immediate response. Beatrix fetched us all another cup of tea .There followed what seemed to be an inexplicable silence from my two young people.

"Oh, Mr. Whistler," says Oscar, changing things around finally, "I have been to four exhibitions today and I am so bored . . . so unimaginably, so unspeakably *bored*. I may never last the season."

That was Oscar when he was a very young man. He was determined to be bored. No, that is incorrect. He was determined

to *appear* bored. He somehow associated boredom with a sophistication, with a worldly wisdom which he in not even the smallest way possessed. He was absolutely incapable of sustaining even the appearance of prolonged *ennui*.

It was enough to make a cat laugh to watch young Oscar tell you how boring life was. He said the words but nothing about the rest of him fit. His brilliant Irish eyes darted all over the place, curious about everything, missing nothing, his whole face eager, his body nearly trembling with enthusiasm and curiosity for a glimpse of what might be around the next corner. The capacity for seeking out and grasping the joyful and interesting in life was young Oscar's greatest charm. He chose to seem bored.

Oscar came to London and for more than two years, with unguarded enthusiasm, sat at my feet. And for a man who would rather talk than eat, he was remarkably quiet. He asked endless questions, to be sure, but he listened most intently to the answers. I introduced him to the great drawing rooms and showed him how to be noticed in them without causing offense; my friends became his friends and from each of them Oscar took something that was to add to the formidable edifice he was building: Oscar Wilde. From me he took a theory of art, evolved by me over a period of some thirty years, first preaching it to the world at large as his own, then later warping and corrupting it into what became known as the Aesthetic Movement, with its ghastly slogan of "Art for Art's Sake," and its effete and decadent productions.

But that was all much later. Young Oscar in my studio that day was eager, generous, inwardly exploding with enthusiasm, unknown.

"Oscar," I said, "do you know if you ever *really* got bored with life, you would die? It would kill you in a week. It's all very well to go about saying you're bored, but you must at the same time develop an aura of insincerity so that no one takes what you say altogether seriously, at least half the time. You can have

it both ways, you see. Clown or sage, no one can be sure, and you'll always have at least half a loaf, sometimes a whole. I know."

One could almost see Oscar writing on his cuff "aura of insincerity causes people to suspect profundity." He had no pencil at the moment, but it was writ in his mind. All he said was, not very earnestly, "But, James—" using for the first time, somewhat presumptuously, the name he was to call me from then on, although no one, not even my parents, had ever called me by it—"I truly *am* bored. London was to have been my Athens, but what have I found?"

"Athens, with a bit of Sparta thrown in for the fun of the thing. Make the most of it, Oscar."

"Boredom, only boredom, ashes . . ."

"Oh, shut up."

A bailiff entered the studio with a letter, the stomach-upset bailiff it was, and altogether appropriate. The letter was brief, civil and to the point. It was from the husband of the fashionable couple I mentioned earlier, the couple whose portraits I was to paint for five hundred guineas. Only it now appeared that I was not going to paint them for five hundred guineas.

No elaborate excuse was given, nobody sick or dead or called suddenly away to Mongolia. Only that "the demands upon our time, at least for the present season, are proving to be far greater than anticipated and the hours quite properly required by you for posing in your studio have become unavailable." Unstinting regret for causing any inconvenience, perhaps at some later time, and he was even my obedient servant . . . There was enclosed, however, neither a check for five hundred guineas nor a farthing.

Well, now, you know, that did not seem to me to be cricket, as my island hosts are forever pointing out to each other. The expression is without meaning for me since the only cricket match I ever attended (Rossetti dragged me) convinced me that should I attend a lifetime of cricket matches I would never know

what was cricket and what wasn't cricket. But an Englishman knows precisely what he means, and when he chooses to use the game as metaphor he means fair play. (Oddly, he never seems to use it in a positive, laudatory sense, as in, leaping from his clubman's chair: "Now that's what I call cricket!") But for all practical ignorance I knew that the letter in my hand—in this country, or in any other with some slim claim on civilization, I'd have thought—was not cricket.

It was true that I had no written agreement with my charming and fashionable clients. I wouldn't even know how to demand a written agreement, much less compose one, but there had been no need, you see. I had had this gentleman's word, and to ask written support for an English gentleman's word is much like asking the Pope to sign a paper declaring that he is an altogether trustworthy Catholic.

It struck me for the first time that this cancellation of a commission might be only the most recent, although by far the most serious, manifestation of a rather sinister pattern that had been vaguely taking shape over the past weeks and months. Nothing spectacular, you know, but a gallery which has long exhibited my work recently returned two of my canvases pleading a temporary lack of space; another gallery, where an exhibition of my etchings had been planned, informed me that the showing would regrettably have to be put off to some indefinite future date; and another two possible sitters to me for portraits —although the arrangements had not been nearly so firmly established as in the present case—had somehow just faded away without explanation.

My suspicion seemed incredible on the face of it, ridiculous. Still, a tot of reassurance would not fall on deaf ears. Fortunately, I had it at hand, or so I supposed.

I stuffed the letter in my pocket and turned back to Beatrix and Oscar, who had remained silent while I read. "I realize I'm sometimes overly inclined to detect the evil hands of my enemies fussing about in my affairs," I said to them, "but I should like to tell you a few plain facts and hear what you make of them."

"Facts, James?" says Oscar. "Personally, I prefer fiction to

fact as fiction seems invariably to lead so much more directly to the truth. But I am your guest."

"Well, I'd like to hear," says Beatrix.

"First of all, that letter I just read, without rhyme or reason but with plenty of gall, cancels two commissioned portraits. There goes five hundred guineas."

"Oh, dear, oh, dear!" Beatrix had not been brought up in a family of artists without noticing that when artists talk seriously among themselves they discuss not art but money. Much as successful bankers discuss not money but art.

"Five . . . hundred . . . guineas . . ." Oscar whispered. He didn't look at all bored. The sum didn't fit easily into his present lexicon. I dare say he was living just then on a third of the amount for a year's expenses.

"But there are other interesting facts," I went on, and I told them about the galleries and the disappearing sitters. And then I waited for their reassurance that I was imagining impossible things, taking coincidence for formal plot, seeing ghosts in broad daylight and so on.

I was amazed to see my two young friends averting their eyes from me, clearing their throats, figuratively shuffling their feet. Finally Oscar tried on a rather empty laugh.

"Well, you know, James," he said, "the old boy does have rather a long arm . . . a long reach . . ."

"What old boy?" I snapped.

"Why . . . why," Beatrix said, looking genuinely bewildered, "Mr. Ruskin, of course."

Of course. I didn't really need to be told; I had only hoped that by some extraordinary miscalculation I had been wrong. But I couldn't let it stand there. "You know that Ruskin viciously and libelously and publicly attacked me," I went on, my voice rising in an unseemly way, "everyone knows it. Everyone knows I'm about to bring him to book for it. Do you mean to tell me that people are so bedazzled by the ravings of a mad, senile, impotent, wrongheaded old man against me that they would actually withhold their patronage of my work?"

"Well . . ."

"Without even hearing my side of the story, without giving me my day in court?"

"People in England are so . . . well, so *used* to Mr. Ruskin," Beatrix said, rather weakly. "They tend to follow—"

"My lawyers assure me that legally Ruskin hasn't a leg to stand on," I interrupted.

"I'm delighted to hear it," says Oscar. "And delighted, too, that we all live in such a law-abiding country, where the legally legless are invariably awarded their just punishments."

"What I don't understand about the two of you," I thundered on, "is that you're young! It would be different if I were talking to a pair of dotty old Academicians. But you didn't grow up when Ruskin was in full cry. How can you accept what you see? You know what he is, you can see and hear what he is now."

Oscar cleared his throat and looked uncomfortable. "James," says he at length, "I beg you to notice that I haven't disagreed with you on anything essential in what you say about Ruskin. I haven't said that he isn't crazy as a hatter or vicious or libelous or senile or impotent—although that last attribute tends to muddle me somewhat as an objective art critic—I have not said above all that he isn't wrong, outrageously, benightedly wrong. He is all of that. I only said of him that he is Ruskin."

There was really not much of anywhere to go with this conversation, apparently. Lovely Beatrix Godwin made a gallant attempt to cheer me over my next hurdle.

"At least, Mr. Whistler," she said, "the great thing is you can be sure that the twelve jurymen who will bring in the verdict were all raised in a spirit of fair play for everyone. I know it's sort of a foolish-sounding thing to say, but they all played cricket."

Cricket. I am reborn.

The trial—Ruskin's trial, not mine—begins in three days.

TEN

\mathcal{M}Y SOLICITORS had long ago made it plain to me that while I had clearly been libeled by Ruskin and that they could prove as much in court, they also explained that, next in importance to my own appearance as plaintiff, would be the appearance of as many expert witnesses as I could round up who would testify in my favor. That is, men of standing and reputation who would make as strong statements *for* me as Ruskin had made *against* me. It was through such expert testimony, the solicitors assured me, that juries are most profoundly influenced. All very sensible, no doubt. And a great deal easier said than done, in the event.

Some of the most famous painters in England—there is no use being a bore and naming them all, just take my word for it— have stood beside me in my studio and told me in a variety of different ways, some generously, some reluctantly, that while I was very possibly being a quixotic fool to paint as I paint at this particular moment in history, my notions of art might well constitute a serious wave of the future.

As practicing artists these men understood perfectly well that art is, always has been and always will be an evolutionary process, and that while I was presently marching out of step there was no telling when the drummer might change his beat. Professionals, they understood this. Only an amateur like Ruskin would dare to speak of "eternal standards" when all he really meant was his own standards. The successful painters and I differed only in the fact that they sensibly followed fashion to the delight of all. I followed Whistler to the derision of the mighty. Ha-*ha!*

Now, it is quite true that these successful men have said such things to me again and again privately in my studio. To expect them—as was my innocent and naïve notion—to repeat their stated convictions in a public court of law in direct contradiction of Ruskin proved to be a gloriously tomnoddy miscalculation.

Ruskin's praise had made many of these men famous and prosperous beyond their maddest dreams. His displeasure could —and I was the living proof—bring about the reverse. In the end not one of them appeared for me in court, offering me instead a wide and imaginative list of excuses, one distinguished portrait painter even pleading a previous engagement to fight a duel in the Orkney Islands.

Finally three men came forward of their own volition and offered to serve, good men and true, to be sure, and I welcomed them, but unfortunately each man in his own way was to some extent flawed as an art expert calculated to sway a jury in my direction.

The first was Albert Moore, and if I haven't mentioned him before I should have. Moore was a highly gifted young painter just beginning to make his mark on the London scene. Sometimes he came along with the Greaves brothers and me on our nighttime rows on the Thames and afterward painted very sensitively some nocturnes of his own. His opinion of my work was simple and unequivocal, very easily stated: I was the greatest artist the world had ever seen since the first imaginative caveman scratched a picture on the wall of his cave to the present day, including anybody and everybody you might care to mention in between.

Now, this was very dear of Albert Moore and I would not be so boorish as to differ with him. The only trouble was that Moore's testimony before a jury, no matter how vigorously presented—and I knew I could count on him for vigor—would be the testimony of a painter the jury had never heard of, or if at all only vaguely. Compared to the mighty guns Ruskin could summon to his defense Albert Moore would be regarded, quite unfairly, as very light artillery indeed.

My second good man and true to step forward was William Gorman Wills, a very old friend, lover of my buckwheat cakes and charming women, amusing conversation and good painting. Wills *was* famous; the jury would recognize his name immediately. His drawback, from my present point of view, was that he was famous for the wrong reason. He had started out as a portrait painter and had achieved a certain amount of success. But his real and very large reputation has been made as a playwright, having written three of Henry Irving's greatest stage successes.

My third volunteer was William Rossetti, Gabriel's brother. Which may sound odd, as Gabriel had always been a much closer friend to me than William. Of course Gabriel couldn't be a witness for me on two perfectly logical counts. First, Ruskin had been almost single-handedly responsible for the public success of Gabriel's Pre-Raphaelite Brotherhood and was owed a debt of loyalty for that; and, second, the very idea of Gabriel getting up in a witness stand and telling the world what an admirable painter was Jimmy Whistler would have been as patently ridiculous as my doing the same thing for him. Both testaments would have been perjury of the blackest sort.

At the same time, William Rossetti was a friend of Ruskin's at least as close as he was a friend of mine. Why did he volunteer to help me? A mystery. William was probably the least talented in his prodigious family, a critical journalist with an earnest, sober mind, totally honest, who had supported the family in their darkest days by a vast variety of deadly hack work. But he was certainly under no obligation to back me against Ruskin. It occurred to me that Gabriel had put him up to it as a sort of roundabout way of helping me out without seeming to do so. I asked Gabriel about it. Here's what he told me, howling with mad Italian glee.

Sometime during the previous summer, it appeared, Gabriel had been collared one day by William Morris and Morris had talked on and on about some characters in Norse mythology, the sort of stuff that Burne-Jones was starting to paint, trying to get Gabriel interested. "Morris was all excited about a couple of citizens of Iceland or Norway or wherever," says Gabriel, "and

he wanted me to paint them. One of them was called Sigurd the Volsung, the other was called Fafner, and they were brothers. Fafner was a dragon. Well, damn it all, Jimmy, it was a hot day and I was on my way to a good lunch and maybe I spoke a little impatiently. 'Morris,' I said, 'that stuff doesn't interest me. It's too unnatural. How can you expect anyone to take a man seriously who has a dragon for a brother?' Morris thought about that for a minute, then he looked me straight in the face and hollered as loud as he could, 'I'd rather have a dragon for a brother than a bloody jackass!' Meaning my good brother William, of course.

"Naturally, I never told William, but the story got out easily enough through Morris himself, who told it to Burne-Jones, who circulated it around London, at dinners, in clubs, everywhere, which wasn't very sweet of him, you'll agree. Inevitably, the story got back to William; and that, Jim, is why you've got a Rossetti to champion you in court."

"I don't quite follow the reasoning."

"Simple as you like. At the trial Burne-Jones is going to be Ruskin's man. He *has* to be. He's been appointed or anointed or something by Ruskin, whether he likes it or not. Automatically that makes William *Whistler's* man, don't you see? On the outside William may seem to people to be a gentle sort of fellow, minding his own business, and so he is. But inside he's as Italian as all the rest of us, and he's been husbanding his secret vendetta against Burne-Jones for some time now. He should make a pretty good witness for you, Jimmy."

And so there was my little army of three defenders, somewhat tattered, perhaps, but plucky: Albert Moore, a fine painter but unknown; William Wills, well known but for the wrong reason; William Rossetti, not a painter at all, but at least a sometime art critic, on hand not to praise me particularly but to defy a hated enemy. Unto the breach!

With Ruskin the case was rather different; no, altogether different. I have mentioned that Edward Burne-Jones had been

appointed by Ruskin himself to represent him at the trial. I can't imagine that Jones particularly cherished the assignment of defending his lunatic mentor's libel of a fellow artist, but he had absolutely no choice. If Ruskin had helped Rossetti and his Pre-Raphaelites to public recognition, he had absolutely invented Burne-Jones out of the whole cloth. Indeed, in Ruskin's *Fors Clavigera* article about the Grosvenor show his libelous paragraph about me had been only one of a dozen others of wild, superlative praise of Jones's work in the show.

Now, nearly a year later, Edward Burne-Jones was the new shining knight of British art in its newest and most dramatic manifestation, Ruskin's hero and therefore Fate's and the Public's as well. (It is perhaps an interesting sidelight on this association that it was not reciprocal. Burne-Jones was famous for his adept flattery of the great and mighty, but when their backs were turned he delighted in telling stories of how crazy old Ruskin mistook a half dozen of his watercolors for oils. This too, perhaps, persuaded honest William Rossetti to appear for me against Jones.)

So there was Ruskin's first witness—more or less his counterpart on my side would have to be poor young Albert Moore, I suppose. Moore, the infinitely superior painter, pitted against the immeasurably more famous humbug.

Ruskin's witness number two was a brilliant choice, probably the choice of his crafty solicitors, since it was reported that after his appointment of Burne-Jones Ruskin had retreated once more to his bed with another attack of "brain fever," from which he could in no circumstances be disturbed to defend his libel of Whistler.

This second witness for Ruskin was to be William Powell Frith, and for strategic reasons no one better could have been chosen to shore up Ruskin's defense. He balanced things off, you see. If, for example, a juryman might have "modern" and "progressive" tastes, well, there was young Burne-Jones to explain the sins of Whistler from that point of view. If, on the other hand, another juror had not quite progressed to the "mod-

ernity" of Jones's allegorical druids and dragons and so on, well, he would have good old W. P. Frith to fall back on—upon whom he had been falling back for some forty years—to hear Whistler deplored in more homespun, understandable terms.

Let me explain about Frith. There has never been any love lost between Frith and me for reasons I will presently recount, but you must understand the man as a symbol, as the exemplar extraordinary, of an accepted view of everyday life in this time and on this island. He has never once in his painting told even the mushiest truth about that life, which has made him probably the most successful painter in England.

Queen Victoria is his greatest admirer and patroness, and has been since the early Sixties. *Noblesse oblige*, or royal parsimony, requires that she pay only 3,000 guineas for one of his canvases; less notable persons must pay 5,000 guineas.

So Frith is a millionaire over and over again and lives in a palace, which is odd, or which is perhaps not odd but must seem so in moments of introspection, if he has any, to the son of a Yorkshire butler who wandered down to London forty years ago to seek his fortune. Nothing in particular in mind, apparently. In fact, he once told some lordly gathering that at an early point in his career it had been a toss-up whether he would become an artist or an auctioneer. (I pointed out to the press at the time that he must have tossed-up. This sort of thing is probably not the most ingratiating way to win friendly witnesses.)

Frith is our century's Hogarth, with absolutely none of Hogarth's candor or moral indignation. He paints what purport to be scenes of London life, pictures of little-boy street sweepers, barefoot, ragged, begging pennies from richly dressed, respectable, bright-eyed young ladies. Only it is clear that everybody exists in the best of all possible worlds. The small boys and girls of the lower orders have virtuous expressions and wear rags as clean as newly fallen snow, smiling shyly up at their benefactors, the well-to-do ladies and gentlemen who smile back.

Frith's most famous painting is "Derby Day." Anybody standing before "Derby Day" gets his money's worth. Roughly

the size of a tennis court, it depicts not just horses, jockeys, bettors and bookmakers but children, dogs, policemen, cats, squires, fops, ladies, food vendors, carriages, footmen—and by the hundreds. There are of course no pickpockets, drunkards or whores about, as at a real Derby Day. That is why everyone in the picture is so happy, you see, unless you want to except the pretty little girl down in one corner whose dolly has been broken and who is crying real tears very prettily about it. There is a reproduction of Derby Day on the parlor wall of every second house in the land.

So there was Ruskin's second witness for his defense. Art, if that is the word I'm groping for, was represented by its practitioners—Burne-Jones if you were a nectar and ambrosia man, Frith if you were a beer and chops man. But what of the nonpractitioner "expert," the man who could judge objectively the merits of any artistic dispute from the sublimely removed position of never having been professionally obliged to draw so much as a single potted geranium? The man, that is, who is finally in the strongest position of all because he does not participate, the critic.

In any other imaginable dispute on an artistic matter of any importance, the choice of expert witness would have been unhesitating and unanimous: John Ruskin. But this particular case raised a unique problem. Ruskin was daft, to be sure, but that wouldn't have mattered. He was also the defendant, which rather took him out of the running. A replacement had been found, no Ruskin in popular reknown, but the next best thing. This was Mr. Tom Taylor, art critic of the *Times*.

Tom Taylor used to be the drama critic for the newspaper. Exactly why they changed him to art criticism I don't know, possibly because the theatrical establishment is more cohesive and organized than the artistic one and they got him booted over to attack us instead of attacking them. In any case, he was an excellent choice to appear as a witness against me.

Tom Taylor had written an almost endless series of diatribes against my work, but perhaps a general notion of his attitude

toward me may be summed up in a single quotation from the *Times*, as it refers not to any single work but to my work as a whole. "All Mr. Whistler's works are in the nature of sketching," he wrote. "It is my opinion that his paintings come only one step nearer to pictures than graduated tints on wall-paper." We will soon meet, Tom, in a court of law.

So there was our full quota of witnesses, three for me, three for Ruskin, and you will have gathered that on the face of things at least, from the public's point of view, Ruskin's forces looked a good deal more formidable than mine.

But a curious miscalculation had been allowed to occur. The rules, agreed upon by the two teams of lawyers, allowed for three witnesses on each side. Well and good, I've named them all. As Ruskin would not be appearing in his own defense, his witnesses remained at three. But what of me? Was Whistler not to be counted as a fourth witness for Whistler? He would certainly have seemed to be to me, but then I know nothing about the law and so didn't venture to point out this seeming discrepancy to anybody. Everyone kept telling me that I was the Plaintiff and Ruskin was the Defendant and Witnesses were something else again and each of us had three, so there was an end to it. I bowed to the majesty of the law. I needed all the help I could get.

It is only rarely, I should imagine, that a man is put on trial for his life without first having committed a capital crime. I refer to my life, not Ruskin's, although he was the nominal offender. What serious difference would a legal decision against him make to Ruskin? Almost none. His hypnotized public would scarcely be shaken in their idiot fidelity by a single artistic misjudgment; his payment of a thousand pounds in damages could be paid by him with no more inconvenience than an overdue tailor's bill. He would endure, causing nuisance only to those few unfortunates he mistook for Satan, and so on.

But, as distinct from Ruskin, what would happen to *me* if the jury's decision went against me? I deplore melodramatic language as much as the next man of sensibility, but events

must sometimes justify its usage. Disaster, complete and total professional ruin, would be the result for me. I had already seen, in the all too solid terms of ready brass lost, what a mere unsupported accusation from Ruskin could cost me with the timid and intimidated public. If the accusation should be formally judged in court to be a valid one—that is, that Ruskin had not libeled me—an artistic livelihood for me in England would no longer be possible. The giant's heel would have squashed the rebellious ant in its passing stride, and that would be the end of that. I would have to go back to France, where there is no Ruskin, or at least where there is no single Ruskin, but several, making Gallic Ruskinism a highly diluted game.

Well, now, you know, I had no intention of going back to France. And for the same reason that I left it twenty-odd years ago. France is a country in which ultimately only a Frenchman will ever be taken seriously. If he happens to be an artist he is permitted to be insane or incestuous or even a Protestant, just so long as he is French he is a serious artist. I am an American and disqualified, although some of my fellow students at old Gleyre's studio, the French ones, I am happy to say, are showing a bit of independence these days. *Impressionisme*, they like to say. Well and good. "Movement," a "School." *Bon Voyage*, but I am my own Movement. I planned to stay in England, my chosen battleground, because I planned to win the battle.

And how do that, noisome American wretch? Ha-*ha!* By the presence of the uncounted Fourth Witness, that poor Plaintiff in the courtroom who was only supposed to look aggrieved, briefly state his complaint and let his barrister look out for his interests.

I was intending to even the odds, you see, with that extra witness—name of Jimmy Whistler.

ELEVEN

I DON'T KNOW whether it is just a peculiar
failing of my own or whether it is more wide-
spread, but I have always had difficulty in following the exact
course of a trial, in fact or in fiction, simply by reading an
account of it. There are so many people to keep straight: judge,
lawyers, witnesses, jurymen, clerks and so on, names, names
that I tend to have to keep turning back to rediscover who is
who. Apart from attending an actual trial, by far the best way
to follow one is on the stage, of course.

The actor sitting high on the bench in robe and wig is obvi-
ously the judge; who else could he be, never mind his name?
The similarly got-up actors before him are counsel, representing
either the accuser or the accused; fat and ugly if they represent
accusers (I am still speaking of the theater), lean and clear-eyed
if they represent the accused. Witnesses are plainly identified as
for or against according to where they sit in the courtroom, and
all is well.

Unfortunately, the trial I'm about to describe must be
described in words alone, without the stage's recourse to the
nasty tone in a barrister's voice or the lifted eyebrow of judge
to jury. But we will manage. I mean, in fact, simply to tell the
whole thing as though it *were* a stage play. That is to say,
primarily in dialogue (precisely as it was uttered in the court-
room), with an occasional parenthesized stage direction for the
sake of clarity.

Only one deviation from the play form seems to me to be
necessary, and that will take the form of some trifling running
comment on the proceedings by the plaintiff-observer, myself.

This comment will not, of course, be in any way intended to influence unbiased judgment. But it may prove necessary—very rarely, one hopes—only to set a scene, offer a word of background, clarify a relationship, etc. A trial that was to last two full days, as anybody knows who has attended even the most dramatic of trials, would normally produce its share of dross, legalistic, formalistic, apparently necessary dross for some mysterious record, and that I have eliminated for the good of everyone's soul. The rest is plain truth.

Watch the rules and everything should be—at least as I begin—as clear as a play with actors to watch. Anything *I* may have to say will appear within brackets—"[]"—so there will be no mistake or confusion about that. I will set the stage.

DATE: Monday, November 25, 1878
PLACE: Court of Exchequer Division at Westminster

[*My paintings were to be shown in this courtroom in evidence. Ill-lit and musty, the place was as suitable for showing paintings as the crypt of Canterbury Cathedral.*]

THE ACTION: Whistler *versus* Ruskin. Mr. James McNeill Whistler claims one thousand pounds for the damage done by Mr. John Ruskin to his reputation as an artist.
JUDGE: Baron Huddleston.
JURY: A special jury selected by the judge.

[*I didn't know, and never found out, just what was "special" about this jury. Twelve oafs of varying sizes, pure in heart, no doubt, and as fit to judge an artist and his work as any other twelve oafs, as I was to discover.*]

COUNSEL FOR RUSKIN: Sir John Holker (the Attorney-General) and Mr. Bowen.
COUNSEL FOR WHISTLER: Mr. Sergeant Parry and Mr. Petheram.
WITNESSES FOR RUSKIN: Edward Burne-Jones, William Powell Frith and Tom Taylor.
WITNESSES FOR WHISTLER: William Rossetti, Albert Moore and William Gorman Wills.

[*The courtroom was packed to the rafters and scores of people, I was told, had been turned away for lack of space. The learned counsel and their assistants sat at tables up front; behind them were the members of the press both domestic and foreign—the United States being represented by young Mr. Henry James covering the trial for* The Nation—*and behind them was the general public, or that section of it that could be squeezed in. The term "general public" is perhaps misleading in this instance, if by general one means the first fifty people one might encounter on the street. No, these were a rather different fifty people. The date of the trial having been announced some time before, it had clearly become the fashionable event of the moment. The spectators were, on the whole, much the same people one would have expected to encounter at a first night at the Lyceum or at Covent Garden when a favorite ballerina was scheduled to perform. As it was morning instead of evening they had come to a courtroom rather than a theater for their entertainment, and I was intended to be their star performer. Fashionably dressed, smiling in anticipation, they sat chatting, waiting for the show to begin. Many of them had been guests at my Sunday breakfasts and I had entertained them then, had I not? Well then, Jimmy in a court of law taking on the Prophet of Art for a thousand pounds should be worth twice as many laughs, shouldn't he? Perfectly logical.*

Mr. Sergeant Parry opened the case for me as plaintiff. Parry had a high reputation as a barrister, and a very expensive one, but if all went well it would not be I but Ruskin who would pay his fee. Parry also took a good deal of pleasure in hearing himself talk, or so it seemed to me, but then courtrooms are not drawing rooms and I bow to experience in all things. Still, I will edit Mr. Sergeant Parry when he gets too long-winded—always indicating that I'm doing so. I will also interrupt.]

MR. SERGEANT PARRY: I speak for Mr. Whistler, who has followed the profession of an artist for many years. Mr. Ruskin is a gentleman well known to all of us, and holding perhaps the highest position in Europe and America as an art critic. Some of his works are destined to immortality. . . . [*Come off it, Parry, whose side are you on?*], and it is the more surprising, therefore, that a gentleman, holding such a position, could traduce another in a way that would lead that other to come into a court of law to ask for damages. The jury, after hearing the case, will come to the conclusion that a great injustice has been done. [*More like it, you know.*]

Mr. Whistler, in the United States, has earned a reputation as a painter and an artist. He is not merely a painter, but has likewise distinguished himself in the capacity of etcher, achieving considerable honours in that department of art. He has been an unwearied worker in his profession, always desiring to succeed, and if he had formed an erroneous opinion, he should not have been treated with contempt and ridicule.

Mr. Ruskin edits a publication called *Fors Clavigera* that has a large circulation among artists and art patrons. In the July number of 1877 appeared a criticism of the pictures in the Grosvenor, containing the paragraph which is the defamatory matter complained of. . . .

[Parry went on to read it—"ill-educated conceit of the artist . . . wilful imposture . . . cockney impudence . . . a coxcomb asking two hundred guineas for flinging a pot of paint . . ." And so on, the whole vile libel, and it was good for my spirits to hear it again. What the jurymen made of it there was no telling. Each man seemed to feel it his duty as a true, impartial Englishman not to allow the smallest flicker of intelligence to cross his face. They might have been dead men, the lot of them. Parry went on to conclude his opening, not bad, not particularly good, a bit dull, but

261

not without its purpose. He was clearing the stage for me, his client, who was scheduled as first witness for the prosecution.]

MR. SERGEANT PARRY: Mr. Ruskin pleads that the alleged libel was privileged, as being a fair and *bona fide* criticism upon a painting which the plaintiff had exposed to public view. But the terms in which Mr. Ruskin has spoken of the plaintiff are unfair and ungentlemanly [*It will be salutory for all of us to remember that to drive a casual poignard into another's belly, while slitting his purse en route, is ungentlemanly*] and are calculated to, and have done him, considerable injury, and it will be for the jury to say what damages the plaintiff is entitled to.

[*Parry sat down and I was called as my own witness, only, or so I had been told, to identify myself professionally. As this was deemed a minor matter, I was questioned by Parry's assistant, Mr. Petheram. I had made a point of looking grand in a subdued sort of way, dressed in a double-breasted dark blue suit and cautious cravat. But it struck me that things were getting a bit too proper, possibly enervating the high spirits of our fashionable spectators. It seemed to me to be my responsibility to brighten things up a bit. Mr. Petheram asked me to tell the jury who I was.*]

WHISTLER: My name is James McNeill Whistler. I am an artist, and was born in St. Petersburg. I lived in that city for twelve or fourteen years. . . .

[*Two cracking good lies in my first two sentences, you see. People must be made to pay attention. But I knew that sooner or later I would have to play the pander for a moment, before I could afford to be myself. An English jury could only be expected to take me seriously if I could establish credentials they would recognize—names, institutions, prices, etc. I had been called ill-educated, so I plodded on into a recital of odds and ends that very nearly put me to sleep. But it was necessary, most necessary in this land—*]

like most others, to be truthful—where merit is established by association.]

WHISTLER: I studied in Paris with du Maurier, Poynter, Armstrong. I was awarded a gold medal at The Hague. I have exhibited at the Royal Academy. My etchings are in the British Museum and Windsor Castle collections. I exhibited eight pictures at the Grosvenor Gallery in the summer of 1877. Some were what I choose to describe as nocturnes, including a "Nocturne in Black and Gold"—the Falling Rocket. Others belonged to the Honorable Mrs. Percy Wyndham and to Mrs. Frederick Leyland. In addition there was an "Arrangement in Black"—Henry Irving as Philip II of Spain and a portrait of Mr. Thomas Carlyle, done from sittings Mr. Carlyle gave me.

[*Get in all the grand names, you know. Nothing so calculated to win over a butcher-juryman to my side as to toss about Carlyle and Irving. Any painter to whom Carlyle and Irving will willingly sit can't be all swine, else the Empire would collapse.*]

WHISTLER: The nocturnes, all but two, were sold before they went to the Grosvenor Gallery. One of them was sold to the Honorable Percy Wyndham for two hundred guineas. The only one that was for sale was "Black and Gold"—the Falling Rocket.

[*Also for two hundred guineas, the statistic that had so alarmed Mr. Ruskin. But the courtroom was growing restive and I could scarcely blame it. It worried me, all the same. I am accustomed to strict attention when I talk. It was a relief to get this whole credentials business out of the way and to hear Petheram start to get down to brass tacks.*]

MR. PETHERAM: Tell me, Mr. Whistler, since the publication of Mr. Ruskin's criticism, have you sold a nocturne?

WHISTLER: Not by any means at the same price as before.

MR. PETHERAM: What is your definition of a nocturne?

263

WHISTLER: I have perhaps meant rather to indicate an artistic interest alone in the work, divesting the picture from any outside anecdotal sort of interest which might have been otherwise attached to it. It is an arrangement of line, form and color first; and I make use of any incident of it which shall bring about a symmetrical result. Among my works are some night pieces, and I have chosen the word nocturne because it generalizes and simplifies the whole set of them.

[*Then Petheram, the ass, didn't pursue the topic of my loss of income since Ruskin's howl—the retracted commissions and so on. Parry had told me that such evidence was inadmissible in court because there was no way to prove a relevant connection between the two happenings. Well, I meant the jury to hear the whole story somehow or other, but for the moment the matter could wait.*

Meanwhile, somebody decided that the time had come to show the jury a bit of Whistler's work. Two or three nocturnes were carted in, along with the Carlyle and Irving portraits, and set up in the stygian gloom. Special attention was given to "Black and Gold"—the Falling Rocket. Carefully it was placed on an easel before the jury, upside down. I demurred gently and the wrong was righted. Some of the spectators, I am sorry to say, found the episode amusing. I am all for amusing the public, but at their expense, not mine.

I was turned over to the Attorney-General, Sir John Holker, for cross-examination. You must see the Attorney-General, as I saw him, to understand his great success with juries. He was a big man in all dimensions, tall, stout, his robes of office rather rumpled, his curled white wig a trifle askew as though it had been dropped from the sky onto his head where it sat without further adjustment. His role in court, you see, was a very clever one: that of a plain, blunt man, a good Englishman who pretended no special attributes other than simple good sense. Forget that he was a

264

*baronet, a rich, landed gentleman, he seemed to say. He was
really only another humble juryman, the thirteenth common
juror just like the rest. What did they all want? Justice, plain
and simple, neither more nor less. Naturally none of them,
the Attorney-General or the jurymen, pretended to know
much about art, that was understood. Art was what those
other odd people, like the bloke on the witness stand, oc-
cupied their time with. But we must be fair, fellow English-
men, even to the odd ones, for that is our tradition. Bend
over backwards if necessary in order to see that even luna-
tics get their fair day in court, don't you agree, Alf? Quite
right, sir, quite as it should be, sir, and after all's said and
done we'll all have a pint together in the local public house
and drink to justice.*

*Sir John Holker, Attorney-General, smiled a good deal,
a kindly ingenuous smile, the smile of a puzzled seeker after
truth. He was to be, I saw, in ten seconds, my most dan-
gerous enemy.*]

ATTORNEY-GENERAL: Mr. Whistler, you have sent pictures to the
Academy which have not been received?

WHISTLER: I believe that is the experience of all artists.

ATTORNEY-GENERAL: What is the subject of the "Nocturne in
Black and Gold"?

WHISTLER: It is a night piece, and represents the fireworks at
Cremorne.

ATTORNEY-GENERAL: Not a view of Cremorne?

WHISTLER: If it were called a view of Cremorne, it would cer-
tainly bring about nothing but disappointment on the part
of the beholders: [*Laughter*] It is an artistic arrangement. It
was marked two hundred guineas.

ATTORNEY-GENERAL: Is two hundred guineas a pretty good
price for a picture by an artist of reputation?

WHISTLER: Yes.

ATTORNEY-GENERAL: Is not that what we, who are not artists,
would call a stiffish price?

WHISTLER: I think it very likely that that may be so. [*Laughter*]

ATTORNEY-GENERAL: But artists always give good value for their money, don't they?

WHISTLER: I am glad to hear that so well established. [*Laughter*]

[*I was beginning to feel my way at last, and the sound of laughter did me good, but I had to be careful to mark where the laughter was coming from. So far it had come from our fashionable audience, which was pleasant, but in concrete terms, meaningless. The jury had remained as stoical as ever, which was different. It was those twelve men who counted, and they were clearly not laughers. I must be more grave. Unfortunately, when I am at my most serious, gravity eludes me. However, I tried.*]

WHISTLER: All these works are impressions of my own. I make them my study. I suppose them to appeal to none but those who may understand the technical matter. Now, I do not know Mr. Ruskin, or that he holds the view that a picture should only be exhibited when nothing can be done to improve it, but that is a correct view. The "Nocturne in Black and Gold," the Falling Rocket, was a finished picture. I didn't intend to do anything more to it.

ATTORNEY-GENERAL: I suppose you are willing to admit that your pictures exhibit some eccentricities? You have been told that over and over again?

WHISTLER: Yes, very often. [*Laughter*]

ATTORNEY-GENERAL: You sent them to the Gallery to invite the admiration of the public?

WHISTLER: That would be such a vast absurdity on my part that I don't think I could. [*Laughter*]

ATTORNEY-GENERAL: Now, Mr. Whistler. Can you tell me how long it took you to knock off this nocturne?

WHISTLER: I beg your pardon?

ATTORNEY-GENERAL: I'm afraid I was using a term that applies rather to my own work. [*Laughter*] I should have said, "How long did you take to paint that picture?"

WHISTLER: Oh, no! Permit me, I am too greatly flattered to

think that you apply, to a work of mine, any term that you are in the habit of using with reference to your own. Let us say then how long did I take to—"knock off," I think that's it—to knock off that nocturne. Well, as I remember it, about a day.

ATTORNEY-GENERAL: Only a day?

WHISTLER: Well, I won't be quite positive. I may have still put a few more touches to it the next day if the painting were not dry. I had better say, then, that I was two days at work on it.

ATTORNEY-GENERAL: Oh, two days! The labor of two days, then, is that for which you ask two hundred guineas!

WHISTLER: No. I ask it for the knowledge of a lifetime. [*Applause*]

[*Yes, there was genuine and spontaneous applause, something even I hadn't ventured to imagine. And the warm reaction—although of course not the indiscretion of applause—came from the jurymen as well as the spectators. Some smiled, some nodded approval. I had happened to give a workingman's answer to a workingman's question, you see, one that applied as well to a carpenter's trade as to my own, and he understood it.*

Baron Huddleston, the judge, whose calling had never required him to work with his hands, didn't think much of the whole thing. He rapped sharply on his bench.]

THE JUDGE: I must warn that if any such manifestation of feeling is repeated I will be obliged to clear the court. Proceed, Sir John.

ATTORNEY-GENERAL: You don't approve of criticism, then?

[*Now here we were at last at the crux of the whole matter. It was finally an intellectual point, of course, and would probably be lost, but by this time I had the concentrated attention of the courtroom and I had to grasp it.*]

WHISTLER: I should not disapprove in any way of technical criticism by a man whose whole life is passed in the prac-

tice of the science which he criticizes. But for the opinion of a man whose life is not so passed I would have as little regard as you would, if he expressed an opinion on the law.

ATTORNEY-GENERAL: You expect to be criticized?

WHISTLER: Yes, certainly. And I do not expect to be affected by it, until it becomes a case of this kind. It is not only when criticism is inimical that I object to it, but when it is incompetent. I hold that none but an artist can be a competent critic.

ATTORNEY-GENERAL: Mr. Whistler, you put your pictures up on the garden wall, or hang them on the clothesline, don't you to mellow?

WHISTLER: I don't understand.

ATTORNEY-GENERAL: Do you not put your paintings out into the garden?

WHISTLER: Oh, I understand now! I thought at first that you were perhaps using a term that you are accustomed to yourself. Yes, I certainly do put the canvases into the garden so that they may dry in the open air while I'm painting. But I should be very sorry to see them "mellowed."

ATTORNEY-GENERAL: Why do you call Mr. Irving an "Arrangement In Black"? [*Laughter*]

THE JUDGE: It is the picture, Sir John, and not Mr. Irving that is the arrangement. [*Laughter*]

[*I have a champion. At least for a minute.*]

I should like to say that a critic must indeed be competent to form an opinion, and he must also be bold enough to express that opinion in strong terms if necessary.

[*My "Nocturne in Blue and Silver" was then introduced for the edification of all. It was painted after a night on the Thames with the Greaves brothers. We had lingered for a time near Battersea Bridge, looking back at it, the moonlight behind us. Cross-examination continued.*]

ATTORNEY-GENERAL: What is the subject of this picture?

WHISTLER: A moonlight effect on the river near old Battersea Bridge.

[*Now the judge decided to take a hand in the game.*]

THE JUDGE: Which part of the picture is the bridge? [*Laughter*]

[*Baron Huddleston here very earnestly rebuked those who laughed, but there was somehow left in my anxious ear an overtone—faint indeed—of mockery in his rebuke. It was so earnest that it seemed almost to invite more levity. There is in England a carefully nurtured, popular tradition of the "witty magistrate," a judge of presumed high learning, total judicial impartiality and so on, who nevertheless is able to leaven the gravity of the proceedings before him with a pinch of wit, a solemn joke dropped here and there. It briefly crossed my mind that I had drawn such a one in Huddleston. Devoutly I hoped I was mistaken. People who use wit to amuse an audience—as I knew as a sometime practitioner—can in serious matters occasionally skimp justice for laughter. I couldn't be sure about Huddleston yet.*]

WHISTLER: Your lordship is too close at present to the picture to perceive the effect I intended to produce at a distance. The spectator is supposed to be looking down the river toward London.

THE JUDGE: Do you say that this is a correct representation of Battersea Bridge?

WHISTLER: I didn't intend it to be a "correct" portrait of the bridge. It is only a moonlight scene, and the pier in the center of the picture may not be like the piers at Battersea Bridge as you know them in broad daylight. As to what the picture represents, that depends upon who looks at it. To some persons it may represent all that is intended. To others it may represent nothing.

THE JUDGE: The prevailing color is blue?

WHISTLER: Perhaps.

THE JUDGE: Are those figures on the top of the bridge intended for people?

WHISTLER: They are just what you like.

THE JUDGE: Is that a barge beneath?

WHISTLER: Yes. I am very much encouraged at your perceiving that.

THE JUDGE: How long did it take you to paint that picture?

WHISTLER: I completed the work in one day, after having arranged the idea in my mind. My whole scheme was only to bring about a certain harmony of color.

[*Well, so much for that particularly trifling bit of nonsense, we would have more. Meanwhile, the court was briefly adjourned so that the jury could cross the street and see an impromptu show of Whistler paintings in a room in the Westminster Palace Hotel. I had arranged for this on the advice of my counsel, the undemonstrable notion being that there was better light and generally better conditions for looking at pictures in the hotel than in the courtroom. Presently everyone trailed back in again, looking exactly as they had looked when they went out. The Falling Rocket was produced again, and again the Attorney-General lit into it, starting with a sort of summary of my testimony so far.*]

ATTORNEY-GENERAL: This picture represents a distant view of Cremorne with a falling rocket and other fireworks. It occupied two days, and is a finished picture. You have made the study of art your study of a lifetime.

Now, do you think that anybody looking at that picture might fairly come to the conclusion that it had no particular beauty?

WHISTLER: I have strong evidence that Mr. Ruskin did come to that conclusion.

ATTORNEY-GENERAL: Do you think it fair that Mr. Ruskin should come to that conclusion?

WHISTLER: What might be fair to Mr. Ruskin I cannot answer. I do not think that any artist would come to that conclusion. I have known unbiased people express the opinion that it represents fireworks in a night scene.

ATTORNEY-GENERAL: Then you mean, Mr. Whistler, that the ini-
tiated in technical matters might have no difficulty in under-
standing your work. But do you think now that you could
make *me* see the beauty of that picture?

[*This was his plain, bluff, no-nonsense, honest-Englishman
pose again. Could I make him see the beauty in a painting?
Meaning, presumably, that if I could I would instantly re-
deem myself as an artist worthy of serious consideration.
Well, I had my answer to this sort of idiot, blackmail logic
of course. But I meant for it to sink in.*

 *I took my time about answering. First, I gazed long into
the Attorney-General's face as if to measure it for serious-
ness, my eyeglass glittering, I hoped. Then I turned to my
Falling Rocket, held up for inspection before the court, seem-
ing to consider its explicability to your common Englishman.
Finally another long, grave look at the Attorney-General's
face. The court was silent, waiting. Go to hell in a hack.*]

WHISTLER: No! Do you know, I fear it would be as hopeless as
for a musician to pour his notes into the ear of a deaf man.
[*Laughter*] I simply offer this picture, which I have con-
scientiously painted, as being worth two hundred guineas.

[*There was much good-natured amusement at all this, and I
felt fairly safe in stepping down in favor of my witnesses
who were scheduled to follow me. Of course, they weren't
likely to be as good witnesses for me as I was witness for
myself—a certain desperation would necessarily be lacking
—but at least an atmosphere of strict attention had been
established in the courtroom. Various dozers had awakened
to life, even members of the jury and the press. William
Rossetti took the stand as my first witness. This good, drab
man, least of an astonishing family, one foot in Ruskin's
camp, one in mine, knowing that I was his brother Gabriel's
friend, yet fearing Ruskin's even insane displeasure, yet
hating Burne-Jones, William Morris and the other more re-*

271

cent Ruskin sycophants because they thought him more jackass than dragon ... Well. I have set down that unpardonably disjointed sentence only to explain that I couldn't really expect very much of so disjointed a man as William Rossetti. All the same, he was all I had. William took the stand. Never flamboyant in dress, he looked, on my precious day in court, like a drenched dormouse. The Attorney-General, as the law evidently prescribed, asked him to identify himself, which William did. He said he was everything —journalist, art critic, poet, philosopher, painter, God knows what—in short, nothing in particular, all in a modest way, you know, thereby securing his audience's notion that they could safely ignore anything he said. The Attorney-General then asked Rossetti's opinion of the paintings of mine he'd seen at the Grosvenor Gallery. Honest William coughed from time to time.]

WILLIAM ROSSETTI: I consider the "Nocturne in Blue and Silver" an artistic and beautiful representation of a pale but bright moonlight. I admire Mr. Whistler's pictures, but not without exception. I appreciate the meaning of the titles.

ATTORNEY-GENERAL: And this one, the Falling Rocket?

WILLIAM ROSSETTI: The Falling Rocket is not one of the pictures I admire.

ATTORNEY-GENERAL: Is it a gem? [*Laughter*]

WILLIAM ROSSETTI: No.

ATTORNEY-GENERAL: Is it an exquisite painting?

WILLIAM ROSSETTI: No.

ATTORNEY-GENERAL: Is it very beautiful?

WILLIAM ROSSETTI: No.

ATTORNEY-GENERAL: Is it a work of art?

WILLIAM ROSSETTI: Yes, it is.

ATTORNEY-GENERAL: Is it worth two hundred guineas?

WILLIAM ROSSETTI: Yes.

[*Think about that exchange for only a moment, and you will have seen a brave man. Ruskin was not likely to take kindly*

*to any Rossetti who flatly contradicted him in public, and
there was no reason why William should be an exception.
The fact that, as art criticism likely to sway anybody in my
favor, his testimony amounted to something less than un-
bridled praise, I still had to honor him for courage. I tried
to catch his eye as he left the witness stand but he wouldn't
allow it. Well, better half friends than no friends. Which
may sound odd as coming from one who admittedly shares
his bed uneasily with compromise, but circumstances can
alter one's private list of acceptable bedfellows, even mine.
A craven confession, possibly, but I have agreed to adhere
more or less to the truth.*

*Next on the witness stand was young Albert Moore, a
friend without qualification, certainly, but a painter whose
very generosity made him somehow suspect. His testimony
had the ring of testimony advanced by one's mother, or by
someone whose life one had once saved in a bathing acci-
dent. Well, here is a small part of it.*]

ATTORNEY-GENERAL: Mr. Moore, in general how would you de-
scribe Mr. Whistler's pictures?

ALBERT MOORE: They are the most consummate works of art.

ATTORNEY-GENERAL: The "Nocturne in Black and Gold" . . .

ALBERT MOORE: Simply marvelous!

ATTORNEY-GENERAL: . . . the so-called Falling Rocket . . .

ALBERT MOORE: No other painter could have succeeded in it as
Mr. Whistler has done. Exquisite!

ATTORNEY-GENERAL: Is the picture with the fireworks an ex-
quisite work of art?

ALBERT MOORE: There is a decided beauty in the painting of it.

ATTORNEY-GENERAL: Is there any eccentricity in these pictures?

ALBERT MOORE: I should call it originality. What would you call
eccentricity in a picture? [*Laughter*]

[*And so on. Good for Albert Moore. If he were not so fine
a painter I could wish him a long career as an art critic, the
only one allowed in the world.*

273

*With the last witness in my defense, William Wills, I
was in much the same fix. Hear him in response to the dubi-
ous Attorney-General.*]

WILLIAM WILLS: I have affirmed that Mr. Whistler's works are
artistic masterpieces. Allow me to go further. They have
been painted by a man of genius.

[*But, as I have said, Wills was a famous playwright, not a
famous painter, and didn't appreciably strengthen my case.
In fact, the Attorney-General, now that I and all my wit-
nesses had been heard, submitted to the court that I had no
case and that all of us might as well go home. Baron Huddle-
ston disagreed.*]

THE JUDGE: No, I cannot deny that Mr. Ruskin's criticism, as it
stands, holds Mr. Whistler's work up to ridicule and con-
tempt. So far it is libelous, and must, therefore, go to the
jury. It is for the Attorney-General to prove it fair and
honest criticism.

[*Well, the Attorney-General made a great show of sighing
and rolling his eyes up to heaven at this dreadful burden
the judge had placed on him. Fancy actually having to prove
that I had not been libeled! Too much, you know. It was all
sham, of course, and he was absolutely delighted because he
would now have an excuse for making a speech, which he
did. It was a very long and amazingly boring speech, but is
not without interest as an illustration of the legal mind
defending the deranged mind in its right to destroy the
reputation of a practitioner of a craft of which both minds
are totally ignorant. Quite wonderful, if one has a taste
for reciprocal illogic.*

*I wouldn't dream of setting down the whole speech,
of course—there are limits to endurance in all things—but
only a few selected insanities.*]

ATTORNEY-GENERAL: It is my hope, gentlemen of the jury, be-
fore this case is closed, to convince you that Mr. Ruskin's
criticism upon the plaintiff's pictures was perfectly fair and

bona fide, and that, however severe it might have been, there was nothing that could reasonably be complained of. . . .

Let the jury examine the "Nocturne in Blue and Silver," said to represent Battersea Bridge. What is that structure in the middle? Is it a telescope or a fire escape? Is it *like* Battersea Bridge? And if those are horses and carts at the top of the bridge, how in the name of fortune are they to get off?

Now, about these pictures, if Mr. Whistler's argument is to avail, critics must not venture publicly to express an opinion, or they will have brought against them an action for damages. After all, critics have their uses. I should like to know what would become of poetry, of politics, of painting, if critics were to be extinguished? Every artist struggles to obtain fame. No artist can obtain fame except through criticism. . . . As to these pictures, critics could only come to the conclusion that they are strange fantastical conceits not worthy to be called works of art. . . .

Now, it has been contended that Mr. Ruskin was not justified in interfering with a man's livelihood. But why not?

Then it was said, "Oh! You have ridiculed Mr. Whistler's pictures." If Mr. Whistler disliked ridicule, he should not have subjected himself to it by exhibiting publicly such productions. If a man thinks a picture is a daub he has a right to say so, without subjecting himself to the risk of an action.

I will not be able to call Mr. Ruskin, as he is far too ill to attend, but if he had been able to appear, he would have given his opinion of Mr. Whistler's work in the witness box. Mr. Ruskin says, through me, as his counsel, that he does not retract one syllable of his criticism, believing it was right!

The libel complained of said, among other things, "I never expected to hear a coxcomb ask two hundred guineas for flinging a pot of paint in the public's face."

What is a coxcomb? I have looked the word up, and

find that it comes from the old idea of the licensed jester who wore a cap and bells with a cock's comb in it, who went about making jests for the amusement of his master and family.

If that is the true definition, then Mr. Whistler should not complain, because his pictures have afforded a most amusing jest! I don't know when so much amusement has been afforded to the British public as by Mr. Whistler's pictures.

I have now finished. Mr. Ruskin has lived a long life without being attacked, and no one has ever attempted to control his pen through the medium of a jury.

Of course, if this jury should find a verdict against Mr. Ruskin, he will have to cease writing. But it will be an evil day for Art, in this country, when Mr. Ruskin is prevented from indulging in legitimate and proper criticism, by pointing out what is beautiful and what is not!

[*Now that everything about Art and the Law had been explained to everybody, Baron Huddleston adjourned the court until the next day, when witnesses for the defendant would give their evidence.*]

Well, now, you know, although I hadn't any knowledge of the law, it seemed to me that if the best case for Ruskin had been summed up in the Attorney-General's endless gabble of nonsense, I already had my thousand pounds' damages in my pocket. Better still, the speech addressed to the jury—although I doubt that any of the jurymen had bothered to make head or tail of it—had bored them, desperately, suicidally bored them. At dinner that evening with Maud I worked out a line of logic that seemed irrefutable to me and I expounded it to her as follows.

It is a serious offense to bore any audience, of course, but most audiences can at least walk away from whoever is boring them. A jury cannot. The poor helpless chaps, captives of a judicial system of which they theoretically approve, may squirm

and yawn and scowl and scratch themselves all they like, but the one thing they may not do is rush for the doors. Which must make them angry, you know, against the bore.

And a jury has at its disposal a unique weapon of reprisal denied to the rest of us who are the victims of bores. Its members may express their verdict on their tormentor by simply voting against his cause, in this case against Ruskin, in order to get even with the Attorney-General for boring them. I, on the other hand, had at least made the jurymen smile a bit, which, by my present logic, put them in my debt for not boring them and would earn me their vote.

"Tell me, Maud," I said, "is it not your opinion" (I'm sorry to say that this ass-headed way of phrasing a perfectly simple question results from even a single day in court) "that the jury was bored by the Attorney-General?"

"I'm afraid I don't know, Jimmy," says Maud.

"But how can you possibly not know? You were watching the jurymen, weren't you?"

"No."

"Not watching? Were you watching the Attorney-General?"

"No."

"What were you doing then?"

"I got drowsy."

Well. Just the right answer to fit my theory. However, if Maud and the jurymen imagined they had been bored enough for one trial, they were to be sadly disabused on the following day, Tuesday.

The first witness called for the defense was Edward Burne-Jones. He was questioned not by the Attorney-General but by his associate, Mr. Bowen. I don't know why this was. Possibly the Attorney-General had exhausted himself the day before or perhaps the defense was only offering the jury a change of cast, for Mr. Bowen was Sir John Holker's exact opposite. Not the least a bluff-and-hearty, beer-and-beef sort, Mr. Bowen was small and neat and precise. He didn't try to make jokes and his wig fitted him, which seemed for some reason ominous.

By way of presenting Burne-Jones properly to the consideration of the court, Mr. Bowen proceeded to read extracts of eulogistic appreciation of this artist written by none other than John Ruskin himself, the defendant! Being a simple man and no lawyer, I should have thought this would immediately have disqualified Jones as a witness for his benefactor. But that was because I am a simple man and no lawyer. It did not disqualify him. Indeed, he went on and on.

I would imagine that Burne-Jones was the British ideal of how an artist should look, youngish, a little shaggy around the head, bearded, gray-blue-eyed, with an easy, earnest manner. Probably the only artist in London with whom a chap might trust his sister after dark. I would not trust him with *my* sister, but then I was not asked.

Examination of the witness then commenced. In answer to Mr. Bowen:

MR. JONES: I am a painter and have devoted about twenty years to the study. I have painted various works, including "Days of Creation" and "Venus's Mirror," both of which were exhibited at the Grosvenor Gallery last year. I have also exhibited . . . [*Blah, blah, blah, blah, you know.*] I have one work, "Merlin and Vivian," now being exhibited in Paris.

In my opinion complete finish ought to be the object of all artists. A picture ought not to fall short of what has been for ages considered complete finish.

MR. BOWEN: These nocturnes of Mr. Whistler's . . . Take the one in blue and silver—old Battersea Bridge—do you see any art quality in that nocturne, Mr. Jones?

MR. JONES: Yes . . . I must speak the truth, you know. [*Emotion. Several people are said to have awakened here.*]

MR. BOWEN: Yes. Well, Mr. Jones, what quality do you see in it?

MR. JONES: It does not, in any sense, show the finish of a complete work of art. Neither in composition, detail nor form has the picture any quality whatever, but, in color, it has a

very fine quality. . . . But it is bewildering in form, it is formless.

MR. BOWEN: Ah. Now, take the "Nocturne in Black and Gold" —the Falling Rocket—is that, in your opinion, a work of art?

MR. JONES: No, I cannot say that it is. It is only one of a thousand failures that artists have made in their efforts to paint night.

MR. BOWEN: Is the picture in your judgment worth two hundred guineas?

MR. JONES: No, I cannot say it is, seeing how much careful work men do for much less. This is simply a sketch. A day or a day and a half seems a reasonable time within which to paint it.

[*The reason for these haphazard sketches is at last revealed!*]

Mr. Whistler gave infinite promise at first, but I do not think he has fulfilled it. I think he has evaded the great difficulty of painting and has not tested his powers by carrying it out. The difficulties in painting increase daily as the work progresses, and that is the reason why so many of us fail.

[*A touching confession? A sinister prediction!*]

We are none of us perfect. The danger is this, that if unfinished pictures become common, we shall arrive at a stage of mere manufacture and the art of the country will be degraded.

[*There was now a bit of a hubbub on the sidelines as two flunkies set up on an easel before the jury another painting, not mine, not Burne-Jones's, certainly, but the work of someone rather more ancient, by the dirty look of the canvas.*]

279

MR. BOWEN: The word "finish" has been applied here many times as it applies to the art of painting. Here is a painting by the great Italian master Titian. I ask the witness to look at it in order to explain what "finish" is.

MR. SERGEANT PARRY (rising): I object! We do not know that this is a genuine Titian.

[*It was reassuring to observe that I had an alert counselor watching out for me, but the fact of the matter was that the painting on display—after a few second's observation—I saw was indeed an early Titian, a very early one. And that was what was so clever, you see. Ruskin must have thought of it from his madhouse bed. The picture didn't in any way at all represent the famous Titian, the great Titian. It was the schoolboy work of a paintbrush virtuoso who had not yet thought seriously about his art, as he was later to do. It was certainly a good example of "finish," in the idiot sense in which that word was being bandied around. It was finished, as a good boot polishing is finished. But it had never been begun.*]

THE JUDGE: You will have to prove that it is Titian.

MR. BOWEN: I shall be able to do that.

THE JUDGE: That can only be by repute. I do not want to raise a laugh, but there is a well-known case of an "undoubted" Titian being purchased with a view to enabling students and others to find out how to produce his wonderful colors. With that object the picture was rubbed down, and they found a red surface, beneath which they thought was the secret, but on continuing the rubbing they discovered a full-length portrait of George III in uniform.

[*All the lawyers chuckled appreciatively at this hoary bit of apocrypha. I suppose if one is a lawyer, and a judge presiding over one's courtroom activities decides to tell a joke, never mind how tiresome, one chuckles. As for me, I was beginning to wonder what had become of my suit for*

libel. I did not chuckle. The witness now examined the painting.]

MR. JONES: This is a portrait of Doge Andrea Gritti, and I believe it is a real Titian. It is a very perfect sample of the highest finish of ancient art. The flesh is perfect, the modeling of the face is round and good.

[*Here the witness took a deep breath and, throwing back his head, stood straight and tall—Art's daring knight in armor.*]

This is an Arrangement in Flesh and Blood!

MR. BOWEN: What is the value of this picture of Titian's?
MR. JONES: That is a mere accident of the salesroom.

[*A rational statement! I could hardly believe my ears. But wait.*]

MR. BOWEN: Is it worth one thousand guineas?

[*A look of reverence now, head cocked in a final examination of a painting whose only conceivable interest or value was of the sort some people place on a postage stamp accidentally printed upside down.*]

MR. JONES: It would be worth many thousands to me!

[*Burne-Jones now stepped down and his place was taken by William Powell Frith. Beyond middle age now, full of so-called honors, Frith's was a name millions of Englishmen—pressed to name a famous artist—would mention well before, if ever, they got around to Rembrandt or Velásquez. He spoke with the splendid natural arrogance that only royalty and drunken sailors dare assume, at least with any charm.*]

MR. FRITH: I am a Royal Academician and have devoted my life to painting. I am a member of the Academies of various

281

countries. I am author of "The Railway Station," "Derby Day" and "Rake's Progress."

MR. BOWEN: You have seen Mr. Whistler's pictures?

MR. FRITH: I have.

MR. BOWEN: Are the pictures works of art?

MR. FRITH: I should say not. The "Nocturne in Black and Gold" is not a serious work to me. I cannot see anything of the true representation of water and atmosphere in the painting of Battersea Bridge. There is pretty color which pleases the eye, but there is nothing more. To my thinking, the description of moonlight is not true. The picture is not worth two hundred guineas. Composition and detail are most important matters in a picture.

I have not exhibited at the Grosvenor Gallery. I have read Mr. Ruskin's works.

[Mr. Frith here got down. A decidedly honest man—I have not heard of him since.]

There would be no point in setting down in any detail the testimony of Ruskin's last witness, Tom Taylor, art critic of the *Times*, for it was only more of the same, except for the fact that Good Tom came equipped with printed testimonials as to the rightness of his criticism of my work, which was more than anyone else had been able to do. The printed matter turned out to be his own writings. This may sound odd, but that was the burden of Tom's irrefutable proof that Whistler's paintings were rot: The *Times* had said so. From the pockets of his overcoat, with the court's permission, Tom fished out and read with considerable unction his own printed criticism!

And there ended all the "evidence" the jury was to hear. On this basis the jurymen were to find where true justice lay. By now these poor put-upon devils would cheerfully have voted to saint a rogue or hang a saint, any old way, to get home in time for supper, so monstrously bored were they with all the

idiotic "art" talk they had been subjected to. I couldn't blame them, of course. Except that the entire course of my life depended on their bored decision, I would have shared their view. In the circumstances, I continued to pay attention.

The jury would not have its supper for a while yet, it seemed. There were to be three necessary legal impediments to an early supper, Baron Huddleston explained, looking rather pleased with the prospect: a summary of its case by both sides followed by the judge's charge to the jury.

Mr. Bowen, in summing up his case for Ruskin, chose to take for him a totally innocent, disingenuous, "but what is all the fuss about?" view of things. All Ruskin had done was to express a simple private opinion of my painting, obviously the right of every free Englishman—else what horrors of censorship lay ahead for the mere expression of an honestly held belief by a common man? And so on. Surprisingly, he didn't talk very long. But that was no doubt wise. It made it possible, you see, not to bother to touch on the criminal charge of which his client was accused: libel. He spoke not of libel but of an overly touchy painter who was brewing a great tempest in a teapot, then he sat down.

Now came something rather amazing, at least to me, from mild Mr. Sergeant Parry in his reply on my behalf. Parry, who had dutifully laughed at the judge's jokes and leaned over backward to give Ruskin his due as a writer of influence, suddenly and rather unaccountably became my passionate advocate. Tucking his robes about him, he strode up and down before the jury on his short legs like an indignant rooster, demanding summary justice. Listen to him.

Mr. Sergeant Parry: I submit that the defense has not dared to ask if Mr. Whistler deserves to be stigmatized as a "wilful impostor." Even if Mr. Ruskin has not been well enough to attend this court, he might have been examined before a commission! No, his decree has gone forth that Mr. Whistler's pictures are worthless. He has not supported that by

evidence. He has not condescended to give reasons for the view he has taken, he has treated us with contempt, as he treated Mr. Whistler.

He has said: "I, Mr. Ruskin, seated on my throne of art, say what I please and expect all the world to agree with me!"

Mr. Ruskin is a great writer, but not as a man. As a man he has degraded himself. His tone in writing the article is personal and malicious. Mr. Ruskin's criticism of Mr. Whistler's pictures is almost exclusively in the nature of a personal attack, a pretended criticism of art which is really a criticism upon the man himself, and calculated to injure him. It was written recklessly, and for the purpose of holding him up to ridicule and contempt!

Mr. Ruskin has gone out of his way to attack Mr. Whistler personally, and must answer for the consequences of having written a damnatory attack upon the painter. This is what is called "pungent criticism" or "stinging criticism," but it is defamatory! And I hope the jury will mark their disapproval by their verdict.

Well said, Mr. Sergeant Parry. I promote you to Sergeant-Major and trust the jury will attend the ceremony. But that taciturn body, enlivened for a moment, had still to hear Baron Huddleston sum up the case and explain the law. This formality began rather promisingly, or so it seemed to me, at any rate.

THE JUDGE: There are certain words by Mr. Ruskin about which I should think no one would entertain a doubt. Those words amount to a libel. The critic should confine himself to criticism, and not make it a veil for personal censure or for showing his power. The question for the jury is, do Mr. Whistler's ideas of art justify the language used by Mr. Ruskin?

[*Well, now, that was all right, you know—a little soft, somewhat lacking in outrage perhaps—but then I expect*

that's the way judges are supposed to behave. It's only the libeled and injured like me, and our counselors, who can reasonably be permitted to go bashing about a courtroom crying out for blood and revenge and so on. No, I would have settled for Baron Huddleston's modest little summary of my problems if only he had shut up and let the matter go to the jury. But this beastly bloke of a baron hadn't finished. Hear him.]

The further question is whether the insult offered—if insult there has been—is of such a gross character as to call for *substantial* damages; whether it is a case for merely *contemptuous* damages to the extent of a farthing, or something of that sort, indicating that it is one which ought never to have been brought into court, and in which no pecuniary damage has been sustained; or whether the case is one which calls for damages in *some small sum* as indicating the opinion of the jury that the offender has gone beyond the strict letter of the law.

And with this perfidious bit of instruction ringing in its ears, the jury filed out. It took those twelve weary, bored, bewildered men one hour—I can't think why—to reach a verdict. Their course had been charted for them. Their deliberations—if that is the word to describe the logical working-out of a syllogism to its inevitable conclusion—must have gone like this: First a vote on the general matter of guilt or innocence. Guilty, no doubt about that, the judge himself said Mr. Ruskin had libeled Mr. Whistler. Agreed, Alf? Got it right the very first time, Fred.

Well, then, in the matter of damages. We got three choices to choose from, all right? Substantial damages, mentioned by his lordship, seem a bit hard on Mr. Ruskin, seeing that the old gentleman has toddled off his rocker a bit in his worthy decline, after serving queen and country all these years. What do you say, Alf? No, wouldn't be right to pop the poor old bleeder for a thousand quid, Fred.

All right, then, the judge said we could award Mr. Whistler some small sum in damages. Now, what do you figure is a proper small sum, Alf? A hundred quid? I dunno, Fred. Two hundred quid? It's all right with me, Fred. It's not my money, you know. Maybe a hundred and fifty?

Charlie spoke up: The trouble with you two blokes is you didn't listen to his lordship. He told us what to do straight out. He did, Charlie? Of course he did, named the sum, too—one farthing. I heard that, too, didn't you, Fred? That's right, one farthing, *contemptuous* damages, he called it. I don't know about the rest of you gents, but I feel pretty contemptuous about this whole bloody business. My sentiments exactly, Alf. Learned a bit too much about art, have you, Fred? Bit of a pain in the arse, I'd have to say, Alf. A farthing it is, then, and we'll all be home in time for supper. Subdued cheers, a unanimous vote.

Back in the courtroom my victory was announced: judgment for the plaintiff—damages one farthing. Baron Huddleston had only one small gift of further information for me. In giving judgment to me, he announced that he did so "without costs." Seeing that I was unfamiliar with the phrase, the judge explained that although I was being awarded the verdict I was not being awarded the court costs; that is, both sides, winner and loser, would have to pay.

There was a little trouble about finding a farthing for me among Ruskin's counsel. A farthing, you see, is a small coin of so little value—one quarter of one penny—that it appeared it is not commonly to be found in the pockets of successful barristers. The Attorney-General was finally able to borrow one from an accommodating policeman.

Court was then adjourned. And Fred and Alf and Charlie and Baron Huddleston and I all got home in time for supper.

TWELVE

IT IS a quite marvelous thing to win a libel suit in England. The result is publicly printed, one's vindication is complete, one's honor totally restored, and one's defamer is brought low. That these are all splendid reasons for rejoicing there could hardly be doubt. I rejoiced. I saw to it that all my friends rejoiced.

I became expert at re-enacting certain bits of the testimony at the trial. At intimate gatherings I could convulse the entire company with my imitations of Burne-Jones contradicting himself or Baron Huddleston on Titian and George III, and I was particularly amusing in imitating myself as I had been examined and cross-examined, in time learning to polish and embellish my cheeky answers to the Attorney-General into even cheekier answers, for memories are short, and to be entertaining one's civilized obligation to one's guests. It was altogether a time for rejoicing.

Still, my private rejoicing was somewhat less unconfined than my public rejoicing. To be exact—and there really is no good quoting facts and figures if they are not exact—I learned that my solicitors' fees for preparing and conducting the prosecution of my suit amounted to five hundred pounds. The court costs came to seven hundred and seventy pounds for its two days of use. (On the basis of these costs, I would advise any young person, with no other compelling vocation and his eye on a comfortable old age, to become a court.) There was at least the redeeming consolation that John Ruskin would have to pay half of these court costs, or so the judge had proclaimed.

Well, now, you know, judges are very important people, the queen's voice, dispensers of her even justice, wearing the biggest wigs imaginable, and so on—as long as they are behind their benches. But once their solemn judgments have been set down, they have hung up their wigs and gowns and gone home to their mutton and Madeira, others, it appears, may subtly or not so subtly subvert the judge's solemn judgment, altogether altering its intent.

I have said that at least Ruskin would have to pay half the costs, or three hundred and eighty-five pounds. Not much to a very rich man, perhaps, but it would be a few drops of blood drawn at any rate. Here is what happened during the fortnight after the trial. An account was opened at the Union Bank of London in the name of Mr. Burne-Jones and others, managed by the Fine Art Society, and a subscription was invited from the British public to pay the expenses of their prophet, Ruskin. That public rallied so admirably that the rich man's court debt was oversubscribed in less than a week, many pounds having to be returned to their donors with appropriate thanks.

I'd never heard anything about this subscription business before, didn't know such a process existed. It struck me as a highly civilized way of declaring one's preference in any contest, rather like wearing the colors of one's favorite in a medieval joust or, more prosaically, placing a quid with a bookmaker at Ascot on your favorite horse, not *the* favorite, your *own* favorite to win the race. A sort of declaration of faith in the long run, I suppose it was, for I am hopelessly committed to the long run. Subscription, I was all for it.

I arranged through my solicitor, Anderson Rose, to set up precisely the same sort of subscription on behalf of my court costs as Ruskin had done, which Rose did, and the list was opened at the office of *L'Art* in New Bond Street, a small publication friendly to me.

Feeling rather like that favorite race horse awaiting his starting odds, guessing at the sum of solid faith to be placed in him—neither of which I suppose actual race horses have the wits

to do, but in literature metaphor, however ridiculous, is what keeps the game going—I sat back and waited.

After a few days I was informed that the office of *L'Art* had received an opening contribution to my subscription list of twenty-five pounds from a Mr. J. P. Heseltine. I didn't know Mr. Heseltine, or at least I don't think I knew him, but I know so many people, too many, it was difficult to tell. While applauding Mr. Heseltine's good sense, I did not, at that moment, consider it unique. Nor was it, quite. The following day I was informed that my subscription had been swelled by a contribution —of ten shillings—by a Mr. Ernest Bright, Bailiff. My Young King David, who had learned in my house, at least, that bailiffs do not come easily by ten shillings. But he had perhaps learned something other, something anyhow worth ten shillings, it seemed.

I thank you, Ernest Bright, and I thank you, Mr. J. P. Heseltine, for in the end it was only the two of you who chose to demonstrate your common faith in me. You should never meet each other, of course. From your separate points of view the subject of your benevolence would seem like two separate people, neither satisfactory to the other, and so you would fall out over the matter.

And that is how it ended, both subscriptions closed: Ruskin embarrassed by his oversubscription of money; Whistler unembarrassed by his undersubscription of money, or making a rather large noise about it.

I sent, or had sent, to both Mr. J. P. Heseltine and Bailiff Ernest Bright, a pastel drawing. They were the best, at least in my opinion, that I had ever done.

So where was I now? For those attuned to arithmetic, I offer a set of figures which will depress them. Also, they depress me, proving only the well-known—or should be well-known—fact that arists of any stripe, between divinely inspired compositions of all sorts, think exclusively about money.

In addition to the sums already mentioned, I also owed a debt of a little over two thousand pounds to the builders of my

White House. Their original calculations as to its final cost had become a bit muddied by some trifling changes in the plans which I had instituted along the way. (There were, of course, also some odds and ends of tradesmen's bills.)

Therefore, sober arithmeticians, my financial plight will not seriously tax your gifts. *Debts:* Four thousand six hundred and forty-one pounds, nine shillings and threepence. *Assets:* One farthing. Even I can manage that sort of arithmetic.

People say I wear Ruskin's farthing on my watch chain, but it isn't true. I carry no watch and hide all clocks. Painting, I do not wish to measure time.

In the interval it takes to tell it, I exchanged the agreeable *badinage*, the jolly give-and-take of the libel court for the awful austerity of the bankruptcy court. A committee was appointed to oversee the sale of my effects, which it did. Every spoon was sold. Henry Irving (born John Brodribb, which seems to me an altogether more fetching name than Henry Irving, but no matter) turned up at the rapidly emptying White House and found his portrait somewhere at the bottom of a pile of canvases. He recognized his legs, which were sticking out, he told me—to flatter the painter perhaps—and bought it for thirty pounds. The bricks and mortar of my extraordinarily beautiful house were sold to Mr. Harry Quilter—an art critic.

One instinctively draws back from the grandiloquent, altogether hothouse, prophecies of oracles who moan their news of the future out of caverns and so on, who see alarming and assumedly accurate portents in the steaming entrails of a lately grazing bull. I am not and never have been one of their adherents.

But a funny thing. I became perhaps my own unconscious oracle—no other would serve, I suppose I needn't point out. At the end of all this I wrote a note to a friend—a friend, take notice, not an enemy—and I signed it with my customary butterfly. But there was a change, an all unconscious change, I maintain, one of which I have no memory. My butterfly had grown a tail.

No, a stinger, a scorpion's stinger, sharp and deadly, pointed at the end. I have never since drawn my butterfly in any other way.

Surely, constant repetition of events in life are just as tiresome and unforgiveable as they are in fiction. Mere truth is surely no excuse. Balzac can tell us of young Rastignac's agony at attending a duchess's ball in Paris wearing the wrong coat and gloves. Balzac, an artist, does not tell us also that Rastignac on some other grand occasion had a hole in his stocking or that he entered a ballroom tripping over the door sill. No, the wrong gloves are enough, symbol of the rustic's humiliation on his introduction to the great world. I would now do well to be a selective Balzac, it seems to me, on an altogether different subject, to be sure, my life.

I have gone on a good deal about my own humiliations hereabouts up to this point, and I, for one, am growing tolerably weary of houses full of bailiffs, devious unsuccessful stratagems for survival, commissions canceled, extraordinary paintings refused in payment by the butcher, holes in the shoes, rascal merchant princes, false prophets of art, and all that.

And although the years, some several years, following the Ruskin trial were in some small ways not without interest, they are in sum and substance merely a repetition of the years before. Ten bailiffs in residence are finally no more interesting than five. The trick to understanding the years I mean to skip or drastically compress lies only in our schoolboy multiplication tables. Take what was five, multiply it by ten, and we've saved a hundred needless pages. Rastignac's yellow gloves (instead of white) tell all we need to know about his debut. My Carlyle portrait, as well as my mother's and a dozen nocturnes, were in pawn for sixty pounds, which may make M. Balzac's point.

Well, what does one do in such circumstances? It is disconcerting to discover how few are one's choices. My personal choice—although I can't conscientiously recommend it to everyone—was to go mad. Definitions, however, are everything, our

only hope of sanity, else we would wind up calling a bishop a hansom cab and only the apocalypse to follow. I did not say I went mad. I said I *chose* to go mad, for there is a somewhat inexact and semantical difference.

I don't mean that I feigned madness like some crafty Hamlet who knew hawks from handsaws when he felt like it; no, I was mad enough, hawks and handsaws all one to me, you know. I only mean that to make the conscious choice is perhaps, in certain circumstances, an indication that there may still exist within oneself a faint, vestigial trace of sanity. I went mad because it seemed the only sensible thing to do. Otherwise, I would just have gone mad in the ordinary way, and ordinariness offends me in all things.

Others who might have found themselves at some point in middle life (my own age was forty-six), after treading a steady path from relative success to public suspicion to public derision to bankruptcy to laughingstock, others in such circumstances, I say, are relieved to wake up one morning and discover that overnight they have miraculously become Julius Caesar or Napoleon Bonaparte. Such is their new reality, all the rest only a dream, and everything is set perpetually to happy rights with them—unless, of course, by some calamity they should happen to grow sane again.

Caesar and Napoleon are the most common identities seized upon by bedlamites, I was once told by the master of one of our most up-to-date bedlams. Oh, of course, he said, you get your Genghis Khans and your Alexander the Greats and, particularly if the season is Yuletide, your smattering of Jesus Christs, but by and large it will be Napoleon or Caesar, odds on.

But I am altogether too vain a man to assume any such shopworn identities. What sort of escape would that be? I mean, where's the fun? One would simply go around nattering about escaping from Elba or crossing the Rubicon or whatever, boring people with exploits you had already accomplished, you see. Not my way of going mad at all. I, a creative man, would invent my own hero and I would be transformed into him, body and soul.

I, Jimmy Whistler, American painter, most serious artist of his generation, would become "Whistler."

With the chilling and dreadful calculation of a wounded tiger, beaten into hiding by his pursuers, "Whistler" would spring out roaring and clawing back into their midst and show them that the "Whistler" of their meager imaginations was a very pale invention indeed.

I would invent them a "Whistler" worth conjuring with, a being so far beyond their wildest descriptions of the old Whistler as to change their passive contempt to stunning outrage, their drawing-room laughter to blubbering hysteria. Had Whistler been eccentric, vain, unconventional in dress, unguarded in speech? "Whistler" would show them something really worth watching along those lines! Had Whistler painted funny pictures that made people laugh, built crazy houses, mocked the respectable Royal Academy? "Whistler" would give them something really worth laughing at; "Whistler" would show them that there are no limitations to mockery! A butterfly with a scorpion's tail would be something new under the sun.

Such was the particular madness I chose for myself. It was a madness that seemed to me to *be* myself, and so it was for several years there in the middle of my life. When at last it ended, and "Whistler" became merely Whistler again—or perhaps a good deal more acceptable Whistler than the old one had ever been—it came as such a shock to me and to the British public that it took us both some time to recover from it. But I am anticipating, and that is against the rules, of time, of form, of logic.

First "Whistler" must be loosed upon the land, his laugh raised to the wild shriek of the angry bird of vengeance. Ha-*Ha!*

"Whistler" began to emerge—far before his full flowering —in Venice. This abrupt change of scene was not because I had any wish to leave England after my bankruptcy; on the contrary, England—no, London—was my chosen battlefield on which I meant to stand or die. But it is true that worthy bankrupts, even

as unworthy and rich art fanciers, have many of the same basic requirements. Food and lodgings, and so on, no racy things, really, but they are essential to sustained fury and retribution.

That no sitters for portraits came to me after the Ruskin trial should not amaze us. A lady or gentleman of fashion would have been open to ridicule had they chosen to do so—unless my fee had been a farthing, of course. "Nocturne," "Harmony," "Arrangement" had become joke words, used in italics in the imagined dialogue underneath clever drawings in *Punch*, most carefully drawn by my old Parisian comrade and whilom friend George du Maurier.

So going to Venice was only an accident, although it responded to a situation of acute necessity. It happened, by nothing but idiot chance, that the Fine Art Society had a new young manager who was determined to be in the *avant-garde*, to fly in the face of current convention, to "encourage the liberality of expression in the arts." (What does that mean? God knows, God knows . . . forgive him.) However, in matters of ready brass it meant at least my temporary salvation. I was advanced by this new-horizon chap three hundred pounds, against later commissions, to go to Venice and produce twelve etchings of the place in a period of three months.

The *avant-garde* manager of the Fine Art Society had no doubt thought he was on safe ground: He would give a commission to Whistler, which was more than anyone else dared to do, thereby establishing his credentials as a rebel. At the same time he was hedging his bet by placing it on Whistler *the etcher*, which was really not a very daring bet, even at my lowest ebb. In that one small, highly and rightly respected realm of the pictorial arts, etching, I had been permitted a grudging survival by my critics and by the public. Why? The most common response, at least as I can best understand it, is simply that any ass can stand in front of a stretch of canvas and splash paint on it— for good or ill, for masterpiece or disaster; it makes no difference, the *process* is easy, you see.

But *etching!* Etching is so complicated a technical process—

so goes our popular wisdom—that any man who is capable of producing a finished plate, drawn with a needle on copper and all the rest, from which accurate reproductions may be taken simply cannot be *all* fraud. It wouldn't be reasonable. Yes. And there are locksmiths who can pick an intricate mechanism in ten seconds with the sharpened quill of a feather that would have bewildered Rembrandt for a lifetime. And what does all that prove? One thing only: Public and critic alike feel really secure in admiring a work of art only in direct balance with the visible amount of dull craft that went into it. Now, etching is such a craft—only relatively difficult in its technical aspects, as crafts go, to tell the truth, but it is respectable.

"Whistler," of course, would have to change all that. It would defeat my entire scheme of madness to remain even 10 percent respectable. I have said I had been given three months to complete my project. A year later I returned to London with a set of etchings that made my young *avant-gardiste* at the Fine Arts Society wish he had stayed behind with the regular troops.

To be in the advance guard automatically implies of course that one is more daring, more sensitive to change than other folk, but also subtly implicit in the term is the understanding that one is being the *advance* guard for another, far greater, guard following along behind. In short, your truly crafty advance-guardsman will look over his shoulder from time to time to make sure the more timid legions are forming strongly at his back.

My poor advance-guardsman had no opportunity to look over his shoulder as my work progressed, since I submitted none of it until the whole was finished. When at last he got hold of my etchings and was obliged to exhibit them in his London gallery, the poor chap finally looked behind him only to find the horizon as unpopulated as a landscape of the Sahara. There were no followers. Indeed, to make matters worse, there were no predecessors. His show was an unrelieved calamity—I speak of professional critical appraisal, of course—his modest monetary advance to me gone down the drain, his announced desire for

295

"liberality of expression in the arts" subject to immediate revision. He had not got at all what he had expected from Whistler, the respected etcher, he publicly declared, he had been duped, so that made me feel better.

One instinctively shrinks from self-appraisal, and I do so with the utmost reluctance. But in the matter of my "Venice Set" of etchings I must cast modesty aside, only briefly, to state the bare truth. If I don't, nobody else will. These etchings are like no others to inhabit the face of the earth, before now or after now. They are glories of daring. They make mock of the dull Italian term *chiaroscuro*, which for all its fancy bandying about in "artistic" Chelsea ateliers means only light-dark or, at a pinch, clear-shadow. What in hell is that, in the end? What is *not*, in art, light and shadow?

My Venice etchings settled the matter, to almost everyone's dissatisfaction. I sometimes left nine tenths of a given space as virgin as the plain white paper, and placed a black, black doorway at the edge. I didn't etch each tile on the roof of a Venetian palazzo, as good etchers should; I scribbled over tiles because the point was not there but must be focused on a grave shucker of shellfish in the foreground, an ugly man in a magnificent decaying courtyard, absent in mind, capable in fact, all of us.

Well, that's enough. But I had accomplished a great deal, from my private point of view. To be "Whistler" required absolute public rejection. That my painting was nonsense had been already established; that had never been in serious doubt. But now that my etching—my last respectable stronghold—had been ridiculed, I was altogether free. A joyous thing. Particularly for a madman. My slate was clean. I was no longer even a serious etcher, not an artist at all. In my despair, I chose to become "A Person."

I began my characterization immediately on my arrival in Venice. There were other non-Italians of some note in the city. Robert and Elizabeth Barrett Browning were in residence, as

were Franz Liszt and George Eliot and the young American John Singer Sargent. To these good burghers I paid not the slightest attention; indeed, it became my business to see that nobody else paid them any attention either. I succeeded very well.

Venice, as it always is, was full of young art students and they became my particular quarry, my claque, my slaves. Not only are the young more easily influenced than their elders, by happy fortune, they actually search out what is different from what has gone before if for no better reason than that it is different, just as I and my long-ago student friends in Paris had championed Courbet, the scourge of the Académie. It made us feel put-upon renegades, the persecuted few who saw a vision of the future in our martyred hero, and of course it all made us deliriously happy, gratifyingly smug. I intended precisely that central hero role for myself, you see. Except, of course, since madness was my guide, I would multiply it madly. The first thing, it seemed to me, was to be as monstrous as possible.

The young art students in Venice knew all about me, or thought they did, which is the same. To them I was the great artist as victim—and victim not only of persecution by a rigid and outworn artistic establishment in England, mark you, but victim as well of a vicious legal system particularly set up to destroy worthy artists. In short, they were already speaking my mind. They could quote verbatim, these admirable young men, every charming response I had made from the witness box at the Ruskin trial to the Attorney-General and everyone else.

And how did I repay their kind attentions? I bade them call me "Master." Which they did, in perfect solemnity. It was not originally their idea, you understand, but a habit they caught from me. I would send one of them, or several of them, to do my marketing—more often with their money than with mine— with certain injunctions: "The Master expects his crabmeat to be absolutely fresh, caught no later than one hour ago, else it must go back" or "It is the Master's wish that the baker be chastised for yesterday's slovenly tarts. Just pop him into the canal for a lesson." And they did, for Art's sake, they imagined.

When I was not the Master I was a Third Person Singular, equally, if not more, remote from my young champions. One evening they gave a surprise dinner party in my honor. I was charmed. I told them so in these words: "Whistler is charmed."

And that was the best of it, you know. Whistler was only occasionally charmed; more often Whistler was vexed or insulted or outraged; the Master was quick to dispense cuts and jibes and bitter sarcasm. The young art students—some of them to become extremely well known in their profession—were carefully taught to vie with each other for the privilege of trotting at my heels carrying my supplies, and not just grounded etching plates and pastel crayons, but a great, monstrous lithograph stone weighing some thirty or forty pounds, in case the Master should be visited by some sudden inspiration among the streets and canals of Venice.

More often than not the Master wasn't so visited, but no matter; at least some sweating, panting disciple had seen that the stone was always within the reach of Whistler's vagarious whim. Well.

Why do decent, good, talented (a few of them) young men put up with such ridiculous indignity? It is in the very nature of the artistic life, I think. Imbedded in Art, as a calling, is a nasty sense of uselessness to the general community that is difficult for the very young to shake off.

Art spelled in reverse, as someone has noticed—possibly it was I—comes out Tra. Tra-la-la offends a strong man's honest ambition. It is no accident that young men who feel a great need to paint pictures also chop lots of wood and build sturdy outhouses in their spare time. Guilt must be assuaged. And that's where I came in, you see.

Whistler, the insufferable Master, was just what the doctor ordered. Whistler had preached, had stood in the public dock to defend, the notion that the glory of art was that it was totally *useless*, that it served no practical end, above all no moral end, that it existed for itself alone. And *that* was its unashamed and magnificent reason for being.

So I could behave as outrageously as I chose; it only bolstered the students' self-esteem. What did it mean to be a willing slave for me to fetch and carry, to subvert every independent impulse to my passing whim? It meant absolutely nothing, in terms of personal sacrifice, so long as Whistler stood at the head of their vanguard shrieking to the wind, and to all others who might care to listen, that art—the thing they had chosen out of all things—was, by news of their Master, the most important thing on the face of the earth. They were given pride through noisy Whistler. It is a gift that permits an uncertain young man joyfully to act the certain fool. Let him miserably carry an enormous stone around the streets. It doesn't matter. In his old age he'll somehow remember it as a privilege, if he doesn't throw up.

I have been speaking of artists. Malleable as clay, they are as easy to deal with as a gaggle of geese, given the proper motivation. Point the leader north and everyone will go north. But there are others who will attack you with *logic*, so blessedly unmentioned a word among the faithful, altogether *infra dig* in the right circles.

After two months Maud joined me in Venice. She observed me for several weeks without comment, behaving when she was with me just as she had always behaved in the past. That is to say, with natural good humor, patience and a clear desire to see only the best in me so far as that was possible. But Maud is not an artist and has no wish to be.

However, in the days before she came to stay with me she had posed for most of the artists in London, came to know many of them well, and as a perfectly natural consequence she had no special way of looking at artists, as a class or as a particular social category. To Maud—unlike my gaggle of young art students, to whom an artist dwelled on some unassailable plain with a set of rules altogether separate from those of ordinary folk— to Maud, artists, on the whole, were simply another group of day-to-day men neither more nor less interesting than a corresponding group of policemen, acrobats or bishops.

To Maud there are only kindly artists and nasty artists,

goatish ones and womanish ones, generous ones and mean ones, dull ones and funny ones. Such judgments are, of course, the very bedrock of common sense, but mad Whistler had unfortunately suspended judgments of that sort. He demanded quite a different and special sort of attention, and from the young artists had had it in full. Maud was another weather on the horizon.

One evening at dinner, after Maud had been with me for something like a month and had shared my daily life with my new young friends for that time, she had something new to say. She was, at the moment, engaged in trying to cook a dainty dish to my taste over an alcohol spirit lamp, the gas supply having been recklessly cut off. There was something terrible in the fact that her very charming smile was no less charming than it had ever been.

"Tell me, Master," says Maud, burning a finger over the inconstant flame of the spirit lamp, "if the Master doesn't think it would be a good idea—seeing as how the Master has run out of the Fine Art Society's advance money—to get down to work and finish the etchings he's promised and get back to London instead of holding bloody court all day in a Venice pub for a crop of toadies? It's only a humble question, Master. What's the Master's opinion?"

Now, this was very unlike the talk to which the Master had lately accustomed himself. It was even very unlike Maud. How did I react to it? What did I do and say? I know it will sound very odd indeed but, do you know, I can't remember. Blind rage, in its more heroic manifestations, is actually blind, and deaf too, I suspect.

I *do* remember hurling over the dinner table and everything on it into Maud's lap, including the spirit lamp which rather remarkably snuffed itself out instead of burning up either Maud or the house we were living in, or both, although neither eventuality at that moment would have concerned me in the least.

And I *do* remember opening my mouth and hearing issuing from it one howling, shattering animal roar—but, well, that's

about the size of it. The rest is silence. No, no, good God, silence is the last thing the rest was. (The danger in quoting Shakespeare is to get the right play to have some bearing on the right day and the right occasion.) I only mean that the rest was, and remains, silence to *me*. Towering, ungovernable, insane rage—and there is no more foolproof way of inducing it than by telling someone the total and exact truth about himself—is, I believe, a sort of fit. A regular physical fit, with precise chemical changes and all the rest, and with a concomitant loss of memory about the whole business.

Just as Nature, in her infinite benevolence, permits the victim of apoplexy—at least a doctor once told me this—to have a fit, which includes knocking out his boss's four front teeth and biting off his mother's ear, to return instantly to a normality so forgetful of current events as to propose to his toothless and earless comrades that they join him in saying grace before dinner.

So it has proved to be with me. I simply don't remember what I said or did. That I shouted and screamed my outrage in an agony of facing unbearable truth seems a reasonable assumption. That I neither knocked in Maud's teeth or bit off her ear was demonstrable after the fact, although that circumstance may have been due only to her youth and physical agility.

All I'm sure of—the total result of Maud's amiable comment on my day-to-day Venetian behavior—is that my madness grew up a bit, grew in grandness, in arrogance, in mock invincibility, in all the tools, in short, that are required to sustain despair in the spirit. No mathematician, I would propose a tentative equation: High talent plus its general ridicule plus total indigence equals insufferable human behavior in talented ass-heads.

The only other thing I know from those particular times—and I know so little with any certainty—is that Maud and I came to some sort of an end. I use vague words because specific ones won't fit. Although Maud never again spoke to me in such incautious language—indeed, she stayed on with me docilely until my Venice work was done and returned with me to London,

lived under my roof, or succession of roofs, for some time after
—things were never the same between us. Only poverty, the
gravest sin, kept us together. Maud began to pose again for
other artists; I found new companionship.

In fact, one such companion—whom I referred to as "an
infidelity to Maud," hoping, I suppose, that Maud would hear of
it and be hurt by it—bore me a child, a girl child. I have here
and there been making gentle sport of what refers to itself as the
avant-garde, and now I must take a step backward. The mother
of my child was a young *avant-gardiste* painter of sorts who was
even a little *en avant* of her fellows in that she rejected not only
all artistic precedents from the past but all social precedents as
well, including the institution of marriage. She did not choose
to marry me. (She was not hugely pressed, to be frank). How-
ever, she was heiress to an enormous amount of money—which
seems to account for any number of radical decisions among the
avant-garde—moved to Paris with my unofficial child, I have
been told, and set up a salon where she could be admired for
her daring ways.

My children, and there are several, as I believe I have noted,
do not particularly interest me. That is, of course, because, as
an unmarried man, I recognize that they are *not* my children in
any real sense, but the children of their various mothers who
will bring them up. God only knows what insidious folklore the
poor little chaps are taught about their father; it doesn't really
matter.

I did not, and do not, believe that artistic talent—I cannot
speak of any other kind—is transmissible from one generation
to another. History is all against the notion. The combined off-
spring of serious artists, measured in terms of countable idiots
and general clots, tends to take the air out of the balloon. Skill
may go on; genius—if the word does not send you streaking to
an adventitious commode—has only one life. That life was mine,
was "Whistler's," and to go snuffling about to find its extension
in another generation was a waste of time. What would con-
temporaneous folk have made—to alter the metaphor slightly—

302

of a composer named Wolfgang Amadeus Mozart, Junior? Well, yes. One "Whistler," many people would agree, and for a wide variety of reasons, is quite enough, not only for a generation but for eternity. I am of their number.

It was back to London now, and at the start a pair of furnished rooms near Oxford Circus. I no longer painted portraits (with a very, very few most happy exceptions in the course of several years, for the plain reason that nobody asked me), nor did I paint anything else worth mentioning. I had no time for painting.

I came back to fight the Philistines, armed with my scorpion's sting, to be "Whistler," the Personage, for there was no market for the painter. The public figure, the highly quotable conversationalist, the writer of letters to the papers, each a barbed arrow, meant to hurt, the crazy man who strode the boulevards dressed each day in clothes outrageous enough to merit incredulous attention in the press and the humor magazines, a figure of such desperate self-advertisement that when someone spoke to me of my quantity of friends, I replied: "No, you've missed the point, you see. I am so much the fashion I cannot afford to have friends."

My cane grew to become nearly as tall as myself, a series of collars sprang from the neck of my long overcoat, my hat shot up three inches in height. No one was spared. At the opening of the Royal Academy I drove up in a hansom and entered the gallery alone, leading a white Pomeranian dog on a yellow ribbon. I spoke to no one, but my presence hushed the place. I inspected the pictures on the walls through my eyeglass, and very audibly murmured: "I haven't stayed away long enough, it appears. Still the same old sad work. Dear me."

It was not, in the beginning, easy to sustain my special character. Public ostentation costs money, and I had none. And there is absolutely no profit in being a shabby showoff. Gaudiness is all. The role, indeed, requires more ready cash than being a bogus Balkan prince, of which our society boasts many, but

303

those chaps have bogus coronets and decorations and things like that, which make an impression. That was not my case. My plan —if outraged madmen may be said to have plans—was to destroy by mockery all of proper London town that had dared to jeer at "Whistler." (Costermongers, saints and constables would be exempted and allowed to continue functioning so long as they stuck to tradition.) But my cause lacked money, you see.

Which brings me to God, Who has always puzzled me. God has in His possession every possible reason for overlooking Whistler in parceling out rewards for merit earned. But His record, in my case, is otherwise. It is very odd. It's almost enough to make me believe in Him, although my view of life as it has been presented to me rejects anything so patently bizarre. Still, God—and I can't really think of anyone else to credit, or blame, take your choice—rather mysteriously took over.

I would have imagined that God would have to be an absolute idiot to look patiently on Whistler's affairs. I, personally, would have paid no attention at all. But God did, or so I sometimes imagine. Perhaps He laughs a lot, which might explain much awkwardness we tend to take seriously. Anyhow, in my dilemma of being the loudest mouth in London on a pauper's income, God suddenly made me rich, or more or less rich. Destroy no Annunciations, no Nativities, turn no ikons to the wall. Perhaps God has some interest in symbols, although I can't imagine why. But play it safe. Christmas trees are relatively inexpensive.

My comparative riches came to me altogether unexpectedly. I have already reported that when they were exhibited in London my Venice etchings were described in the press and in the leading art journals as clearly the work of either a charlatan or a lunatic or, to be absolutely on the safe side, of both. Only a very few etchings were sold, at very low prices, their brave purchasers being immediately categorized with me as fellow lunatics, and brought in barely enough money to the Fine Art Society to get back the miserly advance they had paid me.

And this at a time, mark you, when the British public had for some reason not understood by me decided that etching was all the thing; a great, fashionable vogue for etching emerged. All of a sudden etching was more "refined," more "subtle" than painting, more "pure because lacking all recourse to flamboyant color." And so forth. Color-blind etchers, who for years had been squinting earnestly over their work in ratty attics, un-visited except by dunning greengrocers, were suddenly led totter-ing and blinking out into the sun like so many reprieved convicts to find their beggar's cups abrim with guineas, or anyway shill-ings; by then they couldn't very securely tell the difference.

Painters of some general reputation, sniffing the wind, threw down their brushes and daringly took up the etcher's needle, not exactly an amateur's toy, and ruined enough good copper to cover the bottom of a capital ship of the line. Many profited rather splendidly from the vogue. Whistler was not among their number. Whistler, who, in a possibly unsettling burst of mod-esty, I shall describe as only the *second* greatest etcher in the history of that art, sold to the public only enough etchings to pay the Fine Art Society what he already owed them, leaving him, of course, exactly where he started.

But there was a funny side. Thank God there is usually a funny side. There was a leader at the head of this great new etching army, its busiest and most successful practitioner. This extraordinary new head-man etcher was no other than my own brother-in-law, darling Debbie's doctor husband, Seymour Haden, in whose house I had stayed all those years ago on my arrival from Paris with my friends Legros and Fantin-Latour. Seymour had been a sort of putterer in the craft even then, I remembered, but one could hardly have anticipated anything as lunatic as this.

Gone was plain old Seymour. Well, of course, he had never been plain old Seymour to me, since plain old anybody suggests nothing worse than some sort of affable bore, and Seymour had always had much less to recommend him than that. He had, in-deed, only gained in general pomposity, self-esteem and con-descension to people he deemed less worthy than himself. But

305

he had now also become Sir Francis Seymour Haden—his knight-hood having something to do with surgery, I don't know what; I only want to make clear it had nothing to do with etching—grand satrap of the new vogue, president of art societies and so on, subject of flattering popular articles. Amazing!

Well, you know, perhaps it was not so amazing, due to a very curious and widespread public illusion. Because a surgeon can, as a result of his training, with his hands cut us up and (sometimes) put us back together again, which is anyhow more than the rest of us can do, even sometimes, we tend to transmogrify his hands into hands quite unlike our own, capable of extraordinary excellence in activities totally unrelated to his normal work. Let but a surgeon show even the faintest competence at playing the violincello or knitting tea cosies and winter undergarments for his friends, and we stand back aghast at the subtlety of his accomplishment. It was all on account of his "surgeon's hands," you see.

But Seymour had worked the surgeon game well beyond mundane things of that sort. *Etching* was a brilliant stroke of the imagination for a surgeon. The public, if it ever thinks about etching at all—and it thinks about it only on the occasion of total eclipses of the sun occurring on even-numbered Wednesdays in Lent—but when it does think about etching it is able, for some mad reason, to equate it with surgery. The surgeon's scalpel mysteriously becomes the etcher's needle, the etcher's untouched plate becomes the exposed human body, and similar rot.

The anxious metaphor is not complete, of course, for what one would have supposed to be a reason hardly worth mentioning: A surgeon is a most extraordinary technician, no doubt about it, and I, along with the rest of the world, admire him his skill in knowing how to attach this tube to that valve and all the rest, with his capable hands. But that has nothing whatever to do with allowing him a side trade as an artist.

It may very possibly be (of course I don't believe a single word of this, but I must give an impression of fairness) that surgery is equal in dignity and importance to serious art. To dis-

semble further, let us imagine it to be *more* important than art. It doesn't matter; what matters is only that the two have nothing to do with each other. There is no more inherent relationship between surgery and etching than there is between standing for Parliament and robbing city banks. They are simply different lines of endeavor.

So good old Seymour etched like the surgeon he was and was widely applauded because of the unlikeliness of the whole thing. For some reason, or several reasons—I've forgotten them now—I knocked Seymour Haden through the plate-glass front window of a relatively fashionable restaurant. He was not seriously hurt, though he did bleed a bit, and we have never spoken one word to each other again. Our angry discussion, as I remember it, had nothing to do with etching, only family matters.

But to get back to God and me. If God was not to allow me to run in the great London etching sweepstakes, that did not mean there were no other plans for me. In Venice I had made a great many pastel drawings, sketches really, intended more to remind me of some particular scene or bit of architecture than anything else, something I might later use in a painting. It was a practice I had followed for years, particularly in sketches for my Thames nocturnes, and for a purely practical reason. On the river I often worked at twilight, in fading light, and I had done the same on the canals in Venice. The trouble with drawing in fading light, with my none too perfect vision, with more conventional materials such as pencil or charcoal on white paper, was simply that I couldn't see what I was doing.

By reversing the procedure and drawing on dark paper— gray, blue, chocolate brown, even black—with light pastel crayons, I could see what I was doing until it was almost night, watching the stroke of my hand even though sometimes I couldn't even see the paper I was drawing on.

As I've said, these pastels were of no great importance, except for my special purposes, and I had accumulated scores of them. Their value to me may be judged by the fact that on sev-

eral occasions I actually *gave* a few of them to one or another of my adoring slaves, the young art students, if the recipient had just performed some gigantic and disagreeable favor for the Master and had been repaid for his pains with the Master's sarcastic—though widely quoted—insult. Any single example will do to illustrate hundreds of others:

Adoring young art student: "Oh, Mr. Whistler, while I was out walking today I passed by your studio."

Whistler: "Thank you."

And so on. Such a slave might just possibly receive in the course of his expectable lifetime one—rather small and rather less good than the others—pastel drawing. Should the Master in his bounty condescend to affix to the small drawing a small butterfly, the slave was subject to fits of ecstasy so grave as to alarm his family and close friends into alerting the crazyhouse.

But no work from Whistler's hand is wholly inconsequential, as we've discovered, excepting only his very best, which is at least funny. My pastels, though, took me by surprise. I mean, of course, what happened to them. They were very skillfully drawn, naturally. They were highly decorative; they were swift and gay and made people enjoy pointing out to each other how full a scene an artist could indicate in a few lines. But, to me, at least, they were and always will remain sketches for more serious work.

But let us look in at the Fine Art Society, having lost their stingy bet on Whistler the Etcher, although they at least got their money back. Somebody in that strange place got the pastels idea. Why not? Costs nothing but the sweeper and a bit of heat. Good money sometimes follows bad. Run a tatty show. (No, Whistler won't allow that, awkard chap.) All right, then, run a good show and see whether pastels just might be the thing this season.

So that's what they did—a very stupid decision, it seemed to me—and it worked out in the most extraordinary way.

On the first day of the exhibition—there is no good in asking me why—six hundred pounds' worth of pastel drawings were sold. On the second day, as I tottered back to keep the

score and mark up the prices, twelve hundred pounds were sold!

Eighteen hundred pounds fallen from the sky for the most frivolous of work; my portraits, my nocturnes and harmonies were at the pawnbrokers, the whole lot redeemable for less than one hundred. Ha-*ha!* Well, I redeemed them, some even at reduced prices, so anxious were the good uncles to be rid of them. It was a damn shame, of course, that I didn't have more pastels on hand, but one simply must not have the bad manners to argue with a God who can produce eighteen hundred pounds out of nowhere, so to speak. Still, it *was* a pity I'd gone around giving away pastels to people.

Never mind. My new madness was well encouraged by my new windfall, and that was what was important to me. Maud and I moved into grander quarters, a house off Kings Road, Chelsea, to be close again to the Thames.

(Why Maud and I together at this point in our lives? I can only answer that when one has determined to make the world take great notice of him, certain smaller decisions are simply easier not to make than to make. Not much of an answer, I know, but such was my case. Stick to important matters, you see.)

Also, I took a very splendid studio in Tite Street, Number 13, only a few doors along the street from my lovely White House, near enough to sharpen my anger against those who had deprived me of it. The new studio was to be my swarming hornet's nest, and so it became, in a manner of speaking.

Affluence increased the grandeur of my ways, too. When I was presented with the large check for my success, it seemed to me that the presenter acted with a certain casualness. I threw it back in his face.

"This is careless of you," said I, teaching the gentleman good manners. "You push the check toward me, and you do not realize what a privilege it is to be able to hand it to the Master. You should offer it on a rich Old English salver and in a kingly way."

The widely read British critic Frederick Wedmore, at a

large reception, after hearing Whistler at some length, inquires plaintively, "But what are *we* to do who find ourselves in disagreement with Mr. Whistler's principles?"

"Do, my dear sir?" replies Whistler, not inclined to waste time. "Why, die!"

My mother died in the early spring of 1881. It was an expected event, surprising no one. No, I doubt that such is ever entirely true of anyone's death. I mean only that my mother had been ill in a home by the sea in Hastings since 1876, nearly leaving, but always returning to, life for more than five years, her death only the leaving from which she didn't return.

My brother, Dr. Willie, had gone down from London to stay with her for a day or two, and from Hastings he sent me a telegram suggesting I should join them. That was Willie's way of putting things. A good doctor does not alarm the patient's relatives, even if the relative happens to be one's own brother. But Willie is a good man as well as a good doctor and may even have held some small grain of hope in his heart, against the logic of his science, as all good doctors learn they must.

Willie's telegram reached me in the middle of those wild few days when I was selling pastel drawings like hot chestnuts on a winter morning. The telegram's seeming lack of urgency—although I knew my brother well—told me I could hold off for a day. Which I did, and when I arrived at Hastings my mother was already dead.

No one should ever try to explain to anyone else his remorse at the death of his mother, and for a very good reason. Quite apart from public remorse in general being vulgar, in the particularity of mothers it is also a bore. *Everybody* has a mother, and when she dies we, her offspring and survivors, are harried by guilt, by the summing up in secret anguish of all our sins of omission and commission—the visits not made, the letters not answered, the plain, convenient lies, the pretense of interest in the tenth-told tale (although that may not have been altogether unkind), the hurtful, cutting word, and so forth.

But the true reason that it is a bore lies in the simple fact that everyone already knows all the facts. There is no new news to be had. Your mother's death and my mother's death are two of a kind, interesting only in a game of poker. Otherwise, we have nothing to say to each other. We are the same, and we can only bore each other, possibly with different details. Except for those happy few who had real monsters for mothers and can entertain us with monster-mother stories, we are all alike.

Which, of course, in no slightest way negates the validity of our remorse. In my own case, my mother was a kind and gracious woman who took care to show me that she was proud of my first childish promise in St. Petersburg; a woman of implacable courage, of somewhat limited imagination, of total faith in her God, a believer in the essential worth of existing institutions, of proper social conduct based upon custom and the golden rule. In short, a woman who, had she not been my mother, I would probably not have chosen even as an acquaintance let alone an intimate.

But the mother game, as is clear, is played by separate rules—no, without rules. I put the matter somewhat differently to Willie.

On the day of our mother's funeral there in Hastings, Dr. Willie and I went for a walk together after the ceremony, down close to the sea. We trudged along the windy shore side by side for a time, holding our hats to our heads without trying to speak. Our promenade took us across the field on which Saxon Harold had some eight centuries before tried to hold back Norman William invading from the sea, at the cost of his valiant life. There is certainly no analogy intended and I make none.

But I give you Whistler in the matter of mothers, spoken on England's most fateful battlefield. Anywhere would have done, of course. It is only about the death of mothers.

"Willie, Willie!" I cried into the cutting wind, guilty tears filling my eyes. "I should have done what she wanted me to do. Everything would have been all right if I'd just become a parson!"

311

I dare say it's the funniest thing I ever said.

"Jemmy," she had said when I started to paint her, "you will make me famous."

"No, Mother," I had said, "you will make *me* famous."

As it turned out, we were both right. For all the wrong reasons, as is usually the case. Also, my mother didn't live long enough to see her half of the prediction made fact, as is usually the case. It doesn't finally matter. Anna Mathilda Whistler, a strong American gentlewoman, will be remembered. Her portrait now hangs on a wall in the Louvre in Paris, just to make the point.

THIRTEEN

\mathcal{N}OTHING IN the least surprising happened to mad Whistler until the year 1886, and then it was only a picnic, an *al fresco* luncheon served on a coffin lid, as a matter of fact—an end to madness, however. Quite unexpected.

Only one single event is worth recording in the intervening years of public notoriety before my blessed picnic and my release. I find that even I weary of Whistler's angry japes and quarrels and lawsuits, his abrasive tongue, although God knows I was the one who made sure the news of such matters reached the greatest possible public. In that time I worked as hard over an acidulous letter to the *Times* as ever I had worked over any earnestly conceived nocturne. I also forgot to paint. Not forgot *how* to paint, just to do it.

The event I'm speaking of was my Ten O'clock lecture, the social and, in a curious way, the theatrical event of the London season of 1885.

My Ten O'clock was neither more nor less than an outraged response to the lying, thieving, altogether meretricious public career of Oscar Wilde. Oscar, to be blunt, has never once had an original idea about art. Yet he had been flapping about this island—not to speak of America, *my* home, not *his*—in his self-assured, *bourgeois malgré lui* manner, spouting in frivolous epigram and hopeful aphorism every deadly serious precept about art that I had taught him over a number of years. Oscar was capable of taking my creed that art owes no obligation to morality, sentiment or tradition, and turning it into an advertiser's slogan: "Art for Art's Sake."

And the public was becoming confused, small wonder. It had recently been presented with an operetta by Gilbert and Sullivan called *Patience*, in which the leading character, Bunthorne, was clearly intended to represent Oscar's invention, the so-called "Aesthetic Movement," whatever that is. Now, Bunthorne was just as clearly intended to be Oscar himself in his most ridiculous manifestation. The actor who played Bunthorne carried an enormous calla lily throughout, one of Oscar's less attractive affectations.

But wait! Let me tell you in what other ways the actor had got himself up. He was, first of all, a relatively small and lithe man, in no way resembling the pachyderm-on-tippy-toes that is Oscar; he wore a wig of black curls at the front of which was a conspicuous white lock; he wore a mustache, a tuft of chin whisker, a single eyeglass, and throughout the performance he ended sentences by yelping "ha-*ha!*"

Damn! Damn! May God damn all prophets of confusion, all peddlers of easy lies! Even a relatively sane Whistler could not have endured such mockers of his faith; a relatively insane Whistler was a potential murderer.

Well, on a perhaps less noisy plane, something had to be done. And at once. As a general rule, I rarely find justification for what I do or think in other's words, but I found what I believe to be a just summation of matters as they stood in (of all places) a review in the *Times*, the writer, unfortunately anonymous, reviewing Oscar's *Collected Works*. The gentleman said: "With a mind not a jot less keen than Whistler's, he has none of the conviction, the high faith, for which Whistler has found it worthwhile to defy the crowd. Wilde had poses to attract the crowd. And the difference was this, that while Whistler was a prophet who like to play Pierrot, Wilde grew into a Pierrot who liked to play the prophet."

It was well enough said, but what does the great public know of literary criticism in the *Times*? Well, nothing, of course. It prefers the music hall and the buffoon on the popular lecture platform, which should not greatly surprise us. I laid my plans.

I began unostentatiously with a brief exchange of letters with Oscar in the columns of the *World*.

I wrote: "What has Oscar in common with art, except that he dines at our tables and picks from our platters the plums for the pudding he peddles in the provinces? Oscar—the amiable, irresponsible, esurient Oscar—with no more sense of a picture than of the fit of a coat, has the courage of the opinions . . . of others."

Oscar replied: "With our James, vulgarity begins at home, and should be allowed to stay there."

I replied: "A poor thing, Oscar, but, for once, I suppose your own."

But this sort of thing, while mildly invigorating to me and possibly titillating to certain readers of the *World*, was not genuine artillery, was not the sort of bold battle plan to be expected of a West Pointer. I needed desperately somehow to separate myself once and for all from Oscar's cheap distortions of everything I'd taught him, to go back to beginnings as I'd conceived them and to explain those beginnings to as many people as I could make listen. If I never painted another picture, they should at least know what Whistler stood for.

To do that properly, of course, I would have to play Oscar's game, the lecture hall. But as I am a more serious man than Oscar I must address a more serious audience, and as I am, in every way but the merely physical, a larger man than Oscar I must address a far, far larger audience. It was only fitting.

I did both, as it turned out, all made possible through the unlikely offices of Mr. and Mrs. D'Oyly Carte, the producers at the Savoy Theater of the offensive *Patience*. While it is manifestly clear to everyone that the huge popularity of Mr. Gilbert and Mr. Sullivan's operettas with the general public has made the D'Oyly Cartes successful, it is not so widely known that they are charming people, capable of responding to injustice with positive action.

I had known the D'Oyly Cartes here and there, I don't know where, in London houses, it doesn't matter. Now I suddenly

pursued them like an avenging angel, black wings flapping in the sky just above their heads, demanding that they redress their sins against me in *Patience* by arranging for me a public appearance in London that would eclipse both Oscar and *Patience* all on one night.

Whether through guilt or plain kindness—it is so very difficult to tell the difference—they managed to engage St. James's Hall in Piccadilly for one night, and they spread the word that Whistler would appear on October 20, 1885, to make mad the guilty and appall the free, and they sold tickets as fast as they are sold for the most popular Christmas pantomime or for cups of water in the desert.

Neither are infinite. The entire hall was sold out in four days. And why not? There are only so many plays a season; once seen they are seen. Only so many art exhibitions, fireworks displays, amusing criminal trials, gay flower displays for the benefit of those wounded in wars. Well, now. How about a ticket to a show to be conducted by our favorite American eccentric public entertainer? Mad, of course, but the jokes will surely be good. Cheap at twice the price. The season is so far pretty dull. Send a check, my dear, for we have nothing to lose but the money. On the whole it should prove more entertaining than Madame Tussaud's Wax Works. Whistler is at least still alive.

Assured of both a full house and a public anticipation of high, or low, comedy, I went to work. For two months I was no painter at all. When at last I had written what I wanted to say, and committed the whole to memory, I visited Mrs. D'Oyly Carte in her office daily, sometimes hourly.

Although she was trying to put on a new operetta to be called *The Mikado*, scheduled to open at the Savoy Theater in three weeks, I consulted her night and day about every detail of my coming lecture from the lighting and the design of the programs down to the very dress of the ushers. At times it seemed to me she grew a little impatient, which was curious of her. I mean, given the necessity of dividing one's attention between the producing of a Whistler lecture on art on the one

hand and producing some musical farce about a nonexistent Japan on the other, one would have thought the choice a simple one. In any case, I got my way in everything, including the hour of my appearance, which in turn gave it its title.

Why Ten O'clock? The time struck some people as peculiar, latish, but I have been walked over by latecomers in London theaters after the curtain has gone up for so many years that I was determined my audience should be as comfortable as possible, having had ample time for its dinner, its port and cigars for the men, its gossip for the women, that all should come to my lecture in a properly exalted, or at least satisfied, frame of mind. And come they did.

At a bit before ten o'clock on that February night Piccadilly was choked with elegant carriages, and by the appointed hour their occupants had moved leisurely to their places in St. James's Hall, the most fashionable audience London could produce, with no notion of what to expect beyond an amusing entertainment of some sort. Would their comical Jimmy do a dance turn, sing, draw cartoons, stand on his head, perform conjuring tricks?

Well, they would see no Oscar Wilde, no velvet suits or calla lilies, no flowing ties or mincing steps.

Once the auditorium was dark, there remained, white-lighted on the stage, only an unadorned black lectern at its center. Then from the wings they saw enter an American gentleman, in beautifully cut evening dress—rigidly proper to the last stitch—in one hand gloves and an opera hat, in the other a cane, in the right eye a glittering eyeglass. He sets the cane against the wall, places hat and gloves on the lectern, toys briefly with the monocle, and begins to speak with solemn dignity.

A considerable disappointment, just at the beginning, I have no doubt. Where were Jimmy's juggling balls, where the sword he was meant to swallow? No minstrel songs? Here is a bit of what I said.

"Ladies and gentlemen: It is with great hesitation and much

317

misgiving that I appear before you in the character of the Preacher.

"If timidity be at all allied to the virtue modesty, and can find favor in your eyes, I pray you, for the sake of that virtue, accord me your utmost indulgence. . . .

"I will not conceal from you that I mean to talk about Art. Yes, Art—that has of late become, as far as much discussion and writing can make it, a sort of common topic for the tea table.

"Art is upon the town—to be chucked under the chin by the passing gallant—to be enticed within the gates of the householder—to be coaxed into company, as a proof of culture and refinement.

"If familiarity can breed contempt, certainly Art—or what is currently taken for it—has been brought to its lowest stages of intimacy.

"The people have been harassed with Art in every guise, and vexed with many methods as to its endurance. They have been told how they shall love Art, and live with it. Their homes have been invaded, their walls covered with paper, their very dress taken to task. . . .

"Humanity takes the place of Art and God's creations are excused by their usefulness. Beauty is confounded with virtue, and, before a work of Art, it is asked: 'What good shall it do?'

"Hence it is that nobility of action in this life is hopelessly linked with the merit of the work that portrays it; and thus the people have acquired the habit of looking . . . not *at* a picture, but *through* it, at some human fact, that shall, or shall not, from a social point of view, better their mental or moral state. So we have come to hear of the painting that elevates, and of the *duty* of the painter. . . .

"A favorite faith dear to those who teach is that certain periods were especially artistic, and that nations, readily named, were notably lovers of Art.

"So we are told that the Greeks were, as a people, worshippers of the beautiful, and that in the fifteenth century Art was

ingrained in the multitude. That the great masters lived in common understanding with their patrons—that the early Italians were artists—all—and that the demand for the lovely thing produced it.

"That we, of today, in gross contrast to this Arcadian purity, call for the ungainly, and obtain the ugly. That, could we but change our habits and our climate—were we willing to wander in groves—could we be roasted out of broadcloth— were we to do without haste, and journey without speed, we should again *require* the spoon of Queen Anne, and pick at our peas with fork of two prongs. . . .

"Useless! Quite hopeless and false is the effort! built upon fable. . . .

"Listen! There never was an artistic period.

"There never was an Art-loving nation.

"In the beginning, man went forth each day—some to do battle, some to the chase . . . until there was found among them one, differing from the rest . . . who traced strange devices with a burnt stick upon a gourd.

"This man . . . who cared not for conquest . . . this designer of quaint patterns—this deviser of the beautiful—who perceived in Nature about him curious curvings, as faces are seen in the fire . . . was the first artist.

"And presently there came to this man another—and, in time, others—and so they worked together; and soon they fashioned from the moistened earth forms resembling the gourd. And with the power of creation . . . presently they went beyond the slovenly suggestion of Nature, and the first vase was born, in beautiful proportion.

"And the toilers tilled, and were athirst; and the heroes returned from fresh victories, to rejoice and to feast; and all alike drank from the artists' goblets . . . taking no note the while of the craftsman's pride, and understanding not his glory in his work; drinking at the cup, not from choice, not from a consciousness that it was beauitful, but because, forsooth, *there was none other!*"

(Well, now, you know, the thing was, in an odd way, beginning to catch fire. I could feel it coming across to me all the way up there on the stage—what I'd so often heard actors talk about—the sympathy, there is no other word, between a great faceless audience and the single performer struggling for its attention. Irritated at first, no doubt, because its expectations were not being realized, my elegant audience seemed more and more to relax its inflexibilities as I went along, as if to say: "Oh, well, if this is Jimmy's night to be serious, let him be. After all, that *too* is a novelty. Since we're here, we may as well pay attention. Let's listen to those curious things he's saying about art; surely we won't be defiled just by listening." And they became quiet and attentive and serious—laughing only when they were supposed to laugh—changing their terms of attendance, so to speak. I polished my eyeglass briefly and returned it to my eye. Let me go on. I'll skip, of course, but not the essence, not the point.)

"And time, with more state, brought more capacity for luxury . . . whereupon the artist, with his artificers, built palaces, and filled them with furniture, beautiful in proportion and lovely to look upon.

"And the people lived in marvels of art—and ate and drank out of masterpieces—for there was nothing else to eat and drink out of, and no bad building to live in; no article of daily life . . . that had not been handed down from the design of the master . . .

"And the people questioned not, *and had nothing to say in the matter.*

"So Greece was in its splendor, and Art reigned supreme—by force of fact, not by election. . . . And history wrote on, and conquest accompanied civilization, and Art spread, or rather its products were carried by the victors among the vanquished from one country to another. And the customs of cultivation covered the face of the earth, so that peoples continued to use what *the artist alone produced.*

"And the artist's occupation was gone, and the manufacturer flooded with all that was beautiful, until there arose a new class,

who discovered the cheap, and foresaw fortune in the facture of this sham.

"Then sprang into existence the tawdry, the common, the gewgaw. . . . And the great and the small, the statesman and the slave, took to themselves the abomination that was tendered, and preferred it—and have lived with it ever since!

"And the artist's occupation was one, and the manufacturer and the huckster took his place. And now the heroes filled from the jugs and drank from the bowls—with understanding. . . .

"And the people—this time—had much to say in the matter —and all were satisfied. And Birmingham and Manchester arose in their might—and Art was relegated to the curiosity shop.

"Nature contains the elements, in color and form, of all pictures, as the keyboard contains the notes of all music. But the artist is born to pick and choose. . . . To say to the painter that Nature is to be taken as she is, is to say to the player that he may sit on the piano.

"That Nature is always right is an assertion, artistically, as untrue, as it is one whose truth is universally taken for granted. Nature is very rarely right, to such an extent even that it almost might be said that Nature is usually wrong. . . .

"How little this is understood, and how dutifully the casual in Nature is accepted as sublime, may be gathered from the unlimited admiration daily produced by a very foolish sunset.

"But set apart by them—the gods—to complete their works, he—the artist—produces that wondrous thing called the masterpiece, which surpasses in perfection all that they have contrived in what is called Nature; and the gods stand by and marvel, and perceive how far away more beautiful is the Venus of Melos than was their own Eve."

(Here, for a bit, I explained to my fancy listeners the essential idiocy of the *guilt* about art inflicted upon them by such preachers as Ruskin, the awful gravity, asking them instead to be brave and themselves. No literature of art necessary, no solemn interpreters.)

"We will have nothing to do with them! The artist, in fullness of heart and head, is glad, and laughs aloud, and is happy in his strength, and is merry at the pompous pretension—the solemn silliness that surrounds him.

"For Art and Joy go together, with open boldness, and high head and ready hand—fearing naught, and dreading no exposure.

"If Art be rare today, it was seldom heretofore.

"It is false, this teaching of decay.

"The master stands in no relation to the moment at which he occurs—a moment of isolation—hinting at sadness—having no part in the progress of his fellow men.

"He is also no more the product of civilization than is the scientific truth asserted dependent upon the wisdom of a period. The assertion itself requires the *man* to make it. The truth was from the beginning.

"So Art is limited to the infinite, and beginning there cannot progress.

"A silent indication of its wayward independence from all extraneous advance is in the absolutely unchanged condition and form of implement since the beginning of things.

"The painter has but the same pencil—the sculptor the chisel of centuries.

"Colors are not more since the heavy hangings of night were first drawn aside, and the loveliness of light revealed.

"Neither chemist nor engineer can offer new elements of the masterpiece.

"False again, the fabled link between the grandeur of Art and the glories and virtues of the State, for Art feeds not upon nations. . . . How superhuman the self-imposed task of the nation! How sublimely vain the belief that it shall live nobly or art perish. Let us reassure ourselves; at our own option is our virtue. Art we in no way affect.

"A whimsical goddess, and a capricious, her strong sense of joy tolerates no dullness, and, live we never so spotlessly, still may she turn her back upon us.

"As from time immemorial she has done upon the Swiss in their mountains. What more worthy people! Whose every Alpine gap yawns with tradition, and is stocked with noble story; yet the perverse and scornful one will have none of it, and the sons of the patriots are left with the clock that turns the mill, and the sudden cuckoo, with difficulty restrained in its box.

"For this Tell was a hero! For this did Gessler die!

"Art, the cruel jade, cares not, and hardens her heart. . . . So in all time does this superb one cast about for the man worthy her love—and Art seeks the Artist alone. . . . Ages have gone by, and few have been her choice.

"Countless, indeed, the horde of pretenders! But she knew them not. . . . Their names go to fill the catalogue of the collection at home, of the gallery abroad, for the delectation of the bagman and the critic.

"Therefore we have cause to be merry!—and to cast away all care—resolved that all is well—as it ever was—and that it is not meet that we should be cried at and urged to take measures!

"Enough have we endured of dullness! Surely we are weary of weeping . . . when there was no grief—and, alas! where all is fair!

"We have then but to wait—until, with the mark of the gods upon him—there come among us again the chosen, who shall continue what has gone before. Satisfied that, *even were he never to appear*, the story of the beautiful is already complete—hewn in the marbles of the Parthenon—and broidered with the birds upon the fan of Hokusai—at the foot of Fujiyama."

Well, now, you know, the critics were alarmed by the whole thing, as they were meant to be. Oscar, in particular, in his review in the *Pall Mall Gazette*, took the rather desperate tack of declaring that painters weren't really artists, anyway, or only second-rate ones, and their opinions could therefore safely be ignored. The *poet*, he solemnly announced, was the "supreme Artist, for he is the master of color and of form, and the real

musician besides, and is lord over all life and all arts; and so to the poet beyond all others are the mysteries known."

Yes, yes, Oscar. You must very soon invite Alfred Lord Tennyson and Velásquez to lunch to discuss the matter. Naturally, neither will know what the hell the other is talking about, which could make for a dullish meal, except that I know somehow you will keep the conversation afloat, as is your delightful way, setting reason resolutely apart.

But that was only Oscar and that was only the critics. The public, rather oddly, since my experience with it had been somewhat otherwise, responded differently. I don't mean to the Ten O'clock alone—after all, only a few hundred people had heard it—but, in a curious and unexpected way, to me, to Jimmy Whistler, convicted mountebank. But all that must come later, if at all.

I'm getting peevishly tired of discussions of Art—particularly with that capital "A." I've said my bit. Perhaps I should never mention the word again in this genial review of my life as artist. I wouldn't mind.

Let's quickly get back to my charming outdoor luncheon off a coffin lid, for, as the Oriental philosopher has pointed out, one can draw a circle starting anywhere, meaning that joy can be discovered anywhere along the anxious curve.

Ah, listen.

FOURTEEN

\mathcal{W}HY DOES one picnic from off a coffin lid?
Well, for one thing, of course, a coffin resting
on two sawhorses comes out about the right height. But I realize
that that explanation alone will not satisfy all hands. Some, I
fear, might look upon such an action as bizarre, even unfeeling
or macabre. To those, then, I would submit that the propriety or
impropriety of lunching off a coffin (suitably covered with a
snowy damask tablecloth—I should have mentioned that be-
fore) depends wholly upon the coffin's occupant. To make my
point, had I lunched off the lid of John Ruskin's coffin, for ex-
ample, considering our relationship in life, I should have re-
garded my behavior as nothing short of obscene.

But in the pastoral scene I am about to describe, the coffin's
resident was my old and cherished friend, Edward Godwin,
architect and builder of my beautiful White House in Tite Street,
no longer mine. Godwin, gifted artist, of easy charm, wildly
funny, both sensible and sensitive, casual patriot and rotten
husband, my friend. He was guest of honor at the picnic, you
see.

It came about in this way, changing my life as profoundly
as it changed his. Well, no, I suppose being dead is a rather more
profound change in one's life than merely finding both sanity
and joy while still alive, although it can be difficult for the
survivor to credit it, such is our idiot pride in mortality.

Godwin had died, of living too much and similar symp-
toms—not too long, we were about the same age—leaving be-
hind him a number of noble buildings, the love of all sorts of
people and nothing at all else.

Of course he also left behind his wife, delightful and charming Beatrix, although in another sense he had already left her. Godwin's prodigious number of affairs with women were everybody's gossip and about as fraught with novelty or interest to most of us as the London-to-Brighton railway schedule.

This could hardly be true of Beatrix, however, in spite of her, to me, almost incredible good humor. And so they had lived apart for some time past, a friendly separation although one they could ill afford, each going his own way. Beatrix had a tiny income of her own left to her by her father, John Philip Birnie, the sculptor—the very least he could have done considering he was one of the perpetrators of the Albert Memorial.

Beatrix had taken lately to dropping into my studio toward the end of the afternoon, more frequently than before, to my delight if not always to my work's profit. It mattered not at all to me. She came, we drank sherry and laughed at whatever the other one said, drew each other's pictures, danced sometimes, flirted. The mad, raging middle-aged painter, the neglected, beautiful wife. Flirted? Well, you know, to flirt is a muffin-headed transitive verb of no precise meaning, so far as I know, a euphemism to cloud over any state of affairs lying somewhere between egregious eye-batting and adultery. I have felt singularly left in the dark by a journey to a dictionary. "Flirt (flĕrt), v.t., to move to and fro with a sharp rapid action." At least what flirting means is up to the flirters, apparently.

But I mustn't make sport of a serious subject. Serious, at least, as it proved to be to me. I changed her name—all in a jolly way, of course—from Beatrix to Trixie. Why Trixie? No rational reason, a gay-sounding name for a gay person, no more. But there is always more in our trifles than accident; there is always vanity, call it by as many other names as you like.

Beatrix was the name of another man's wife, you see, and another's daughter. Trixie was a new person, cut from the fresh cloth, my own invention. A new lover's lips must speak a new name, if only to show how new he is. There must be no con-

nection with the old, or one is in danger of being a mere continuation, which is unthinkable. Wise Trixie, kind and thoughtful and knowledgeable Trixie, knew this from the start and insisted that I never call her by any other name.

And so Godwin died one night in St. Peter's Hospital. Dr. Willie attended him to the last, although there was really nothing much even so capable a doctor as my brother could do for the shattered body of my Don Juan friend. Trixie and I were with him as was his old friend and patroness, Lady Archibald Campbell.

The first thing I did was to send a friendly emissary to tell Ellen Terry the news so that she and her (also Godwin's) children wouldn't hear of it first in the newspapers. Then we set about death's formalities.

Godwin had made it clear that he wanted to be buried in the village of Northleigh in Oxfordshire, where he had come from, so that was settled. The coffin was taken by train to a wayside station, then transferred to an open farm wagon, and the three of us—Trixie, Lady Archibald and I—climbed aboard. It was a glorious early October afternoon and as we jogged along the country road the ladies produced, from mysterious baskets they had carried, a simple but altogether pleasant picnic lunch which we ate in the circumstances I've already described.

"We must drink a toast to Edward," said Lady Archibald, gravely.

"And what should that be exactly?" said I. "Godwin was quite a different man to each of us and to everybody else, I should suppose, unless you count policemen."

"There's no good in fussing," says Trixie Godwin, smiling, and making an end of the matter, raising her glass of Bordeaux to the lovely autumn sky. "Edward was a man who lived his life the way he thought it should be lived, and that's quite enough for anybody."

We drank to that. (I'll drink to it any day in the year.) Although I did have the feeling Lady Archibald had been searching for a sentiment a bit on the loftier end.

That was the finish of the whole business. We buried Godwin in the corner of a field at Northleigh, and we rued him.

But the living are awesome people, and we return from our dead to ourselves with startling snap. All probably as it should be, you know. I'm not saying it shouldn't.

Beautiful, lonely, so-long-set-aside Trixie, within the week, now began to drop into my studio not at four but at three, and nearly every day. And everything began gradually to change—everything, everything, about my entire life.

It was passing strange and, I fear, in the telling will turn out more mawkish than stylish. It is at the very least awkward to describe how a fifty-two-year-old madman artist, the self-styled Master, arrogant strutter of fashionable drawing rooms and boulevards, public insulter of everyone and everything—it is awkward to describe such a one being restored to even relative sanity and humanity through the love of a gracious and generous young woman. It's too absurd to swallow, you know, and certainly not permitted in serious literature.

Even Jane Eyre, when she returns to her once rebellious and outrageous Rochester, now subdued, finds that he is at least blind. That's something, anyhow, showing that there are certain social drawbacks to be expected along the road from wickedness to reformation. But I wasn't even blind, you see, anyway not any more than usual. And all the same I was awarded both reason—or at any rate that portion of it with which I had been originally supplied—and joy as well. For a time. But I am anticipating events, a fault unknown to scrupulous Miss Brontë.

Trixie and I came soon to live in a wholly private world, amusing figures to the world outside, I'm sure, figures of gossip and conjecture, of no interest to us. We *were* funny, of course. Middle-aged people—well, Trixie only halfway middle-aged— fallen wide-eyed in love must be. Only young people are supposed to fall in love. They look better at it. The young man is tall and lithe, the young woman slim and graceful, the romance has been conventionally adorned.

Well, now, you know, Trixie was an inch or two taller than I, black-haired as a glorious Romany gypsy, beautifully approaching her fortieth year, pleasantly plump, and I was . . . well, you know what I was, every inch the West Point officer who had been expelled unjustly, standing straight as a finger in spite of being rather a bit over fifty, wielding my cane like a poignard. Lovers are meant to look otherwise. No matter. The heart does not hunt according to fiction, thank God.

Along about here it is not unreasonable to expect that Maud's name might come up, and so it does. Maud, with her little calling cards with "Mrs. Whistler" engraved on them, was not amused by the turn of events, as why should she be? While it was true that since our return from Venice Maud and I had lived together in only a strictly technical sense, each of us going his own way, we had lived together quite otherwise for a good many years.

And those years had naturally established in Maud's mind a sort of proprietary feeling, if not lately about me, at least about my house.

Although, as a matter of fact, she wasn't in it much any more. Modeling for other painters most days, she no longer bothered to keep up the household accounts or plan our meals. Her friends and my friends were two quite different sets of people. Still, Maud wanted things both ways, you see. She wanted to go her own way, but she wanted to go on being at least nominal mistress of my house at the same time. Awkward.

But things were fast changing. Where once my studio, when I was working, was closed to all but a few invited guests, including Maud, now Trixie was running in and out at any and all hours of the day or night, bringing her jokes and sweet buns for tea and an inexpressible gaiety over life in general. To my delight, but not to Maud's, as she explained to me one morning at breakfast. She chose the time judiciously, for it was not likely, though not impossible, that Trixie would turn up for breakfast.

"Jimmy," says Maud, gazing at me balefully across the top

of her teacup, "you're making an ass of yourself, you know."

"Yes, of course."

"Then why do you do it?"

"Habit, I suppose."

"People, important people—I hear the rumors—are laughing at you."

"As they always have."

"But, Jimmy, I'm not talking about your painting. This time it's quite different."

"Yes, it is, Maud."

"More serious. You and Mrs. Godwin prancing all about London to the theaters and restaurants and parties, acting like children in public places . . ."

"Would our behavior be more suitable to you in private places?"

"Oh, now you're just talking for the sake of talk, the way you always do. You know what I mean. Things aren't the way they used to be between us, I know that, but you might think of me. I'm the one who fought the day-to-day battle with all the unpaid servants and grocers and butchers . . . while you were off—"

"Off painting pictures that didn't pay them. Quite true. I'm sorry it wasn't better, Maud. But that only brings us to a very ordinary truth. Injustice is almost invariably the reward for sacrifice, tit is rarely paid for tat. Just as happiness can come suddenly through no deserving effort at all, fallen from the sky as a reward for absolutely nothing."

"Well, it shouldn't be like that."

"No, of course it shouldn't. I only said that it is. Tell me, Maud—" I paused to roll a cigarette because sometimes a moment of preoccupation has been known to lend temper to my words—"tell me, why do you want to run about with your little 'Mrs. Whistler' cards? I mean, what's the point?"

"You've always *known* about that, Jimmy?"

"Of course."

"You weren't meant to."

"Gabriel Rossetti got hold of one of them just before he died

last spring. Up to his ears in drugs, he made me a joke about it."

"A dirty, ugly man. What did he say?"

"No, no, you mustn't say that about Gabriel, Maud. He was on your side. He said: 'Since Mr. Whistler has turned out to be so far our century's leading mountebank, perhaps "Mrs. Whistler" through conjugal good nature may teach him to paint.' "

"I don't see anything funny about that."

"No, I suppose not. But the calling cards . . . I don't understand. We never promised each other anything, Maud, but the sharing of the razor's edge."

"Well, if you want to know—and it was precious little else I had—my calling cards gave me a certain standing with my friends . . . sometimes a little extension of credit with the tradesmen . . ."

"They *did*? I'm afraid you're flattering me, Maud, well beyond the cold facts."

Maud gave me a long, cool look and then neatly summed up the reason for her engraved calling cards, and perhaps much else. "Don't you see, Jimmy," says she, at length, "that it is better for a woman who is altogether alone to become attached to a man mentioned every day in the metropolitan newspapers as a charlatan than to attach herself to an honorable Mr. Smith who is never mentioned at all?"

"You put it well."

There was no way, of course, to dispute such admirable logic, nor did I try. Little was solved in this amiable conversation, however. And I was sorely tried. Maud would not take hints. I now needed dear, gracious Trixie as I needed breath and light, but how does your West Point gentleman maneuver?

It all worked out in a very srange way indeed. It all had to do with Art again, that awful word that has alarmed us and caused us so much trouble from the beginning.

Among my young men "followers" who called me Master and all that rot was a painter by the name of William Stott. Stott was a painter of very small talent who tried to imitate not

only my manner of painting but my manner of dress and speech and everything else as well. But he wasn't a bad fellow for all that, and he had a good little wife and a house in the country. Both of them were friends of Maud's and she used to spend weekends with them. It was this friendship that solved my dilemma.

Apparently Stott had worked out in his head a curious artistic theory that I suppose could be stated something like this: Since it had become plain to him that he would never become an intimate of his idol, me—having once ill-advisedly tried to keep me up till two o'clock in the morning telling me *his* notions about art—the next best thing was to paint his idol's sometime model, Maud. Which he did.

Well, that was all right, you know. Stott got half his equation and Maud got a few extra pounds. It was only that Stott—as unimaginative painters will—decided to paint Maud as "Venus" or "Nymph" or somebody, and as everybody knows both Venus and Nymph run about the woods naked as peeled hard-boiled eggs. Tradition demands it, and traditionalists presented with a Venus in a ball gown would be as outraged as they would be by a picture of a duchess *without* a ball gown. No, no, please, I am not the one to explain such matters; I merely report.

Anyway, Stott painted his nude Maud-Venus picture and when he was done he sent it to an exhibition at the British Artists, where it was accepted. At the same time a dealer of mine sent to the same exhibition a portrait I had done of Maud a few years earlier, which was also accepted. It was one I'd called "Arrangement in Black and White" and which some idiot gallery manager had shown as "La Belle Americaine"—idiot because Maud was approximately as American as Stonehenge. The only point to be made is that in my picture Maud was wearing frock, bonnet and furs.

Well, art critics, having so little to think about as they plod around this city, the art and the weather being what they are, suddenly stumbled onto a gold mine. Something amusing to write about at last.

For Stott, while an extraordinarily pedestrian painter, was at least a most accurate one. His Venus, bashing about naked in her woodland paradise, was Maud to the very life, no doubt about it. And in the next room at the gallery was *my* Maud, easily recognizable as the same model, fully clothed and decorous as you please.

The inference was clear—at least it was to critics and sniggering public alike. Whistler's chaste model had become Stott's naked one, and wasn't that a jolly turn of events? The critics had their malicious heyday in their papers; there was much laughter and shaking of heads in the drawing rooms, as the gossip-mongers explained to each other that a shared model was naturally the same things as a shared mistress, with Whistler in this case the cuckold.

Even in spite of my recent and relative return to sanity, in spite of Trixie's benevolent influence on my nature, when I learned on good authority that Maud and the Stotts also privately considered the whole episode a riotous good joke, it was too much. I was furious, very red about the collar, a distinctly second-rate portrait had I seen it on a gallery wall. And I acted.

Motives are always suspect, I suppose, and someone might have pointed out—and no doubt did—that a man who had made very nearly a second profession of ridiculing other people did not easily bear ridicule himself. And someone else might have pointed out that the greater my fury the better my excuse to send Maud packing. In any event, I reacted as instinctively as a good fencer answers a lunge with his riposte.

I wrote a delicately formal letter to Mr. and Mrs. Stott explaining that "*Madame*" was unwell and would surely benefit from a brief stay with them in the country. They invited her, Maud went, and I didn't see her again.

That is not strictly true, and I will digress from my rule of precise chronology this once to tell why it isn't. For Maud has played out her part hereabouts, and who among us doesn't like happy endings?

Several years after this event Trixie and I were sitting on

333

a bench in the Bois de Boulogne, lolling in the sun, holding hands, amazed at ourselves, feeding pigeons the little grains of corn that the vendor sold for a sou in a gaudy paper cornucopia. There is that long avenue down the center of the Bois, you know, and all of a sudden down it came a motorcar, a very elaborate early one, open like a landau, painted glistening black and yellow and driven by a chauffeur in a dashing uniform, moving at a stately pace. In the rear seat sat Maud, looking very lovely and no older than the rest of us in a fashionable broad-brimmed hat, a small pug dog in her lap, a parasol held lightly in one hand, and smiling gently. In passing, she didn't notice us pigeon-feeders, as indeed why should she?

I heard it all only second hand, but it is apparently the truth. Maud had wandered—no, Maud does not wander, she migrates, as do birds finding a particular climate unsuitable to their temperament—from London to Paris, where she almost instantly met the chap who owns Brazil. Or the Argentine or whichever it was. This good South American gentleman had fallen in love with Maud's clear charms and her red hair, just as I had, married her and shuttled her opulently back and forth from continent to continent and from townhouse to country house for the time of his life.

Justice is rarely so precise, and when it is we should do well to smile on alternate Sundays.

"I don't marry, though I tolerate those who do." Somebody remembers my saying that, I don't recall who, but it is very likely that I *did* say it because it nicely expresses my feeling in the matter for most of my adult life.

I mean to say, what's the *use* in getting married? In order to live with the woman one desires? In order to produce children? I had done both several times over without sensing any need for a formal agreement with either church or state. In order to achieve a respectable standing in society? But I had spent a lifetime defying respectable society (making me its most hunted lion, of course, but that is another story and should not be intro-

duced here, for it would only muddy the otherwise crystal-clear waters of my cogent argument against marriage). For me, for *me*, I insist, not for others. I have, in fact, stood as best man (a curious label, by the way, for the man who *isn't* getting married) for many of my friends. My father and mother were, after all, married and I have never held it against them. No, my antipathy had always been entirely personal.

But now it seemed to me that I should marry, to my astonishment. I don't know why exactly. Well, yes, I do. It was altogether inconsistent of me, of course, and fatuous, requiring all sorts of rearranging previous logic, but I knew that I must marry Trixie. And why, given all my former solemn ratiocinations? Because she might get away, that's why.

After Maud had left, Trixie and I moved together about London, living variously in lodgings and hotels as Mr. and Mrs. Whistler—to the despair of a few and to the delight of many.

Our private, nighttime passion was of course our own affair, and, great mystery of mysteries, it was proving to be, in what ought to have been sedate middle life, a very nearly transcendental experience for us, lying brooding marvelously in the mind as we went about our daily occupations, clouding normal thought with recent memory. Wearing the scars of Godwin's easy indifference, Trixie loved to be loved, and I was the same, both giving, both taking all that was in both of us without stint or reservation.

But we had no wish to be treated like middle-aged, lovesick fools, so that our public behavior tended toward the casual, possibly the overly casual. Trixie became a master at the game, even with me.

One night, over supper at the Café Royal, I found myself saying what I could not possibly have imagined myself saying one or ten or twenty years before. Trixie was eating a Dover sole, and there is no better, say what you like about tasteless England. She wore a dinner frock that showed her shoulders, modestly of course, but there can be no modesty about Trixie's shoulders. Her shoulders are white and round—no, round sounds silly, like tennis balls—shaped like happy ivory under a Japanese master's

lifetime manipulation. Trixie, I don't think, knew about her shoulders, or that they brought joy into the world. She didn't bother about things like that.

"Trixie," I said, "it seems to me we should have a plan."

"All right," says Trixie. "A pity you ordered the beef. About what?"

"Well, about ourselves."

"If you think so, Jimmy."

"Yes, I do."

"What's the plan?"

"It seems to me we should plan to be married."

"No real harm in it, I suppose," said Trixie, taking another bite of sole.

But there were sudden tears in her eyes, which she had not evidently expected, and she went quickly back to eating.

There is something strange about having lived with no binding ties for many years, with no fixed relationship to anybody or anything. And it had become a part of my daily living, I now saw, with a certain alarm. For example, I had never once actually settled into a flat or a house—not even my beautiful White House—in a way that suggested permanence. Always I had left a crucial wall unpainted so that it was not yet ready for pictures to be hung, always an absence of all but the most essential furniture so that nothing could possibly be assigned to a given space, always a hall full of unpacked packing boxes whose contents were never designated to go into this room or that, never opened.

All at once I wanted a whole sort of permanence I had never known, but at the same time it appeared to me to be a sneaking resignation of independence, somehow a loss. I couldn't manage to set a date, even assured as I was that the whole business was right. A whole year slipped past, held back by my idiot indecision, as Trixie and I cheerfully drifted back and forth between London and Paris, in our fog of love.

Naturally, it took a politician to set things straight, a French one, Henry Laubouchere, a Tory member of Parliament and a

very old friend, French only by descent. Labby, I had always called him. He had us to dinner one evening, and said, over the entree, making a presumed joke of it: "Jimmy, will you marry Mrs. Godwin?"

"Certainly," I said.

"Mrs. Godwin, will you marry Jimmy?"

"Certainly," says Trixie, pretending to look a little bored at the game.

"When?"

"Oh, some day," I said.

"That won't do," says this president Labouchere. "We must have a date."

"Then *you* set the date and find the parson and the church," I said, "and give the bride away, and perhaps Trixie and I will turn up, won't we, Trixie?"

"Certainly," says Trixie.

And that was just the way it happened, you know. Naturally it is not to be supposed that two serious middle-aged people actually decided to be married as the result of a silly dinner-table game. On the contrary, I believe Trixie and I used the game to settle for us what we knew must be settled, wanted to be settled, and which we (or I) had put off settling. Labouchere, a man of most consummate tact, had merely sensed our dilemma and helped us out of it by making a joke of a very solemn matter, while allowing Trixie and me, at least apparently, to retain our casual style without embarrassment. We could all do with more like him, I dare say.

Speaking of style, Labby told me some time later that on the day before our wedding he happened to meet Trixie hurrying down the street.

"Now, Mrs. Godwin," he said to her, "don't forget to-morrow."

"Oh, no," said Trixie. "I'm just going to buy my trousseau."

"A little late for that, isn't it?" Labby said, imagining new gowns and bonnets and all the rest fashioned and finished on twenty-four hours' notice.

"No," Trixie answered him, "I'm only going to buy a new

toothbrush and a new sponge, as one ought to have new ones when one marries."

So we did it all exactly as it is supposed to be done, at least the ceremony part of it. Labouchere got the chaplain of the House of Commons to say the correct words over Trixie and me in the solemn precincts of St. Mary Abbott's Church in Kensington, the wedding party small but distinguished. Dr. Willie was there with his English wife and was gratified to see his brother, however, tardily, finally touched with respectability's careful brush.

My own post-ceremony arrangements were less successful. I had invited everyone in the party to a new studio I had just taken (back in Tite Street again) for a splendid wedding breakfast supplied by the Café Royale, and the banquet appeared and it was very beautiful and it was set upon the table, but there were no chairs, only packing cases. The guests sat on the cases and breakfasted well, much laughter, much gaiety and so on, as I had hoped.

But as Trixie and I sat on adjoining packing cases, nibbling at the paté, sipping the champagne, anxious leg-to-leg, you know, I made a curious determination—at least it was for so uncooperative a social citizen as I had become. I determined that wherever Trixie and I might choose to live in the future, there would be chairs for people to sit down on.

An astonishing determination. Love can lead any man to excess. Mine would be chairs. Trixie and I would have chairs, and the packing cases would be unpacked. I had wanted to know, and now I knew where I permanently belonged.

"The Butterfly Chained at Last!" said the *Pall Mall Gazette*, and, do you know, I didn't even bother to write an angry letter? Amazing!

The night of our wedding day we sailed for France.

FIFTEEN

*I*T NO DOUBT sounds rather simple-minded to say so, but I had never imagined that there could ever possibly come an interval in my life of the sort I spent with Trixie the rest of that summer and autumn in France.

It was my first real holiday, you see. That is, if you take holiday to mean a period of time consciously set aside in which to do nothing, or nothing whose purpose was in the least useful. Oh, I'd had my enforced holidays, of course, but this one was intentional.

We spent the time wandering lazily about the country from Boulogne on to Touraine, stopping on the way at Chartres, Loches, Bourges, Tours, dawdling about villages and beaches and cities in our straw hats and white shoes, wildly rejoicing in such remarkable things as grapes and melons. And so on, that sort of time. I even etched a bit, painted some watercolors when I felt like it, or didn't if I didn't feel like it. And when at last we got back to London, I found that in those few short months it had subtly, and in some ways not so subtly, become a different place for me.

It never rains but it pours I had always supposed to be a purely negative maxim, meaning merely that if one encounters a disaster on Monday one is sure to encounter five more disasters before the week is out. I really don't think it had ever occurred to me that the phrase might have a positive meaning, having been rained on so little in that sense and poured on not at all. Trixie was my miracle of rain now, quite enough to green a lifetime or what was left of it, and I expected no pourings of any other sort. Strangely, my expectation proved false.

Before I go on to tell how London had changed, perhaps it would be instructive to pause on the way for an instant to show how in this brief time other things had changed as well.

One otiose August afternoon Trixie and I had sat on the bank of the Loire at the edge of a yellow wheat field after a pic-nic lunch of pears and bread and cheese and a bottle of the local ordinary white, when a pretty little peasant girl of ten or twelve appeared out of nowhere to peer at us shyly while pretending to count the blades of grass at her feet. In no time she and Trixie were dearest friends, and nothing would do but that I make a watercolor of the child. Well, it was either that or fall fast asleep, and Trixie immediately produced my watercolor box from a vast, bottomless satchel sort of thing she always carried into the countryside, holding everything from a sketching pad to the makings of my cigarettes.

So I set about finding a reason to paint the little girl, for one must have a reason to paint anything, even if one is half asleep. A reason was not hard to find. The child's face and arms were golden brown from the summer sun, her hair sun-struck to much the same color, and she wore a rough brown pinafore. Set against the yellow wheat field, she made a most acceptable "Har-mony in Brown and Gold," if one cared about such matters after a good lunch on the banks of the Loire on a summer afternoon. Unfortunately, the little girl had bright blue eyes, which didn't fit the "Harmony," of course, but then harmonies are made by men. I set about painting her eyes brown, naturally, possibly planning some yellowish highlights, but I never got that far.

Dimly I became aware that Trixie was mucking about in my paintbox, fiddling a brush into a point between her lips, as close behind me as my shadow, you know. And then she struck.

"Blue, Jimmy, *blue*," says Trixie, suddenly painting the eyes in my picture blue as lapis lazuli or the summer sky.

Now, I know of men—the "Master's" pupils—who would cheerfully have disemboweled themselves before they would have dared to touch a work of mine in progress, or any other time for that matter. But now I looked up at Trixie, grinning

down at me over my right shoulder like a bad child, blue paint on her lips from sucking the brush, and—yes, it took a moment, but only one—I smiled back, finally laughed back. And that, I submit to those who have known me, was Whistler gone quite mad with love.

I suppose I haven't sufficiently mentioned that during the past years my dealers had from time to time sent pictures of mine to various international exhibitions on the continent, fairly constantly to the Paris Salon, but also to Munich, Amsterdam, The Hague and so on. It was a way of becoming more widely known, nothing more, and nothing more came of it, except once.

A year or two earlier I had been asked to show at the International Exhibition at Munich, so I arranged to have sent along my portrait of Lady Archibald Campbell. A little later I was rather breathlessly informed that I had been awarded a second-class medal. I wrote the following letter of acknowledgment: "I hereby send the Committee my sentiments of tempered and respectable joy, and complete appreciation of the second-hand compliment."

Well, now, you know, Germans put great store by medals of any class, and I supposed I'd heard the last word out of Munich. But when we got back to London I was informed that, wonder of wonders, I had just been elected as Honorary Member of the Bavarian Royal Academy! And as though feeling they had not quite made sufficient amends, the officials informed me only a few months later that I had not only been awarded the first-class medal but the Cross of St. Michael as well. I don't know who Michael is, or was, but I'm sure he was a very nice man who deserved sainthood and knew all about painting.

But that was only the beginning of the downpour the maxim speaks of. For your regular Sahara Desert man, it was very odd indeed. Next came a gold medal from Amsterdam; then the first-class medal at the Paris Universal Exhibition. Then, the following year, two Grand Prix—one for painting, one for etching—awarded at the Paris Exhibition.

Now, all these medals and honors and things of that sort from abroad were all very well, and most gratifying, but there were two things notably lacking: money, and any recognition from England. Oh, there was a bit more money, but mostly from the sale of etchings, certainly no downpour. Still, nibbles began to come in for portrait commissions with at least the chance of future money. So that was not the main thing.

The main thing was that I had lived and worked in England for thirty-five years, entertaining London society and its newspaper readers almost daily, charming its passers-by in the streets with my dress and in the courts with the sharp edge of my tongue, in the lecture halls with my erudition, while all the time I had filled its galleries with paintings that were now being recognized and officially honored by half a dozen foreign countries.

It is, of course, axiomatic that the English are always the last to recognize and accept anything that is new and beautiful. Innovation of any sort amounts to a national terror among them. But, you know, it seemed to me that, given the foreign precedent now offered them, some slight official nod might have been dared for their longtime entertainer. I don't mean that I should have been made a duke; I am an American and don't want to be a duke. But they could at least have offered me membership in the Royal Academy, so that I could have refused it. But nothing happened—nothing ever has. Ha-*ha!*

But we're only just getting to the interesting part of all this honors business. Some time in 1891, when Trixie and I had been married for a little more than two years, it happened that "Arrangement in Gray and Black," my mother's portrait, was exposed for sale in the gallery of a Parisian dealer. Seeing it there, Georges Clemenceau, already an influential figure in French affairs, induced the *Ministre des Beaux-Arts* to purchase it for the nation. The price was a bit cut-rate, 4,000 francs, but the French know how to make up for their little parsimonies in other ways.

First of all, they hung my picture in the Luxembourg, in the Louvre—in the halls where hang Velásquez and Rembrandt and

Hals—those same halls where I had once copied pictures of ship-wrecks and groceries for mad Stonington Bill at twenty-five dollars apiece, stealing paint from the palettes of rich tourist copyists when I had none of my own. Those same halls through which I had tramped a thousand miles, the better to learn my trade.

And, second, the French Government appointed me officer of the Legion of Honor, a signal gift for an American. Perhaps it will look grander in French, for I want it to look extraordinarily grand: *Officier de la Légion d'Honneur.*

Well, you know, it began to strike me that perhaps I had made a rather grave mistake when I had decided to leave France to settle in England all those years ago. I had always said that the French could not, or would not, take seriously any work of art not created by a Frenchman. And now look at me! I began to talk to Trixie about our moving to Paris, where people knew how to value artists.

But they were beginning to show a little life back across the Channel in Britain. You will notice I didn't say *England*, for it was not the English who paid me the compliment of buying one of my pictures for permanent exhibition in a public gallery, but the Scotch.

My "Arrangement in Gray and Black, No. II," my portrait of ugly, unsure old Thomas Carlyle, had been shown at the Glasgow Institute, and a movement was begun to purchase it for the city. I asked them a thousand guineas, which seemed an amiable round figure for so nice a picture of their hero. But the Scotch being Scotch, there was a certain amount of opposition from those within the Glasgow Corporation who thought that to buy pictures, especially an American's, was "a wasteful piece of extravagance," as their president carefully phrased it.

Then something happened that was very touching, almost touching enough to lower my price, though not quite. There had been arising in Scotland, apparently—one can't be expected to keep in touch with everything—a younger generation of artists

who called themselves the Glasgow School, and they were becoming a power, at least at home.

These young artists had even written a sort of declaration of their principles, or a manifesto or whatever you call it, which stated in so many words that three great influences had accounted for their present development. The first was Whistler; the second was the Japanese (who, of course, were pointed out to them by Whistler, although modesty naturally forbade me from drawing attention to the point); the third was Mr. William McTaggart, a Scot. Who was McTaggart? Well, never mind, you know. If *you* were trying to raise a thousand guineas from the Corporation of Glasgow, and you had started off your list of heroes with an American and a nation of Japs, wouldn't *you* have put a Scotsman on your list? Bloody right you would.

They did more. They got up a petition signed by over ninety Scotch artists and presented it to the City Corporation, demanding that the city buy my Carlyle. The Corporation weakened a little. There was only one bone still stuck in the Scottish official craw: Why was the official painter of their great and now official literary monument, Carlyle, an *American?*

Nothing more fitting, I explained, when the facts were finally known. An American I was, surely, but all Americans have only been tossed into the great melting pot from somewhere else, and I had been tossed into it from Scotland. Was not my middle name McNeill, was not my mother a McNeill of the McNeills of Barra? She was; I was. The young Scots artists shouted their affirmation. The Glasgow Corporation frowned and sighed, if it may be said that corporations do such things, and sent me a check for a thousand guineas, hanging the picture in a place of public prominence, where it remains, at least the last I heard of it.

Trixie and I were now in a curious sort of dilemma. We were voyagers, both of us unsure of where we belonged, traveling for a year or two back and forth at a moment's notice between England and France, England and Belgium, Holland, Alsace. It didn't really matter so much to us because, being tiresome middle-aged lovers to the world, we found ourselves intensely amusing

344

and entertaining to each other, and nobody outside likes that, of course. We, so people kept telling us, ought to settle somewhere.

We considered. Trixie was English, naturally, though not at all as I have described English in general attitude. Trixie was—it is difficult for a distinctly middle-aged man to say about a younger wife—a woman who could probably be peaceful and happy almost anywhere, in almost any good company. We, the crotchety, don't like to think about things like that. Trixie inclined to the idea of Paris as a permanent home for us, partly I'm sure because she thought I would be more at peace there and not always quarreling with some Islander. And I agreed with her.

I mean to say, if one is entitled to sport the modest red rosette of the Légion d'Honneur in one's buttonhole one should do so in the country of its gift and origin, where it is all but revered, not in England, where, if it is recognized at all, it is regarded with amused tolerance. To put the matter in the odds of an English bookmaker at a race course, I should say that in England ninety-six *Légion* rosettes are the right odds against one Harrow necktie.

Well, I suppose that's all right. It's not *their Légion*, after all. And, anyhow, the whole French-English question of national superiority had long ago been established on the field at Waterloo. If something was French it was nowadays by definition suspect in England, and very possibly immoral. Except for food, of course. It has always struck me as somehow rather sad, but also as an admirably audacious inconsistency in the English, weaned on warm beer and cold soup, to yearn after, to insist upon, the gently risen French *soufflé*, the delicate *sauce meunière*, when they are abroad.

So Trixie and I were agreed that we should live in France. All that we had to do was to settle up, tie off the tiresome strings that long residence in any one place make for anyone, and go. Somehow we lingered. Lovers of any age are not much good at positive action, inclined as they are simply to maintain a sort of drowsy *status quo*.

A dotty old peer helped bring me to action, by the merest

chance. We attended the same dinner party, and when the ladies had left us for the drawing room this ancient flower of the English aristocracy and I found ourselves seated side by side. He noticed the rosette in the buttonhole of my evening coat. Our conversation was short.

"French, eh?" says he. "A French honor?"

"Precisely."

"Well, they make damned good cheese, no mistake about that."

"I feel that I've missed some vital connection."

"What?"

"Between me and the French and you, sir."

"Don't know what you could have missed. You'll probably get a better lunch from the Froggies than I will, having their red sprout in your buttonhole."

"Yes, I'm sure of that."

"But they tell me, Whistler, you're actually planning to move from England to France."

"That's true."

"But, good God, *why*, man?"

"Because the French have better manners."

"But surely you must know that French manners are all on the *outside*."

"And the best possible place for them to be, I should have thought. Good evening, sir."

Things like that, so small as they were, were not uncommon. And on them we made our decision. But there was some devil in me that simply could not allow me, after thirty-five years, to slip out England's back door, wiping the dust of London off my shoes forever, so to speak, quietly and peaceably without making some sort of last fuss. So I managed one. I made London take one long, last look at Jimmy Whistler, see him whole, see what he'd been up to all these years, bludgeoned it over the head with more than thirty years' work, all in one gallery, all in one glorious one-man show.

I chose the Goupil Gallery in Bond Street because it was large, as well as fashionable, and a great deal of space was my first requirement. It took me weeks of letter-writing to every one of the owners of the pictures I wanted, asking that they loan them for a month to the gallery. Many agreed at once, some required persuasion, a few flatly refused.

I ended up with forty-three paintings, a bit of everything, portraits, nocturnes, seascapes. It wasn't absolutely what I would have liked, some good things left out, but the fact that I am able to state the matter so mildly will at least indicate that the final collection was far from bad.

I played my game with considerable calculation, as a matter of fact. Let me say it frankly: Not only had I most curiously been selling my pictures to the official governmental representatives of France and Scotland, not only receiving medals and honorary memberships in solemn academies, and similar odds and ends, I at the same time smelled in the wind a subtle drift of change, something far more serious.

The very young had always been my champions, the old and established my detractors. While very little can be said for the passage of time as a purely abstract phenomenon, there's no getting around the fact that the phenomenon makes young people older and their influence on society greater, and old people older and their influence commensurably less. (Of course, *I* had grown older, too, but as I had begun my professional life fifty years in advance of anybody else, by artistic criteria, I was just about to be born. Ha-*ha!*)

Of my forty-three pictures in the Goupil show not one was for sale. That fact alone seems for some curious reason to give the general public a sense of confidence and reassurance. Not a marketplace but a museum is, I suppose, the way it feels. Exhibit the "Mona Lisa" with a price tag of two shillings and threepence and you will get an immediate counter-offer of two shillings tuppence. Offer it for nothing and it is worth a million pounds.

Well, I did not propose to end my English career on any proposition as shaky as all that. I composed a catalogue of the

pictures, most expertly printed, a delightfully different butterfly on each page, and following each identification of a picture I had printed in bold type selections from the writings of the critics who had originally assessed them. Many of the same critics who would now have to assess them again. This section was called "The Voice of a People."

Times change. The critic who had once described my "Nocturne in Blue and Gold"—old Battersea Bridge—back in the Sixties as "a Farce in Moonshine with half-a-dozen dots" now found it "exquisite . . . haunting . . . a modern masterpiece." *Punch* and *The Artist* who had once found my "Harmony in Gray and Green"—Miss Cicely Alexander, respectively to be "a gruesomeness in Gray" and a "Rhapsody in Raw Child and Cobwebs" similarly altered their views to detect now "the unmistakable hand of 'genius'" in the portrait.

And so it went. Crowds thronged the gallery all day, just ordinary people off the street, you see, policemen being required to let them in by manageable lots so as not to trample each other, and an exhibition which had been planned for a two weeks' stay was extended to three and finally to five. My artistic vindication in England was suddenly total. Trixie rejoiced.

I . . . well, I only *semi*-rejoiced, to be perfectly candid. I suggested we send a season ticket for the show to John Ruskin. To find, all in a day, that one has been forgiven for the work a nation has for more than thirty years treated with contempt and ridicule told that the whole thing was a regrettable small mistake, but now everything is all right, is not absolutely ingrained in my nature to accept out of hand, although it was in Trixie's good nature. She urged me to visit the gallery, as everyone wanted me to do. I refused. "I will forgive," says I, for all the world like some Old Testament complainer of his unjust God, "when I forget."

"You're being bitter, Jimmy," Trixie said.

"Oh, absolutely, my darling."

"But all those people, hundreds of them clotting up Bond Street just to admire your work, Jimmy. Don't you think you ought to let them know you appreciate their being there?"

"No."

"Why not?"

Then I said something quite unpleasant (drawn from that most splendid mine of invective, the Holy Bible), which I set down only to indicate a frame of mind, one that showed, I suppose, that England and I could never quite be honest friends. It was all too late now, no matter what the present fuss. "Well, you know," I said, "they were always pearls I cast before them, and the people were always—well, the same people."

Trixie stared at the backs of her hands in her lap for a moment without saying anything, then nodded her head, coming to some sort of agreement with herself. "Jimmy, dear," says she, "we had better move to France."

"Yes. When?"

"The sooner the better, I should think, you feeling the way you do."

"Quite right. What would you think about Monday?"

"Monday's always a good day. It gives you six days to Sunday, doesn't it, when nobody will do anything, for some reason."

"Christianity, I dare say."

"No good blaming them, I expect," says Trixie, very soberly. "France is the thing, Jim. You'll live a good life there; we both will. We'll find the right small flat, I'll work a bit more on *être*, and you'll be proud of me bargaining for vegetables at the proper price, and I promise to keep away the bores. You'll see."

"I know I will."

"We'll rejoice in Paris, Paris will rejoice in us, we'll astound Paris."

"Really?"

"Oh, yes!" Trixie looked truly surprised, and she touched her soft, dark hair to see that everything was all right for a visit to the President. "You are somebody very grand in France, Jimmy."

"No doubt, setting Napoleon apart."

"Bother Napoleon."

"I love you, Trixie."

"You are a crashing, dreadful hero," says Trixie, "and you are making me cry. It is because you never went to Oxford, or

you wouldn't talk that way. If you had, you would have known to address me as a horse or a spaniel. You went instead to some military place in America."

"West Point. The United States Military Academy."

"Whatever. I'm sure it was perfectly all right."

"Oh, well, love's the same."

"Yes, I suppose it is. It would be a rotten shame if it weren't, wouldn't it, Jimmy?" says my bride.

SIXTEEN

So THERE we were at last, Trixie and I settled
down in Paris for life, although that expression
has always struck me as indicating a somewhat indeterminate
lease. We moved into our new apartments at No. 110 Rue du Bac
near Montparnasse, and miraculously peace threatened to take
up her abode in our little *ménage*.

Our rooms were on the ground floor of a seventeenth-
century house, very near the lively center of the city but as
seemingly remote from it as a country cottage. You approached
the place from the street through a curious sort of tunnel be-
tween walls and two shops, and suddenly you were in a brilliant
little cobbled courtyard where any visitor who knew me could
tell my front door because it was peacock blue with a polished
brass knocker.

When you went inside you went down a step or two to a
hall that led to a large sitting room. The walls were blue, the
doors and window frames white, and blue matting covered the
floor. Well, that could have been a house of mine anywhere, any-
time. But that wasn't all. Trixie lived in this one too, you see.

This charming room also had in it an Empire couch and a
variety of Empire chairs (not a packing case in sight), my God, a
grand piano, and an elegant table that had once belonged to
someone so famous I've forgotten his name. On it there were
always fresh flowers in porcelain bowls.

From this sitting room you could go through a glass door at
the back into a large garden, rich in delicate undergrowth, shaded
by trees, the whole ending at a convent wall. This latter fact will
perhaps illustrate the salutary effect of happiness on a bellicose

nature. Each evening at sundown the pious ladies in the convent, by ritual, gathered together to sing their evensong, their Latin vespers. It is quite possible that in former times, had anybody decided to sing just over my back fence every evening in the year, I should have pelted their convent with eggs from my side, or set up a retaliatory ringing of Swiss cowbells or something of the sort.

I did neither. People have told me, though I can scarcely credit it, that they had sat together with Trixie and me in the garden at the hour of evensong, and when the singing began I had actually stopped talking, to listen.

It had now become no longer disreputable to have one's portrait done by me. To the contrary, it had become absolutely *de rigueur* after the London show. (The London success, I may as well report, was repeated in absolute detail at the Salon in Paris a few months later. There is no doubt vanity in reporting such things, but if we are to suppress facts we also suppress history, which would be dishonest and not at all my dodge.)

My first bidder for a commissioned portrait was very swank indeed, from an English point of view. It was from the Duke of Marlborough. He invited Trixie and me to spend the autumn with him at Blenheim, where I would paint him. Well, here we were, just cozily settled into our charming little place, the sycamores in the garden beginning to turn yellow, and we were supposed to throw over everything and spend the best season of the year in a wretched drafty castle. Have you ever *seen* Blenheim, or even pictures of it? Well, Waterloo Station with sheep, you know.

Trixie left it entirely up to me, but I could tell she wanted to go. Trixie may act the bohemian, and in most of her heart she is, but in a tiny recess of the heart of any English child, born and bred—Tory, Whig, or anarchist, it matters not a jot—there is a secret, romantic wish to do once in a lifetime just such a thing as spend a couple of months at Blenheim with the Duke of Marlborough. There is no explaining it; it is simply so.

I wanted to stay exactly where I was, but not to disappoint Trixie, and as a sort of compromise measure, I wrote His Grace one of my "charming letters." This is not my designation but, over the years, the recipients'. The replies to such of my letters always begin: "Thank you for your charming letter of such-and-such, but have you gone stark, raving mad?"

The thing is that my "charming letters" are indeed charming in a purely literary sense, but their plain import is to demand of my correspondent for whatever it is he wants me to do (and which I *don't* want to do) a sum of money so outrageous that only a lunatic or a duke would agree to it. Such was my gamble.

As luck would have it, a few days later we read of the death of Marlborough in the Paris papers. "Bad luck for you, Trixie," I said. "For me, there's only one bother. Now I shall never know whether my letter killed him, or whether he died before he got it."

"Shame on you, Jimmy," says Trixie, wistful child of England, denied a duke's hospitality.

But nowadays it was not only dukes who wanted their portraits painted. Everybody did. I was besieged suddenly by millionaire Americans—yes, *Americans*—who wanted to pour all of California and Philadelphia and Detroit and New York and Boston into my lap. This was a determination to which, in theory at least, I had no objection.

But it was the *work* I objected to. All that bloody concentrated work, standing for hours on end before a sitter, desperately thinking, planning the right way to execute the image that was still only in the back of my head, getting it down in the way that would fulfill that plan to its utmost, above all *feeling* the crying need to make it so.

Well . . . It simply wasn't there any more, you know. As a man and an artist pressing sixty, in love with a loving woman, respected by that infinitesimal bit of the world's population who thinks about art one way or another, living in charming circumstances in the first real home I had ever known since childhood,

353

I just saw no need to be bothered with all these proposed portraits. I refused them all. With Trixie's complete compliance, I should add, a rather remarkable compliance considering it was tossing half a million dollars, or something like that, I suppose, into the sea.

But Trixie understood me when I yelled, "Why wouldn't these people be painted by me years ago, when I wanted to paint them, and I could have painted them just as well?"

"Because then they didn't know what a good painter you are, Jimmy."

"Clots and baboons, Trixie!"

"Of course. But now they do, and isn't that a fine thing? Let me fetch you a glass of Mr. Ruskin's fine sherry before dinner, Jimmy dear. Calm your nerves."

You can see how far my natural animosities had been curbed by Trixie's gentleness. I even allowed Ruskin's sherry in our Paris quarters. Amazing! Of course, it didn't always work precisely in that way. Our conversation went on, as follows:

"I happened to pass your desk today," said Trixie, pouring the wine, "and saw you were drafting a letter to the *Times* against something Ruskin's just written. He's a poor crazy old man, Jimmy, can't you leave him in peace? He already has one leg in the grave."

"Yes, that's true, Trixie," I said, "but you see it's the other leg I want."

Such sentiments, however, were more rare than usual and, apart from Ruskin—who had, when all is said and done, with his vicious, misguided power, smashed me down to poverty for the best part of a decade—I was benevolence itself to my former detractors.

I pretended that I saw virtue in the work of certain Royal Academicians, because they were kind men and old, and in the stream of art their work would finally blow up no tiny ripple, anyway. It was as though I came finally to honor the impulse of the artist, and never mind his production, because I understood it. That impulse is not, I was learning to my absolute

astonishment at least, a permanent condition. I would never have believed it possible.

To give a simple illustration: A rich man came to my Paris door and offered me a sum quite unprecedented to paint his portrait in life size (it must always be life size, you see, whatever size *that* may be), and I said to him, "I beg you to excuse me, sir. You would not want your portrait. You see, I used to paint for joy, and now I live for joy, so the portrait would not be what you want. I apologize."

I don't mean, of course, that I did no work at all, although Trixie and I found so much to laugh at and so many lovely excursions to make together that three or four days of a week often went by without so much as a stroke. I seemed also to be formulating a most curious proposition in my work: Love and happiness and comfort make art grow *smaller*.

Quite literally smaller, not less interesting, only smaller. I don't mean the concomitant proposition that hate and misery make art grow *bigger*, either; no, no, that would be nonsense. And I certainly don't mean to support the rot that says an artist to do his best work must starve in an attic, scrounging pennies and ducking the landlord, for that *is* rot. (That good work has come out of such circumstances, I don't deny, but only proves the rot. Just try giving the same gifted young man a nice warm little studio and a couple of thousand a year with no strings attached, and *then* see what he'll produce.)

My own phenomenon had only to do with physical size. Portraits in "life size," as we have seen, were now a thing of the past with me. I painted in watercolors, I etched, I made lithographs, but even these were dependent for their size on the adducible degree of my contentment, much as the price of turnips in the marketplace is dependent upon the supply of, and the general demand for, turnips. Thus, on a day when Trixie was away for several hours, shopping or visiting one of her sisters who happened to be in town or whatever it might be, I would do a watercolor on the normal-sized paper that came off the watercolor block.

But on a day when Trixie was at home all day, after we had spent a morning together, say, wandering along the warm pebbled paths of the Tuileries in the spring sunshine, sailing toy boats in the ponds (*yes*, damn it, we sailed toy boats in the ponds; we even raced them, if the facts must come out), and screaming along with the pinafored children at the Petit Guignol crying out in blood lust for *Polichinelle* to brain the policeman with his club —well, I worked differently on such days.

On these days I would take the same sized piece of the watercolor paper and trim it down with a scissors, you know, until it was perhaps only half as big as it had been, and paint a little picture on that.

And as my weeks and months with Trixie passed by, sitting in our garden with her, having lunch or tea, smiling like an idiot over nothing at all, not even objecting to singing nuns a stone's throw away, my pictures grew smaller and smaller.

I don't attempt to explain it or make any rule out of it for others. My God, Frith or Alma-Tedema might very well, in similar circumstances, have run out and painted a barn door each day at five, for all I know. I speak only for myself.

For anyone to suggest the notion that personal joy in life could ever be in any way a plausible substitute for the vital insistence of a born artist to express what he must express, I would immediately reject, of course. They are, after all, two quite different things. A contented lover sits about with his feet up, fondling his lady's blessed odds and ends; an artist flings himself with raging fire into his work.

But my work got smaller and smaller, not necessarily shorter of execution, until Trixie one day remarked, altogether agreeably, "Jimmy dear, I think you should think seriously of the demands of the postage stamp. They're pretty rotten, as a rule, and you might elevate things and make it more fun for the rest of us to get a letter."

"Good idea," says I, "only let's take a lunch out to Fontaine-bleau tomorrow noon. We can talk about it."

"Oh, good. I've got a new sort of egg," says Trixie. And we went.

It would not be unreasonable to ask, since the contented life had so drastically reduced my output, what in the world we were living on all this time. Aha. There is one advantage—I can think of no other—the unsuccessful artist has over his successful brother: His studio is apt to be crammed to the gunwales with pictures of one sort or another, all the ones no one would buy at any price, you see. Let the public discover in its mysterious wisdom that it has been mistaken, that the unsuccessful artist has all along been a pearl beyond price in an unopened oyster, and the unsuccessful artist overnight finds that his studio has been transformed into a branch of the Bank of England.

Does Trixie need a few new frocks, some hats and shoes and perhaps a pretty golden brooch to pin at her throat? Nothing simpler, you know. Only fish about the studio for ten minutes and find in an old portfolio—among hundreds of others—a nice little watercolor, done in a quarter of an hour a quarter of a century ago, put a butterfly in some corner, and the bill for these trifles is instantly paid.

If the demand is somewhat larger—say, a year's rent for the Rue du Bac and two servants' wages for the same period—simply fish out some little oil, a seascape or whatever (again among scores of others), and the matter is wholly attended to.

I will very shortly stop boasting of all this money, for all my life I have known it is vulgar to discuss money, except among those who don't have any. But there was one sale I would like to mention because it fits into this story and worked wonders for my vindicative nature. The Falling Rocket, that nighttime fireworks picture which Ruskin had valued at "a pot of paint thrown in the public's face," and brought him into court, was sold for eight hundred guineas.

But in a purely banker's way of looking at things, that was a drop in the bucket, amazing as that may seem.

A year or so after we'd moved to Paris I asked my banker, to whom my art dealer sent the earnings of my sales, how things were coming along for me. The receipts for the year just past, he informed me, were very grand indeed, but the receipts from one particular patron were even grander than the rest. A Mr. Charles

Lang Freer, railroad multimillionaire of Detroit, Michigan, had in the past twelvemonth paid for my "Harmony in Blue and Gold: The Little Blue Girl," three pastels and a couple of water-colors the sum of 13,000 guineas! Fumette would never have believed it. I didn't believe it either, to tell the truth, until my dealer showed me a statement.

It's so easy to jam people into stereotypes, and I'm as likely to do it as anyone else. What, for example, is a millionaire American art patron? Well, he is a man of humble origins who, by virtue of a ruthless ambition and no interest in normal society's rules of morality, has clawed his way to the top of some industry or other over the prostrate bodies of friends and foes alike until he is king of the hill, blood on his hands, his pockets stuffed with thousand-dollar bills.

In late middle age, having built several regal palaces and bought a procession of yachts and mistresses and everything else he can think of, he is dismayed to discover that he has scarcely made a dent in the great mass of his fortune, so out of general guilt or a desire to be loved a little by someone before he pops off, he starts giving it away, to the very people he has spent his life bilking, in the worthy form of museums and libraries and opera houses, all with his name over their front doors.

Now, that's a fairly reliable sketch of a millionaire American art patron, isn't it? Well, if it is of some, it bears no jot of re-semblance to C. L. Freer, who walked into our Paris apartments one autumn day in 1894 and introduced himself. This was a small, gracious man, meticulous in dress and manner, a bachelor of impeccable artistic sensibilities, which—save the mark—he announced he owed entirely to me as a result of buying a few years before a set of my etchings in America. He had become obsessed with pictures and objects of Oriental art, and now his millions allowed him to travel much of the time, buying any-where in the world the beautiful things he loved.

Well, we all hit it off at once, Freer and Trixie and I, talk-ing away the entire afternoon of his first visit, and he came to

see us again and again, sending me beautiful objects from the Orient when he was there, and once he sent Trixie a singing lark from an Indian jungle, a lovely creature which she adored.

How, in God's name, one asked oneself, did this sensitive, mannerly man even manage to *survive* in the wildcat, savage game of American railroading in our century, far less emerge as the multimillionaire holder of a great many of the chips, when he was not yet forty years old?

Freer himself never spoke to us about this part of his life, but I once managed to get at least some sort of explanation out of a man, an American rival of Freer's, who perhaps better fitted my earlier stereotype. He spoke with a sort of wistful envy, I thought.

"How did Freer make all that money?" said my man, more or less repeating my question. "You mean he doesn't quite seem to fit into the newspapers' description of a 'Robber Railroad Baron,' as they call us."

"Precisely."

"You don't picture him out there on the tracks busting strikers' heads with a club, kicking widows and orphans off land he's stolen for his right-of-way, all of that?"

"How well you put it."

"Well, you're right. Freer had nothing to do with anything like that, never."

"Then how?"

"I don't know how much you know about large-scale corporate finance, Mr. Whistler . . ."

"Absolutely nothing at all, thank God. Do go on."

"It's simple, really. Charlie Freer just happens to have been born the greatest God-damned bookkeeper the world has ever known."

"*Bookkeeper?*"

"That's right. There are plenty of pirates and gamblers in railroading, and they'll fight anybody for anything, most of them, but they can't add and subtract very well, it's not what they're interested in. Freer isn't interested in anything else about

business. His love of bookkeeping, managing corporation funds, is detached in a way the others could never understand. While they, including me, went charging off in all directions, making their moves on the basis of anger or grudges or just plain hunches, Charlie Freer was calmly studying his columns of figures.

"When his figures finally told him it was better to buy this railroad than that railroad, or better to lay track to this city instead of that city, he followed the figures' advice, first with other people's money, later with his own. And the figures were never wrong. Oh, some of the rest of us made a lot of money by our methods, too, but some of us also lost our shirts. Freer never lost a collar button, never even came close, and all because he understood the pattern of the columns of figures under his nose better than anyone else in the world. Well, Mr. Whistler, do you understand what I've just told you?"

"No, not really."

"That's all right, you're an artist."

"But it's precisely because I'm an artist that I can appreciate what you've told me about Freer. For solitary detachment and quiet concentration, be it directed to a column of figures or a blank bit of canvas, is the way we both achieve results, you see. I thank you for your patience, sir."

So this was Charles Freer, my new friend and patron. Patron apart, it is always an unusual experience for a man no longer young—perhaps particularly for a man like me, whose lifetime avocation has been alienating friends—to find just then a new and sympathetic friend and to find that he has remained so.

A little ago I promised to speak no more of money. Well, I've just changed my mind. Every coin has its other side, valid as its opposite. Human venality is worthy of study, I suppose, if only to warn us against it—not that there seems to be much we can do about it—but my own experience as soon as I'd moved to Paris may have established some sort of classic exhibition of hitherto unexpected venality.

I've recounted here from time to time how in the normal

course of a commercially unsuccessful artist's career I had sold pictures of every description to anybody who would buy them for whatever trifling sum I could bargain for. Well, that's all right, you know. I got the best prices I could get at the time, and occasionally the price paid the greengrocer's bill, sometimes not, but never mind, it was fair.

Now, suddenly, as though by misdirected lightning bolt, everything had changed. What I had once sold for ten pounds was worth a hundred in the galleries and auction rooms, what I had sold for a hundred now brought a thousand to its nominal owner, and so on. And almost everybody sold.

Those kind and perceptive people personally unknown to me who, in the Sixties and Seventies, chose to buy a Whistler off some gallery wall for a few pounds, or even shillings, I salute. They bought my bread and wine, what there was of it, and if nowadays they may take back a 100 percent return on their investment, so they should, exactly as though they had bought railway shares in a similar amount (although railway shares would have yielded them less—ha-*ha!*).

I'm not speaking of such folk. I'm speaking of "friends." These were people who had begged me to paint their portraits, people who had sat at my Sunday-morning table and insisted that my latest nocturne on the wall was a work of genius and that they must own it, live with it forever—for ten pounds. Well, I needed the ten pounds, you see, and I liked all the guff and admiration, and after all no serious painter wants his work only stored in an attic. Also, of course, in those days I believed there were always plenty more where the others had come from.

And so the early pictures went—for ten pounds, twenty pounds, never much more—but often to "friends," to people who genuinely admired the work and wanted to keep it. But now these people, too, suddenly decided they were missing out on a good thing, and they sold their "treasures" to the highest bidder. One dealer told me that in the single year following by successes at the Goupil and the Salon 80 percent of my work that passed through his hands came from the original owners.

And it was not only that these people were venal turncoats, making fortunes from my work and spending their time in continental holidays at my expense; they were something even worse, as I learned from someone who knew a number of them well.

These onetime friends had decided that "the Whistler boom" had reached its peak at the time of the Goupil and that they had better sell out at the top of the market before its inevitable decline. The Whistler they had patronized for pennies, now selling for guineas, they had decided, was probably a flash in the pan. (That last expression derives from the practice of modern photography, if you should find it unfamiliar, and refers to the brilliant flash of ignited magnesium in a metal pan used by photographers these days to light their subjects. What will they think of next to ruin the art of portraiture?)

Where was I? About my friends selling my work at the top of the market. Well, you know, it was something of a satisfaction to me—and a good deal less of one to the greedy ones, I should imagine—to discover that, had they only managed to contain their greediness for just two or three years, they would have increased their investment not by 100 percent but by 500.

All these people were bad enough, you know, but there was one man so audacious that I came close to admiring him. A total and absolute scamp is not nearly so common in our experience as most of us imagine. We are daily exposed to whining, rotten exploiters, such as those I've described, but an Alexander or a Bonaparte who has it in the back of his mind to steal the whole world turns up only occasionally and deserves our attention.

That my particular man was an English lord goes without saying, of course. The lower orders are lacking in the necessary courage for true audacity. This man had, a dozen years before, bought four canvases of mine for a small sum. He was a delightful man, as are all blackguards, naturally, else more would be socially required of them than mere blackguardism. So delightful was he, indeed, so appreciative of my work, that after he had bought my four pictures I made him a present of another—a

particularly beautiful one, I thought, of a long stretch of fore-shore sand and sea and sky, done on the beach somewhere near Dieppe.

Now, it happened that for reasons I don't know and couldn't care a perishing damn about, my man found himself at the verge of financial ruin, whatever that means. (I, who have lived for a lifetime on the lip of the volcano's crater called "ruin," find the term somewhat on the blurry end.) Now the chap wanted to sell his Whistlers by way of recouping his losses. Well, there's nothing wrong with that. It was his last capital, and the market looking sprightly for a change, so he sent his pictures to me, feeling I would know better how to dispose of them at a good price than he. Which was true. He was putting himself absolutely in my hands, he said, altogether pitiably.

How many paintings arrived at my studio at last for sale? Now watch your earnest blackguard at work. He sent the four pictures he had bought from me; well and good, and help a gentleman out of his difficulties, and so on. But he also sent the painting I had *given* him, also currently for sale, it was clear.

What did I do? I saw to it that a dealer sold the four pictures the man had bought, and for a rather fancy profit. As to the fifth, I simply kept it, explaining in great detail: "This picture is now mine again."

I have since sold it to Mrs. Jack Gardner of Boston for a most proper sum.

Well, that's enough of money, of exhibitions, of critics, of painting, even. The good and happy life is finally made so by people more than anything else, and the stream of people that flowed through No. 110 Rue du Bac could make anywhere a joyful place. I went back to my old custom of Sunday-morning breakfasts and before long Trixie was grilling buckwheat cakes absolutely as well as I, which is to say merely that there were now two perfect buckwheat cake chefs in the world instead of only one, as formerly.

The people . . . It's difficult to know even where to begin

with my Sunday, and everyday, guests and friends. No, I suppose there is a logical place to begin because my friendship with Mallarmé, the very great French poet, afforded me one of the single highest points of my life. Stéphane Mallarmé, already a Paris legend, although a younger man than I, could not have started out on better terms with me—he introduced himself as a fervent admirer of my painting.

A man of charm and cultivation, Mallarmé knew everyone in Paris worth bothering about—and a few, like monstrous Dégas, who were not—and he had long ago instituted his own tradition of *Mardis*, much like my own *Dimanches*, except that his gatherings took place in the evening. Here one chatted with or laughed with or yelled at artists and writers of total dissimilarity. That was Mallarmé's sly gift.

The Manets were usually there—Édouard beginning to seem an old man, unlike me, of course—and Rodin and Emile Zola, poor little Toulouse-Lautrec and, rarely, wild, uproarious Gauguin, his huge chest fitted into a sailor's jersey, waving his great hands and shouting in his raucous voice, on a visit between two voyages to Tahiti. And Degas.

It is very difficult for me to report, but dedication to truth forces my hand: Degas is the only man I've ever known—with the possible exception of Robert E. Lee—who left me speechless, without an answer. After observing me in silence for some time, one evening at Mallarmé's, Degas remarked very calmly: "Whistler, you behave as if you had no talent." I couldn't think of an answer, and I've never got over it, you know.

To return to happier subjects, in addition to the people I've already named who came to Mallarmé's and also to the Rue du Bac—except Degas in the latter case—came the young English artists and at last the young Americans. I had the pleasure of making Aubrey Beardsley weep by telling him he was a very great artist; I found a good friend in young John Singer Sargent, who, in spite of my having rather testily characterized him somewhere as "an acrobat in paint," had the kindness to forgive me

and become, at the same time, the leading American portrait painter of fashion of his generation. Joseph Pennell, an excellent American etcher, and his wife, Elizabeth, became constant companions, hinting from time to time that they would set aside their normal work if I would designate them my official biographers, which I may even do.

And finally there were the young American art students, those poor devils, so long in the artistic wilderness, who had finally found a modern compatriot they could hold up as their own. There *could* be a serious modern American painter, they told me in amazement, either in words or simply in bright faces. I welcomed hundreds and hundreds of them in the Rue du Bac, a few I even classified as my students. There was one particularly attractive and talented young couple, Mary and Lawrence Williams from New York, but in the end, alas, they adored me overmuch and it showed in their work.

But to return to Mallarmé. I've said he admired my painting, but listen to this. He had translated Edgar Allan Poe, and he told me that he found in me, another American, a touch of the same *diablerie*, as he called it, and would I grant him permission to translate my *Ten O'clock?* I could imagine no greater compliment, and I paid it back as best I could by doing a lithograph portrait of him which he thereafter used as a frontispiece to his collected works.

The translation was published in Paris in the *Revue Independante* and made a great fuss in literary and artistic circles, but Mallarmé was not a man to do things by halves, nor to ignore fitting ceremony. Grace is the word for the man, in his work, in his life.

He arranged for a very particular one of his *Mardis*, a special evening to which only a score of the Paris intellectual toffs were invited, and he read his translation of my Ten O'clock to them.

Well, now, you know, I sat there with Trixie beside me listening to my own words, transmuted and transfigured by the

beauty of another language, spoken in impeccable French, quietly but distinctly, by a great poet. There is, I suppose, a curious pleasure for any writer to hear his work in good translation, depending on the language, of course. To hear oneself in French is to find oneself instantly witty; in German one would find oneself instantly profound, I should imagine.

Now, my Ten O'clock was already witty, naturally, and Mallarmé was not just a good translator, but a translator of genius. The combination was rather overwhelming. Public tears are not my game, you know, and I shed none, but I came very close and I grasped poor Trixie's hand until it was white. Oh, all was well!

Just a little joke about these happy Paris days, and I'll get on with it. If I seem to be boasting about my celebrity, it is because I am.

At this time the great thing in Paris was to have read Marcel Proust's *Les Plaisirs et les jours.* Now, Proust, although still very young, was reported to be a semi-invalid, possibly hypochondriacally so, but in any event almost impossible to lure out into society from the cork-lined room in which he lived. Mallarmé, who knew Proust, invited him to a *Mardi* evening to meet me, not really thinking he would come.

But come Proust did. There was not much talk between us, in the event. He was enormously agreeable, but his conversation inclined to the vague, to the pleasantly, always courteous, general. But then came the joke.

At one point I turned to speak to someone else sitting nearby, and as I did so I put my gloves—gray, they were, tinted a little blue—on a table. In a moment, only out of the edge of one eye, talking the while, I saw M. Proust pick up a single glove and surreptitiously slip it into the pocket of his coat. Only one, mind you—not a thoughtful thief, you see, but a hunter of souvenirs.

All was well, oh, all was well!

• •

In the fall of 1894 Trixie thought it might be a good idea for us to take a little holiday from the gay rigors of our life in the Rue du Bac and suggested we visit Brittany, which she had never seen, for a few weeks. Well, nothing pleasanter, you know. I could take her about the charming little fishing villages, picnic with her on the sands, paint her in watercolors of a size commensurate with my present happiness.

So we went. Things did not go quite according to my plan, in the event, not quite. We walked together through the villages and on the sands, to be sure, but after a quarter of an hour Trixie's arm, tucked through mine, grew heavy and she walked more slowly. She never *said* she was too tired to go farther, but when I took her back to our hotel she slept deeply for an hour, sometimes for two. And in the morning she often was seemingly as tired as she had been the night before.

One morning, the first such morning, when she woke, she said, "Jimmy, dear, would you think it was rotten of me if I didn't get up and dress for a little while?"

"No, of course not, but what is it?"

"Just laziness, I expect, too many parties in Paris. But don't let me keep you indoors. You go out and we'll meet in the dining room at lunch."

"I don't want to go out alone, Trixie. You just lie there and rest, that's all you need. I'll sit by the window and read the newspapers. They're all a week old, you see, so that any bad news in them has already happened. Most comforting. Just sleep a little more, my darling."

But my advice was unnecessary. Almost before I had finished speaking, Trixie was slipping back into her heavy sleep.

Well, it was all my fault, of course, and it made me altogether ashamed of myself. I was so proud of Trixie, had been so eager to show her off to everyone, that I'd exhausted her, that was all. We went straight back to Paris, where she could be more comfortable in our own flat, and for ten days we saw absolutely no one, never went out for a single meal, Trixie keep-

ing mostly to a chaise-longue I had brought to our bedroom beside which I took my own meals from a tray on my lap.

But, well, it was strange that the peace, the resting, didn't seem to make all that much difference. Oh, Trixie was cheerful enough, plenty of jokes and all that just as before, but she wasn't eating; rather, she was pretending to me that she was eating, clearing a bit of space on her plate with her fork, then craftily dropping her dinner napkin over most of the untouched food just as the servant took away her tray. And then there was the sleep, the unnatural, too long sleep. In a short time there was one day, flashing briefly across Trixie's pale face, a quickly disguised wince of pain.

"Trixie," says I, carefully polishing my eyeglass, for it was useful to polish an eyeglass, "while it is a well-established fact that doctors don't really know anything of much use, I suppose it's barely possible that they could know some trifle more than we know, don't you agree?"

"Doctors, Jimmy? I hadn't thought . . ."

"Well, I mean all those years they spend in medical colleges, robbing graves and so on, it must come to something in the end, wouldn't you imagine? I was thinking specifically of my brother Willie in London. Willie," I went on, trying to gentle my way into a course of action that must evidently now be followed while causing the least possible alarm, "is some sort of Harley Street larynx nob. It is his medical dedication, at least as I understand it, to keep German sopranos singing Wagner at Covent Garden, which doesn't speak at all well for him, I realize, but I'd like to know his opinion of your general health, his and perhaps some of his friends'. The trip wouldn't tire you too much, would it?"

"Oh no, I'm sure not, but it seems an awful nuisance for you."

"Don't talk about nuisances where you're concerned, Trixie," I said, rather crossly. "Please, it makes me feel as though you didn't really understand what you . . . Well, you mustn't, you know."

"I understand, Jimmy, and I'll go whenever you say."

"Good. It'll just be a little London holiday, really, put our minds at rest. We can go watch Irving botching Shakespeare, things like that, cheer ourselves up."

"Just the thing."

And so we set off in a day or two, a regular entourage, we were, in this, the season of our rather alarming opulence. With us traveled our two Paris servants, Louise and Constant, and Mr. Freer's marvelous singing Indian lark in its baroque cage.

The lot of us took rooms in Long's Hotel in Bond Street, and I took Trixie to see Dr. Willie.

Willie is a strange man. No, of course he's not; I only mean he is a strange man to be my brother. He is a kind and generous man, both solid and stolid, serious and dependable, portly where I am slim, dignified and retiring where I have been characterized otherwise by the undiscerning; and I have no doubt that Willie's friends, on learning of his relationship to me, turn my original phrase upside down, crying out marvelously: "What a strange man to be *your* brother." The whole business has no doubt hurt his practice.

But what can one do? Willie and I, springing from identical loins, learning together whatever it was we learned in school, skating together on the frozen Neva in St. Petersburg, watching helplessly together beloved parents die, sharing common blood and mortality—well, what matter that we were no more alike as grown men than Whig and Tory, blue and yellow, saint and monster? None at all, of course; we were brothers, and we simply loved each other illogically. God's intention, possibly, in spite of His getting off to a rather shaky start with Cain and Abel.

Willie and Trixie hit it off at once, but since I have never known anyone with whom Trixie did not hit it off, that is not a very interesting disclosure. What was more interesting, or anyway more compelling, was the look in Willie's eyes after he had asked Trixie dozens of questions and examined her physically for nearly an hour.

When he had finished, Trixie was so visibly exhausted, so

drooping in a chair in Willie's consulting room, that I sent her straight back to the hotel in a cab, staying on alone with Willie.

"Willie," I said, sitting across his desk from him and watching his face, "no doubt you've developed a most convincing and reassuring bedside manner that works splendidly on *Heldentenors* with laryngitis, but I'm your brother and can't carry a tune, which changes everything, you see. Why are you looking so funny? What is it?"

"I have a funny face, that's all, you know that. You always said you'd never paint me on account of it."

"I will if you'll make Trixie's health what it was a few months ago. What is it, Willie? She's tired, isn't she, sort of run down from too much of our Paris life? We can change all that in a minute; we have, in fact."

"Yes, she's tired, Jim, unnaturally tired, as you can see for yourself," says Willie, looking just past my ear, "but tiredness is only a symptom . . . only a signal, isn't it?"

"Signal, signal?"

"That something has gone wrong. Your wife is sick, Jemmy."

"Sick! What the hell kind of a word is that for a doctor to use? 'Thank you, Doctor, for telling me. Here are your two guineas, and I will now go home and be sick.' Sick! Sick from what imaginary ailment beyond a natural fatigue?"

"I don't know."

"You don't know! Oh, better and better; you don't know, but of course she's got to be sick, else how would you pill-pushers manage to make a living?" I was up out of my chair, pacing around, slapping at bits of furniture in the course of my short parade. "Well, why *don't* you know, Willie?"

"Because I'm not a specialist."

"Why, yes, you are. What about all those larynxes?"

"There is nothing the matter with your wife's larynx."

"Damn decent of you to admit it, very decent, considering the loss in practice. So what do you propose?"

"I want to send Trixie to a specialist, a man who knows more."

"What kind of specialist?"

"Well . . . someone who's kept up with internal medicine better than I, that's all. His diagnosis will be trustworthy, but if you feel it isn't, we can get others."

"Yes, we can, can't we?" I got up to go. "Forgive me for my rotten nature, Willie, yelling at you."

"Yell at me all you like, Jim. Brothers are allowed to yell at each other. No harm done."

"No, I shouldn't, but it's just that I feel . . . Well, this business of Trixie's going to other doctors and so on, it *is* only so much precautionary professional rot, isn't it?"

"Yes, it's precautionary. I very much hope it's also rot."

So poor patient Trixie was put through another long examination and an endless series of tests, never complaining, mind you, but, oh, so drained of strength by them, enough to make a stone cry, you know.

And when all that was done I went to see this bloody "specialist," as Willie had described him, and demanded that he tell me the truth. Naturally, this was quite outside his professional province.

"We must wait, Mr. Whistler," says wretched Dr. Quack, brushing his white beard gently upward from his chin, tapping his front teeth with his pince-nez.

"Wait for what?"

"Laboratory findings, highly informed technical opinion and so on, all the pertinent information available." Well, Dr. Quack's office was twice as large as Dr. Willie's and better situated in Harley Street, so I thought I'd better be quiet and listen. But the doctor went on. "Whereupon," says he, "we will be able to arrive at a reliable diagnosis."

Now, it is my opinion that any man who says "whereupon" in the course of ordinary conversation must be a cad. How else explain it?

"Whereupon, Doctor," says I, "you will summon me back here to your office and instruct me in your findings?"

"No, no, that's not quite our way, Mr. Whistler. Every profession has its special etiquette, its professional traditions, has

it not? Your own . . . Well, no, perhaps not your own." The doctor forced himself to the special grimace that indicates gaiety along Harley Street. "I'm afraid I'm wading beyond my depth," he said. "Your brother, Dr. Whistler, having recommended your wife's case to me, is the one to whom I am obliged by courtesy to transmit my findings, and he, in turn, will transmit them to you."

"And you, *Herr Doktor*," says I, at his door, charming to the end, "are in gravest danger of ending your life strangling on a conjunction."

It was only a few days later that Willie sent me a note by messenger. He thought it best not to come to me, he said, but that I meet him in his office.

Willie wasn't sitting at his desk as usual when I arrived, but in a little side chair, as though he didn't want to be a doctor. So I sat behind his desk, putting his stethoscope around my neck, my foot on his desk, adjusting my eyeglass.

"Well, Willie," says I, "so, you see, it *was* all rot, wasn't it? Even Dr. Frankenstein agrees?"

"No, Jim, not entirely."

"Not entirely? Entirely, entirely? What does that mean?"

"Well . . . there are certain indications of . . . of a foreign growth, a malignant growth. I don't like having to tell you this, Jemmy."

I ripped his stethoscope from around my neck and threw it at my brother with all my strength and anger, striking him in the chest. Willie only set it on a chair, almost absently.

"What the hell do you know about such things!" I yelled at him, jumping up out of his desk chair.

"Not very much."

"You and your bleeding pompous chum down the street . . ."

"He's pretty well accepted as London's leading cancer specialist, Jim."

"*Cancer*. You dare use that word to me! How dare you, *dare*

you, God damn it! Trixie has about as much cancer as you have wit, meaning that both your slates are clean!"

"I'm only passing on a highly expert opinion," says Willie mildly. "But if you should want others, and I think for your peace of mind you should . . ."

"Oh, let us by all means dwell on my peace of mind, Willie! Your own contribution to it today alone is worth a Victoria Cross at the least. But it won't work, you know, not with Trixie and me. We're sensible people and we can't be taken in as easily as you think. You can't frighten us. We'll go back to Paris, we'll live a simple, quiet life, Trixie will rest until she's strong again, and live longer than you and Dr. Faustus put together."

"I'm all for it, Jimmy."

I was already halfway out the door, but there was a chill in my brother's amiable words that made me turn back, in spite of myself. "What do you mean you're all for it?" I said to him. "What kind of doctor are you, anyway? If you, as a doctor, really believed what you just told me, you'd prescribe something, wouldn't you? Some definite course of cure? Some medicine? Even some sort of surgery, if you believed it would make Trixie well?"

"Of course I would and I will. I thought that went without saying. I promise you Trixie will be made as comfortable as modern medicine can make her—"

"Comfortable!"

"—if you'll only let me help."

That we can only accept acceptable information is probably too banal an observation to notice, but at least I can prove it. The implication in Dr. Willie's words was altogether unacceptable. It seemed to me that I should tell him so.

"You're making up a whole doctor's daydream!" I shouted at him. "Liar! Faker! Doctor! I don't believe a single word you say! If you doctors know so bloody much, why don't you find the elixir of life instead of talking about making people 'comfortable'?"

"Only an expression."

"You condemn my wife to death without a single solid fact to go on, pious as a hanging judge!"

"No, no, I'm only saying that at the moment we don't know."

"And never will!"

"We may, Jimmy."

"Lie, lie! You don't know anything! You have to make things up to stay in your business!"

"You must hear other opinions."

"What for? To hear more self-serving lies?"

"No. To hear what some person may have learned in years of work. It happens all the time."

"And that's your scholarly remedy for Trixie?"

"We must wait and see, Jemmy."

"You may go to hell, Willie!" says I, fighting, fighting, for one must fight against the unimaginable.

And those are the last words I ever spoke to my brother, incredible as that may seem. A good man, he needed more gentle kin. May God forgive me for the sin of inexactness to him. Nothing is a worse evil, including murder, you see. One should not lie, even to one's brother. Only, when one must, to oneself.

Trixie and I went back to the Rue du Bac, Trixie mostly in bed for a good rest. Mr. Freer's lovely lark woke us each morning with its song, making hopeful sounds from its perch, until Trixie slept again. We stayed only a month or two, as it turned out. You can't, after all, just sit and watch someone suffering from even a trifling illness. Pain must be allayed. The idiots must be employed, if only because they have a monopoly on the useful nostrums. Trixie had a clearer head than I.

"Jimmy, dear," she said one day, drowsing after lunch, "the doctors in London think I have a cancer."

"Never use that word to me again! What does it mean? *They* don't know. Hiccups would serve as well."

"Well, then, hiccups, if you like. But rather severe hiccups, my darling, and even if they don't know how to cure hiccups, they do seem to know how to make you hic a bit less."

374

It is really quite astonishing what a swine devotion can make of a man. Selfishness called optimism, or whatever, self-support, is all it is. Trixie's pale face was closer to the truth.

"We'll go back to England tomorrow, Trixie," says I. "See what the blighters can do. And forgive me."

"For what?"

"Loving you more than's good for you."

"Pretty good fault I should have thought, Jim."

What is the good of describing in detail, of protracting the anguish of the next year and a half of our lives? There is none, and I will not. For the most part Trixie and I simply moved from pillar to post, all on the advice of the multitudes of doctors, for senseless reasons of climate or altitude or natural springs, or similar recommendations by which the unknowing doctors must survive—from the Red Lion Hotel in Lyme Regis back to London to apartments in Half Moon Street to Garland's Hotel in Suffolk Street to rooms in the Savoy, high up, overlooking the grand and artistically useful Thames.

I even came, almost, to understand the doctor's special plight. It is essentially hypocritical, of course, because it is a bylaw of his trade that he must have an answer of some sort to suit any situation at all, however unanswerable. But he keeps you busy, which has a certain use. You cough? Go south. You sneeze? Go north. You have a pain in your vitals so agonizing that you scream in the night and the only way to keep from making a fool of yourself in the day is to clench your teeth and bite your tongue, unmanageable tears in your eyes? Well, take rooms at the swank Savoy, you know. Morphine will also help.

I pause at the Savoy for a particular reason, not because it was the end of our hegira but because it was a curious sort of turning point for me. We had a little suite of rooms in the hotel, seeing the river from the balcony.

One morning Trixie was lying in bed, snoozing a bit, looking very sweet, and I did a little watercolor sketch of her. It was damn good, you know. All the simplicity and inner gravity that so many chaps can't do, while losing none of Trixie's charm.

At the bottom of the paper I scribbled "The Siesta," because that was what I was still telling myself it was.

Now, you must accept an awful man, for I won't name him. He came from a newspaper wanting to talk to me, to get information from me, for a Sunday article of some sort, I don't remember what it was. More foolish foreign medals or something.

But he looked at Trixie, stretched out on her chaise-longue, pale-faced and thin, and he looked at my watercolor called "The Siesta," and when I was showing him to the door he turned for a moment and said, at a whisper, "Is it positively a *siesta*, Mr. Whistler? The right name, you think?"

I reached for a cane—there were several in a sort of tall jar in the hall—found an earnest one and began to flay wildly about this particular journalist's head, but journalists are used to this sort of thing and run faster than most of us.

"Yes, a *siesta*, a *siesta!*" I roared at him. "You foul and monstrous ink-stained wretch, *siesta!*" One pretty good shot got him on the left ear as he fled out the door, but that was all. It would please me very much some day to hear of an unemployed one-eared journalist, but I suppose I won't have the luck.

The point of the incident—monsters can make points as well as the saints among us—is that I made no more sketches of Trixie called "Siesta" or "Napping" or "Dozing" or whatever. I sketched her dozens of times, but the sketches now had no names; they were not called anything.

"But you must do your work, Jimmy," says Trixie. "You mustn't let me keep you from it. It's good for you, your work. I'll feel guilty if you don't."

"All right then, Trixie, I'll work," I said, and I brought a lithograph stone into her bedroom. It didn't turn out very well in the end, as a matter of fact, because I wanted to sit up at her bedside during the nights as she slept, off and on, not well, waking at any moment in need of medicine, and it was difficult to concentrate on the stone. Sometimes I fell asleep myself, not sure of the time when I woke again.

Both Sargent and Walter Sickert offered me their studios to work in when I chose, and for a time I tried to work in one or the other of them in the afternoons, but I kept falling asleep, you see.

My mind wouldn't stay with a bit of work, either, even when I was awake. If I wasn't in Trixie's room, part of my mind was there and work didn't amount to much. It was becoming gradually, no, swiftly, more and more apparent to me—the rouser who had explained to the world that art *was* life, the seed and the flower—that there might be a trifle more to it than that.

Trixie's anxious bedside became my true world. At the very beginning I couldn't believe it in myself, so sure I was that the serious practice of making art was an absolute and total fulfillment of life.

But one betrays oneself, no matter what one *thinks* one thinks. For in the end I will give you, singing happily, you know, everything I have ever painted, ripped to shreds, throwing in for good measure the Sistine Chapel and five alarmingly great Velásquez portraits, all bombed out of existence, if the doing of it would take away a single pathetic whimper of pain from Trixie's awful night.

I am told that I did not appear well in these times, which is no doubt true. My white forelock began to blend with the rest of my hair, or, to put it the other way around, the rest of my hair began to blend with the forelock. I forgot to lie about my age. My clothes lacked thoughtfulness.

One day as I was hurrying to a chemist's shop in Regent Street for some pills, I think it was, I bumped into my friend Joseph Pennell, the American etcher and honest man. I hadn't much time to spend in chitchat, you know, but the man brought me up rather short.

"Whistler," says he, "you're wearing one black shoe and one brown shoe. Is it a new fashion?"

I looked down at my feet, and do you know it was quite true? Amazing. No one would have believed it of me not long

before. But I somehow hadn't noticed, very stupid. I had to get out of it with a joke, a particularly small joke, as will be apparent, but the plain fact gave me rather a shake.

"No, no, Pennell," says I. "You see, I have a corn on my left foot and that takes brown."

I hurried on, I hurried on along Regent Street to the chemist's, pretending a slight limp.

Spring came to us at last and with it another move. We left our rooms at the Savoy and went to a place called St. Jude's Cottage in Hampstead, a "nursing home," it was called, recommended by whichever croaker we were then in thrall to.

It was May and most lovely, Hampstead Heath all in flower. Trixie, deep in drugs, saw nothing of it, only the little I could bring to her bed, as a buttercup or a dandelion, she pressing them for a moment against her mouth, at once to fall asleep again.

Now, I don't know whether I can write about this as I should. I will do my best, but that may not be very good, because what is the most vivid image of my life is at the same time the one I try most consciously to excise from whatever part of my brain lodges it. I do so daily, as a surgeon with his knife may cut away diseased tissue. Only, unlike the surgeon, I don't succeed.

Gallant Trixie, shrunken now to nearly three-quarters her size, little arms like broomsticks, her wild and fevered eyes staring out at a bewildering world, groped on the coverlet for my hand. It was a hand I had had to learn not to squeeze, not to press too firmly through the long nights, for it was so fragile, you see, I could cause her pain.

"Jimmy . . ."

"I'm right here, my darling. Perhaps you should sleep a little longer."

"No . . . Jimmy?" She spoke as if she must hurry.

"Yes?"

"You're an awfully nice man, Jimmy Whistler," says my Trixie, dying, "no matter what they say."

In a little I ran out onto Hampstead Heath, ran and ran like a crazy man, without direction or purpose. A man saw me, an acquaintance, I don't know who it was, caught up with me, alarm in his face. I knocked him aside with my elbow.

"*Don't speak!*" I yelled at him. "*Don't speak!*" And I ran on.

There is nothing more to go on about, really. Or, what little there is I've already written in a letter to Charles Freer, American railroad baron, though not in response to his gracious letter of condolence.

". . . She loved the wonderful bird you sent with such happy care from the distant land! And when she went—alone, because I was unfit to go too—the strange wild dainty creature stood uplifted on the topmost perch, and sang and sang—as it had never sung before. A song of the sun—and of joy—and of my despair. Loud and ringing clear from the skies—and louder! Peal after peal—until it became a marvel the tiny beast, torn by such glorious voice, should live.

"And suddenly it was made known to me that in this mysterious magpie waif from beyond the temples of India the spirit of my beautiful lady had lingered on its way—and the song was *her* song of love, and courage, and command that the work, in which she had taken part, should be complete—and so was her farewell.

"I have kept her house in Paris—in its fondness and rare beauty, as she had made it—and from time to time I will go to miss her in it."

I do not pray in the Temple of Art.

EPILOGUE

*W*ELL, NOW, you know, one must keep up appearances as one grows a bit older. One owes it to oneself, to one's friends. As I approach seventy— though looking nothing of the sort, of course—it is nowadays only polite for me to elude the clock. I have never thought much of clocks.

For example, one does not slump while walking, in spite of some ridiculous lumbar twinge; one gains no extra weight, or at least such must be the impression, which amounts to the same thing. One's hair and mustache must be properly groomed, one's eyeglass must glisten as brilliantly as it has always done. I consider it a simple social obligation to present the *expected* Whistler.

Such thoughtfulness is not universally understood, as I discovered tonight, guest of honor at the London townhouse of a marchioness—exactly which marchioness, I'm not absolutely sure, to be honest, for in these times I am forced to turn down four invitations to accept the fifth, so much am I London's special lion, secure in my present glorious reputation, secure a trifle late in the season perhaps.

May God damn all your vile and chancy seasons, letting simple merit draw a breath! No? No, and I'm growing shrill, which has certainly never been my way.

I was admitted to this very elegant house by a young footman in livery, who took my hat and stick and ushered me along the entrance hall.

(The house, by the way, was not far from Leyland's house

and my Peacock Room, and I wondered again, as I have occasionally wondered before when I happened to be in this part of the city, if that room is in fact a work of art or merely an ostentatious conceit, which I sometimes nowadays suspect. Well, I'll never know, of course, since I haven't seen it for thirty years and assuredly never will again. But it's odd in me to wonder about such things. I never used to wonder.)

I paused in the hall before a mirror, letting the young footman precede me into an adjoining room. From there I overheard a brief whispered conversation between him and an invisible parlor maid. A pretty parlor maid, I hoped, possibly his lover? I am all in favor of domestic love.

"There's got to be some sort of mistake, Mildred," he whispered in an anxious voice. "There's a strange old actor out there in the hall."

"Never!" whispers lovely, unseen Mildred.

"He's wearin' a tight corset anybody could see from a mile off, rouge on his cheeks, and he's arrangin' his dyed black curls in front of the mirror, primpin' up proper."

Well, the younger generation, so long as it remains young, should not be expected to understand the older's sense of social responsibility. How can they know, for example, what my hostess expects of Jimmy Whistler?

Undismayed, I entered the drawing room, a gracious gentleman. There is so little choice, is there not? I greeted the marchioness, whichever marchioness she is, kissing her hand, for marchioness's hands are intended for no more lively purpose. And the marchioness was an art fancier, it turned out. Knows everything. Knows a Nocturne from an Arrangement. So she said, it must be true.

Oh, one more thing before we go in to dinner. One of my dealers told me today something amusing. Well, relatively amusing—it depends really on how much grand larceny makes you laugh.

Fumette, wherever, would laugh, and General Robert E. Lee

and Rossetti and old Legros and Seymour Haden and honest Bailiff Bright and even batty Ruskin would laugh.

My dealer told me—and there were anxious tears in his eyes, having to do with business reasons—that there exists today a widespread and most profitable underground traffic in *fake* "Whistlers."

Ha-*ha!*